The Handbook of Art and Design Librarianship

Every purchase of a Facet book helps to fund CILIP's advocacy, awareness and accreditation programmes for information professionals.

The Handbook of Art and Design Librarianship

Second edition

Edited by
Paul Glassman and Judy Dyki

facet
publishing

Published by Facet Publishing
7 Ridgmount Street, London WC1E 7AE
www.facetpublishing.co.uk

Facet Publishing is wholly owned by CILIP: the Library and Information Association.

British Library Cataloguing in Publication Data
A catalogue record for this book is available from the British Library.

ISBN 978-1-78330-200-0 (paperback)
ISBN 978-1-78330-201-7 (hardback)
ISBN 978-1-78330-202-4 (e-book)

First published 2010
This second edition 2017

Text printed on FSC accredited material.

Typeset from author's files in 10/13pt Elegant Garamond and Myriad Pro by Flagholme Publishing Services.
Printed and made in Great Britain by CPI Group (UK) Ltd, Croydon, CR0 4YY.

Contents

List of figures and tables

Figures

Tables

Notes on contributors

Editors

Judy Dyki is Director of Library and Academic Resources at Cranbrook Academy of Art and Editor of *Art Documentation: Journal of the Art Libraries Society of North America*.

Paul Glassman is Director of University Libraries and Adjunct Instructor of Architectural History and Design at Yeshiva University. He teaches art librarianship and library design at Rutgers during the summer session.

Contributors

Leo Appleton is Director of Library Services at Goldsmiths, University of London.

Greta Bahnemann is Metadata Librarian at the Minnesota Digital Library of the University of Minnesota.

Sandra Ludig Brooke has been Head of Princeton University's Marquand Library of Art and Archaeology since 2007.

Jonathan Bull is Scholarly Communications Services Librarian at Valparaiso University.

Alyssa Carver is an assistant librarian and project archivist for the Chip Kidd Papers at the Special Collections Library of the Pennsylvania State University.

Pat Christie has been Director of Libraries and Academic Support Services at University of the Arts London since 2012 and was chair of ARLIS/UK & Ireland from 2009 through 2011.

Rachel Ivy Clarke is an assistant professor at Syracuse University's School of Information Studies. She was previously the Cataloguing Librarian at the Fashion Institute of Design & Merchandising in Los Angeles, California.

Rebecca Coleman is Research Librarian for Architecture at the University of Virginia, where she has built and maintained a materials collection in the Fine Arts Library.

Nancy Fawley is the Director of Information & Instruction Services at the University of Vermont in Burlington.

Katie Greer is the Fine and Performing Arts Librarian at Oakland University in Rochester, Michigan.

Catherine Haras is the Senior Director of the Center for Effective Teaching and Learning at California State University, Los Angeles, with a faculty appointment in the University Library.

Amanda Nichols Hess is e-Learning, Instructional Technology, and Education Librarian at Oakland University in Rochester, Michigan.

Stephanie Kays is Fine Arts Liaison Librarian at Denison University.

Jeannine Keefer is Visual Resources Librarian at the Boatwright Memorial Library of the University of Richmond.

Ken Laing is Co-Ordinator of Library Operations at Emily Carr University of Art and Design.

Karen Latimer is Chair of the Designing Libraries Advisory Board UK, a member of the LIBER Architecture Group and a former chair of the IFLA (International Federation of Library Associations) Library Buildings & Equipment Standing Committee.

Sarah Mahurter is Manager of the University Archives and Special Collections Centre and convener of the Archives and Special Collections Community of Practice at University of the Arts London.

Beverly Mitchell is Assistant Director and Art and Dance Librarian at Hamon Arts Library, Southern Methodist University.

Gustavo Grandal Montero has been a librarian and special collections curator at Chelsea College of Arts and Camberwell College of Arts, University of the Arts London, since 2007 and has been Deputy Editor of *Art Libraries Journal* since 2012.

Beth Morris is an assistant librarian at the Yale Center for British Art, Reference Library and Archives, where she has served since 2011.

Rachael Muszkiewicz is a research services librarian at Valparaiso University.

Barbara Opar has worked in architectural librarianship at Syracuse University for over 40 years.

Clive Phillpot is Publisher, Fermley Press, London, and former Director of the Library, Museum of Modern Art, New York.

Mark Pompelia has been Visual + Material Resource Librarian in the Fleet Library at Rhode Island School of Design since 2010 and was the founder and five-year moderator of the Materials Special Interest Group for Art Libraries Society of North America.

Colin Post is a doctoral student in the School of Information and Library Science at the University of North Carolina at Chapel Hill.

Andy Rutkowski is the Geospatial Resources Librarian at the University of California Los Angeles.

Lori Salmon, who indexed this edition of the *Handbook*, is Librarian in the Art & Architecture Collection at the New York Public Library.

Molly Schoen is the Visual Resources Curator at the Fashion Institute of Technology.

Lee Sorensen is the Photography, Art History and Visual Studies Librarian at the Lilly Library, Duke University.

Aimee Tomasek is the Chair of the Department of Art at Valparaiso University.

Patrick Tomlin is Associate Director of Learning Environments at Virginia Tech.

Alexander Watkins is an assistant professor and the Art & Architecture Librarian at the University of Colorado Boulder.

Hillary Webb is Systems and Technical Services Librarian at Emily Carr University of Art and Design.

Tony White is the Florence and Herbert Irving Associate Chief Librarian at the Metropolitan Museum of Art.

Stacy R. Williams is the Head of the Helen Topping Architecture and Fine Arts Library at the University of Southern California.

Michael A. Wirtz is an associate professor and Head of Research and Library Technology at Virginia Commonwealth University in Qatar.

Foreword

Why is there a demand for a handbook of art and design librarianship? Presumably this book is needed by what I will call 'art librarians' (even though this entity is made up of several species, including, notably, 'design librarians'). Would not a handbook of librarianship be enough? Well, the success of the first edition of this work, which ran to 330 pages, suggests not.

Why might art librarians, or budding art librarians, require their own specialized handbook? Perhaps it is the 'art' in art librarianship that is the fly in the ointment. Libraries devoted to art, or to art and design, are inevitable, for there are, after all, libraries devoted to any subject you can imagine: maritime libraries, music libraries, zoological libraries, and there are, of course, many kinds of art libraries. Even so: why do we need specialist art librarians?

It must be that art librarians bring other skills or knowledge to libraries of art. Foremost among these qualities must be a knowledge of art and design and art history – even an inside knowledge of art.

The art librarian needs not only to speak the language of art and design but also to be able to read images and objects, to be highly visually literate. That there are such requirements for the art librarian, as well as the need to be in the swim of new ideas and techniques in library science reported in such a book as this, is testimony to the challenges and complexities of connecting hungry users with their prey.

So how might such knowledge help art librarians to engage with their users? It concerns their ability to understand the terms of reference of the users, and thereby to better interpret their needs. Some users of art libraries will have far-out preoccupations; if so, one's attempts at connecting them involve the kind of process that makes art librarianship interesting. Inevitably art librarians, like other librarians, are engaged in life-long learning.

Art librarians facilitate connections between people and art, and most of these interconnections begin at the level of sharing data. Initially the librarian and the user

need to agree on the nature of an enquiry through conversation, or by interrogating images. Then the enquiry might be satisfied with surrogates for art: prose, reproductions, books of images, electronic duplicates, filmic doppelgangers and other forms of information.

In parenthesis, it should be noted however that occasionally art librarians are privileged to be able to respond to enquiries with art itself – witness the portability of movies, prints, some art objects, conceptual art documents, book works and images of many kinds in many forms of presentation.

The contributors to this book are writing from the front line. So, art and design librarians of the world, read on, you have nothing to lose but your innocence.

Clive Phillpot
Fermley Press, London
(formerly Director of the Library, Museum of Modern Art, New York)

Preface

In the seven years that have passed since the publication of the first edition of this handbook, the world of art and design libraries has been rocked by rapid advances in technology, an explosion in social media, the release of new standards and guidelines, shifts in the materials and processes of contemporary art, innovative developments in publishing models, expanding roles of librarians, new perspectives surrounding library spaces, and the evolving needs and expectations of art and design students. What has not changed is each library's deep commitment to art, which manifests itself as collections that are developed around images and objects; library instruction with an emphasis on visual literacy; and a student body consisting of artists, designers, art historians and art educators who approach the use of the library in unexpected and creative ways.

The goal of this second edition is the same as the first: to present a selection of essays that take a careful look into the world of academic art and design libraries, whether they are part of universities or support independent art and design schools. A few of the essays are revised and updated from the first edition, but most are new to this book and present topics that are now gaining prominence in the profession. Throughout the handbook, authors were asked to maintain an international perspective in their research and examples.

The volume is divided into six sections with three to eight chapters in each. Part I, 'Roles and responsibilities', considers several management concerns faced by art and design librarians. These include the general governance and administration of the library, evolving trends in the field, the changing roles of the art librarian, accreditation procedures and design thinking. One of the characteristics that distinguish art and design libraries from other libraries is their unique collections. Authors in Part II, 'Materials and collection management', explore visual resources, digital collections, archives, special collections, artists' books and materials collections in the context of the library.

Library instruction is a large and important part of the work of academic and art and design school librarians, and new methods and priorities are reshaping the field. Chapters

in Part III, 'Teaching and learning', examine embedded librarianship, threshold concepts and the *ACRL Framework*, teaching with special collections, meta-literacies, instructional design and cultural differences. Part IV, 'Knowledge creation', investigates the involvement of art and design libraries in developing new information, including digital art history, digital map-making, professional exhibition opportunities and scholarly communication.

The physical design and space usage of the library have undergone dramatic transformations in recent years. The chapters in Part V, 'Physical environment', look at contemporary library design, effective classrooms for library instruction and developing spaces for collaboration. Unless users are aware of a library's collections and services, even the most compelling facility will be under-used. Part VI, 'Promotion and sustainability', presents effective methods for developing marketing plans, using social media, and designing websites to engage the target audiences. The final section of the book contains profiles of the authors' libraries. Even a quick scan of this listing demonstrates the wide diversity in size, collections, facilities and staff that exists among art and design libraries.

The field of art and design librarianship continues to be challenging and energizing. Our sincere thanks are extended to all of the chapter authors who shared their wisdom, knowledge and enthusiasm for working with some of the most beautiful collections and imaginative patrons on the planet.

Part I

Roles and responsibilities

The task of organizing material and making it accessible to a constituency is no longer the totality of academic librarianship – nor is it a straightforward undertaking – and collecting material in a variety of formats represents, for the contributors in this section, only one aspect of the profession. Understanding campus culture and politics (and employing that understanding wisely), communicating across disciplinary boundaries and administrative zones, shepherding projects to completion, staffing and supervising, understanding the information-seeking behaviour of library users, managing change and planning programmes for the purposes of outreach and public relations. Some or all of these feature prominently in the set of responsibilities of the responsive and successful art and design librarian. Library science education has evolved over the past two decades, mostly in response to the cosmic shift from print and analogue to digital formats, but library science education remains heavily theoretical nonetheless. As a result, most of us have little formal training or indepth practical education in key administrative roles, such as budget manager, accreditation self-study co-ordinator, public relations writer or project manager. The following chapters outline key aspects of many of these roles and offer step-by-step guidance and keys to success.

Chapter 1

The governance and administration of the art and design library

Paul Glassman

Introduction

Whether supervising a professional library with support staff members or acting as solo librarian in a one-person library, the library manager will benefit from basic administrative tools. Starting with questions about parent organization's governance structure, this chapter recommends essential administrative and managerial tools for the art and design library: the mission statement, long-range or strategic planning, shorter-range annual plans (known also as operating or business plans), fundamentals of administration, promotion and advocacy, financial support, management of materials (the library's nonpersonnel assets) including electronic resources, performance appraisal and accreditation.

Governance

Notably, among the first aspects of art and design libraries examined by the National Association of Schools of Art and Design (NASAD; https://nasad.artsaccredit.org) is governance. The UK Arts and Design Institutions Association (www.ukadia.ac.uk/about/aims-objectives) also emphasizes best practices in administration and defines one of its goals as 'To provide a platform to share good practice in academic development and managerial effectiveness for specialist arts and designs institutions'. Even if you are not engaged in an accreditation self-study, it may be useful to understand the relation of the library to its administration.

In discussing library governance, NASAD states: 'The functional position of the art/design collection within the total library structure shall be clearly identified, and the responsibilities and authority of the individual in charge of this collection shall be defined' (NASAD, 2016–17, 65).

The organizational structure of the design library in relation to the larger context of the academic library varies within institutions: it may be a collection within a central

library; it may be a branch library; it may also be either of these with the addition of a resource, materials or product collection in proximity to the studios. This chapter will describe a variety of scenarios and management tools.

In understanding the governance of the larger institution, the librarian will develop an awareness of the larger institutional culture and degree of collegiality. These relationships can be understood by examining the reporting structure for and within the library, which might be expressed through an organizational chart that addresses these questions:

- To whom is the library director accountable, and who supervises that individual?
- Who develops and administers policy for the library?
- Do the librarians have faculty rank and status?
- If so, do they serve on a faculty or academic senate?
- What is the procedure for reappointment, promotion and tenure?
- Is the library director a faculty member?
- If so, who evaluates the library director?
- Does the library director serve on a curriculum committee or on a president's council?
- If the library or library representative does not serve on the curriculum committee, how are the information needs of a new academic programme relayed to the library?
- If the library director does not serve on the president's council, how are library goals and their resulting needs relayed to upper-level administration and other key decision makers?
- If librarians do not have faculty status, how do they relate to the faculty?
- Do librarians serve on faculty committees, even if they do not have faculty status?
- If not, how do committees, such as a curriculum committee, assess the implications of new courses and academic programmes for the library?

If there are multiple library sites, their relation to one another is important:

- Who supervises each?
- Are there adequate communication channels between the sites, or from the subsidiary sites or branches, to the central facility?

Branch libraries provide the opportunity for additional examination:

- Do librarians attend the departmental faculty meetings of those curricular areas they serve?

- Does the branch director meet regularly with the deans or department heads of those curricular areas they serve?

Mission statement

A mission statement quickly and concisely identifies purpose, connects it to the mission of the parent organization, and describes briefly what the library does (Policastro, n.d.). Even if there is a solo librarian, there is value to the clarity a mission statement provides. A library committee, president's council or other governing body may approve the mission statement, and the approval process in itself affirms the presence of the library. If there is concern about confusion between the larger institution's mission statement and that of the library, the latter can be referred to simply as a statement of purpose.

Planning

Although time-consuming, both short-term and long-range planning strengthen time management by setting priorities, enhance internal communication by clarifying goals, and cultivate support by providing language for envisioning the future. Strategic or long-range plans establish the goals of an institution or unit for a specified period of time, usually between three and five years. They often begin by examining strengths, weaknesses, opportunities and threats (a SWOT analysis). This simple listing allows the agency to assess its place in relation to similar or competing interests within its community. Beyond that benefit, the planning process is often, with staff members at all levels participating at one time or another. By pursuing an inclusive planning process and infusing that process with openness and deferred judgement, the facility or institution permits itself to imagine the future more broadly. The expression of the plan need not be lengthy or detailed. In fact, a concise plan may resonate more effectively and lend itself to essential annual progress review (Figure 1.1, page 6). Work groups can assume responsibility for action steps and their implementation.

A library's annual plan, also referred to as an operating plan, is equally valuable: it clarifies to library staff what the priority projects will be, outlines a timetable for those projects and aligns them with the annual budget. It may serve as a useful tool for developing the next year's budget request and may provide a persuasive rationale for that request to the budget overseers. With the emphasis from accrediting agencies on regular assessment, the annual plan may take the form of an assessment matrix (Figure 1.2, pages 6–8), which incorporates a focus on continuous improvement (Middle States Commission on Higher Education, 2009, 2). The outcomes analysis and indication of changes comprise the assessment, which occurs at the close of the academic year.

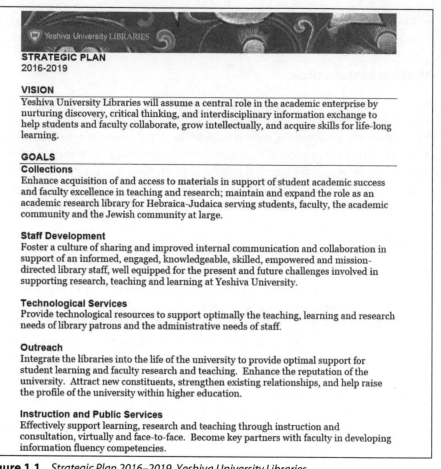

Yeshiva University LIBRARIES

STRATEGIC PLAN
2016-2019

VISION
Yeshiva University Libraries will assume a central role in the academic enterprise by nurturing discovery, critical thinking, and interdisciplinary information exchange to help students and faculty collaborate, grow intellectually, and acquire skills for life-long learning.

GOALS

Collections
Enhance acquisition of and access to materials in support of student academic success and faculty excellence in teaching and research; maintain and expand the role as an academic research library for Hebraica-Judaica serving students, faculty, the academic community and the Jewish community at large.

Staff Development
Foster a culture of sharing and improved internal communication and collaboration in support of an informed, engaged, knowledgeable, skilled, empowered and mission-directed library staff, well equipped for the present and future challenges involved in supporting research, teaching and learning at Yeshiva University.

Technological Services
Provide technological resources to support optimally the teaching, learning and research needs of library patrons and the administrative needs of staff.

Outreach
Integrate the libraries into the life of the university to provide optimal support for student learning and faculty research and teaching. Enhance the reputation of the university. Attract new constituents, strengthen existing relationships, and help raise the profile of the university within higher education.

Instruction and Public Services
Effectively support learning, research and teaching through instruction and consultation, virtually and face-to-face. Become key partners with faculty in developing information fluency competencies.

Figure 1.1 *Strategic Plan 2016–2019, Yeshiva University Libraries*

Office/Department/Unit Name: Library & Information Services				
Mission Statement: The Felician College Libraries are a centre for knowledge, discovery, instruction and the exchange of information, ensuring access to a set of global resources, with the overarching purpose of helping students and faculty, both on and off campus, conduct research, collaborate, explore an increasingly complex architecture of information, achieve academic success and acquire skills for life-long learning.				
College-wide goals	Unit objectives	Assessment tools and measurements	Outcomes analysis	Changes based on results
To affirm, uphold, and perpetuate the centrality of the Catholic, Franciscan, Felician tradition in a 'Students First' environment.	1. Increase opportunities for student productivity. Introduce technology for access to new formats.	1. Purchase, promote, and circulate iPads or equivalent e-readers by start of fall semester. 2. Install room divider in lower-level group study to preserve goal of two group study rooms during summer.	1. College acquired iPad in late fall semester. 2. Installed in December.	1. Moderate use by students. Will be promoted further in fall. Library faculty will use iPads in workshops and classes.

Figure 1.2 *Assessment template for Felician College Libraries*

Figure 1.2 *Continued*

College-wide goals	Unit objectives	Assessment tools and measurements	Outcomes analysis	Changes based on results
	2. Maintain the Library as an arena for collaboration and productivity. 3. Meet the needs of Rutherford-campus students for collaborative work space and library services.	3. Promote group study areas in Blessed Mary Angela BMA Hall Business Library at start of fall semester. Implement refurbishing of Toron Curriculum Library to accommodate reference services, group study, quiet study, and instruction. Complete by September 1.	3. Blessed Mary Angela group study promoted with Library Updates. Toron refurbishing completed for fall semester.	2. Capacity for group study doubled. 3. Toron Curriculum Library attracts students from all disciplines. Success resulted in request for extended hours to midnight for fall in upcoming budget.
To offer Academic and Professional programmes within the Liberal Arts tradition that promote learning, integrity, competence and service.	1. Provide an in-depth, credit-bearing course for acquiring information literacy skills.	1. Enrol all library faculty in e-certification courses in spring and fall. 2. Open conversation in Library Committee and faculty meetings for a campus-wide information literacy plan and the place of information literacy in the general education curriculum.	1. Two library faculty members have completed the course. 2. Begun in fall semester and will continue in spring semester.	1. Both faculty members taught pilot sections of The Architecture of Information 1-credit course. 2. Revised curricular commons required The Architecture of Information 1-credit course.
To ensure a high-quality learning experience for a diverse student population through strong student development and academic support systems.	1. Provide instructional opportunities for off-campus and transfer students. 2. Increase student success and retention.	1. Revise and update existing video tutorials. Provide off-campus information literacy instruction with video conferencing. Train library faculty in use of video conferencing by September. Introduce option at faculty meeting during fall semester. Create three instructional animations by January 15. 2. Introduce pilot programme of personal librarians for probationary and/or at-risk students in fall.	1. To be completed spring semester. New video conferencing software identified in late fall. Will be piloted with one library faculty member in spring. Will be completed in the spring. 2. Completed. The programme will continue in spring.	1. Piloted in advance of half of first-year experience user education sessions. Post-session testing indicated 30% higher mastery for flipped sessions. 2. Faculty members provide qualitative assessment indicating improvement in content and form of final projects.
To provide faculty, staff, and administrative development programmes that promotes professional growth, sensitivity to the diverse needs of all members of the College Community, and the quality of student learning.	1. Support a culture of continuous improvement.	1. Propose two workshops on the integration of information literacy competencies into teaching and learning for each Faculty Development Day (January and June), with each Library faculty member presenting at least once during the year. 2. Subscribe to and implement LibQual+® survey in spring.	1. Offered in January session. 2. Budget retrenchment disallowed this.	1. Fully enrolled with lively Q&A session.

Figure 1.2 *Continued*

College-wide goals	Unit objectives	Assessment tools and measurements	Outcomes analysis	Changes based on results
To develop and implement assessment strategies which measure learning, integrity, competence and strengthen confidences in the College and its programmes.	1. Employ assessment tools in information literacy instruction to measure student growth and library faculty effectiveness.	1. Continue to employ and tabulate data from the post-tests that have been piloted and refined for use in the First-Year Experience (FYE) programme.	1. Will be completed in spring semester.	1. Longitudinal analysis will indicate direction for revision, if any.

Promotion and advocacy

In an era of functional consolidation on campuses, plentiful but unauthoritative information online, and closer scrutiny of cost centres (whether or not they are central to the institutional mission), reminding multiple constituencies of the value of the library has become essential. If delivered in the form of a concise, well designed template (Figure 1.3), the library can produce a regular newsletter, be it in paper form, web based or a monthly

Learn about the **renovation of the Mendel Gottesman Library** of Hebraica-Judaica (levels 5 and 5A) scheduled for this summer. ROART will present the schematic design for the project on Monday, May 8 at noon in the Mendel Gottesman Library Building, 2nd floor by the new windows along Amsterdam Avenue.

Steven Fine, the Dean Pinkhos Churgin Professor of Jewish History and founding Director of the Center for Israel Studies, will present his recent book **The Menorah: From the Bible to Modern Israel** (Harvard University Press) and discuss it with Shulamis Hes, Electronic Resources & Reference Librarian, on Monday, May 8 at 6:30 p.m. in the Laulicht Commons, room 102, on the Beren Campus, 245 Lexington Avenue.

Join us for a **Celebration of University Authors** on Thursday, May 4 at 4:00 p.m. in the Sky Café.

Figure 1.3 *Example of a Yeshiva University Libraries Update*

email message to the whole institution, noting new services, books, journals or web-based subscriptions that would be of interest.

Library committees can play an important part in advocacy as well. The library committee is usually a small, multidisciplinary group that acts as a liaison between the library, its users and the administration. Advisory in nature, its purpose is to assist the librarian in planning and achieving library goals. Committees can be involved in collection development (and deselection), promotion of library programmes to students via classroom announcements, and serving as liaisons to committee members' academic departments and divisions.

Considerations in establishing a library committee include clarifying its advisory role and relation to the library director or representative of the library. If the chair is other than the library director, there needs to be a mechanism for electing or appointing the chair. Meeting frequency, charge or mission, and method of appointment and terms of committee membership, all merit definition. If membership is by invitation (perhaps from the chief academic officer), faculty members and administrative members who already show an interest in the library and its services are likely to become strong committee members and the library's most effective champions.

Interagency agreements

Co-operative agreements can enhance the services the library provides through reciprocal access and borrowing privileges, union catalogues, interlibrary loan, technical support and professional expertise.

If the library participates in any consortia or co-operative agreements, the terms of those agreements are important, and the library director may participate in their nego-tiation. Alternatively, institutional practice may require that an upper-level administrator assumes that responsibility. Nevertheless, the primary contact between the library and the consortium needs to be identified, the mechanism for making operational decisions at the co-operative level needs to be evident, and the library's participation in the decision-making process needs to be defined. If consortium members share an integrated library system, understanding how it is managed and how the library participates in its administration and operation are reasonable components of the negotiation process.

Time management

In smaller libraries especially, time management may be challenging if individuals are expected to accomplish several tasks, play multiple roles and service various constituencies simultaneously. Building personal relationships in complex academic environments is likely to ensure support of the library much more readily than immaculate cataloguing or flawless circulation procedures, recognition for which may prove elusive (Wagner, 2008). Since library science degree programmes often place more

emphasis on procedures rather than on relationship-building, librarians early in their careers will benefit from a clear sense of priorities. Including cultivation of support and other less quantifiable goals in the annual plan may help achieve a balance of task-related and interpersonal activities (Delumeau, 2005; Patterson, 1999; Pausch, 1995).

Decision making

Closely related to effective time management is sound decision making. Some decisions can be made spontaneously (and independently), others require research, and still others merit a collective process. Knowing when to consult peers, when to seek professional advice, and when to confer with upper-level administrators is instinctive for some and can be learned by others. All library managers benefit and achieve success sooner if they acquire a simple set of strategies for making good decisions (Hayes, 2001). A general rule and strategic approach is to support decisions and requests with data and always to link them back to the mission statement. Powe and Plung (2001) identify four principles of strategic decision making: maintain a basic philosophy of library operations, carefully articulate reasons for decisions, pursue interlibrary networking and co-operation, and assess internal and external influences.

Budget development

The administration of an institution may or may not allow the library director to take a significant role in the budget process. However, no one understands the library's operation as well as the library director and no one else can more accurately predict its future financial needs. Being prepared, as well as having the opportunity, to justify and rationalize the budget request increases the likeliness of approval from financial officers. Line item budgets are the most common and easiest to prepare. They show expenses broken down by major categories, and those that align with statistical surveys, such as the Association of College & Research Libraries annual survey and the Library Statistics Program of the National Center for Educational Statistics, administered through the Integrated Postsecondary Education Data System, allow for easier and more efficient completion of those surveys (NCES, 2016). Miscellaneous expenses are best kept to a minimum. A standard approach to budget development begins with a report of actual expenses from the previous year. These are some expense areas to include:

- salaries and benefits (not all institutions separate these by department, and often benefits, such as medical insurance, are reported by the institution only)
- books
- non-print physical materials (if any), such as microforms and DVDs
- purchased electronic materials (e.g. electronic books)
- journal and other serial subscriptions

- subscriptions to electronic resources (e.g. indexes, fulltext databases)
- supplies
- cost of purchased services (e.g. outsourced cataloguing or processing of materials)
- equipment and furnishings (often part of a separate budget for capital expenditure, which add to the institution's physical assets).

Essentially a planning tool, a budget is not necessarily a guarantee of resources, and the institution may require purchase order approval in addition to the approved budget, which ensures fiscal responsibility in relation to cash flow variations.

Financial support

In academic institutions, most financial support for library materials and services derives from institution-wide income sources, usually tuition or endowment income, but the library may be in a position to identify and cultivate donors of collections and monetary gifts. Any cultivation of donors, however, is best pursued in consultation with the institution's development or fund raising office.

There are numerous grants available for increasing the resources of the library. They are almost always in support of projects, rather than general operating expenses. Grant applications are often time-consuming, and a wise investment of time suggests that only those grants that support projects already identified as priorities be pursued.

Materials and information resources

A collection development policy statement is fundamental in clarifying the essential nature of the library's material assets, whether physical or virtual, and brief statements often work as well as those that are elaborate and detailed. Periodic revision is essential, and perhaps the key elements of a useful statement are the ratios of print, electronic and pictorial materials. A useful collection development policy statement will include a gift policy that outlines the procedure for evaluating a potential donation, along with a retention policy. This component of the policy is an especially helpful tool in declining unwanted donations.

A valuable collection development tool is an acquisitions profile with a distributor. There is no cost, and it can accelerate the selection process.

Staffing

A volunteer programme can augment library staffing significantly. Many academic libraries also rely heavily on student employees, whose compensation often derives primarily from a federally funded college work–study programme and is included as part of a financial aid package. Whether using volunteers, student employees or paid staff, be sure to give a thorough orientation to the library and its services and teach basic library

skills to all. The orientation may begin by emphasizing the importance of customer service, and the mission of the library. Providing feedback, knowledge and encouragement are all essential components of staff training, for short-term volunteers, temporary employees, student employees and permanent employees.

Regular staff meetings, whether formal or informal, provide opportunities for staff to discuss concerns, new services to be added, and areas for improvement. Printed agenda items help manage meetings and limit them to the allotted time (Lowes, 1998, 73–8; Rutledge, 1984, 285).

Performance appraisal

Appraisal of staff performance can be either a source of conflict or an opportunity to help employees achieve their potential. There are benefits to starting the appraisal period with an annual or six-month work plan, which can steer employees toward success. A concisely stated plan provides the criteria for and forms the basis of the appraisal at the end of the work plan period. It helps clarify goals and can be developed by the employee in consultation with the supervisor, or it may be initiated by the employee. Typically, action steps and deadlines accompany each goal, and the plan usually omits routine and ongoing job responsibilities. Therefore, the work plan is not a substitute for a clear job description, but instead encourages momentum. It functions best when it is realistic in its time parameters, and the employee needs to be comfortable with the plan and have a sense that the goals of the plan are achievable.

In addition to maintaining staff morale, self-evaluation is a useful component of performance appraisal in giving employees a voice for providing feedback to supervisors about the position and its challenges. Including a process for appeal or disagreement by employees is essential, so as to achieve conflict resolution.

Performance appraisal forms often include an unnumbered scale in the form of an assessment rubric. Occasionally the scale of the rubric is binary (satisfactory or unsatisfactory); sometimes it is a three-tiered scale; and it may be as much as a fivetiered scale. As the farthest from a numerical score, the binary scale may allow for the greatest amount of assessment based on predefined objectives. In their resemblance to a Likert scale, three- and five-tiered scales work best when they incorporate a set of standards or expectations. Fewer tiers may be preferable, however, so as to distinguish the process from classroom grading and to associate it more with a mentoring process. Many academic libraries prefer an essay that concentrates on the accomplishments, as well as areas for growth or improvement, coupled with a self-evaluation.

Accreditation

Academic accreditation is the source of considerable anxiety for all institutions, although the accreditation process usually begins with a self-tudy, which can be a valuable tool apart from reviews by an external agency. If a self-tudy from a peer library can be

acquired, it can serve as a comparative tool and starting point. Accrediting agencies can be helpful in providing guidance for development and growth, and they often remind upper-level administrators of standards and best practices for libraries (Brown, Glassman and Henri, 2003).

Conclusion

All art and design libraries benefit from a strong organizational infrastructure, whether large or small. A clear sense of mission, ongoing outreach efforts, financial accountability, effective supervisory skills and short- and long-term planning lead to a culture of continuous improvement and ensure that the library is a vital organism.

References and bibliography

Brown, J. M., Glassman, P. and Henri, J. J. (2003) *The Library and the Accreditation Process in Design Disciplines: best practices*, Art Libraries Society of North America.

Delumeau, A. (2005) *Time Management for Library Professionals*, www.liscareer.com/delumeau_time.htm. Offers good sources of information about time management and ways to use time more effectively.

Hayes, R. M. (2001) *Models for Library Management, Decision Making and Planning*, Academic Press.

Lowes, R. L. (1998) 10 Keys to Running a Good Meeting, *Medical Economics*, **75** (1), 73–8.

Middle States Commission on Higher Education (2009) *Becoming Accredited: handbook for applicants and candidates for accreditation*.

NASAD (2016–17) *Handbook*, National Association of Schools of Art and Design.

NCES (2016) *Library Statistics Program*, National Center for Education Statistics, US Department of Education, http://nces.ed.gov/surveys/libraries.

Patterson, K. (c. 1999) *Special Libraries Management Handbook: the basics*, http://faculty.libsci.sc.edu/bob/class/clis724/SpecialLibrariesHandbook/ INDEX.htm. A product of the University of South Carolina College of Library and Information Science, the handbook includes an impressive array of topics, such as 'A bad boss: how to handle' and 'Branding your library'.

Pausch, R. (c. 1995) *Tips for Effective Time Management*, University of Virginia, www.cs.virginia.edu/helpnet/Time/time.html.

Policastro, M. L. (n.d.) *Introduction to Strategic Planning*, US Small Business Administration, https://www.sba.gov/sites/default/files/articles/Introduction%20to%20Strategic% 20Planning.pdf. This article demonstrates how to develop a strategic plan and a mission statement.

Powe, K. B. and Plung, D. (2001) Strategic Decision Making in a Time of Information
 Overload, *Information Outlook*, **5** (11), 22–30.
Rutledge, D. (1984) Chairing the University Committee: the elements of successful
 meetings, *Journal of Academic Librarianship*, **10**, 285.
Wagner, P. (2008) Everyday Leadership: how to increase your influence at the
 institutional level, workshops, *Proceedings of Art Libraries Society of North America
 36th Annual Conference*, Grand Hyatt Denver, Art Libraries Society of North
 America, http://arlisna-mw.lib.byu.edu/denver2008/program_workshops.htm.

Suggested resources

Fritts, J. E., Jr (ed.) (2009) *Mistakes in Academic Library Management: grievous errors and
 how to avoid them*, Scarecrow Press.
Golden, J. and Williams, D. E. (2014) *Advances in Library Administration and
 Organization*, Emerald Group.
Gordon, R. S. (2005) *The Accidental Library Manager*, Information Today.
Grote, D. (2002) *Performance Appraisal Question and Answer Book*, AMACOM Books.
Hallmark, E. K., Schwartz, L. and Roy, L. (February 2007) Developing a Long-range
 and Outreach Plan for your Academic Library: the need for a marketing outreach
 plan, *C&RL News*, 92–5.
Hastreiter, J. A., Cornelius, M. and Henderson, D. W. (1999) *Mission Statements for
 College Libraries*, American Library Association.
Matthews, J. R. (2007) *Library Assessment in Higher Education*, Libraries Unlimited.
O'Connor, S. (2015) *Library Management in Disruptive Times: skills and knowledge for
 an uncertain future*, Facet Publishing.
Smith, G. S. (2002) *Managerial Accounting for Libraries and Other Not-for-profit
 Organizations*, American Library Association.
Stueart, R. D. and Moran, B. B. (2002) *Library and Information Center Management*,
 Libraries Unlimited.
Van Duinkerken, W. and Mosley, P. A. (2011) *The Challenge of Library Management*:
 leading with emotional engagement, ALA Editions.
White, L. L. and Molaro, A. (2015) *The Library Innovation Toolkit: ideas, strategies, and
 programs*. ALA Editions.

Chapter 2

Evolution not revolution: evolving trends in art and design libraries

Barbara Opar

Introduction

Art and design libraries do not look like or position themselves the way they did in the past. Team rooms, maker spaces and galleries have been added. Arts collections are hybrid but rarely all digital. Resources such as material samples are being collected. Staff job titles and duties have shifted. Libraries are different, but much of what is being done currently or is being considered builds on the past. Libraries evolve, responding to internal challenges and outside forces.

This chapter explores some recent library trends and their effect on art and design libraries in particular. It uses a survey distributed in October 2016 by the author to relevant listservs, a literature search and over 40 years of work experience to identify evolving trends in buildings, staffing and collections and to define how and why they are occurring. The author sent the 16-question survey covering many aspects of arts librarianship to ARLIS-L (Art Libraries Society of North America), ARLIS-LINK (ARLIS/UK & Ireland: the Art Libraries Society), AASL-L (Association of Architecture School Librarians), and ACRL/ARTS (Arts Section of the Association of College and Research Libraries). The full survey and the responses may be viewed on Facet Publishing's website (bit.ly/OparSurvey).

Services

Circulation

'Public service' was the old umbrella term for activities related to assisting the public. Reference, circulation and instruction were considered essential, and staffing was structured accordingly. These services remain central to the library's mission, but administratively they may reside in different departments. Circulation desks are still present, but self-service options have been added. At the Architecture Library of the

University of Maryland, for example, self-checkout is the norm (Frank, 2016). In some libraries, circulation and reference are handled at the same desk, with staff from different units working side by side.

Non-circulating libraries do exist, but the trend is to circulate most materials and increase access. Pragmatic libraries may see circulation as a quick way to secure shelf space. Art and design libraries must consider circulation policies for challenging formats, such as pop-up books or portfolios with loose plates. Some libraries choose to restrict circulation of these formats.

Tracking materials in libraries has changed. Radio-frequency identification (RFID) is used to inventory and ensure proper shelving. Karen Coyle (2015, 486) provides a basic explanation: 'Briefly, the RF in RFID stands for 'radio frequency'; the 'ID' means 'identifier'. The tag itself consists of a computer chip and an antenna, often printed on paper or some other flexible medium. The shortest metaphor is that RFID is like a barcode but is read with an electro-magnetic field rather than by a laser beam. The use of RFID, as is true for other technologies, has libraries re-evaluating privacy policies.

While the term 'circulation' is still used, many academic libraries have access services departments that include circulation, course reserves, interlibrary loan, accessibility and delivery. Circulation now includes technology loans. Acquisition units can be equipped to handle loans as well as purchases.

In academic libraries, campus delivery has become a common service for faculty and sometimes graduate students. This trend has increased circulation, but at a time when libraries are consolidating and/or eliminating certain activities, it is surprising to see such a labour-intensive initiative. Nonetheless, it is part of the drive for access services to seek ways to improve the user experience.

Reference

Reference services remain at the core of what libraries do. Writing in the *Journal of Library Administration*, Coleman, Mallon and Lo (2015, 674) provide insight into the changing nature of reference:

> While no changes are universally applicable, there are several well documented developments worthy of note. These include changes in the volume and nature of patrons' information needs, modifications to the array of channels through which reference services are offered, alterations in the staffing patterns for in-person and virtual services, and the adoption of innovative technologies to improve convenience and efficiency of virtual services.

How have patrons' needs changed? Online access has enabled patrons to locate more resources on their own. Library search engines mimic those of the internet, improving discoverability. However, the volume of information readily available requires a nimble

patron. The search plan, strategies and evaluation of content still pose problems. Citation indexes are challenging to those expecting full text.

Libraries, while still offering in-person reference services, have developed additional conduits. Writing in *The Journal of Academic Librarianship*, C. R. Stevens discusses the need to move away from desk-centric services (2013, 202–13). Among the solutions are encouraging e-mail queries, augmenting chat reference, creating FAQs, roving reference and using social media. To attract younger patrons, libraries are posting blogs and encouraging the use of RSS feeds as well as turning to Facebook, Twitter and YouTube to reach their audiences. Rarely are these services carried out exclusively by librarians.

Fewer staff with Master in Library Science (MLS) degrees serve on reference desks. The elimination of costly operations and consolidation of service points have become the norm in art and design libraries. Of the 87 respondents to the author's distributed survey, 17 stated that branches or special units of the library had been eliminated, with another 17 reporting the removal of the reference desk. Use of the reference desk has changed as well. The welcome desk has been replaced by signage; the reference desk has given way to consultations or e-mail. The subject specialist has been removed from frontline operations. Nearly half (39) of respondents observed that fewer questions were being asked in person, although there was an increase in group consultations.

Trends in reference services appear to be on a different trajectory from those of access services. While access services are providing more and different services, reference services are streamlining. The focus seems to be away from growing reference departments or acknowledging subject expertise: 38 survey respondents had responsibility for more than one subject discipline, with 28 stating that they lacked expertise in the areas assigned to them. Laura Saunders (2015, 288), writing in *The Journal of Academic Librarianship*, reports, 'According to the plans reviewed here, collections, physical space, collaboration, and instruction are the top priorities, with each of these areas being integrated into over three-quarters of the strategic plans.' Perhaps the need for reference services is implied.

Instruction

Emphasis on student success and learning outcomes address the concerns about retention and the importance of information literacy. Librarians are assisting and partnering with faculty. New roles include the clinical librarian who works alongside faculty or museum curators, providing reference and resource support. The embedded librarian attends classes, providing formal and informal instruction. Personal librarians are assigned to incoming students, especially those deemed 'at risk'. Peer-to-peer instruction works with international students. The world of the MOOC (massive open online course) opens up opportunities for librarians to develop learning modules.

Information Competencies for Students in Design Disciplines (Brown et al., 2006) identified core skills and tools to address student needs. The goal was standardization.

The Association of College & Research Libraries (ACRL) adopted the *Framework for Information Literacy for Higher Education* (2015) in 2016, but to date there is no parallel arts framework.

Liaison activities

Liaison work or outreach is another service activity that is often performed by the subject librarian, including 58 of survey respondents. Liaison work involves close communication with patrons, especially faculty. Multiple assignments and lack of expertise are affecting successful performance in this arena. One-third (29) of respondents noted there was an increase in patron engagement, while 14 felt that their patrons were less engaged with the library. While no assumptions can be made about why engagement has changed, a case can be made for continuing outreach.

One survey respondent questioned the validity of the liaison role noting, 'It's that liaison work is not really what a library does. We build the learning environment and researchers' possibilities.' As libraries compete with Google and face budgetary cuts, librarians feel the need to brand themselves and make constituents aware of services and collections. Helen H. Spalding and Jian Wang make a strong case for this activity:

> In the twenty-first century, libraries of every type must contend with competition from other information sources. Marketing, by conveying the value of the library to potential users, offers librarians a means to compete more effectively. Outreach and promotion have long been part of librarianship, but over the past ten to 15 years librarians have adapted marketing techniques increasingly to this and other library functions. (Cited in Trendler, 2016, 131)

Liaison work requires a variety of skills; outreach takes many forms. The liaison librarian must be able to promote resources and determine what materials and services will improve the library's image and use. Looking to the business world for ideas is likely to continue in libraries.

Collections

Library collections will change. Arts collections are still hybrid and will remain so for the immediate future. The e-book has a strong foothold, but despite past predictions, the physical book remains a viable purchase option.

In many disciplines and even in certain art and design libraries, e-texts are preferred over print. Why? There is solid content. ACLS Humanities, EBSCO and JSTOR are publishers with strong humanities collections; Books 24/7 and Springer supply core engineering and technology titles. Package pricing and catalogue records are available. E-versions are often published simultaneously with print, and unlimited use options are increasing. Libraries with space concerns see e-books as a way to expand content while

maintaining the same footprint. Having 24/7 access serves today's users, especially those in distance programmes. In academic institutions, faculty can add texts to course software or suggest readings, confident they are available.

Off-site storage is increasing in large libraries, necessitating a review of alternative formats. Why then are art libraries not all digital? Ease of use is one reason. Many students do not like to read online. The user's ability to toggle between book chapters is difficult if not impossible in an e-format. Printing limits frustrate potential converts. A lack of consistency in how the material appears on the screen and how it is downloaded are problematic. For librarians, selection considerations include possible higher cost, duplication of other formats, printing quotas and inconsistent platforms.

Few libraries are adding microforms, with many repurchasing available content in other formats. Infrequently used titles are being de-accessioned or placed in storage. While many libraries have equipment to digitize selections from film, this is not a widely used service.

Other materials being discarded include VHS tapes and analogue slides. Streaming content is preferred, and vendors offer a wide range of commercial and academic series, though this content is not always reflected in library catalogues. Visual resources are even more complex. Analogue slides have been replaced in most cases by online resources. Slide collections were often built up in-house through copy stand photography, supplementing images not commercially available. While some slide collections have been digitized, many have simply been disbanded or transferred to storage, with users left to take a different approach to selecting images.

Art and design libraries collect unique formats such as artists' books. Architectural drawings are being digitized, removing storage and care considerations. Formats such as physical materials samples and games are creating new challenges.

Open access publishing is coming under the purview of collections. Many universities now mandate open access publishing for their faculty. Institutional repositories exist in many academic institutions. New publishing structures are gaining a foothold but are nowhere close to replacing the conventional model. New directions also draw attention to copyright. In addition, data sets and data services bear noting. Data sets may not be serviced from arts libraries, but geographic information systems and digital humanities require such integration.

Emerging collection trends can be summarized as openness to new formats with their access and storage challenges. While technology has eliminated the need for certain formats, it has not simplified or replaced every format, especially the art and architecture print book.

Collection 'building' has also changed. Few libraries aspire to be libraries of record. Infrequently used materials are being de-accessioned, and collection size is viewed differently. No longer do libraries collect 'just in case' but rather look to 'just in time' or services like interlibrary loan to fulfil patron needs.

Acquisitions

Reliance on established automated selection tools is common. Many libraries also rely on a specific range of vendors. Academic imprints and core publisher titles are acquired through vendors, using approval plans and profiling. Some libraries use Amazon.com, but preference is usually given to specialized suppliers for international or language-specific resources. One survey respondent had used more independent publishers with non-conventional purchasing models like Etsy. eBay can be a source for unique titles, but most libraries with small budgets rely on traditional purchasing models and focus on current imprints.

Survey respondents also reported reduced budgets, and one described purchasing only those titles requested by readers. Demand-driven acquisition models are commonly used for online or streaming titles.

Around one-third (34) of respondents preferred e-books over print books, while 39 expressed a strong concern with e-book consistency, including simultaneous users, display options and printing quotas.

Only 16 of respondents reported a wider range of geographic areas being covered in their library than in previous years, and even fewer (five) had added a wider range of foreign language materials. Scaled-down acquisitions departments will be challenged by the need to purchase one-off artists' books, building models or samples of translucent concrete.

Cataloguing

The introduction of the online catalogue improved access, but it also changed perceptions of the need for precision. In the past, cataloguing was undertaken primarily by librarians. There was less 'as is' acceptance of bibliographic records from OCLC and other utilities. Catalogue departments were among the first to be cut, so streamlining has driven the process, and 34 survey respondents acknowledged the acceptance of vendor-created cataloguing. Vendors often catalogue new acquisitions for their clients, even barcoding titles and designating locations. While 14 of those responding to the survey noted overall improvements to OCLC and other automated cataloguing systems, 20 respondents noted that such cataloguing was often less detailed than records supplied in the past. One respondent observed, 'Management is less interested in quality records and much more interested in throughput of "good enough" records from vendors (or non-cataloguing staff), which may not be good in any form.' This is an interesting comment when current strategic plans stress discoverability.

Respondents reported that materials are being received in many languages and formats with less expertise to process them. The general de-emphasis on language education and the retirement of staff with language skills have affected technical services. Yet, libraries must address globalization and respond to the growing need for international imprints.

The range of materials to be catalogued has increased and includes new formats such

as materials samples. Some libraries provide brief catalogue entries, and others use spreadsheets to record the information or record holdings in content management systems. Harvard Graduate School of Design and the Rhode Island School of Design launched Material Order, a shared materials database and materials consortium. Mark Pompelia, in the November 2016 AASL column for *ACSA News*, stated, 'Material Order provides a shared cataloguing utility and collection management system, as well as a framework for a growing community' (Pompelia, 2016).

Visual resources remain complex. Many academic libraries have disbanded their slide collections, and staff have been transferred or laid off, resulting in a loss of cataloguing expertise and knowledge of systems like the Fogg classification. Many libraries have digitized their analogue collections. In-house databases have been developed, while others have made use of Artstor's Shared Shelf or Flicker. Gaming centres are also being developed, and board and video games are being added to collections.

Another major change in cataloguing is the new resource description and access (RDA) standard. RDA is three-dimensional and designed for the online world in which the concept of 'main entry' is less meaningful. It allows libraries to do more customization. RDA operates within the conceptual model of Functional Requirements for Bibliographic Records (FRBR). 'RDA is about creating well-formed data that would then be entered into the encoding scheme of the cataloguer's choice' (Lipcan, 2012, 211). RDA has been implemented in major libraries, but museum libraries still use cataloguing designed for cultural objects.

Cataloguing departments are 'behind the scenes' operations and so will continue to suffer from staffing reductions. Operationally, many acquisitions departments seem better equipped to handle increased activity. Use of vendor-supplied cataloguing will only increase. Departments need to seek relief by relying on the expertise of subject librarians and employing more information studies interns and graduate students with foreign language skills. The use of other methods and software to record unique holdings may alleviate work flow issues as well.

Staffing

Art and design libraries are facing staffing challenges. Attrition has come through traditional and sponsored retirements. Librarians have added duties without requisite skills or training. Survey respondents commented on 'deprofessionalisation', or layoffs of experienced librarians with replacements hired at lower pay.

The ALA-accredited MLS degree is generally required for librarians, with subject expertise requirements often intentionally vague. Reading knowledge of Western European languages appears frequently in job postings, and specialized requirements like familiarity with geographic information systems software or use of Encoded Archival Description may be added. Libraries are re-evaluating vacant positions and often refocusing them. Less attention is being placed on traditional roles; new positions like

online education or oversight of institutional repositories are being created. Once new services are up and running, there may be renewed interest in growing the staffing of traditional services.

Spaces

Since 'library as place' gained popularity, library administrators have been seeking to improve the user experience. Libraries are no longer content with providing comfortable study spaces; such spaces must also be furnished with technology. Team rooms allow groups to collaborate in well-lit spaces, equipped with white boards and internet connections. Public as well as academic libraries have introduced collaborative spaces, often weeding or moving collections off-site to accommodate these changes.

Learning commons exist in most academic libraries; scholars' commons are a more recent development and are often aligned with the digital humanities. While these spaces have been designed for project support and training, some spaces have been programmed for data and visualization labs. Duke University is a pioneer in this area.

Makerspaces (facilities for making, learning and exploring with technology tools from 3D printers to sewing machines) gained popularity in public libraries before they did in academic venues. The Toronto Public Library introduced digital innovation hubs where patrons can scan old photographs or convert VHS tapes. The 3D printing workstations are popular, and the library offers digital design classes and other programming around this activity.

Library staff are also trying to create spaces attractive to tech-savvy users through pop-ups. Public libraries have travelling labs, while academic libraries offer spaces for short-term group projects.

Today's libraries are looking for ways to partner with specific groups to demonstrate value. Central libraries as well as art and design branches often have galleries where student and faculty work can be showcased.

Many of today's libraries need renovation or expansion. North Carolina State University's Hunt Library (www.lib.ncsu.edu/huntlibrary/explorespaces) is one of the most respected new facilities. Opened in 2013, the new library offers advanced technology resources to the university community (media production studios, visualization and virtual environments, a video seminar room, game lab, makerspace and more), plus the building has a LEED (Leadership in Energy and Environmental Design) Silver environmental rating. Recent library projects can inform programming and generate ideas for changes at one's own institution.

Conclusion

Libraries do not all change in the same ways or at the same pace. In the arts, print remains popular but new formats are emerging. Streamlining and downsizing are occurring, new technologies are being implemented and new skills sets are sought. Approaches vary

across libraries with some more entrepreneurial and visionary than others. Changes are driven by internal forces as well as external factors. It is a process and more evolutionary than revolutionary.

References and bibliography

ACRL (2015) *Framework for Information Literacy for Higher Education*, Association of College & Research Libraries, www.ala.org/acrl/standards/ilframework.

ACRL Research Planning and Review Committee (2014) Top Trends in Academic Libraries: a review of the trends and issues affecting academic libraries in higher education, *College & Research Libraries News*, **75** (6), 294–302.

ARL (2014) SPEC Kit 342: Next-Gen Learning Spaces, Association of Research Libraries, http://publications.arl.org/Next-Gen-Learning-Spaces-SPEC-Kit-342/.

Bilandzic, M. and Johnson, D. (2013) Hybrid Placemaking in the Library: designing digital technology to enhance users' on site experience, *Australian Library Journal*, **62** (4), 258–71, doi:10.1080/00049670.2013.845073.

Brown, J. et al. (2006) *Information Competencies for Students in Design Disciplines*, Art Libraries Society of North America, www.arlisna.org/publications/ arlis-na-research-reports/148-information-competencies-for-students-in-design-disciplines.

Coleman, J., Mallon, M. N. and Lo, L. (2015) Recent Changes to Reference Services in Academic Libraries and Their Relationship to Perceived Quality: results of a national survey, *Journal of Library Administration*, **56** (6), 673–96, doi:10.1080/01930826.2015.1109879.

Coyle, K. (2015) Management of RFID in Libraries, *Journal of Academic Librarianship*, **31** (5), 486–89.

Dallis, D. (2016) Scholars and Learners: a case study of new library spaces at Indiana University, *New Library World*, **117** (1), 35–48.

Dizikes, P. (2016) MIT Task Force Releases Preliminary 'Future of Libraries' Report, MIT News Office, www.news.mit.edu/2016/mit-task-force-releases-preliminary-future-libraries-report-1024.

Downey, K. (2013) Why Did We Buy That? New customers and changing directions in collection development, *Collection Management*, **38** (2), 90–103, doi:10.1080/01462679.2013.763741.

Frank, C. (2016) The Architecture Library at Maryland Transitions to a Professional Model, *ACSA News*, April.

Gerolimos, M. and Konsta, R. (2011) Services for Academic Libraries in the New Era, *D-Lib Magazine*, **17** (7/8), doi:10.1045/july2011-gerolimos.

Haapanen, M., Kultamaa, P., Ovaska, T. and Salmi, K. (2015) Reducing Library Space

Can Promote the Shift from Storage of Print-Collections towards a Learning-Centre without Limiting the Access to Information, *Library Management*, **36** (8/9), 685–89.

Hampton, N. (2015) A Library of Design: electronic collections inspire modern research spaces, *Codex*, **3** (2), 68–79.

How, L. and Bystrom, S. (2016) Architecture and Access: navigating a new space, *OLA Quarterly*, **22** (1), 9–14.

Kennan, M. A., Corratl, S. and Afzal, W. (2015) 'Making Space' in Practice and Education: research support services in academic libraries, *Library Management*, **35** (8/9), 666–83.

Lipcan, D. (2012) Faith-Based Cataloging: resource description and access and libraries, archives, and museums, *Art Documentation: Journal of the Art Libraries Society of North America*, **31** (2), 210–18, doi:0730-7187/2012/3102-0007.

Lippincott, J. K. and Duckett, K. (2013) Library Space Assessment: focusing on learning, *Research Library Issues*, **282**, 12–21.

Mitchell, C. and Chu, M. (2014) Open Education Resources: the new paradigm in academic libraries, *Journal of Library Innovation*, **5** (1), 13–28.

Opar, B. (2016) *Evolving Trends Survey*, www.facetpublishing.co.uk/ckfinder/userfiles/files/Ch2%20Survey.pdf

Opar, B. (2017) The Legacy of the Information Competencies for Students in Design Disciplines, *Art Libraries Journal*, **42** (2), 86–8, doi:10.1017/alj2017.8.

Pompelia, M. (2016) Material Order: building collections and creating community, *ACSA News*, November, www.acsa-arch.org/acsa-news/read/read-more/acsa-news/2016/11/08/material-order-building-collections-and-creating-community.

Saunders, L. (2015) Academic Libraries' Strategic Plans: top trends and under-recognized areas, *Journal of Academic Librarianship*, **41** (3), 285–91, www.dx.doi.org/10.1016/j.acalib.2015.03.011.

Stevens, C. R. (2013) References Reviewed and Re-Envisioned: revamping librarian and desk-centric services with LibStARs and LibAnswers, *Journal of Academic Librarianship*, **39** (2), 202–14.

Trendler, A. (2016) Branding the Branch: a case study in marketing the architecture library at Ball State University, *Art Documentation: Journal of the Art Libraries Society of North America*, **35** (1), 130–43, doi:128.230.086.039.

Wang, J. and Spalding, H. (2006) The Challenges and Opportunities of Marketing Academic Libraries in the USA: experiences of US academic libraries with global application, *Library Management*, **27** (6/7), 494–504.

Wilson, K. (2016) The Knowledge Base at the Center of the Universe, *Library Technology Reports*, **52** (6), 1–35.

Chapter 3

Expanding roles for fine arts liaison librarians: re-visioning the liaison model

Stephanie Kays

Academic libraries continue to wrestle with changes in higher education and their implications for library services. Over the past years, many libraries have re-evaluated the role of liaison librarians in their institutions and, in doing so, expanded their responsibilities to include greater outreach across campus with a resulting move from collection-centric models to models focused on engagement. The University of Minnesota is often cited as an early leader in this transition. Indeed, their position description framework is frequently used as a model for other research libraries. This description framework articulates several roles including campus engagement, scholarly communication, digital tools, outreach and exhibit and event planning (Jaguszewski and Williams, 2013). Since then, other areas of positional interest have and continue to emerge. In Duke University's revisioning of the liaison model, 'Liaison librarians (subject librarians) are in the forefront of interacting with faculty, students, and researchers; their roles have been changing and will probably remain in a state of continuous change' (Daniel et al., 2011).

Kenney (2014) identifies three emerging themes in the recent development of liaison models: engagement strategies with scholars, continued refinement of liaison roles to meet new demands, and a growing emphasis on promoting digital tools. With the expectations on liaison librarians continuing to rise, the pressure on them to 'do it all' can leave some with a feeling of uncertainty about how to prioritize and manage time, how to measure progress, or how to define success. As liaison models change, our tools for assessment needs to change as well. Kenney writes, 'Shifting focus from what liaison librarians do to how their efforts impact faculty, students, and others will be critical to future development of this model' (2014). At the same time, liaison librarians need not excel at every new skill that is added to their list of responsibilities. Instead, a more plausible aim is that of 'continued refinement', grounded in a liaison librarian's ability to establish useful partnerships with a colleague in the library or elsewhere on campus for leveraging relevant expertise (Jaguszewski and Williams, 2013).

Although how the liaison model is changing or how it is implemented varies widely across institutions, some of the trends and issues raised above can be seen at research institutions and small liberal arts colleges alike. Here is an example describing how the liaison model has been put to work at Denison University.

Liaison librarians at Denison University

Denison University is a private four-year liberal arts college located in Granville, Ohio, 30 miles east of the state's capital. While its Carnegie classification is 'small, mostly residential', Denison has an enrolment just under 2300 students, making it larger than most liberal arts colleges. The William Howard Doane Library is the central library building on campus and a hub for student research, learning and collaboration. The library also houses the Center for Learning and Teaching (CLT), administered by the Provost's office. The CLT provides a variety of learning and teaching seminars, mentorship and other support to help faculty explore and strengthen pedagogy (University Communications, 2015). Many of their programmes are also open to librarians, providing another opportunity for librarians and faculty to work side by side to strengthen student learning.

There are currently four liaison librarians, serving departments in the fine arts, humanities, natural sciences and social sciences. Along with a general assignment of one librarian for each of these divisions, each librarian also takes on liaison responsibilities for interdisciplinary programmes and concentrations. Those assignments are usually based on the individual's subject knowledge, personal preference, or the amount of faculty crossover among disciplines. The flexibility of these assignments, especially for liaison librarians who work closely with a specific faculty, is particularly important so that faculty members do not have multiple liaison librarians. For example, a professor of fine arts who teaches cross-disciplinary courses in women's studies and international studies, rather than interact with and respond to three different liaison librarians, relies on a previously built relationship with a single liaison librarian. In addition to subject areas, liaison librarians also share the library instruction load for Writing 101 classes, a required course for all first-year students. Though the subject areas for Writing 101 courses are multidisciplinary, the library sessions for these classes are foundational in nature and usually do not require subject specialist knowledge. On paper, liaison librarians' duties are roughly divided into categories of instruction, reference and collection development. But increasingly, as in academic programmes, their duties are far more interdisciplinary and considerably more wide ranging than the traditional liaison librarian categories suggest.

Having started with the university in 2016, the current fine arts liaison librarian is in the process of establishing collaborative partnerships with faculty and other campus groups. The fine arts division includes art history and visual culture, studio art, cinema, dance, music and theatre. She is also the liaison librarian for two interdisciplinary programmes, women's and gender studies and East Asian studies.

Denison offers BA (Bachelor of Arts) and BFA (Bachelor of Fine Arts) programmes for students majoring in the arts. The university's General Education Program, created to ensure that students develop core competencies in the liberal arts, requires all students to take at least two courses in the fine arts. Because the student–faculty ratio is 9:1, the classes the liaison librarian works with may have enrolment of as few as 5 or as many as 25 students. It follows that, for the fine arts where the classes are usually smaller than, for example, economics classes, the student–librarian ratio is also ideal.

Liaison librarian positions are by their very nature essentially collaborative. The fine arts liaison librarian works with library colleagues, faculty and students to ensure there is access to all information resources across all formats in order to support the curriculum and research needs of the Denison community. There is also direct collaboration with other departments across campus to ensure there is access to a broad range of information and educational services housed within the library. The Library Commons, located on the main floor of the library, is a flexible, user-cantered environment with social space, individual study space and group study spaces. The Commons offers support for learning, teaching and research and features the research help desk, which is staffed by liaison librarians and other librarians. Additionally, during select hours, personnel from Information Technology Services, the Writing Center, Academic Support and Modern Languages are available to assist students.

The arts are an important and well supported part of life on campus. In 2009, Denison's Bryant Arts Center was completed. The 45,000-square-foot facility, which was built within and alongside a century-old building, houses studio art and art history. In early 2017, the college broke ground on the Eisner Center for Performing Arts, which will be home to the music, dance and theatre departments. It is slated for completion in 2019. In integrating with the Denison community it will be present to support the initiatives of colleagues and students, while also taking advantage of the considerable resources the college has to offer. Arts programming at Denison brings in local, regional and international artists and arts scholars for residencies, events, festivals and lectures. The fine arts liaison librarian engages arts faculty and the Director of Fine Arts Programming to offer library space and services to visiting artists and to discuss other collaborative opportunities. The liaison librarian also offers collections support to ensure acquisition of the latest publications, video or audio recordings in support of these events. A rotating display at the entrance to the library reminds students and faculty of upcoming arts events and showcases related library materials.

Among Denison's more noteworthy recent initiatives is the Denison Arts Space, a college-run multi-arts centre located in Newark, Ohio, which offers novel ways to connect a mostly residential collegiate arts community with a small community at large nearby. Attending faculty presentations and performances, student dance and music recitals, senior exhibitions, student plays and summer research presentations has been central to the liaison librarian's connection to the institution and relationship-building with students and faculty.

Collection development, reference services, and teaching and learning

Library instruction, reference services and collection development are the long-established focal points of liaison librarianship. While the role of the liaison librarian is expanding as a whole, the nature of the services provided is also evolving. Jaguszewski and Williams (2013) note that, while the purpose of collection development remains the same, the ways of being successful in this area have changed dramatically. The new terrain is one of different strategies and collaboration among institutions. An Association of Research Libraries (ARL) *Issue Brief*, also cited by Jaguszewski and Williams, states 'Twenty-first-century collection management will . . . require increased collaboration within and among institutions, as well as a shift from thinking of collections as products to understanding collections as components of the academy's knowledge resources. A multi-institutional approach is the only one that now makes sense' (ARL, 2012).

Increasingly, libraries are partners in consortial environments, working together to collect and provide cost-effective access to an expanding array of print and digital resources. This may have an effect on how collection development occurs at individual institutions, giving liaison librarians the added responsibility of shepherding faculty through the process. Denison University is a member of the Five Colleges of Ohio and OhioLink consortia, which give access to nearly 50 million volumes and over 450 electronic resources. The online catalogue, CONSORT, contains records of the combined library collections of Denison University, Kenyon College, The College of Wooster and Ohio Wesleyan University, and offers 4.64 million volumes. Being a part of multiple consortia has resulted in a hybrid of development styles, including reliance on approval plans and working directly with fine arts faculty who send acquisition requests. More broadly, there is collaboration to ensure that selections reflect the curriculum and research needs of students and faculty of the arts.

In The Tenacious Book, Part 1, Kam (2014) reflects on art and architecture collections and asks, 'Are we special collections librarians?' Zines, artists' books and ephemera are materials that might naturally be housed in either art library collections or special collections and archives. At Denison, print resources in the arts are housed in the main library, so that art resources that need mediated access or preservation care are housed in the University's Archives and Special Collections. The fine arts liaison librarian works closely with the university archivist on collection development for zine and artists' book collections, as well as for managing other art books that have appreciated in value over time or have become rare. But Kam writes that issues around 'specialness' go beyond this. More broadly, art libraries and their holdings may become even more special in the future because the majority of their materials are in print, rather than in electronic, format and likely will not be digitized in the future. This is mostly because of issues related to image rights and a business model that recognizes customers' preference for print editions.

Reference services

Over the years, many academic libraries have reduced in-person reference desk hours because of staffing challenges and the changing needs of patrons. Many recurrent needs are met by online tools such as LibGuides, screencasts and other tutorials. Some libraries may have support staff or student workers offering basic services and make referrals to liaison librarians if subject knowledge or advanced research is needed. In other cases, libraries may have moved to roving reference and embedded librarian models, while others are even more experimental. Dickerson (2016) writes that reference services are at a crossroads and describes beta spaces as a model for recontextualizing reference: 'Beta spaces are user-oriented environments with a focus on innovation and experimentation, much like a makerspace but with an emphasis on ideas over technology. A beta space model for reference services would enhance opportunities for active learning, help make the research process visible and tangible, and effectively demonstrate the value of reference.' At Denison, while liaison librarians still spend a fair number of hours at the reference desk, much of reference service has been replaced by scheduled one-on-one consultations with students, staff and faculty who need expert help or assistance with specific assignments. Most consultations are with students who have been referred by their fine arts professors.

Teaching and learning

One of the main responsibilities of Denison fine arts liaison librarians is to provide instructional needs for the fine arts division and to promote the use of information and technologies in research and teaching. This usually happens with library instruction sessions that are scheduled throughout the year and developed in collaboration with faculty. Many of the sessions are held in the library's e-classroom, a fully networked and wireless-enabled computer lab with 18 desktop stations, an instructor's station, a liquid-crystal display (LCD) projector and an interactive white board. One of the benefits of holding the instruction sessions in the library is that students are not restricted to online learning and demonstrations; rather, they may be asked to leave their seats to find tangible resources or discover other services located throughout the library. However, this is not always the scenario. In some cases, professors may request instruction on a very specific digital tool or resource for a portion of the class time, and therefore it makes more sense to meet them where they are, whether in the classroom, studio, lab or other space.

Most of the instruction requests are from professors of art history, though some come from professors from studio arts, cinema, dance and music. The number of different faculty members who request library instruction is quite low, with the same faculty members typically asking for multiple sessions throughout the year. This could be for a number of reasons. In some cases, professors conduct research instruction themselves and do not see the need to enrol the librarian. Gregory (2007) writes that studio arts faculty may assume that students are getting training through other means and as a result may not request instruction for their students. His survey of studio arts faculty in the

Southwestern USA shows that 47% of studio arts faculty members have never requested library instruction.

With the Association of College & Research Libraries' (ACRL) new *Framework for Information Literacy for Higher Education* (2015), adopted in 2016, librarians may have a new tool to communicate the benefits of library instruction to studio arts faculty. At Northern Illinois University, Garcia and Labatte (2015) identified two concepts within the framework that allows for 'relating the creative process to the research process'. These include the metaliteracy approach, where multiple literacies (visual, digital, media) converge; and threshold concepts, which represent core knowledge that, once accomplished, are irreversible or unlikely to be forgotten (Meyer, Land and Baillie, 2010). Garcia, who is a librarian, and Labatte, an assistant professor of photography, collaborated on a library session centred on the artist's statement, which allows artists to contextualize their work in both art history and ideology. In this session the artist's statement was used to relate to 'scholarship as conversation', one of the six ACRL threshold concepts (Garcia and Labatte, 2015).

Expanding roles for fine arts liaison librarians

Not only must art liaison librarians continue to keep up with advances in collection development, research, teaching and learning, but also, an engaged liaison librarian must seek to enhance creative and scholarly productivity with arts faculty in all forms, which increasingly involves an ever-shifting selection of digital tools. At Denison, more fine arts faculty are becoming technically savvy and want to create learning experiences that rely on a digital environment, whether teaching their students to curate an online exhibition using Omeka or using a learning management system to support a flipped classroom strategy. As faculty and students continue to experiment with new tools, emerging opportunities for partnerships with liaison librarians and arts faculty will arise.

References

ACRL (2015) *Framework for Information Literacy for Higher Education*, Association of College & Research Libraries, www.ala.org/acrl/standards/ilframework.

ARL (2012) *21st-Century Collections: calibration of investment and collaborative action*, ARL Issue Brief, Association of Research Libraries, www.arl.org/storage/documents/publications/issue-brief-21st-century-collections-2012.pdf.

Daniel, L., Ferguson, J., Gray, T., Harvey, A., Harvey, D., Pachtner, D. and Troost, K. (2011) *Engaging with Library Users: sharpening our vision as subject librarians for the Duke University Libraries*, Duke University, https://library.duke.edu/sites/default/files/dul/about/subject-librarian-report-2011.pdf.

Dickerson, M. (2016) Beta Spaces as a Model for Recontextualizing Reference Services in Libraries, *In the Library With The Lead Pipe*, May, www.inthelibrarywiththeleadpipe.org/2016/reference-as-beta-space.

Garcia, L. and Labatte, J. (2015) Threshold Concepts as Metaphors for the Creative Process: adapting the Framework for Information Literacy to studio art classes, *Art Documentation*, **34** (2), 235–48.

Gregory, T. (2007) Under-Served or Under-Surveyed: the information needs of studio art faculty in the southwestern United States, *Art Documentation*, **26** (2), 57–66.

Jaguszewski, J. and Williams, K. (2013) *New Roles for New Times: transforming liaison roles in research libraries*, Association of Research Libraries, www.arl.org/storage/documents/publications/nrnt-liaison-roles-revised.pdf.

Kam, V. (2014) The Tenacious Book, Part 1: the curious state of art and architecture library collections in a digital era, *Art Documentation*, **33** (1), 2–17.

Kenney, A. (2014) *Leveraging the Liaison Model: from defining 21st century research libraries to implementing 21st century research universities*, Ithaka S+R, www.sr.ithaka.org/wp-content/mig/files/SR_BriefingPaper_Kenney_20140322.pdf.

Meyer, J. H. F., Land, R. and Baillie, C. (eds) (2010) Editors' Preface. In *Threshold Concepts and Transformational Learning*, Sense Publishers.

University Communications (2015) New Center for Teaching and Learning Initiative Announced, press release, Denison University, 20 March, https://denison.edu/news-events/press/40504.

Chapter 4

Accreditation and visual arts libraries

Judy Dyki

Introduction

Accreditation in an academic institution can be viewed either as a necessary burden or as a valuable opportunity for careful self-examination, strategic planning and recommitment to the institution's mission. Most art and design school libraries balance the requirements of a regional accrediting agency along with those of one or more professional accrediting agencies. The nature of art and design programmes often makes it difficult to address general accreditation standards, such as assessment of student academic achievement. Electronic collections, new technologies and new models of information delivery also challenge traditional accreditation measures. This chapter provides a general overview of academic accreditation purposes and processes, discusses self-study strategies for art and design school libraries that go beyond the required data collection and presentation of statistics, and provides recommendations as to how libraries can use the process to strengthen their resources and their role within their institution.

Global perspective on quality assurance in higher education

The voluntary, peer-review system of self-regulation used in American institutions of higher education is unique since in most other countries education is regulated by a national, state or regional governing body. American institutions show a high degree of diversity in size, purpose and scope, and the peer-review process helps each institution reach its full potential according to its mission. They operate with significant independence and autonomy. This is quite different from countries that have each developed their own governmental system of regulation and quality assurance.

In 1999, 29 European countries signed the Bologna Declaration, which was an attempt to make academic degree standards and quality assurance standards more uniform and compatible across the European Higher Education Area (European Higher Education Area, 2017). The number has since grown to 48. The goals of the Bologna

Process were to provide a consistent approach to higher education governance and methods of evaluation, making it easier to move from one country to another for further study and ensuring a broad, high-quality system of education throughout the region.

Functions of accreditation

At its best, the process of accreditation encourages educational improvement and quality assurance through a combination of self-assessment and peer review. Many institutions use the process as a springboard for further strategic planning.

The website for the US Department of Education (2017) lists the following functions of accreditation in the USA:

1 Assess the quality of academic programmes at institutions of higher education
2 Create a culture of continuous improvement of academic quality at colleges and universities and stimulate a general raising of standards among educational institutions
3 Involve faculty and staff comprehensively in institutional evaluation and planning
4 Establish criteria for professional certification and licensure and for upgrading courses offering such preparation

Types of accrediting agencies

In the American accreditation system there are two types of accrediting agencies: institutional or regional, which examine the viability and integrity of the institution as a whole; and disciplinary or professional, which focus on a programme, department or professional school within a university setting.

The regional agencies have jurisdiction over the institutions within their geographic boundaries. These agencies are:

- the Higher Learning Commission of the North Central Association of Colleges and Schools
- the Middle States Commission on Higher Education
- the Southern Association of Colleges and Schools
- the New England Association of Schools and Colleges
- the Northwest Commission on Schools and Colleges
- the Western Association of Schools and Colleges.

Visual arts programmes or schools most often work with the following disciplinary or professional accrediting agencies:

- the National Association of Schools of Art and Design
- the National Architectural Accrediting Board
- the Council for Interior Design Accreditation
- the Landscape Architecture Accreditation Board
- the Planning Accreditation Board.

Process of accreditation

No matter what the type of agency, the process of accreditation generally follows the same steps. There is first a period of candidacy in which the institution must prove it meets the basic criteria for eligibility. The institution then prepares a formal self-study report, which evaluates the strengths and weaknesses in relation to criteria and/or standards set forth by the agency. These normally pertain to educational programmes, faculty, governance, finances, academic support services and so on. It is typical for an institution to assemble a self-study committee to co-ordinate the preparation of the document.

This report is studied by the members of the review team before their site visit to the campus. The team members, usually faculty or administrators from similar types of institutions, provide a peer-review process. While on-site, they meet representatives of the constituent groups (students, staff, faculty, alumni, board members) and observe the buildings, equipment and other physical resources of the campus. Usually a room is set aside for the use of the team members that contains relevant documents and reports, sample transcripts and any other materials the team requests. At the end of the visit, normally three to four days in length, the team meets the president or director and other selected staff members to summarize the team's findings.

The team then prepares a formal written report to document the strengths and weaknesses of the institution along with the team's recommendations for improvement. The report is normally shared with the institution to provide an opportunity to correct any factual errors before submission to the accrediting agency. The agency then uses the team report, the institution's self-study report, and any other supporting documentation to make its decision. It may be full accreditation for the next cycle, it may be conditional accreditation with the requirement for follow-up reports or visits, or in extreme cases accreditation may be withdrawn.

Some institutions choose to have a joint reaccreditation with two accrediting agencies. This is most common with 'single purpose' schools such as an independent art and design school. Such schools are normally accredited by a regional accrediting organization as well as a professional organization like the National Association of Schools of Art and Design. The institution prepares one self-study report that meets the requirements of both accrediting agencies. The visiting team consists of members from both agencies. Although one team report is prepared at the end of the visit, the documents are submitted to both agencies separately, and accreditation decisions are made independently according to the respective schedules of the two agencies.

The self-study report and libraries

Whether institutional, disciplinary or professional, the first stage of the reaccreditation process is the preparation of the self-study report, and a section on the library is required. Accrediting agencies seek evidence of qualified library staff members, appropriate facilities, collections that support the programme, bibliographic control of these collections, access to additional resources, library instruction, sufficient budget support and ample hours. It is a straightforward task to describe and document this type of information, which is typically supplemented by additional materials in the resource room for the visiting team: policy manuals, job descriptions and curricula vitae for library staff members, samples of instructional materials and budget information.

This descriptive aspect of the report is a chance to focus on the strengths and weaknesses of the library. Honest assessment is the key. The strengths of the library's resources and services certainly help the institution to achieve its reaccreditation, so it is important to document them clearly. However, no library is perfect, so it is best that the institution identify its own challenges and describe the plans for addressing them. If issues in the library have been cited by a previous accreditation visiting team, a follow-up response is needed.

Many libraries benefit from a negative report by an accrediting team regarding inadequate collections, facilities, budget and staffing levels. An institution's administration normally feels increased pressure to correct such weaknesses when singled out in a team report – even if library staff members have been reporting them for years.

Most accrediting agencies have moved away from the concept of minimum quantifiable standards for libraries and instead focus on appropriate support for an institution's own mission and purposes. This puts the burden on libraries to perform their own comparison with peer institutions. There are numerous library standards, both general and specialized, that libraries may use in completing their quantitative and qualitative comparisons; Jeanne M. Brown compiled a comprehensive list in *The Library and the Accreditation Process in Design Disciplines: Best Practices* (Brown, Glassman and Henri, 2003, 25–32). In addition, the library directors' group of the Association of Independent Colleges of Art and Design collects and shares statistics each year among its member libraries.

However, the Council for Higher Education Accreditation states that the general trend of most accrediting organizations over the past decade has been away from the simple enforcement of minimum standards toward greater engagement with institutions and programmes. Review processes have become more flexible and problem-driven to allow institutions to focus on issues of importance to themselves. This allows high-end institutions that easily meet minimum standards to continue to view the accreditation process as a valuable one while still assuring accountability (Ewell, 2008, 144).

The role of the library in the life of an educational institution therefore goes far beyond the physical contents of the library building, and accrediting agencies are recognizing

this need to have the library services fully integrated with the mission and purpose of the school or department. Library effectiveness, although more difficult to document, is really the essence of what the self-study report needs to address. Ralph A. Wolff (1994, 127) proposes that the following information be included:

> analysis of the library's relationship to the mission of the institution and evidence of how effectively the library was accomplishing its role; analyses of usage data, especially in a desegregated format by school, program, or discipline to establish appropriate comparative benchmarks; data and analyses of faculty usage or surveys of faculty perceptions of the library; analysis of the faculty's relationship to the library and the role of the library in curriculum and program development; analysis of student perceptions of the library; analyses of the interlibrary loan system – typical users, time for delivery, cost issues, and the like; evaluations of bibliographic instruction efforts; the impact of new technology on the library; and the relationship of the library to the institution's computer centre.

The library's role in the education of the students – from curriculum support and development, to information and visual literacy education, to collaboration with all constituents of the institution – needs to be the focus. The library must be integral to the mission of its specific institution and not just meet the numeric standards of a model library.

Edward D. Garten describes the self-study process as 'one that can lead to important new insights about the college or university. The process can lead to new affirmations about what is really important and valued within the institution. And the process can lead to new opportunities for innovation and change in a climate of new-found consensus among many campus constituencies' (1994, 36). The library should be in the centre of this process.

Role of the art librarian in the accreditation process

When an institution begins to prepare for its self-study report and reaccreditation visit, the art librarian should play a proactive role. Volunteer to serve on the self-study committee, or at least a sub-committee – or perhaps even in the role of the self-study co-ordinator. The librarian is often viewed as a neutral party on campus (an important factor in the self-study process) and frequently is well respected within the institution. The fact that librarians normally have a high degree of organizational skills certainly does not hurt, either.

The librarian should use this opportunity to review and update library policies, document activities, collect statistics, prepare analyses and gather samples of instructional materials. If the library does not have its own strategic plan, this is an excellent time to draft one. Review and update staff position descriptions if needed. Become familiar with

any applicable library standards, general or specialized. Ideally the art librarian will be asked to prepare the section of the self-study report that pertains to the library. If that is not possible, provide significant input to the self-study committee member to whom it has been assigned, then request to review a draft once it has been written.

Remember that other departments on campus will be going through similar preparations. Offer to assist them with research and analyses. Volunteer to organize the resource room for the visiting team. Obtain the names of the visiting team members and prepare information on their backgrounds and interests for the self-study committee. In visual arts institutions, documentation of student work for the visiting team is critical. If the library is not already involved in this process, offer to work with the committee that is preparing the images.

When the visiting team arrives on campus, one team member will be assigned to visit the library and meet library staff. Since librarians are rarely part of visiting accreditation teams, the designated team member may know very little about libraries and may need to be gently guided by the art librarian to come away with the right information.

Once the team has completed its report, the librarian should review any references to the library – positive and negative – and use these in future strategic planning for the library.

Conclusion: the future of accreditation

Accreditation and quality assurance in higher education are constantly under review and in flux. There is pressure to base accreditation on new metrics such as affordability, student retention and graduate rates, student outcomes and employment rates (Brown, Kurzweil and Pritchett, 2017). The traditional role of accreditors as gatekeepers for federal financial aid is also being questioned. Globally, the American system of accreditation (but still under government sponsorship) is beginning to replace audit and programme review for higher education quality assurance (Ewell, 2008, 154).

No matter what form accreditation may take in the near future, art libraries continue to play an integral role in the mission of their respective institutions. The process of self-evaluation and peer review leading into institutional improvement should be a critical one in strengthening the position of the library in the organization.

References and bibliography

Astin, A. W. and Antonio, A. L. (2012) *Assessment for Excellence: the philosophy and practice of assessment and evaluation in higher education*, 2nd edn, Rowman & Littlefield.

Blumenstyk, G. (2015) Accreditation Reformers Propose a Model of Their Own, *Chronicle of Higher Education*, **62** (12), www.chronicle.com/article/Accreditation-Reformers/234168.

Brittingham, B. (2008) An Uneasy Partnership: accreditation and the federal government, *Change*, **40** (5), 32–38.

Brown, J., Kurzweil, M. and Pritchett, W. (2017) *Quality Assurance in US Higher Education: the current landscape and principles for reform*, Ithaka S+R, www.sr.ithaka.org/publications/quality-assurance-in-u-s-higher-education/.

Brown, J. M., Glassman, P. and Henri, J. J. (2003) *The Library and the Accreditation Process in Design Disciplines: best practices*, Art Libraries Society of North America.

Contreras, A. (2008) International Quality Control is No Easy Task, *Chronicle of Higher Education*, **54** (38), A33.

European Higher Education Area (2017) European Higher Education Area and Bologna Process, www.ehea.info/.

Ewell, P. T. (2008) *US Accreditation and the Future of Quality Assurance: a tenth anniversary report from the Council for Higher Education Accreditation*, Council for Higher Education Accreditation.

Garten, E. D. (1994) Reflective Self-Study as Cornerstone of Accreditation: part I. In Garten, E. D. (ed.) *The Challenge and Practice of Academic Accreditation: a sourcebook for library administrators*, Greenwood Press, 35–44.

Gaston, P. L. (2014) *Higher Education Accreditation: how it's changing, why it must*, Stylus.

GUNI (2006) *Higher Education in the World 2007: accreditation for quality assurance: what is at stake?*, Global University Network for Innovation, Palgrave Macmillan.

Kelderman, E. (2015a) Support for Overhauling Accreditation Raises Hard Questions, *Chronicle of Higher Education*, **61** (31), www.chronicle.com/article/Support-for-Overhauling/229237?cid=rclink.

Kelderman, E. (2015b) US to Put New Requirements on Accreditors, *Chronicle of Higher Education*, 6 November, www.chronicle.com/article/US-to-Put-New-Requirements/234082.

Mitchell, E. and Seiden, P. (2015) *Reviewing the Academic Library: a guide to self-study and external review*, Association of College & Research Libraries.

Sandmann, L. R., Williams, J. E. and Abrams, E. D. (2009) Higher Education Community Engagement and Accreditation: activating engagement through innovative accreditation strategies, *Planning for Higher Education*, **37** (3), 15–26.

Saunders, L. (2011) *Information Literacy as a Student Learning Outcome: the perspective of institutional accreditation*, Libraries Unlimited.

Schwarz, S. and Westernheijden, D. F. (eds) (2004) *Accreditation and Evaluation in the European Higher Education Area*, Kluwer Academic Publishers.

Suskie, L. A. (2015) *Five Dimensions of Quality: a common sense guide to accreditation and accountability*, Jossey-Bass.

UNESCO (2002) *Globalization and the Market in Higher Education: quality, accreditation and qualifications*, United Nations Educational, Scientific and Cultural Organization, Editions Economica.

US Department of Education (2017) Overview of Accreditation in the United States, https://www2.ed.gov/admins/finaid/accred/accreditation.html#Overview.

Wolff, R. A. (1994) Rethinking Library Self-Studies and Accreditation Visits. In Garten, E. D. (ed.), *The Challenge and Practice of Academic Accreditation: a sourcebook for library administrators*, Greenwood Press.

Chapter 5

Design thinking for design librarians: rethinking art and design librarianship

Rachel Ivy Clarke

Introduction

For thousands of years, libraries and librarians have designed tools and services to enable access to and use of information resources. Protocols like cataloguing rules, classification schemes, co-operative programmes and readers' advisory were the expert purview of libraries around the world for centuries, enabling and assisting users with access to information. With special attention to unique information behaviours practised by artists and other creative patrons, art and design proffer similar expertise, often developing specialized tools and services to overcome obstacles and solve problems other libraries may not typically face.

But despite a historical track record of innovative tool and service creation, American librarianship is traditionally considered a social science field. Although the application of specific methodologies varies, scientific perspectives pervade library practice, research and teaching, from Pierce Butler's early admonition for application of positivist thought in the library field (1933) to today's contemporary emphasis on 'evidence-based librarianship' (Eldredge, 2006). Various methods and methodological approaches were drawn on throughout the 20th century, yet few have approached librarianship as if it was not a science at all.

In recent years, alternatives to traditional scientific approaches have emerged. One of these is design. Many people think of design in specific, applied contexts, like fashion design or architecture. However, a well established record of research across numerous applied fields shows that design reflects creative approaches that differ from traditional science.

This chapter illustrates the relevance of design approaches to librarianship and how design principles and methods can apply to art and design libraries. After a general overview of design writ large and how it relates to librarianship in general, the chapter discusses one particular approach in more depth: the design thinking process.

Recommendations for art and design librarians are then offered, with special attention to how their unique backgrounds and skill sets might dovetail with this approach.

Librarianship as design

What is design? Ask ten people and you will get eleven different answers. By dictionary definition, 'design' means 'to create, fashion, execute, or construct according to plan; to conceive and plan out in the mind; to have as a purpose; to devise for a specific function or end' (Merriam-Webster, 2017). People typically think of this creation in terms of specific industries or applications, like graphic design, fashion design, architecture or technology (like software design or website design), to name a few. However, all of these specialized fields have commonalities. Beginning in the 1960s, when the first formal investigations of processes and methods of design began, to the present day, scholars like Herbert Simon, Donald Schön, Brian Lawson and Nigel Cross, among others, have identified consistent factors and aspects of design processes across a diverse range of disciplines.

The major difference between traditional science and design worldviews stems from the idea that science is about *what is*, while design is about *what could be* (or arguably what *should* be) (Liedka, 2004). Unlike 'natural' sciences, which observe and describe the existing world with the goal of replicability and prediction, the 'artificial' focus of design offers alternative paradigms of knowledge with the objectives of creating artefacts (Konsorski-Lang and Hampe, 2010) and addressing problems (Binder et al., 2011). Such different goals and focus call for a different approach: what Cross (2011) calls a 'designerly way of knowing'. Review across this body of design scholarship (Clarke, 2016, 2017) reveals the following common set of fundamental elements that underlie what constitutes this design way of knowing (Table 5.1).

Table 5.1 *Common elements of design epistemology (ways of knowing) from a review of the literature of design scholarship* (from Clarke, 2016, 2017)

Elements of design epistemology (ways of knowing)	Creation of problem solutions	Artefacts
		Wicked problems
		Problem finding, framing and reframing
		Emphasis on service
	Generation of knowledge through making	Iteration
		Repertoire
		Reflection
		Use of representations
		Abductive reasoning
	Design evaluation methods	Rationale
		Critique
		Criteria-based evaluation

On examination, librarianship, especially the kinds of work done by librarians, seems to have much in common with design. Librarians do not observe and describe the existing library world in order to predict what may happen next; rather, librarians create things with the intention of solving problems. The 'things' may be tangible, physical objects, like printed indexes, handouts like pathfinders, or even colouring book pages for passive programming. Or these 'things' may be intangible, such as digital products, new classification schemes for special interests, curricula for library instruction, or even event planning. Whatever the form, librarianship is a discipline rooted in making artefacts to solve problems.

With such an emphasis on making tools and services, it seems that librarianship is less about science – discovering and understanding the world – and more about design – making things that solve problems in the world. Yet if you talk to librarians, many (if not most) do not think of themselves as designers. Even user experience librarians – people in positions that are directly inspired by fields like interaction design – consider their role specifically as a research role rather than a design one, de-emphasizing design-related tasks and relegating design to other staff and departments (MacDonald, 2015). Because of this disconnect, elements of design ways of knowing, if drawn on by librarians when creating problem-solving artefacts, are implicit, and thus not harnessed to their full potential.

The design thinking process

How can librarians create better tools and services by explicitly incorporating design ways of knowing into their work? There are numerous frameworks drawn on by designers, such as user-centred design or participatory design, and many concrete methods designers partake in, from A/B testing (showing two variants of a web page to two groups at the same time) to word clouds. Entire books can (and have) been written on these varying approaches. Because of this, the present discussion eschews these narrower lines of focus (such as what kinds of personnel are included on a user-centred design team vs a participatory design team, or whether a cognitive walkthrough is a more useful idea-generating method than concept mapping) in favour of one overarching approach to help libraries and librarians: the design thinking process.

The design thinking approach is a problem-centred, iterative process for finding problems and creating solutions to them. Although the process has always been employed in design work, most people drawing on this method agree that the explicit articulation of the steps in the process was first codified and popularized by David Kelley, co-founder of the product design firm IDEO and creator of the Hasso Plattner Institute of Design (a.k.a. the 'd.school') at Stanford University. Since its original explicit articulation, many variations on the process have emerged. Although the specific verbiage varies, the design thinking process consists of four major phases:

- an investigative phase, wherein a problem is defined and understood
- a planning phase, where ideas are generated
- a development phase, where products or artefacts are actually created
- and an evaluative phase, intended to assess the product.

These phases are not linear, but form an iterative cycle (see Figure 5.1), allowing constant reflection and improvement.

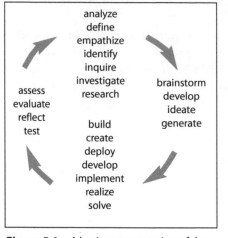

Figure 5.1 *A basic representation of the design thinking process, including various terminology used in different sources*

The investigative phase establishes a problem-solving mindset by recognising patterns, clearly identifying and articulating issues and goals, and emphasizing empathetic understanding of users and customers by seeing things from their perspective (Clark and Smith, 2008). Empathetic understanding of users is a key component to understanding and framing problems.

The planning phase, in which many possible solutions are brainstormed, encourages collaboration and innovation. This phase relies on divergent thinking and brainstorming – coming up with as many ideas as possible, no matter how absurd they may seem. Because design thinking emphasizes multiple approaches to solving a problem, it generates more – and more innovative – solutions (Guterman, 2009).

The development phase encourages creativity in the most literal sense, through the creation of problem solutions, but also encourages adaptation and flexibility, as designers find themselves navigating constraints and restraints. This includes creating prototypes or low-fidelity preliminary mock-ups to test ideas and gather more feedback before committing to full development. Sometimes prototyping is delineated as a separate phase between ideation and development.

The evaluative phase pushes leaders to communicate value clearly, and feeds back into investigation for continued improvement. In addition to merely judging a product's reception and use, this phase is used to expose and identify new problems, thus connecting to the investigative phase and starting the cycle anew.

Although it could be argued that much of the work in librarianship traverses these phases, as noted earlier, it does so implicitly, and therefore not with the strength and power it could have. However, there are some examples of explicit use of the design thinking process in librarianship. For instance, the Chicago Public Library has actively embraced a design thinking perspective, from programming ideas to staff hires (Schwartz, 2013). Temple University Libraries also draw on design thinking to improve library user

experiences, from services to branding (Bell, 2008, 2011). To help assist libraries, IDEO offers a toolkit called Design Thinking For Libraries (http://designthinkingforlibraries. com), which offers librarians a step-by-step guide to adopting design thinking as a staff-driven process for change.

Recommendations for art and design librarians

It is evident that design approaches like the design thinking process described above are highly relevant to librarianship. Yet, with rare exceptions like the Chicago Public Library and Temple University, much of the time librarians do not even realize that they are doing design work. To improve library tools and services, librarians need to draw explicitly on established successful principles and techniques. And who better to forward these ideas than art and design librarians?

While librarians come from all walks of life and a variety of educational and experiential backgrounds, art and design librarians are especially well positioned to harness these kinds of design skills and rethink library work as design work. Compared with librarians at large, art and design librarians have a higher proportion of educational backgrounds in art and design fields. In a fairly recent survey of 280 art librarians (Tewell, 2012), 35% had an undergraduate degree in art history and 12% in art or studio art. More than half (52%) of respondents had a second masters, most frequently in art history (52%), fine arts (16%) and architecture (11%). In addition to education, art and design librarians can be drawn to practising librarianship in these settings because of personal interests, evidenced through avocations like fibre arts, drawing, painting, or other creative endeavours. Because of their familiarity with design – through formal education or informal hobbies – these librarians often are already familiar with design concepts and have the potential to bring explicit design skills and knowledge to their work.

Of the many elements related to design ways of knowing identified previously in this chapter, many art and design librarians are especially equipped to harness repertoire, rationale and reflection in their work.

Repertoire

Repertoire is the name given in design to previous experiences and bodies of knowledge. Designers draw on repertoire both to guide current choices and to evaluate decisions and artefacts. Schön describes repertoire as the 'capacity to see unfamiliar situations as familiar ones, and to do in the former as we have done in the latter, which enables us to bring our past experiences to bear on the unique case' (1983, 68). He points out that a designer's ability to create increasingly better solutions hinges on the scope and diversity of his or her repertoire: the more past experiences a designer has, the more familiar situations he or she can draw on, and thus then be more informed in making decisions in uncertain situations. Lloyd and Snelders (2003) highlight the idea that repertoire need not be limited solely to previous design experiences, but to other external factors such as passive

information reception. A prime example of repertoire in librarianship might be in the work of reader's advisory, a service requiring librarians to supply reading recommendations to patrons (Saricks, 2005). There is not one authorised list librarians memorize and use to suggest reading materials. Rather, to perform this work, librarians must draw on their own personal experiences: every book read, as well as reviews of books read; recommendations and reports from other professionals, friends and family; advertisements on television and magazines; and all manner of unpredictable sources. Each librarian's range of knowledge will differ from that of another, who may end up offering different suggestions based on individual repertoire. Greenberg and Buxton (2008) point out that repertoire is a crucial aspect that separates rigorous design evaluation from mere personal opinion, as designers draw on extensive repertoires to evaluate new artefacts.

Rationale

Design rationale, in the broadest sense, refers to the reasons and justifications for designing an artefact, the notation or documentation of justifications and reasons, and explanations of why an artefact is the way it is (Moran and Carroll, 1996). In a casual application of design, these reasons may be tacit or unarticulated. However, capturing the artefacts created in design with the reasoning behind the decisions for creating them is critical in the idea of design rationale. Again to use a knowledge organization example, we might think of this as akin to warrant, or the justification and verification of decisions in the creation of classification systems. Although not specifically framed in the language of design, Beghtol (1986) specifically refers to warrant as the 'semantic rationale' underlying a classification system. The congruency or divergence of articulated rationale with the artefact itself offers evaluative information. For example, classification systems can be evaluated on the basis of warrant: if justification for terms in a vocabulary is based on presence in the literature (known as 'literary warrant'), but terms in the vocabulary are not found to be present in the literature, the disconnect between the stated rationale and the execution of the artefact offers evaluative insights as to the vocabulary's success. In addition to merely evaluative uses, design rationale can also refer to a method of design wherein the reasons for the design are made explicit. Thus rationale becomes part of the knowledge-making process rather than just a technique for assessment (Carroll and Rosson, 2003).

Reflection

This idea that designers iteratively frame and reframe, making choices about each subsequent move based on previous moves and future 'what if' moves demonstrates what Schön (1983) calls 'reflection-in-action'. Many of us are familiar with reflection, or the idea that we look back on a completed project or past situation with serious thought and consideration, such as a reflective essay we might write for an English class. There is also

some evidence of reflection occurring in librarianship, such as in the project Valuable Initiatives in Early Learning that Work Successfully (VIEWS2), which found that purposeful reflection is a key component in the continuous improvement of storytimes intended to increase literacy skills (Campana et al., 2016). Designers, too, look back on projects in a reflective manner, often drawing on such reflection as an evaluation technique. Reflection can help designers learn from their experiences, become more conscious about design activities and choices, and analyse what worked well against what did not (Reyman and Hammer, 2002). This type of after-the-fact 'reflection-on-action' is familiar to most people. It is arguably designers' engagement in 'reflection-in-action' or the ongoing, continual reflection throughout the process of creation that is one of the major aspects distinguishing design from other epistemologies. Design is often attributed to innate talent or intuition by people unfamiliar with design, and many designers refer to relying on their personal discretion or intuition when making choices. Tacit understanding of what is meant by 'personal discretion' or 'intuition' often contributes to the mystery perceived to surround the design process. But what is commonly attributed to intuition has been dissected and teased out by design scholars and researchers as a type of knowledge based in reflection-in-action (Cross, 2011).

Although librarians may not describe their own skills in such formal terms as these accorded by design scholarship, the ability to draw on a repertoire of knowledge; the justification of decisions through rationale; and the use of reflection to create knowledge are all skills that many art and design librarians already have and employ tacitly, either in their personal lives or professional practice. Formally naming and articulating these skills not only allows librarians to harness them explicitly in their libraries, but also begins to advocate for their value, in turn potentially according more time and resources to be spent using and honing these skills.

For the last 100 years, American librarianship has traditionally been considered a scientific field. Yet on examination, the work of librarianship has more in common with design than with science. This leaves librarians to practise design work implicitly, without explicit fundamental knowledge, approaches and skills inherent in design. Although this issue challenges libraries of all sizes and types, art and design librarians serve artistic and creative patrons with unique information habits and needs, so innovative designs for tools and services are critical.

Re-conceptualizing librarianship explicitly as a design discipline allows librarians to use well established tools, methods and techniques that have been proven to lead to the creation of better tools and services. Thankfully, art and design librarians are well positioned for this challenge by finding themselves more capable of harnessing elements of design ways of knowing. Due to their own personal repertoires of knowledge, via formal education, informal interests, or even exposure to design ideas through interactions with their collections and patrons, art and design librarians hold powerful potential for rethinking library work from a design perspective.

References

Beghtol, C. (1986) Semantic Validity: concepts of warrant in bibliographic classification systems, *Library Resources and Technical Services*, **30** (2), 109–25.

Bell, S. (2011) Design Thinking for Better Libraries, *Information Outlook*, **15** (6), 10–11.

Bell, S. J. (2008) Design Thinking, *American Libraries*, **39** (1/2), 44–9.

Binder, T., De Michelis, G., Ehn, P., Jacucci, G., Linde, P. and Wagner, I. (2011) *Design Things*, MIT Press.

Butler, P. (1933) *An Introduction to Library Science*, University of Chicago Press.

Campana, K., Mills, J. E., Capps, J. L., Dresang, E. T., Carlyle, A., Metoyer, C., Urban, I. B., Feldman, E., Brouwer, M., Burnett, K. and Kotrla, B. (2016) Early Literacy in Library Storytimes: a study of measures of effectiveness, *Library Quarterly*, **86** (4), 369–88.

Carroll, J. M. and Rosson, M. B. (2003) Design Rationale as Theory. In Carroll, J. M. (ed.), *HCI Models, Theories, and Frameworks: toward a multidisciplinary science*, Morgan Kaufmann.

Clark, K. and Smith, R. (2008) Unleashing the Power of Design Thinking, *Design Management Review*, **19** (3), 8–15.

Clarke, R. I. (2016) *It's Not Rocket Library Science: design epistemology and American librarianship*, unpublished doctoral dissertation, University of Washington Information School.

Clarke, R. I. (2017) Toward a Design Epistemology for Librarianship, *Library Quarterly* (forthcoming).

Cross, N. (2011) *Design Thinking*, Berg.

Eldredge, J. (2006) Evidence based Librarianship: the EBL process, *Library Hi Tech*, **24** (3), 341–54.

Greenberg, S. and Buxton, B. (2008) Usability Evaluation Considered Harmful (Some of the Time), *Proceedings of the ACM SIGCHI Conference on Human Factors in Computing Systems (CHI 2008)*, 111–20.

Guterman, J. (2009) How to Become a Better Manager . . . By Thinking Like a Designer, *MIT Sloan Management Review*, **50** (4), 39–42.

Konsorski-Lang, S. and Hampe, M. (2010) Why Is Design Important? An introduction. In Konsorski-Lang, S. and Hampe, M. (eds), *The Design of Material, Organism and Minds: different understandings of design*, Springer-Verlag, 3–18.

Liedka, J. (2004) Design Thinking: the role of hypothesis generation and testing. In Boland, R. J. and Collopy, F. (eds), *Managing as Designing*, Stanford University Press.

Lloyd, P. and Snelders, D. (2003) What Was Philippe Starck Thinking of? *Design Studies*, **24** (3), 237–53.

MacDonald, C. M. (2015) User Experience Librarians: user advocates, user researchers, usability evaluators, or all of the above? In *Proceedings of the 2015 Annual Meeting of the Association for Information Science and Technology (ASIS&T 2015)*, vol. 72.

Merriam-Webster Dictionary (2017) Design, www.merriam-webster.com/dictionary/design.

Moran, T. and Carroll, J. M. (1996) Overview of Design Rationale. In *Design Rationale: concepts, techniques, and use*, Lawrence Erlbaum Associates, 1–20.

Reyman, I. M. M. J. and Hammer, D. K. (2002) Structured Reflection for Improving Design Processes. In *Proceedings of the International Design Conference – Design 2002*, Dubrovnik, 14–17 May, 887–92.

Saricks, J. (2005) *Readers' Advisory Service in the Public Library*, 3rd edn, American Library Association.

Schön, D. A. (1983) *The Reflective Practitioner: how professionals think in action*, Basic Books.

Schwartz, M. (2013) First Year in the Second City: Brian Bannon's first year at the helm of the Chicago Public Library, *Library Journal*, **138** (11), 42.

Tewell, E. C. (2012) Art Librarians' Professional Paths: a careers survey with implications for prospective librarians, *Art Libraries Journal*, **37** (1), 41–5.

Part II

Materials and collection management

Visually oriented collections are a defining characteristic of art and design libraries. From sumptuous print books to rich digital images, publications with unusual formats and three-dimensional objects, art librarians need to work with specialized vendors and follow non-traditional procedures for acquisition, cataloguing, promotion and preservation of these collections. Librarians can also use creative methods to integrate these materials into the curriculum for research and inspiration. Authors in this section explore the changing nature of visual resources collections – from analogue to digital – and the impact on staff and facilities; best practices for the development of new digital collections; the use of archives and special collections to help spark students' imaginations; the creation and management of artists' book collections and the countless ways they may be used to inspire and inform art and design students; the rapidly changing publishing landscape for exhibition catalogues, collection catalogues, *catalogues raisonnés*, sales catalogues and art ephemera; and recommendations for acquiring, organizing and promoting materials collections to support programmes in art, design and architecture.

Part B
Materials and collection management

Chapter 6

Visual resources: from analogue to digital and beyond

Molly Schoen

Introduction

In a professional context, visual resources refers to the line of work that encompasses creating and managing collections of visual content. Working primarily with images, but also with video, virtual reality and other new media, visual resources professionals are involved heavily in digitization, cataloguing and preservation of these materials. In general, visual resources departments are found in academic institutions and museums, but they also exist in public and private libraries and archives. Some businesses may have visual resources units, often operating under a different name, such as digital asset management.

The study of art history relies heavily on image technologies (Kohl, 2012). Interaction with visual materials has also risen dramatically in the internet age. By staying on the cutting edge of technology, visual resource professionals can continue to provide targeted, meaningful advice to their patrons on finding, creating and using images effectively and ethically.

What are visual resources centres?

In the past, visual resources centres existed as slide libraries. Developments of photography and magic lantern slides in the 19th century enabled the study of art history as the discipline known today; without reproducible images, the study of art was limited. Art history degree programmes developed alongside early slide libraries, which included glass lantern slides and printed image collections for study.

By the 1950s, the development of 35mm slides provided a vast improvement over large, clunky lantern slides. Magic lantern projectors were susceptible to fires, but 35mm projectors ran safely and efficiently. The 35mm slides provided rich colour and were more portable. Slide libraries were necessary to house collections of images for the teaching of art history – everything from cave paintings to modern art (Kohl, 2012).

Towards the end of the 20th century, as the use of digital images increased, slide libraries underwent an immense transition. Slides gradually fell out of favour and today are rarely used for teaching. Visual resources centres shifted their efforts from creating slides to digitizing them. This continues to be an ongoing effort for many visual resource offices, having had hundreds of thousands of analogue images in their collections.

While visual resources centres have gradually shifted from slide libraries to become digital image repositories, the transition is not over. They are continuing to transform into more collaborative environments, working with shared resources – such as linked open data – that benefit the communities outside their campuses. Visual resources professionals are exploring data mining, 360° photos and virtual reality as new means of exploring digital humanities. They also may specialize in underserved areas, such as Eastern art history, or in local history.

Visual resources centres offer many other services, such as photography, copyright advisement, technology training and equipment lending. With less time needed for managing in-house image collections, visual resources centres are able to expand beyond their traditional scope.

Who are visual resources professionals?

Technicians, specialists, cataloguers, photographers, directors, librarians and curators are among the most prevalent roles in visual resources. A 2015 survey of the profession found that most respondents (59%) work in higher education, with museums in second place at 29%. The number of visual resources staff working in museums has increased by a significant margin – almost 20% – since the previous survey in 2007 (VRA, 2016). This is no surprise considering that many museums are expanding their online presence with high-quality digital images of their collections.

Graduate-level degrees in art history and in library and information science are the most common credentials for visual resources professionals: 85% of those in visual resources have at least one graduate degree, 55% with one master's, 19% with two master's and 11% with a doctorate. For master's degrees, library and information science ranked just above art history, followed by museum studies (13%) and studio art (10%). Those with doctoral degrees had mainly studied art history (55%), with other disciplines such as information science at less than 10%. The most common undergraduate degree obtained by respondents is in art history, followed closely by studio art (VRA, 2016).

The core duties of visual resources professionals have remained essentially the same for over a century: creating, collecting and cataloguing images for their users. Of course, in the digital age, these tasks are performed much differently: photographing and scanning objects, prints and film; researching online image sources; and performing complex data operations to ensure the accuracy and accessibility of images.

However, the roles of most professionals go beyond digitization or cataloguing. Additional responsibilities may include research and copyright assistance, leading class

presentations and workshops, technology training, event photography, IT or audiovisual support, reference desk shifts, teaching, web design, social media and marketing. Many individuals have split appointments or work part time.

Skills development

There is no specific degree programme or academic trajectory for aspiring visual resources professionals (Iyer, 2009). Many students, new professionals and seasoned veterans alike take it on themselves to stay on top of the evolving technologies in the field.

Fortunately, there are numerous resources available to novice and experienced individuals alike. Popular organizations among visual resources professionals are the Visual Resources Association (VRA), the Art Libraries Society of North America (ARLIS/NA), the American Alliance of Museums and the Digital Library Federation. In addition to conferences, these organizations host webinars, workshops, Twitter chats and other informative events.

Local chapters and student groups of these organizations are also excellent resources. Visual Resources Emerging Professionals and Students (VREPS) and Art Libraries Students & New ARLIS Professionals (ArLiSNAP) collaborate on a virtual conference each year. Each group also shares opportunities in the field, such as calls for papers, fellowships, job postings, workshops and new resources.

Perhaps one of the most effective, hands-on ways to fill any educational gaps is to attend the Summer Educational Institute, an intensive week-long programme created by ARLIS/NA and the VRA Foundation. Its curriculum covers digital imaging, metadata, intellectual property rights, digital asset management and more. In her analysis of visual resources job postings, Hemalata Iyer finds that 'a master's degree programme in library and information science, supplemented with training in the Summer Educational Institute, would provide appropriate training for a visual resources career' (Iyer, 2009).

Digitization best practices

An effective digitization workflow is paramount to the core functions of visual resource centres. Many have backlogs of thousands of legacy items to digitize, not to mention the day-to-day requests from their patrons. Establishing priorities is necessary for all digitization projects (Eklund, 2012).

Appropriate computers, software and devices are essential for successful digitizing endeavours. Many visual resources centres are equipped with flatbed scanners, digital SLR (single-lens reflex) cameras and copy stands. Programmes from the Adobe Creative Suite are most often used for imaging.

Digitization practices vary widely. An image scan for an upcoming publication may look different from a scan done for a PowerPoint presentation, but individual items should not be digitized more than once. Re-scanning is a waste of time and resources, and

because older materials are often quite delicate, they should not be handled more than is necessary.

Standard practice is to make a master file for each image digitized and to have separate access copies for downloading and editing. Master files should be in a non-compressed format with a high resolution, and they should be stored securely in networked servers that are backed up regularly. TIF images are the prevailing format for archival digital images, but because of their large size, smaller institutions may not be able to accommodate them.

Access images are usually smaller versions of the corresponding master images. They are often saved as JPEGs, a compressed image format that uses significantly less memory. Images should only be altered on derivative copies of the master. For instance, in scanning a damaged film negative, there should be no retouching of the master file. Restorative work alters the original information of the film image, so only copies should be restored. An art history professor who requested the scan may want a touched-up image for teaching, since visible damage such as burns or scratches is distracting. Conversely, a conservator may be interested in the original damaged image, showing the negative in its condition at the time of the scan. Furthermore, if an original photograph is overly or sloppily retouched, there is often no way to undo these changes.

There are no overarching standards for high-quality digital images because of institutions' widely varying needs and evolving technologies. However, the Federal Agencies' Digitization Guidelines Initiatives routinely publishes standards used by the US National Archives and other agencies. Other resources may be found at the Image Permanence Institute, which offers a wealth of information on conserving all types of images – film formats in particular, but also digital images.

Metadata best practices

Without textual information to describe them, images are essentially inaccessible. Image recognition technologies, such as those in Google's Reverse Image Search, often do not produce any results, especially for rare images.

In visual resources, metadata identifies and describes images. There are three basic types of metadata:

- *technical metadata:* digital file information such as capture time, pixel dimensions and image resolution
- *administrative metadata:* local data used for records management, including accession numbers, file names and notes about the image (e.g. 'slide missing')
- *descriptive metadata*: describes the content of the work depicted in the image.

Embedded metadata is stored within the image file itself, and images can be linked to database records on the visual resources centre's content management system. The image

and accompanying record are typically what a user sees when viewing a visual resources centre's online image collection.

Examples of different databases within visual resources centres include vendor-provided options from Luna or Artstor, or customized programmes built in FilemakerPro or Microsoft Access. Some visual resources centres use the same system that their parent institutions use, but this can be problematic because museum and library databases were not designed for visual resources use.

To address this, the data standard VRA Core was created for the specific needs of those working with images of cultural heritage objects. One of VRA Core's main features is that it delineates the artwork from the image. A *work* record describes a distinct object or structure, be it a painting, sculpture, original photograph or archaeological site. An *image* record describes the visual representation of the work. Image records store information such as the source of the image and specific description of the image in relation to the work (e.g. 'detail of hands' or 'view of mosque looking northwest').

The relationship of work records to image records is parent–child. In a relational database, the image record links to the work record. Relational databases link many different kinds of records together, such as all images of artworks at the Louvre, or all Chinese ceramics. This is different from a 'flat' database, such as an Excel spreadsheet, which has non-linked data (Eklund, 2012).

Cataloging Cultural Objects is a manual for describing works and their image surrogates. Developed in 2006 by the VRA, *Cataloging Cultural Objects* maps to VRA Core and to another metadata standard, Categories for the Description of Works of Art (CDWA).

Finally, authority lists ensure consistency of data across institutions. The Getty's Art & Architecture Thesaurus (AAT) and Union List of Artist Names (ULAN) provide the preferred spellings and hierarchies of terms and names. For example, should an artwork by El Bosco be catalogued under his colloquial name or by his full name, Hieronymus Bosch? ULAN indicates that the preferred entry is Bosch, Hieronymus.

Open content

Many museums and collections, recognizing the value of added scholarship, have made their digital collections fully accessible. The Rijksmuseum in Amsterdam was a pioneer in providing high-quality, open access images to the public. Images of their public domain artworks are completely free for any purpose, including commercial use. The Getty's Open Content Program has the same idea. High-quality downloads of more than 100,000 museum images are available, and no permission is needed to re-use or publish them (Getty, 2017).

Metadata, too, has become open and shared, leading to new discoveries. In 2015, the Museum of Modern Art released a dataset of 100,000+ records on GitHub, open for anyone to use. One data professional compared the years of artwork acquisitions to the

gender of the artist. News website FiveThirtyEight used the data to publish illuminating graphs of the Museum of Modern Art's artworks, including date of creation versus date of acquisition, and a comparison of paintings' dimensions, showing how many are taller than wide and vice versa (Romeo, 2015).

Openly available content leads to new insights. GitHub's users include computer scientists, programmers and creative technologists; their unique backgrounds can add a new layer of meaning to art information.

De-accessioning 35mm slides

Even while promoting forward-thinking initiatives like open content, many visual resources centres are still challenged by a legacy problem: what to do with obsolescent 35mm slide collections? Some colleges may have older professors still dutifully filling slide carousels for their lectures, but many visual resources professionals have since guided them into the digital era. Circulation of slides dropped dramatically, starting around 2004 or 2005, and most institutions had stopped circulating them altogether by the start of the 2010s (Godfrey, 2014; Cartledge et al., 2014).

Should slides be retained, moved or discarded – or some combination of the three? What do visual resources centres look like without slides? Can they justify their space and budget needs to administrative heads? Unfortunately, some visual resources centres did not survive the transition and have been shuttered. After retirement, other professionals found that their positions were either not filled or reclassified at a lower level.

A 2014 survey of 112 35mm slide collections revealed that 85% of respondents were located in an academic environment, with most of the rest in cultural institutions. Collection size ranged from 80,000 to 550,000 slides. Only 24% of collections were reported as being intact. The rest were either undergoing culling, had already been disseminated, or had been sent to remote storage (VRA Slide & Transitional Media Task Force, 2014).

Reasons for the de-accessioning of slides varied: lack of use, lack of funds, lack of space, administrative pressure, facility closure or some combination of the above. Around half of the survey respondents had had their collection space reduced.

Criteria for weeding slides included:

- poor image quality
- poor slide quality (film deteriorated)
- equivalent digital images being available
- slides being duplicates
- slides being unlabelled
- slides being book images (copy photography)
- slides being outside the collection scope.

Conversely, slides were kept for the following reasons:

- They were rare or original images.
- They were gifted or donated slides.
- They were slides kept for cataloguing information (labels).
- There was no immediate pressure to cull.
- They were slides selected by faculty to be retained.

In many instances, such as at the Getty Museum's Slide Library, or in Oxford University's art history department, slides that document the history of their institutions – event photos, fieldwork photography, architectural plans – were retained. Art and design schools often keep slides of student work and exhibitions.

At Cardiff University, Visual Resources Librarian Jenny Godfrey found reasons for institutions to keep at least some part of their slide collections: 'The sensual nature of the slide is a novelty to students who have only known the digital image on a bland screen' (Godfrey, 2014). John Davis, visual resources curator at Manchester Metropolitan University, found that there was a 'significant increase' in the number of students visiting the visual resources centre to view slides because they are interested in working with 'found images and pre-digital technology' (Davis, 2012).

Once a collection is reviewed, staff must decide what to do with the discarded slides. They can be discarded, but because many visual resources centres are located in art-centric environments, they can often be given away for creative re-use. Many slides are still protected under copyright, but the chances of someone using discarded slides in a way that would not be considered fair use is extremely unlikely. Slides have been used to make lampshades, light catchers and viewfinders. They have also been incorporated in contemporary art exhibits. In 2012, Ithaca College's visual resources centre invited faculty, staff and students to pick up bags of de-accessioned slides to use in creating new artworks. Completed works were exhibited in a show later that year (Cartledge et al., 2014).

In the music world, vinyl records and even cassette tapes have made comebacks. Recently, instant cameras have also surged in popularity after being almost nonexistent a few years ago. A second coming of slides is not entirely implausible. Nostalgia and the desire for tangible objects run strong in the digital age.

New spaces, new collaborations

One big benefit of reducing or eliminating slide collections is increased space. Bulky rows of slide cabinets have the effect of a wall or barrier; without them, the cleared space can be transformed into something more open and inviting.

The extra space at Connecticut College was used to create a digital photography studio (Braunstein, 2013). At Massachusetts College of Art and Design, the Visual Resources Department invited the archives to use their refashioned space as a reading room. This

increased the collaboration between the two departments (Cartledge et al., 2014). At the University of Georgia, the fine arts librarian was invited to host office hours inside the visual resources centre. Similarly, at the University of New Mexico, professionals from the Bunting Visual Resources Library and the Fine Arts and Design Library began a 'staff sharing' initiative that placed visual resources professionals at the reference desk and in collaborations with library exhibitions (Kline, 2014).

Duke University's Wired! Lab for Digital Art History & Visual Culture brings faculty, librarians, curators, technologists and students together on digital humanities projects. These projects integrate 3D modelling, web development and data visualization as part of its digital pedagogy, equipping those involved with a deeper understanding of technologies and the creative ways in which they may be used (Jacobs, 2016).

No longer dusty slide libraries, revamped visual resources centres are more like information commons or makerspaces, collaborative environments that foster learning through technology. One of the attractions of such spaces is that they provide equipment and software users would not be able to afford individually (Milewicz, 2009). Another advantage is the space they provide for collaboration and exploration.

Conclusion

In the age of Google, where thousands of images can be found with just a few keystrokes, are visual resource centres still relevant? They are, and will continue to be, so long as they keep evolving. Patrons interact with visual materials now more than ever, but that does not mean they know how to find, interpret or use images effectively. Visual resources professionals can stay relevant by advocating for visual literacy and by curating repositories of images that may not be available elsewhere.

Changes at visual resource centres parallel what is happening to libraries in general: where less space is needed for physical collections, more space can be dedicated to 'defining the user experience' (Houston, 2015). Serendipitous discoveries can be made in the stacks or slide drawers, and human connections are made daily. These experiences cannot be replicated in online environments. The slide library may be a dying breed, but the growing use of visual media in virtually all forms of communication ensures that the visual resources profession is here to stay.

References and bibliography

Baca, M., Harpring, P., Lanzi, E., McRae, L. and Whiteside, A. (eds) (2006) *Cataloging Cultural Objects: a guide to describing cultural works and their images*, American Library Association.

Baron, C. and Schoen, M. (2015) Rethinking Visual Resources Centers in the Digital Age: case studies at the University of Georgia and the University of Michigan, *VRA Bulletin*, **41** (2).

Braunstein, M. (2013) Eulogy to a Slide Library, *VRA Bulletin*, **39** (3).

Cartledge, J., Lanzi, E., Millman-Brown, R., Pereria, C., Pompelia, M. and Whiteside, A. (2014) Redesigning Visual Resources Facilities for 21st Century Challenges, *VRA Bulletin*, **40** (2).

Davis, J. (2012) E-mail message posted to ACADI listserv, 2 November, unpublished.

Eklund, J. (2012) Cultural Objects Digitization Planning: metadata overview, *VRA Bulletin*, **38** (1).

Getty (2017) Open Content Program, www.getty.edu/about/opencontent.html.

Godfrey, J. (2014) Dodo, Lame Duck or Phoenix? How should we view the slide library?, *Art Libraries Journal*, **39** (3), 28–33.

Houston, M. (2015) Revisiting Library as Place, *References & User Services Quarterly*, **55** (2), 84–6.

Iyer, H. (2009) A Profession in Transition: towards development and implementation of standards for visual resources management, *Information Research*, **14** (3).

Jacobs, H. (2016) Collaborative Teaching and Digital Visualization in an Art History Classroom, *VRA Bulletin*, **43** (2).

Kline, H. (2014) Visual Resources Outreach: success and challenges in a new role, *VRA Bulletin*, **40** (1).

Kohl, A. (2012) Revisioning Art History: how a century of change in imaging technologies helped shape a discipline, *VRA Bulletin*, **39** (1).

Milewicz, E. (2009) Origin and Development of the Information Commons in Academic Libraries. In Forrest, C. and Halbert, M. (eds), *A Field Guide to the Information Commons*, Scarecrow Press.

Romeo, F. (2015) Here's a Roundup of How People Have Used MoMA's Data So Far, *Medium*, https://medium.com/@foe/here-s-a-roundup-of-how-people-have-used-our-data-so-far-80862e4ce220#.cjazlqwwl.

VRA (2016) *2015–2016 Professional Status Task Force Report on Professional Status*, Visual Resources Association, http://vraweb.org/wp-content/uploads/2013/02/2015-16-VRA-Report-on-Professional-Status.pdf.

VRA Slide & Transitional Media Task Force (2014) *Summary of Survey Conducted in Fall 2014*, http://vraweb.org/wp-content/uploads/2015/07/VRA2015SlideSurvey-Summary.pdf.

Chapter 7

Developing digital collections

Greta Bahnemann and Jeannine Keefer

In the late 2000s manuals, such as Terry Reese and Kyle Banerjee's *Building Digital Libraries* (2007), provided a detailed guide to the creation of digital collections. This chapter does not seek to supplant the guidance provided in this and other texts, but to focus on the best practices, to emphasize the fluid nature of collection building and to recognize potential beyond the collection to create new knowledge and interoperability.

Introduction to digital collections

Institutions, groups and individuals create digital collections that comprise a number of different types. A collection might stand alone (for a course or an exhibition), serve as a digital archive, contribute to a digital humanities project, enhance an institution's digital repository, or aggregate a multiple collections, such as Artstor or the Digital Public Library of America (DPLA; https://dp.la/).

Regardless of type, all digital collections have two basic components: the digital file and its associated metadata. This is true whether the original materials are textual, visual, audio, video or three-dimensional objects. The digital file can either be born-digital, such as an image captured using a digital camera or created on a computer, or it can be a digital surrogate of an analogue original. The associated metadata includes descriptive, administrative, technical and preservation metadata that aid in the discovery, use and management of the digital file. The content of your collection determines some of the decisions you will make regarding file types, metadata schema and presentation possibilities. Whether your collection is temporary or permanent, institutional or aggregated, or focused on art, science or history, the same rules and best practices apply.

Getting started

Motivators for planning and building digital collections include preservation of rare or

fragile materials, providing access to unique or valuable materials, and increasing exposure to all collection items.

No matter the reason for building a collection, there are several questions you will want to answer as you develop a project plan and workflow. Good planning eases the format migration, data creation and the pursuit of future projects. It also enables simultaneous sharing of content in multiple venues. The only constant in digital collections is change, and you need to be sure your content can adapt to new technology and tools for storage, access and delivery.

What am I going to digitize and why?

The format of the original content will determine digitizing workflows and delivery considerations. The format and the subject content of your materials will guide your plans for storage, metadata schema, controlled vocabularies and delivery tools.

Are you duplicating efforts?

Given the ease of digital production, your content may well exist in digital format somewhere else on your campus, at another institution, or somewhere in the world. Determine if your project should proceed by conducting a thorough scan for your particular items at other organizations and on the web. If your content currently exists in a reputable and viable collection, you may need to reassess the need for your project. Alternatively, you may wish to move forward if your efforts can offer significant quality enhancements, expanded access or even supplant work that has already been done.

What needs are you meeting or filling?

The needs are often the motivators for creating a collection. Is the material rare or unique? Will digitization help preserve fragile materials? Will digitization provide remote access to scholars and expose users to materials new to them? Will the digital collection assemble disparate analogue collections into one access point? Will the collection meet research and/or pedagogical needs?

Who is the intended audience?

Will this collection serve the institution, scholars, groups and classes or the general public? The answer may be one, all or any combination of these. There can be, and likely should be, multiple audiences for some digital collections, but the delivery, outreach and promotion may differ for each, which leads to the next question.

How do you intend to connect your digital collection with its intended audience?

We digitize to connect users with materials. This core concept is what drives all digitization projects. We can inform, entertain, enlighten and connect people to ideas, objects and images not previously available to them. Developing the digital collection is the first step. The second step is to promote the collection and connect it to its audience. In our increasingly connected digital age, it is important to consider the use of social media as one tool to connect your digital content with users. Various social media platforms can quickly and easily reach a wide audience. Using these tools effectively can inform and engage, as well as raise awareness of your digital collection. Various social media platforms, such as Facebook, Twitter, Instagram and YouTube, can quickly and easily reach a wide audience. These platforms allow for the sharing of both text and images. For example, Facebook, Twitter and Instagram can be used to promote items from a digital collection as well as to publicise special events and happenings associated with a digital collection. YouTube can promote and disseminate short training videos.

Multiple points of entry will also foster discovery and [re]-contextualization of your content for different audiences. Collections and repositories may have local access points, but they may also be discovered via larger aggregated collections. For example, you can search many museum collections via their websites, but you can also discover that same content, along with other relevant resources, in Artstor (www.artstor.org). The same is true for libraries, archives and museums that contribute their content to DPLA. A third, more localized, example is Yale University's site Primary Sources at Yale (http://primarysources.yale.edu). This collection-landing page quickly and easily directs users to the myriad of primary source materials owned and licensed by Yale University.

Evolving solutions

Failure to answer the questions stated above adequately may necessitate a re-evaluation of your project and its parameters as the project progresses. If you plan your project with flexibility, accuracy and comprehensiveness in mind, your content can populate a number of delivery schemes, be harvested and analysed, be used in collaborative scholarly projects, and survive the ever-changing landscape of digital storage and delivery. For example, you want your collection to be nimble enough to adapt to advances in digital collection interoperability, such as linked open data. This landscape becomes even more complex as the lines between digital asset management systems and content management systems have become increasingly blurred. A digital asset management system organizes digital content of all types; it is essentially a big bucket for digital content. A content management system pushes content out to the web and may use assets from a digital asset management system, but it is focused on the discovery of, access to, and contextualization of such content rather than the original asset. Sometimes the two are integrated into one product and at other times digital asset management content is pushed out to a content

management system for consumption. Ideally your content can be used and consumed from a number of starting points.

Although changes in technology and digital asset management presentation solutions have altered workflows, physical media also affect workflows. Are there time constraints on access to the material? Must the materials be scanned in situ? Does your system allow for simultaneous digitizing and cataloguing of items? Or, must the workflow progress in a linear fashion from one area to the next?

Some digital collections are now more than 20 years old and to remain usable they have been reworked and have migrated at least once. Twenty years ago slides and print images were scanned at lower resolutions for reasons including copyright, storage capacity, cost and technological capabilities. If this content is still relevant and needed, it has likely been re-digitized at higher resolutions. Digital asset management systems have progressed as well from simple flat databases, to hierarchical ones, and eventually to the multi-functional systems we have today. Adherence to metadata standards and long-term planning made it possible for many collections to migrate. Even quickly assembled collections can be expandable if you considered the questions above and think about the long-term life of the content.

Digital preservation

Before beginning a digitization project, consider digital preservation planning. Too often digital preservation planning is left to the end of a project, but a well planned workflow includes it at the onset. Including digital preservation planning from the start will ensure the longevity and sustainability of your digital objects.

Not every digital item needs to be, or should be, preserved. An assessment of your digital content will undoubtedly unearth items of poor quality, lesser importance, and duplicates. Completed digital projects should be regularly assessed for their enduring value. Decisions to retain, preserve or discard content should be based on criteria established by your institution or organization.

Digital preservation planning acknowledges that digital content is inherently more fragile than many of its corresponding analogue formats simply because it relies on technology (both hardware and software) to be seen, heard or read. Technology can fail, be surpassed by new versions, and become obsolete. Changing technologies and new equipment may necessitate managing the migration of files to new archival and access formats. It is good practice to digitize using archival file types and the highest resolution possible, knowing that you will distribute a variety of derivatives and will likely need to supervise the migration of originals into new file types in the future.

Digital content requires active and planned management to ensure ongoing access. Two organizations leading the field in preservation planning and preparedness are the Library of Congress and its Digital Preservation Outreach & Education (DPOE) programme and the Digital Preservation Coalition. The DPOE website has extensive

information on digital preservation training opportunities. The Digital Preservation Coalition provides extensive resources on digital preservation planning, including general information and format or topic specific resources.

Assessing needs and capacity

As you move through the planning process, make a thoughtful assessment of institutional needs and capacity. Decisions made here will drive the work of building, maintaining and disseminating your collection to its appropriate audience(s). The following questions should be considered and answered before any digitization or format conversion work begins:

- Is your project supported?
- What are your software needs?
- What are your hardware needs?
- What is your staffing capacity?

Is your project supported?

Do you have institutional and financial support for your project? Does your institutional support extend from the top levels of your organization down to your co-workers? If support does not exist, what educational and outreach efforts are needed to guarantee a level of organizational buy-in to your project? Does financial support exist for this project?

Next, ascertain the project's budget. Have the costs of technology been added to the budget? Will staff be available? Have funds been budgeted to maintain and expand the project in the coming years? If your project lacks a sustainable funding source, what can reasonably be accomplished with the resources currently available to you?

What are your software needs?

One of the first steps in assessing a digitization project is to evaluate your software needs. Software solutions can range from purchasing a licence to downloading and using free tools. Two types of software are essential to the creation of a digital collection: content editing software and content management software.

Content editing software

The essential actions of image editing software include the ability to crop, resize and colour-correct a raw image, as well as the ability to save images into multiple file formats (e.g. tiffs or JPEGs). For image editing and manipulation, many find Adobe Photoshop to be useful. If your budget does not allow for this purchase, consider downloading one of the free photo editors (current options include GIMP, PIXLR Editor, PhotoScape).

There is software for editing and reformatting time-based materials (audio and video). Current paid and free options for audio and video include Audacity, Windows Media Player, Final Cut Pro, Windows Media Player and Adobe Premier.

Digital asset management and content management systems

Does your organization currently support content management software? Is the version up to date? Will this project necessitate an upgrade? The primary functions associated with digital content management software are the product's ability to store, display and provide discoverability to digitized content.

Options exist either to use [free] downloadable software, build your own system, leverage the cloud, or purchase a licensed content management system such as CONTENTdm, Shared Shelf or Luna Insight. These licensed products offer robust content management, storage and retrieval options. The functionality of the major content management systems have become increasingly similar in recent years. As a result, the factors that determine your selection may shift to other priorities including price, institutional buy-in and technical support. Table 7.1 compares the functionality of CONTENTdm, Shared Shelf and Luna Insight.

Table 7.1 *Comparative analysis of three content management systems*

Functionality	CONTENTdm	Shared Shelf	Luna Insight
External hosting?	Yes	Yes	Yes
Support single page items?	Yes	Yes	Yes
Support multi-page items (compound documents)?	Yes	Yes	Yes
Support audio and video file formats?	Yes	Yes	Yes
Ability to convert images into text through optical character recognition (OCR)?	Yes	No	Yes
Can content be exported out of the collection?	Yes	Yes	Yes
Built-in display functionality?	Yes	No. Content can be published to multiple display targets such as the Artstor workspace, SharedShelf Commons, a custom website, and Omeka using its open API and OAI harvesting.	Yes

Free options also exist, but usually with more limited storage and file backup options. Home-grown solutions can also offer robust and customized solutions to complex problems, but may require high staffing levels and detailed maintenance. Any consideration of these three options should account for your collection's primary needs as well as the resources that currently exist at your organization. If you have adequate staffing and storage options within your institution, perhaps a custom or free programme that offers display and discoverability is an optimal choice. But if you are looking for a more hands-off solution, consider purchasing licensed software that provides off-site storage of files and an out-of-the box discovery system.

What are your hardware needs?

Digitization projects also demand hardware, specifically, the equipment needed to digitize your analogue materials, and unless you are using cloud storage, a server. Has your organization considered the need to purchase scanning and/or digitization equipment as well as a designated server? Have the costs of this kind of equipment been accounted for in the budget? Digitization equipment can take the form of scanners, such as flatbed scanners, scan-back cameras, copy stands and digital SLR cameras and/or book scanners.

The required equipment depends on the types and size of analogue or original items. A large collection of pamphlets and books may warrant the purchase of a book scanner, whereas a collection of photographs and maps may require a flatbed scanner.

Next, determine if your organization is prepared to make a purchase. Consider the merits of co-operative purchases (perhaps partnering with other organizations or departments). In some cases, it may be more cost effective to outsource the digitization to a reputable vendor, especially if there is little projected need or demand for the equipment after the project is completed. This is sensible if your collection is relatively small or if it consists of multiple formats, such as prints, photographs, audio or video recording or three-dimensional objects. Since multiple analogue formats several different pieces of equipment, working with a vendor may be more efficient and cost effective.

What is your staffing capacity? How will you provide training to staff?

All in-house digitization projects require staff. Before beginning a project, determine who will serve as the project's manager and establish the workflow. Who will conduct the various tasks? Will new staff be hired to manage digitization and image-correction, or will this work be completed by existing staff members? How will work be delegated? Do you have an adequate number of workstations to accommodate these staff members? An important role for the project manager will be to determine the amount of training needed to complete the project. Who will provide that training?

Standards for digitization and metadata creation

National standards and best practices exist for digitization and metadata creation. It is important to remain abreast of new trends and developments. To stay current involves constantly working towards improvements in digitization work and metadata creation. As with any project rooted in technology, it is also necessary to plan for your project's migration to new platforms or software versions.

No matter what your collection's subject, size of your project, or the file types of your content, standards make your collection more nimble. Standard metadata schema make it easier for your collection to 'play well' with other collections via crosswalks. Standardized vocabularies make the aggregation and sharing of your metadata more seamless, and digitization standards optimize your efforts and support your preservation plans. Collections not using these standards create the need for considerable data cleanup and normalization if they are ever to be more than standalone projects.

The decisions you make about what schema, standards and controlled vocabularies to use will be based on your collection and its parameters. Multiple metadata schemes currently exist – schemas intended for a more general application and schemas that work for very specific collection types. No single standard exists that will work for all digital collections. The information we present in Figure 7.1 opposite shows some of the various options that currently exist. All digital projects necessitate a careful review of available options. Any decisions made about metadata should reflect what is appropriate for your institutions, users and the content of your digital collection.

Rights and intellectual property

No issue drives the use and re-use of digital content more than copyright and regard for intellectual property. The DPLA is taking the lead on helping all digital content creators become better managers and disseminators of information about digital content and rights.

The issues of copyright and intellectual property with regard to your digital collection can be complex. Considerations for display, consumption and transformation depend on individual materials as well as creator information, intended use and re-use of materials as well as the provenance of the analogue original.

Several important factors should be noted. First, physical ownership of material does not automatically bestow ownership of its intellectual property. Second, do not overstate your rights holdings. Third, there are a number of resources to help you navigate the consumption, sharing and transformation of materials. DPLA and Europeana have joined forces to create a set of standardized statements that digital content creators can review and adopt at rightsstatements.org/en. Additional resources include the VRA's page on intellectual property rights and copyright at vraweb.org/resources/ipr-and-copyright and the College Art Association's Code of Best Practices for Fair Use in the Visual Arts at www.collegeart.org/fair-use. Remember that copyright laws differ by country and that US copyright law is interpreted on a case-by-case basis.

Digital collection development resources	
For updated links and ongoing scholarship consult the Cataloging, Metadata and Data Management page at http://vraweb.org/resources/cataloging-metadata-and-data-management.	
Digitization standards and best practices	
Federal Agencies Digitization Guidelines Initiative (FAGDI), www.digitizationguidelines.gov/guidelines	
NISO, *A Framework of Guidance for Building Good Digital Collections*, National Information Standards	
ALA: American Library Association Minimum Digitization Capture Recommendations, www.ala.org/alcts/resources/preserv/minimum-digitization-capture-recommendations	

Metadata schemas	Intended application
VRA Core: Visual Resources Association Core, www.loc.gov/standards/vracore	Art and art history Architecture Archaeology Cultural heritage
Categories for the Description of Works of Art (CDWA), www.getty.edu/research/publications/electronic_publications/cdwa	Art Architecture
Metadata Object Description Schema (MODS), www.loc.gov/standards/mods	Digital collections Library application Cultural heritage
Metadata Encoding and Transmission Standard (METS), www.loc.gov/standards/mets	Digital collections
Encoded Archival Description (EAD), www.loc.gov/ead	Archival collections
Dublin Core and DCMI: Dublin Core Metadata Initiative, dublincore.org	Digital collections Physical collections Archival collections Cultural heritage

Metadata standards	
Getty Metadata Standards Crosswalk, www.getty.edu/research/publications/electronic_publications/intrometadata/crosswalks.html	Digital collections
Library of Congress Standards, www.loc.gov/standards/	Digital collections
Cataloging Cultural Objects (CCO), cco.vrafoundation.org	Visual resources Cultural heritage Art Architecture Archaeology
VRA Web-enabled Data and New Initiatives, vraweb.org/resources/cataloging-metadata-and-data-management/web-enabled-data-and-new-initiatives/	Digital collections Embedded metadata RDF Linked open data

Controlled vocabulary resources	
Getty Vocabulary Program, www.getty.edu/research/tools/vocabularies/ • Art & Architecture Thesaurus (AAT) • Cultural Objects Name Authority (CONA) • Thesaurus of Geographic Names (TGN) • Union List of Artist Names (ULAN)	Art Architecture Cultural heritage Geographic
Library of Congress Authorities, authorities.loc.gov/	Digital collections
Iconclass, www.iconclass.nl/home	Art Iconography

Figure 7.1 *Digital collection development resources, digitization standards and best practices, metadata schemas, metadata standards and controlled vocabulary resources*

Digital art history and digital humanities

The terms 'digital art history' and 'digital humanities' are broad in scope – and purposely so. They can relate to digital creation, digital analysis and digital production. Digital creation refers to making something new using various digital tools (e.g. a map created from statistical data or a virtual environment created from a written description). Digital analysis refers to the application of computational methods to analyse and dissect data or digitized content. This analysis work can apply to data from any source including texts, such as novels, letters, monographs or articles; visual objects; or new research and new data sets. Digital production or 'digitization' refers to the process of reproducing an analogue object into a digital format so that it can be manipulated and accessed digitally (e.g. scanning an historic photograph and creating a master tiff file and a web access jpeg2000).

Digital projects can be tools for scholarship and/or ends in themselves. A textual analysis of *The Aeneid* might not be intended for public consumption but might be infinitely useful for the scholar. The project Mapping Inequality: Redlining in New Deal America from the Digital Scholarship Lab at the University of Richmond (https://dsl.richmond.edu/panorama/redlining) visualizes a large amount of data gleaned from materials produced for the Home Owners' Loan Corporation. This scholarly project presents data in a dynamic and appealing way. Academics and researchers are using it to create innovative scholarship on New Deal housing inequality and urban planning in the USA. It is also an engaging standalone project. Many users of this resource interact with it to learn about the evolving landscape of American home ownership.

Well-crafted digital collections can provide fertile content for curation, data mining, micro and macro analysis, visualization, mapping and almost any other imaginable digital practice. Visual resources professionals have been creating digital content and associated metadata, crafting and supporting metadata schema and standardized vocabularies, and establishing rules for that metadata for over two decades. For many faculty and administrators this content creation and data collection was supplanted by the ubiquitous Google Image Search, but much of the collection building work done in the past can now be exposed and used in digital art history and digital humanities projects. In fact, the better, more complete and sharable the content, the more potential the collection has for digital practitioners to examine, analyse and transform the materials into new knowledge.

Conclusion

The creation of a vital and enduring digital collection demands both pre-planning as well as ongoing evaluation. In this chapter we have attempted to showcase some of the myriad resources available to you. Accept at the onset that digital collections demand a multi-faceted planning process. Accommodations need to be made to include your organization's needs and demands, the creation of user-oriented metadata, and the long-

term preservation of your work. The regular monitoring of your digital collection workflow for potential changes and improvements will ensure your collections' sustainability in an ever-changing environment. Including collection planning at the onset will insure that the digital project adheres to current best practices and [inter]national standards. Careful planning also positions digital content to be cross-walked, migrated and integrated into other digital projects. Finally, it should be noted that because of changing technologies and evolving best practices digital collections are never really complete and are never 'perfect'. There is always room to improve and enhance the work we have previously done. Our role as stewards of digital content is to strive to make things better and plan for ever-changing solutions.

References and bibliography

Baca, M., Harpring, P., Lanzi, E., McRae, L. and Whiteside, A. (2006) *Cataloging Cultural Objects: a guide to describing cultural works and their images*, American Library Association.

Digital Humanities and the Visual (2016) *Visual Resources Association Bulletin*, special issue, **43** (2).

Journal of Digital Media Management (2012–).

LeFurgy, B. (2012) Why Does Digital Preservation Matter?, blog, The Signal, Library of Congress, 21 December.

Reese, T. and Banerjee, K. (2007) *Building Digital Libraries: a how-to-do-it manual*, Neal-Schuman.

Riley, J. (2017) *Understanding Metadata: what is metadata, and what is it for?* National Information Standards Organization (NISO).

Zhang, A. and Gourley, D. (2008) *Creating Digital Collections: a practical guide*, Chandos Publishing.

Websites

Digital Curation Centre. List of Metadata Standards, www.dcc.ac.uk/resources/metadata-standards/list.

Digital Library Federation, https://www.diglib.org/.

Rogers, J. (2014) File Naming Standards for Digital Collections, B Sides, http://ir.uiowa.edu/cgi/viewcontent.cgi?article=1048&context=bsides.

Chapter 8

Inspirational encounters: the management and use of archives and special collections in the art and design library

Jess Crilly, Gustavo Grandal Montero and Sarah Mahurter

Introduction

Archives and special collections are an essential element in the documentation of the history and practice of art and design. They play a major role in the collections of academic libraries, supporting teaching, learning and research. These collections have never been in more demand – in an age of superabundant information we are experiencing 'a material turn', a return to the physical and the idea of the authentic and unique. Institutions value and promote them as strategic assets, and their academic use is increasingly popular and wide ranging. This chapter presents a general overview of current best practices in the development and management of archives and special collections within the specific context of art and design academic institutions, primarily in the UK and USA.

There is a general consensus in the professional literature about the definition of archives: 'Archives are collections of information (. . .) in many forms such as: letters, reports, minutes, registers, maps, photographs and films, digital files, sound recordings (. . .). Some archives are created by official bodies such as governments, businesses or professional organisations. Others are private collections' (National Archives). Definitions for special collection(s) are more varied. An elastic term, archives often comprises rare books and manuscripts and also a range of other formats (ephemera, rare periodicals, artists' publications, zines and so on). The Association of College & Research Libraries uses the following definition: 'The entire range of textual, graphic and artefact primary source materials in analogue and digital formats, including printed books, manuscripts, photographs, maps, artworks, audio-visual materials and realia' (ACRL Code of Ethics for Special Collections Librarians, 2003).

Policies, resources and acquisitions

Institutional context and strategies

Archives and special collections play a particular role in distinguishing and characterizing

institutions, and are rich resources for teaching, learning and research internally and for engagement with communities beyond the institution. This differentiating role and relationship to institutional mission and identity was described in a recent report on unique and distinctive collections by Research Libraries UK: 'a collection that, regardless of format or location within an institution, derives significance from its interest to research, teaching, or society through its association with a person, place or topic, such as to distinguish the consistent items from similar items which may exist elsewhere' (Research Libraries UK, 2014).

In the UK, archives and special collections play an established role in supporting institutional submissions to the Research Excellence Framework. Archives and special collections inspire research activity and research outputs, informing Research Excellence Framework impact case studies, and form an important element of the institutional research environment statement. In England, university librarians are now considering how special collections and archives can inform institutional submissions to the Teaching Excellence Framework. The institutional submission includes the contribution of libraries to excellent teaching and learning.

These assessment frameworks, along with other drivers such as the need to evidence progress against strategic statements and initiatives, to satisfy the requirements of any external funders as well as to inform internal business cases for expanded space, resources or facilities, have led to an increased requirement for quantitative and qualitative evidence of the use and impact of archives and special collections in teaching, learning and research. Therefore, evidence of use and impact needs to be systematically recorded for these multiple purposes so it can be retrieved and presented in a variety of contexts when needed.

Acquisition and collection development policies

Legacy collections may include the works and archives of significant alumni or historic institutional archives. Collections in archives and special collections need to be guided by a clear collection development and management policy that encompasses their selection, acquisition, maintenance, exploitation and preservation.

The decision to accept a donation requires an investigation, including fit to selection criteria, resource assessment, risk assessment and cost analysis. The following selection criteria might be considered adaptable to any institution:

- Underpin research activity; inform and enrich teaching and learning practice in response to institutional need.
- Inform and inspire current and future developments within art and design education and practice.
- Build on and complement existing collecting strengths or address identified areas of current weakness, providing a key resource for researchers of creative practices in art and design.

- Celebrate the histories of the institution in its historic form and collect the work of current students, staff and alumni to articulate the development of education in the art and design practices.

The collection development and management policy will specify areas for collection, usually building on existing subject strengths. There is an element of opportunism in acquiring new collections; good networks with academics, artists and curators and relationships within and beyond the institution make it more likely that collections will be offered to an archive or library.

Managing relationships with donors is a particular area of expertise and a critical aspect of managing archives and special collections. A donation agreement and legal support on a case-by-case basis are essential to make sure that the donor and the institution clearly understand:

- the terms of ownership of the collection
- how the collection will be used in teaching, learning and research
- intellectual property rights, including copyright.

Donation vs deposit

The National Archives (UK) defines a loan (deposit) as when the archives are in the custody of the repository or its parent body but remain in the ownership of an external individual or organization. A gift, bequest or purchase usually passes outright ownership of the archives to the repository or the organization of which it is a part. The term 'permanent loan' can lead to misunderstandings between depositors and repositories. The term should be avoided in any acquisition agreements.

Gifts, bequests or if necessary purchases are preferable to loans as repositories secure ownership of the archive collections in question and gain the freedom to manage them at their own discretion. Note, however, that certain reserved rights may apply to archives that pass into the repository's ownership. Care should be taken in particular in respect to copyright, which does not automatically pass with ownership of the archives. It may be necessary, for example, to include in a loan agreement an indemnification from the depositor for claims of breach of copyright. When considering the legal implications of a donation, the collection manager and legal adviser will consider in the UK the Data Protection Act 1998, the Freedom of Information Act 2000 and other relevant legislation.

Funding and grants

In academic libraries, archives and special collections are typically funded as a part of the university library's ongoing service. However, in some cases there may be an expectation that an archive service will also generate additional funding, which may be needed to

develop the collections or service – for example, for additional digitization, cataloguing or curation activity, or for improved storage or access to the collections.

It is increasingly important to be able to demonstrate the status and value of collections by seeking accreditation status from national bodies (such as The National Archives) and designation status for collections (Arts Council England) to support applications for funding streams, as well as to enhance the institution's reputation and to protect the national heritage. There may be additional sources of funding made available within the institution, which is where an ability to demonstrate congruence with institutional goals is essential.

A strategic development plan is essential, along with an associated fundraising strategy with a clear idea of where additional funding is needed and a systematic approach to securing it. This fundraising is likely to be achieved in liaison with other specialists within the university, including alumni relations and research and enterprise staff. Fundraising for archives and special collections may be carried out as part of broader institutional developments such as the building of a new university library.

Accessing funding outside the institution is a broad and specialist subject, requiring up-to-date training, such as that provided by The National Archives. Large-scale funding applications are likely to include collection development activity (for example, digitization as an activity that supports a larger research project) and to be institutional or multi-institutional in scale. There are numerous grant-giving trusts and foundations; it is essential that any application meets the stated goals of the trust or foundation, and that the institution is eligible to apply.

Staffing; accreditation and standards; professional bodies

Managing archives and special collections requires a range of professional skills and profiles. Qualified librarians and archivists, sometimes museum curators, are part of these teams, as are conservators, cataloguers and digitization specialists. Subject expertise is important, particularly when working with collections being actively developed (e.g. artists' books collections). Personal and institutional membership in relevant professional organizations should be encouraged.

Collection management

The tension between preservation of and access to collections remains at the centre of our professional activity. It is our duty to ensure that archives and collections are preserved for the future, but without use and users, how can they contribute to inspirational encounters? The task of the collection manager is to preserve for access, both now and in the future. There are many tools available to aid this venture. Developments in technology for the care and description of analogue and digital archives and collections continue to progress at a rapid pace.

Cataloguing

The purpose of cataloguing is to describe, locate and discover the material in the collection. Archival catalogues follow the ISAD(G): International Standard of Archival Description (General). This standard is hierarchical to reflect the creation and the nature of archive collections. It shows how items relate to each other and the collection as a whole.

In arranging collections archivists try to keep what is known as original order – the arrangement or way that the papers were maintained by their originator or owner. Where this is not possible, a logical arrangement is applied. Even where some evidence of original order exists but is not logical, the archivist may still adapt it. If this is done, it must be noted in the catalogue.

Archival cataloguing is hierarchical – from top down – and the top level is known as the fonds level. Typical fields of information at this level include arrangement, administrative history, custodial history, appraisal and accruals. These are then broken into sub-fonds or series to show relationships between records and to give them a contextual structure. For example, financial records are given meaning by being placed in context rather than having a set of accounts without purpose.

A hierarchical archival catalogue has these levels:

- collections or fonds
- sub-fonds
- series
- file
- item.

It is not necessary to include all possible levels in a catalogue. If there is only one item and it does not fit in a series, there is no need for a series level description.

Library collections, including many special collections, are catalogued using library cataloguing standards:

- RDA (resource description and access) can be applied to physical and digital resources and provides a unified cataloguing standard. RDA incorporates elements from FRBR (Functional Requirements of Bibliographic Data), a model that has great potential to enrich the functionality of catalogues, including for special collections.
- DCRM(B): Descriptive Cataloguing of Rare Materials (Books) provides guidelines for cataloguing printed monographs of any age or type of production receiving special treatment within a repository.

Museum collections use Spectrum, the UK Museum Documentation Standard. It describes 21 collections management procedures, along with the policies and minimum standard required to meet each procedure (Collections Trust, n.d.).

Some standards can be applied generically across all three sectors:

● Library of Congress authorities
● International Standard Archival Authority Record (ISAAR) for Corporate Bodies, Persons and Families
● Getty Thesaurus of Geographic Names.

These standards require management systems to store and give access to the data generated to describe the collections. Proprietary and open source systems are available. When considering which management system to select, it is advisable to adopt a programme to explore the marketplace, consider and define the organizational requirements, and apply a project management approach to the selection and implementation of an appropriate system, in liaison with the organization's IT department.

Integrating access to information for library, archives and museum collections using a single interface (discovery layer) is now possible, and this presents major advantages but also some disadvantages, such as loss of some links between data and searching options. New integrated collection management systems that cater to all of these resources within the same database are also in development.

Discovery of archives and special collections is further facilitated and enhanced via participation in co-operative catalogues, portals and online directories, such as the Art Discovery Group Catalogue and Archives Hub.

Preservation

The skills of professional conservators can add immense value to the understanding of the collection's conservation and preservation needs, and advice can be sought from specialists on the Institute of Conservation's Register (UK) (ICON, n.d.) and the American Institute for Conservation's Find a Conservator (USA) (AIC, n.d.). Collection managers can make a self-assessment of their conditions by using the Benchmarks in Collection Care 2.0.

Carrying out a survey of the conditions of collections enables strategic planning and resource allocation. From a checklist such as 'Benchmarks', the collection manager can identify the achievements of good practice – the priority actions to secure the well-being of the collection and the resource requirements for reaching realistic targets. These can be presented to governance bodies and funders when strategic financial decisions are under consideration.

Emergency planning

Museum and archive accreditation standards require institutions to have a clear and workable emergency plan that applies to the workforce, visitors and collections. A pre-

incident plan can be drawn up with reference to templates which are available from Collections Trust, CILIP and The National Archives.

Key components of a successful emergency plan include:

- building a successful relationship with facilities teams
- creating an effective incident management team
- key content such as business continuity and health and safety.

Digitization and digital archives

The purposes for digitizing archives and special collections can be multiple, and again relate to the perennial debate over preservation and access. 'We have moved on considerably from the position of needing to just get stuff into digital form, to thinking much more carefully about what the reader/viewer might want to do with the resulting content in terms of identifying, selecting and using it for teaching, learning and research' (Findlay, 2016). Digitization for preservation has become legal for all not-for-profit libraries and archives libraries in the UK since the changes to copyright law in 2014. These changes help the sector to serve users more effectively.

The generation of born-digital material requires us to consider how to manage this media, which contains content of equal significance to the analogue of 20 or 400 years ago but challenges our traditional ways of preserving and providing access to it. It is essential for the art and design librarian or collection manager to find systems to fulfil the specific needs of digital assets.

Digital asset management is key to success in this area. Analogue items to be digitized require description, using the standards referenced. Digital asset management provides the ecosystem that will deliver storage, management, preservation, discovery, access and interaction with digitized or born-digital materials.

For the highly visually literate audience that is served by the art and design librarian, archivist or collection manager, the quality of the digital representation and the ease of viewing it are critical. Users place a high value on the objects and archives, either analogue or digital, so the user experience is paramount.

The International Image Interoperability Framework has emerged as a viewing standard. A growing community of the world's leading research libraries and image repositories have embarked on an effort to produce an interoperable technology and community framework for image delivery collaboratively. The International Image Interoperability Framework has the following goals:

- to give scholars an unprecedented level of uniform and rich access to image-based resources hosted around the world
- to define a set of common application programming interfaces that support interoperability between image repositories

- to develop, cultivate and document shared technologies, such as image servers and web clients, providing a world-class user experience in viewing, comparing, manipulating and annotating images.

Access and use

As primary resources, archives and special collections often have specific physical locations, conditions of access, and description and discovery pathways. Invigilated areas or reading rooms and use rules are common with these materials in order to protect them. The use of ink is often prohibited, as are food and beverages. Protective gloves are sometimes required when consulting specific types of materials, such as photographic prints. Very large or damaged books are read in special cradles or on pillows. It is good practice to explain these rules to all new users and to provide them in written form as well. Library users need to have an understanding of any restrictions on access and handling, why these restrictions are in place and the significance and vulnerability of unique primary resources.

Academic use and users: learning, teaching and research

Many special collections in art and design libraries originated as teaching or study collections. In an art and design environment, archives and special collections support both academic and creative work, integrating practice and research. They can be used from foundation to PhD level and beyond, in course inductions, themed workshops integrated with course briefs and projects. These resources are key to supporting a comprehensive information literacy programme, where object literacy should be included alongside other literacies. The growing importance of information literacy in academic libraries, and the proliferation of the 'teacher-librarian' embedded within courses and academic programmes, is replicated within archives and special collections.

Collections can be used in a range of innovative pedagogies, including object-based learning, which is based on the idea of having direct access to an object to learn about it, including its relationships with other objects, people and ideas. By interacting with objects, learning becomes a richer and more active experience for the mind and the body (via different senses), integrating cognitive and affective elements. In addition to inspiration and enjoyment, direct involvement with archives and special collection items increases the quality and richness of a learning or teaching activity, making it more memorable, and complex or difficult concepts easier to comprehend (Chatterjee and Hannan, 2015).

Artists' books collections, a type of special collection common to many art and design libraries, are a good example of the benefits that can be gained from the use of these materials in teaching and learning. They can offer opportunities for enhancing and increasing the acquisition of subject-specific knowledge and skills; be used as a source of material, technical and historical knowledge and serve as inspiration. Cross-subject and

multidisciplinary subject knowledge can also be gained as well as transferable skills, including listening and verbal communication, discussion, presentation, organization and team work, time management, independent thinking and lateral thinking (Grandal Montero, 2012).

The use of archives and special collections in research is well established. In addition to their traditional use as primary source materials, in an art and design environment they are also used to support practice-based research – for example in an exhibition context. Significant collections or groups of collections can also support the creation of research groups and centres and are central to many funded, large-scale research projects. Close collaboration and even integration between specialist library staff and research teams is a growing trend, where in addition to their traditional supporting role, librarians contribute their specific expertise to the development and production of new research. This is an area rich with strategic opportunities for libraries and library professionals as 'researcher-librarians'.

Widening access and collaborations

Lack of awareness and discoverability by library users and the 'hidden gem' syndrome are traditional problems with these collections, and embedding these materials into the induction or the curriculum of as many courses as possible is an ideal way to facilitate access. The importance of close collaboration with courses and programmes and the development of professional partnerships with faculty are crucial to developing projects using collections. A precondition for this is awareness of these resources, and collection inductions should be included in the induction programme for all new faculty.

It is also essential to consider diversity and inclusivity throughout the life cycle of collections management of archives and special collections. Collections must support and inspire all students, so inclusivity must be considered in the acquisition of collections, in prioritizing collections for cataloguing and digitization, and in the ways that collections are described, promoted and used in teaching, learning and research. Collaborations and partnerships with students should be supported and facilitated in recognition of the changing student profile, increased numbers of international students and the diverse student population. In addition, voluntary or paid work placements for students and alumni are beneficial in peer-to-peer sharing of experience of using collections or peer-led introductions to them, as well as for employability.

Third-party or external collaborations, when there is a good fit between organizations and projects, offer opportunities to develop projects that would not otherwise be possible to realize and to open the collections to new audiences. The range of potential partners is enormous: other collections and academic collections, galleries and museums, publishers, magazines, professional bodies and more. Clear objectives and analysis of costs and benefits are important to avoid potential problems at a later stage.

Advocacy and marketing

Increasing awareness and discoverability of archives and special collections, internally and externally, has always been a major preoccupation for those responsible for their management. A large range of tools are used for this purpose: print and online guides (e.g. LibGuides), displays in the library and other spaces, use of websites and social media (blogs, Twitter, Instagram), publications, films, conferences, talks and events, residencies and exhibition loans. Social media has become particularly popular in recent years as a means to engage internal and external users directly in two-way conversation and to facilitate the creation of communities around these collections.

Many art and design libraries have dedicated exhibition spaces or facilities. An integrated programme that includes material from the collections – curated or co-curated by library staff, faculty and students – is an excellent way to promote it. Exhibition loans are common for larger, well established collections and an important way of raising their profile and knowledge about them. Compliance with national and international standards of best practice and comprehensive procedures are essential to avoid risks.

Publications also raise the profile of collections, and supporting publishing by both users and staff within the institutional framework of research and scholarly communication should be part of the core activity for all libraries. Some libraries can develop their own publishing programme, or one-off publishing projects, alone or in partnership with others, internally or externally.

Conferences, talks and other events are also proven ways of promoting and encouraging further exploration of collections. Other excellent methods include reading groups, groups of friends, bursaries and prizes, and artists' residencies. All these activities should be systematically recorded and documented and archived.

Conclusion

Like the library and information sector as a whole, archives and special collections are undergoing rapid and large-scale changes, from the fundamental impact of digital technologies to the transformation of higher education – many discussed in detail elsewhere in this handbook. Change creates challenges but also many opportunities for developing and delivering innovative collections and services that support a rich and diverse culture of engagement and creative use. These materials are central to the mission of art and design libraries as well as their parent institutions – their future is essential to our future.

References

ACRL (2003) *Code of Ethics for Special Collections Librarians*, Association of College & Research Libraries, https://rbms.info/standards/code_of_ethics/.
AIC (n.d.) Find a Conservator, American Institute of Conservation, www.conservation-us.org/membership/find-a-conservator#.WKnMeH-WGtE.

Chatterjee, H. J. and Hannan, L. (eds) (2015) *Engaging the Senses: object-based learning in higher education*, Ashgate.

Collections Trust (n.d.) *Spectrum 4.0: valuation control*, http://collectionstrust.org.uk/spectrum/spectrum-4/valuation-control/.

Findlay, P. (2016) Continued Thinking about Using Archives for Teaching, Learning and Research, Jisc Content and Digitisation, blog, https://digitisation.jiscinvolve.org/wp/2016/12/20/3466/.

Grandal Montero, G. (2012) Artists' Books in HE Teaching and Learning, *The Blue Notebook*, 7 (1), 36–43.

ICON (n.d.) Conservation Register, Institute of Conservation, www.conservationregister.com.

Research Libraries UK (2014) *Unique and Distinctive Collections: opportunities for research libraries*, www.rluk.ac.uk/wp-content/uploads/2014/12/RLUK-UDC-Report.pdf.

The National Archives (n.d.) *What Are Archives*, www.nationalarchives.gov.uk/help-with-your-research/start-here/what-are-archives/.

Resources

ACRL, Rare Books and Manuscripts Section, Association of College & Research Libraries, https://rbms.info/.

ACRL (2003) *Special Collections: statement of principles*, Association of College & Research Libraries, www.arl.org/storage/documents/publications/special-collections-statement-of-principles-2003.pdf.

ACRL (2009) *Special Collections in ARL Libraries: a discussion report from the ARL Working Group on Special Collections*, Association of College & Research Libraries, www.arl.org/storage/documents/publications/scwg-report-mar09.pdf.

ACRL (2012) *ACRL/RBMS Guidelines for Interlibrary and Exhibition Loan of Special Collections Materials*, Rare Books and Manuscripts Section, Association of College & Research Libraries, www.ala.org/acrl/standards/specialcollections.

ACRL (2017) *Guidelines: competencies for special collections professionals*, Association of College & Research Libraries, www.ala.org/acrl/standards/comp4specollect.

Archives and Records Association, www.archives.org.uk/.

Archives and Records Association (2016) *Code of Ethics*, www.archives.org.uk/images/ARA_Board/ARA_Code_of_Ethics_final_2016.pdf.

Archives and Records: The Journal of the Archives and Records Association, www.archives.org.uk/publications/archives-and-records-ara-journal.html.

Archives Hub, https://archiveshub.jisc.ac.uk/.

ARLIS/NA (2010) *Artists Files Revealed: documentation and access*, Art Libraries Society
 of North America,
 www.arlisna.org/images/researchreports/artist_files_revealed.pdf.
ARLIS/NA (2016) *Artists' Studio Archives: managing personal collections and creative
 legacies*, Art Libraries Society of North America,
 www.arlisna.org/images/researchreports/asaworkbook.pdf.
ARLIS UK & Ireland, Committee for Art & Design Archives, Art Libraries Society UK
 & Ireland, www.arlis.net/about/committees-groups/art-design-archives.
Art Discovery Group Catalogue, http://artdiscovery.net/.
Art Documentation, www.arlisna.org/publications/art-documentation.
Art Libraries Journal, www.arlis.net/content/art-libraries-journal.
Art Libraries Journal (2017) Information Literacy in UK and US Art Libraries, special
 issue, **42** (2).
Arts Council England (UK) *Designation Scheme*, www.artscouncil.org.uk/
 supporting-collections-and-archives/designation-scheme.
Berger, S. E. (2014) *Rare Books and Special Collections*, Neal-Schuman.
CILIP Rare books and Special Collections Group, www.cilip.org.uk/about/
 special-interest-groups/rare-books-special-collections-group.
CILIP Rare books and Special Collections Group (2015) *Bibliographic Standards
 Advice and Guidance*, www.cilip.org.uk/rare-books-and-special-collections-group/
 bibliographic-standards/advice-and-guidance.
Collections Trust (2014) *Benchmarks in Collection Care 2.0*,
 www.collectionstrust.org.uk/collections-link/collections-management/
 benchmarks-in-collections-care.
College Art Association (2015) *Code of Best Practices in Fair Use for the Visual Arts*,
 www.collegeart.org/fair-use/.
College Art Association (n.d.) *Resource Directory for Diversity Practices*,
 www.collegeart.org/diversity/.
Cornish, G. P. (2015) *Copyright: interpreting the law for libraries, archives and
 information services*, 6th edn, Facet.
Cullingford, A. (2016) *The Special Collections Handbook*, 2nd edn, Facet.
Foundation Directory Online, https://fconline.foundationcenter.org/.
Galbraith, S. K. and Smith, G. D. (eds) (2012) *Rare Book Librarianship: an introduction
 and guide*, Libraries Unlimited.
ICA (1996) *Code of Ethics*,
 www.ica.org/sites/default/files/ICA_1996-09-06_code%20of%20ethics_EN.pdf.
IFLA (2015) *Guidelines for Exhibition Loans*, International Federation of Library
 Associations, www.ifla.org/publications/ifla-guidelines-for-exhibition-loans.

IFLA Rare books and Special Collections Section, International Federation of Library Associations, www.ifla.org/rare-books-and-special-collections.

International Image Interoperability Framework, http://iiif.io/.

JISC (2016) *Digitising Your Collections Sustainably*, www.jisc.ac.uk/guides/digitising-your-collections-sustainably.

JISC (2017) *Make Your Digital Resources Easier to Discover*, www.jisc.ac.uk/guides/making-your-digital-collections-easier-to-discover.

JISC (2017) *Using Social Media to Promote Your Digital Collections*, www.jisc.ac.uk/guides/using-social-media-to-promote-your-digital-collections.

John Rylands Research Institute, www.jrri.manchester.ac.uk/.

LibGuides Community, https://community.libguides.com/.

MacNeil, H. and Eastwood, T. (eds) (2017) *Currents of Archival Thinking*, 2nd edn, Libraries Unlimited.

Matassa, F. (2014) *Organizing Exhibitions: a handbook for museums, libraries and archives*, Facet.

Millar, L. (2017) *Archives: principles and practices*, 2nd edn, Neal-Schuman.

Milne, C. and McKie, A. (eds) (2009) *Displays and Exhibitions in Art Libraries*, ARLIS UK & Ireland.

The National Archives (2006) *Loan (Deposit) Agreements for Privately-Owned Archives*, www.nationalarchives.gov.uk/documents/archives/loanagreement.pdf.

The National Archives (2016) *Archiving the Arts*, www.nationalarchives.gov.uk/archives-sector/projects-and-programmes/archiving-the-arts/.

The National Archives (n.d.) *Archive Service Accreditation*, www.nationalarchives.gov.uk/archives-sector/archive-service-accreditation/.

The National Archives (n.d.) *Finding Funding*, www.nationalarchives.gov.uk/archives-sector/finding-funding/.

The National Archives (n.d.) *Legislation*, www.nationalarchives.gov.uk/information-management/legislation/.

The National Archives (n.d.) *Trusts and Foundations*, www.nationalarchives.gov.uk/archives-sector/finding-funding/funding-programmes/trusts-and-foundations/.

NYARC (n.d.) Web Archiving, New York Art Resources Consortium, www.nyarc.org/content/web-archiving.

OCLC (n.d.) *Demystifying Born Digital*, www.oclc.org/research/themes/research-collections/borndigital.html.

OCLC (n.d.) *FRBR projects*, www.oclc.org/research/activities/frbr.html.

Padfield, T. (2015) *Copyright for Archivists and Records Managers*, 5th edn, Facet.

Pedley, P. (2012) *Essential Law for Information Professionals*, 3rd edn, Facet.

RBM: A Journal of Rare Books, Manuscripts, and Cultural Heritage, http://rbm.acrl.org/.

Rare Books and Manuscripts Section (n.d.) Bibliographic Standards Committee, Association of College & Research Libraries, https://rbms.info/committees/bibliographic_standards/.

Society of American Archivists, http://www2.archivists.org/.

Society of American Archivists (2012) *Core Values Statement and Code of Ethics*, http://www2.archivists.org/statements/saa-core-values-statement-and-code-of-ethics.

Theimer, K. (ed.) (2014) *Outreach: innovative practices for archives and special collections*, Rowman & Littlefield.

Thomas, L. M. and Whittaker, B. M. (eds) (2016) *New Directions for Special Collections: an anthology of practice*, Praeger.

White, M., Perratt, P. and Lawes, L. (2006) *Artists' Books: a cataloguers' manual*, ARLIS/UK & Ireland.

Chapter 9

What is special about special collections?

Lee Sorensen

Introduction

Art libraries are more likely than any other branch or special-subject libraries to maintain protected or limited access separate collections within their boundaries, known professionally as 'special collections' (Carter and Whittaker, 2015, 354). The reasons such distinctions are necessary are as varied as art libraries themselves. Because scholars in the discipline of art and art history study material culture, the object rendering the information itself can engender a separate meaning from the textual aspect. Much of art's literature becomes an object of study and appreciation in itself. A second reason for maintaining restricted collections is that a good deal of art documentation is still limited to physical print (often for reasons of intellectual property rights control) and these printed materials are the only form of dissemination; this unique form can become hard to replace. Books become special because of their lack of availability or cost. A third reason for maintaining restricted collections is user-driven: artists value the object *qua* object and digital surrogates do not satisfy that aesthetic experience.

Though few of these criteria would qualify these titles for transfer into a standalone special collection, this material falls under the whimsical library sobriquet of 'medium rare': housed in a restricted section of the art library. In the age of digital surrogacy and laptop delivery, the criteria for these special collections are both fast changing and long standing (Barker, 2009). As the cost of storing, cataloguing and conserving special material becomes higher than for open-stack or digital literature, art librarians as well as their administrators necessarily need to examine the question, 'just how special is special?' What can or should constitute an art-subject special collection in 21st-century librarianship?

Art libraries fall under three broad genres, a classification based more on their constituencies than their material content: academic, museum, and art or design school libraries. The organization and mission of the special collection within each of these library types fluctuates with the identity of the library. For example, art museum libraries

can in one sense be considered standalone special collections in themselves: they are non-circulating and object-based; their items are frequently catalogued descriptively more than in other art collections; and they often supervise their readers. Museum libraries often maintain an additional restrictive-access level for some of their materials and thus create a special collection within their special collections. Academic art libraries, often branches of main libraries, maintain their special collections, with few exceptions, as a small stack space within the art library and without special librarian oversight. Design school libraries can be a hybrid of these previous two, characteristically with a mandate of encouraging the highest level of patron interaction with the material.

How, then, to generalize about any of these and their collections within a collection? This chapter examines the development, current practice and future guidelines to a functional art library special collections irrespective of their professional arrangement.

Definitions

Under its broadest rubric, an art library special collection is any group of objects under library control requiring extra curatorship, housing, use-supervision and review. They frequently do not have (or need to have) an intellectual organizing principle governing them, though frequently they do. One of the most driving needs for art library special collections grew from the need to separate titles that over the years came to be considered the monuments of art history. Libraries fortunate enough, for example, to own Franz Kugler's *Handbuch der Kunstgeschichte* (1842) or Crowe and Cavalcaselle's *A New History of Painting in Italy from the Second to the Sixteenth Century* (1864) would keep those secure despite allowing other 19th-century titles to circulate.

A second principle for 'specialness' is uniqueness. Art libraries frequently find themselves alone in collecting (and organizing as such) art ephemera documenting singular or local interests. These primary sources are the least likely to be books and are usually collected at the impetus of the librarian-scholar who sees that individual institutional initiative can create a set of materials or information sources value-added because of their organization, cataloguing and staff knowledge. Much of what is contained in artist's files, for example, might be replicable via newspaper databases, public library archives and internet searches; the advantage for the scholar of dedicated artists' files intentionally gathered, carefully organized and descriptively catalogued into a special collection is incomparable. Art libraries often added uniqueness to their special artists' files by mailing questionnaires to artists.

The two guiding principles to any special collections but particularly to the branch or standalone art libraries are material desirability for a directed scholarly purpose and location assistance unique to the organization. A tenet of macroeconomics is that neither age nor rarity alone determines value; value is assigned to an object through the less tangible criteria of societal worth (desirability) – a judgement requiring a solid knowledge of art scholarship and trends.

This chapter considers two distinct special collections genres. The first is the smaller-library informal 'special collection' materials cloistered for reasons of security, such as the closed stacks of many academic branch art libraries. The second collection is the larger, intellectually cohesive collection of library materials designed to address a single art research issue comprehensively, such as a collection of dealer catalogues or material on the history of collecting. A third, the archive, is treated in Chapter 13. While these kinds of special collections can overlap, particularly in mid-sized or regional art libraries, their curation and management is often different.

History

The art library special collection has a distinguished and insufficiently studied history in the USA. These collections may in fact antedate rare book libraries. Major art museums with their constituent book collections, such as the New York's Metropolitan Museum of Art and Boston's Museum of Fine Arts (both founded in 1870) and the Art Institute of Chicago (founded 1879), precede the founding of major US rare book libraries, New York's Grolier Club (1884), Cleveland's Rowfant Club (1892) and Chicago's Caxton Club (1895). As Galbraith and Smith point out, the founding of rare book libraries themselves is difficult to pinpoint – and art library special collections even more difficult – because of the problem with the definition of what an art book is (2012, 3). Likewise, early art museum and some academic libraries found themselves maintaining vertical files not overseen by their curatorial or general rare-materials library. At a time before the prevalence of photographs in art books or the ease of travel, art libraries maintained separate mounted photograph collections of works of art for study (Bredekamp, 2003, 422; Mahard, 2003, 9ff).

Three streams of special materials contributed to the founding of art library special holdings: art archives, rare books and study aids. Academic and smaller art museum special collections began on shelves in the art librarian's office and then moved to locked closets. Larger museum art libraries housed their singular collections in separate stacks, although they frequently considered them part of their general collections. Concomitantly major special collections departments or libraries were collecting books with the subject classification of art.

The earliest of these collections were books as works of art, such as William Morris's Kelmscott Press editions of Ruskin's art critiques. By 1910 when the Library of Congress developed its 'N' (art) classification, it drew it largely from Melvil Dewey's 700 'Fine Arts' book classification. But because special collections are a genre and not a subject definition, records about and literature on art-genre special collecting are scarce. Many art school libraries found they were maintaining 'special collections' without formally designating them as such. High-use or one-of-a-kind items art students frequently requested was no more formal a procedure than asking the art librarian to see the title. Even as the profession of art librarian developed, scant attention was paid to this need when Pacey's

seminal *Art Library Manual* appeared in 1977. Externally, the need for art special collections was growing. In 1954 the Archives of American Art was founded through the Detroit Institute of Art in a joint private–public sponsorship. Though an archive, their principal initial mission was to microform and disseminate primary source artists' documentation. Interest in the history of collecting spurred (most frequently) art museum libraries to accept dealer records.

By the 1990s, the three key reasons for creating separate special collections for art libraries were the frequency of the costly *catalogues raisonnés*, increased interest in art through the explosion of art prices, and the popularity of the artist's book as a collecting genre. By the close of the 20th century, the typical standalone art library contained a designated special collection.

Curating art special collections

The smaller 'safe keeping' collection: *mutatis mutandis*

Safe keeping (of closed-stack) special collections are likely to be the most unique type of collection from art library to art library, and conversely also those with the fewest genuinely unique items. Over the years, art libraries end up owning volumes that in some way need greater supervision. Generally these are books of the 'medium rare' variety, titles with a high local usage, controversial material, or formats requiring special storage. For example, the art library at Duke University in 1990 was typical. The 'locked stacks' collection amounted to 8000 books and 1100 folios; the latter, because of their greater height, required secure horizontal storage. It also included a pamphlet collection of items under 49 pages housed in archival envelopes in file cabinets. Although the number of titles can vary among libraries, mid-sized academic art library special collections of that time were all similar; many smaller art libraries still maintain collections similar to these in size and types of media.

The 'medium rare' titles included 19th-century foundational art histories, in which the collection was strong, and *catalogues raisonnés* deemed expensive at the time of their purchase. High-demand items placed there included a few out-of-print books by art faculty and the university art museum's catalogues. The controversial literature there was largely photography books with sexual content, such as Robert Mapplethorpe surveys and Will McBride's ground-breaking sex education book for children, *Show Me*. The folio collection, known as 'the cage' because it stood in a public area behind wired grating, comprised many 18th-century architectural folios and presentation volumes. None of the items had high use. The collection grew slowly, perhaps by 20 volumes a year, both through new costly items directed there at the time of acquisition and through stack items discovered to be of high replacement. Circulation of items was limited to on-site use only although users were free to examine the items anywhere in the library. Exceptions were items borrowed for in-class presentation or slide creation. Photocopying was at the discretion of the librarian.

Over the succeeding 25 years, this collection was almost completely transformed because of changes in users and usage. Such changes underscore the major difference between the safe keeping and other kinds of art special collection libraries: mutability of criteria.

The major agent of the change in the status of the special art book was the internet, although a change in usage patterns also played a role (Anderson, 2013). The advent of internet-based out-of-print dealers (AbeBooks, Ray Hennessey) gradually made replacement easier or, in some cases, even possible. Whereas earlier a severely damaged art book could be replaced only via watch lists and dealer catalogues, these titles were now available and often sold at competitive prices. The safe keeping reason for maintaining a barrier between student and title decreased. A second reason for the change in the status of the special art book was space. While most academic libraries began to select titles for off-site book storage, 'medium rare' titles usually remained on-site. Increasing the space for limited access collections was likewise not a possibility. Changing the criteria of restricted access material became necessary. A third reason to re-evaluate the status of the special art book was the realization that, since so many art books had risen in value, cloistering all expensive titles was an impossibility. Nearly all art titles, if not expensive to begin with, grew exponentially in value (Heyman, 2013, 44). A fourth reason for criteria change was the decline in book use in general. Although art libraries, given the dominance of print format for their texts, may have faced the smallest decrease in circulation after the advent of electronic books, students nevertheless increasingly avoided books requiring staff retrieval, and there was also less demand for books that could be removed from the library. Finally, overhead book scanners provided students with a portable copy of the book with less wear than photocopying. The case for protecting rarer books withered.

The final criterion for special collections inclusion – material with controversial images – withered with the internet as well. With world wide web image sharing, images of erotic or private enjoyment are so numerous that seeking the art library for such material was unnecessary. Whereas 25 years ago cannibalized books would need periodic replacement, today they are simply not an art library issue.

At Duke University's art library, these changes in demand resulted in a thorough re-evaluation of the locked stacks collection, a task necessary for all art special collections but critical for the safe keeping collection. Materials received new dispositions. *Catalogues raisonnés* – with some exceptions – were transferred to the open stacks or off-site locations, as were much of controversial collections. The university library special collections department was invited to review materials in the art library's locked stacks and, owing to a broadening of some of their collecting criteria, some art library titles were transferred there. Titles that were available free through the Internet Archive (archive.org) or HathiTrust (https://www.hathitrust.org/) were moved to off-site locations. A rethinking by technical services staff in conjunction with the university library's access services department resulted in protecting some ephemera with phase boxes or pamphlet binding

and sending the remaining envelope items to remote stacks, where they circulate on request. These decreases in the use of formerly locked stacks materials (despite a growing art history department) allowed for leveraging the space for growth of the open-stack collection without noticeable access decline or having to replace expensive books relocated to the open stacks. The redefinition of locked-stack materials also resulted in adding fewer but more significant items to that collection.

If the need to revise collection development and management policies seems self-evident, nevertheless that practice occurs infrequently, largely because of the costs involved. Examining usage of a non-circulating collection and mapping it to (assumed) user expectations is difficult. Immutable criteria for transfer rarely exist, and item-by-item selection is almost always necessary. A critical shortage of space precipitated this activity at Duke's Lilly Library, but since then materials are reviewed annually.

The unified (focused) special collection: calling more users

The second special collection genre related to art is a focused, intellectual collecting principle, one with a specific set of users or research questions in mind. More typical of museum and larger art research libraries, the holdings of this special collection are published material, not particularly rare (although they can be), whose organizing idea is to create a central efficient research point for scholars of that area. Large collections of this type include the Frick Art Reference Library with its magisterial holdings in auction catalogues, dealer inventories and secondary literature, or the Yale Center for British Art Library, a special collection focusing on British art, artists and culture within the larger holdings of the Yale University art libraries. Typically these collections are separately endowed or funded with separate viewing and research spaces accorded them. Less often they may be historic collections of a single scholar such as Harvard's Berenson Library at the Villa I Tatti Center in Florence. But they need not be large. In every case the collection is envisioned as a destination point for scholars – virtual or physical – of that subject and the collection's validity resides in the ongoing public interest in the topic.

As these collections are driven by scholarly need, the library must ensure that as research questions change, the collection and its access points change with the user, either by adding new tools to the collection or new access points, such as e-access, HathiTrust and Google Books. For example, art provenance research centres began primarily with dealers who were interested in tracing art authenticity. In the latter part of the 20th century, the history of collections emerged as a larger discrete scholarly topic, with specialized journals and scholars devoted to this study. The economic study of art markets also blossomed, and dedicated special art collections found they could draw new researchers to their collections.

All libraries are necessarily limited in scope, but the focused special collection encounters definitional limitations in a different way from other art special collections. For example, how much support literature on a topic should be purchased to assist the

scholar at the time of the research in the particular library? What are the principal languages of the materials that scholars would want to use? Are there active subscriptions to the electronic tools researchers in this area want?

The need for assessment

Special collection libraries face the question of how to assess their users and how to ensure that the scholarly public – and the public in general – know of them. All libraries have an online presence and most have publicly accessible online catalogues. Cataloguing down to the individual item level is often not possible, however. Collection-level cataloguing (e.g. 'Sotheby sales catalogues, New York, Western European art and furniture, 1990–present') or volume check-in records may be all the online presence a library can give.

As many of these resources are being converted to digital format, either by libraries themselves (where copyright has expired or been obtained) or by the copyright owners themselves, focused special collections need to review who their users are and where they will be. Where consultation is limited to the paper copy itself, focused collections can assist researchers by creating detailed online indexes to their holdings or aggregated databases, such as OCLC's SCIPIO database. Metrics for electronic use are critical to demonstrate the collection's worth. However, the question will be asked of a fully digitized special collection (as could be asked of safe keeping libraries), why retain the hard copies at all? Since fully digitized focused collections are few, statistics on how this affects in-person usage is scarce. In such places where this has been measured, an online presence has served to increase interest in the physical collection, not decrease it (Green and Courtney, 2015, 695).

Perhaps the largest issue for all special collections, but most critical to the focused collection, is how to define the user. Nearly all focused special collections – even outside art – assumed scholars would travel to the institution. Of course, individual questions are answered by staff as time permits, but increasingly scholars either expect to be able to conduct substantial portions of their research before visiting the collection or accomplish their work without visiting the collection at all. As libraries open their collections to the broader, digital research community, mission creep can push the library to a scope it cannot sustain. Deciding how much of a public presence a focused collection library wants to have and can manage is essential.

Finally, focused collections should consider whether their mission should include big data. While many of these collections pursue digitization by scanning images of the page with optical character recognition (OCR), the focused special art collection may be sitting on a trove of technical data. As digital art history emerges, collections would do well to seek support to scrape data from their digitized holdings or to present it in ways that users with technical expertise (not necessarily art expertise) could manipulate. Big data researchers tend to gravitate toward existing data, rather than collect it themselves from

analogue sources. One of the opportunities for 21st-century focused collections is to present what they have via a wider range of tools, rather than keep adding to their unique holdings.

Future: the end of art special collections?

For special collections, the question remains, with all the changes in use that digitization and the Internet Archive have brought, with the cost of maintaining them, and with decreased physical use, will there be a need for art special collections in the future (Kenney, 2009)? If demand for special materials parallels demand for end-point electronic delivery, why own the item at all?

Art special collections can once again take the lead by archiving the ephemera of born-digital projects. As digital art history becomes a mainstay of art scholarship, the tools of the art librarian – not simply archiving, but also organizing a collection into a focused resource for scholars – return. This new type of art special collections offers the opportunity to art libraries of like interests and size (but with disparate locations or presenting other barriers) to combine customized special collection interests. In 2010 the New York Art Resources Consortium (NYARC) – Brooklyn Museum of Fine Art, The Frick Collection and the Museum of Modern Art – began a project of web-archiving digital ephemeral art sources into a tool that saves the format in which born-digital information was created (Duncan and Blumenthal, 2016, 116). They have done much the same for online *catalogues raisonnés* (Duncan, 2015, 50–5).

Digital art collections need not be the realm only of large private art libraries. Academic art libraries may want to forge partnerships with their digital collections departments to save home-grown digital projects created at their institutions, especially after the immediate currency of the site is gone. A recent study found that humanities graduate students with databases as part of their dissertation faced challenges of where to archive the interactive component of their research (Fong, 2017, 135). As more humanities research combines scholars' efforts into a single digital tool, the legacy of where the interactive tools remain might reside with the specialized subject librarian. With so much scholarship and creative work created digitally in colleges and art schools today, and to contain costs for server space, judicious selection and conservation of historic digital art projects restores the art librarian's mission of creating a collection within a collection to the principles that first governed much of art special collections.

References and bibliography

Anderson, R. (2013) Can't Buy Us Love: the declining importance of library books and the rising importance of special collections, Ithaka S+R, www.sr.ithaka.org/wp-content/mig/files/SR_BriefingPaper_Anderson.pdf.
Barker, N. (2009) Introduction. In Cronenwett, P. N., Osborn, K. and Streit, S. A.

(eds), *Celebrating Research: rare and special collections from the membership of the Association of Research Libraries*, Association of Research Libraries.

Bredekamp, H. (2003) A Neglected Tradition? Art history as Bildwissenschaft. *Critical Inquiry*, **29** (3), 418–28.

Carter, L. and Whittaker, B. (2015) Area Studies and Special Collections: shared challenges, shared strength, *Libraries and the Academy*, **15** (2), 353–73.

Crowe, J. A. and Cavalcaselle, G. B. (1864–1866) *A New History of Painting in Italy: from the second to the sixteenth century*, John Murray.

Duncan, S. (2015) Preserving Born-Digital *Catalogues Raisonnés*: web archiving at the New York Art Resources Consortium (NYARC), *Art Libraries Journal*, **40** (20), 50–5.

Duncan, S. and Blumenthal, K.-R. (2016) A Collaborative Model for Web Archiving Ephemeral Art Resources at the New York Art Resources Consortium (NYARC), *Art Libraries Journal*, **41** (2), 116–26.

Evans, M. (2015) Modern Special Collections: embracing the future while taking care of the past, *New Review of Academic Librarianship*, **2** (2), 116–28.

Fong, B. L. (2017) An Exploration of Changing Dissertation Requirements and Library Services to Support Them, *Libraries and the Academy*, **17** (1), 129–44.

Galbraith, S. and Smith, G. (2012) *Rare Book Librarianship: an introduction and guide*, Libraries Unlimited.

Green, H. and Courtney, A. (2015) Beyond the Scanned Image: a needs assessment of scholarly users of digital collections, *College & Research Libraries*, **76** (5), 690–707.

Heyman, S. (2013) The Bibliophile's 401(k): some art books skyrocket in value just a few years after they're published, *New York Times Magazine*, 14 April, 44.

Hubbard, M. and Jackson, R. (eds) (2016) *Forging the Future of Special Collections*, Neal-Schuman.

Kenney, A. (2009) The Collaborative Imperative: special collections in the digital age. *Research Library Issues*, 267, December, 20–9, http://files.eric.ed.gov/fulltext/ED509216.pdf.

Kugler, F. (1842) *Handbuch der Kunstgeschichte*, Ebner & Seubert.

Mahard, M. (2003) Berenson Was Right! Why we maintain large collections of historical photographs, *Art Documentation*, **22** (1), 9–12.

Mapplethorpe, R. and Danto, A. C. (1992). *Mapplethorpe*, Random House.

McBride, W. and Fleischauer-Hardt, H. (1975) *Show Me!: a picture book of sex for children and parents*, St. Martin's Press.

Pacey, P. (ed.) (1977) *Art Library Manual*, R. R. Bowker.

Chapter 10

Artists' books in the art and design library

Tony White

What is an artist's book?

Artists' books were an important part of the experimentation in the visual arts that started in the late 1950s and continued into the 1960s. This was a time of anti-establishment thinking, experimental ideas and actions, seeking to get art off the wall and into the hands of the viewer and reader. Examples at that time included happenings, performance art, mail art, pop art, Fluxus and conceptual art – where concept was more important than its realization, and when there was a shift from art as an object to art as an idea. Many artists held the conviction that art must be withdrawn from its special status as rarefied experience and shared among the public at large. By the early 1970s, curators began attempting to define and describe these publications. In 1973 Diane Vanderlip curated an exhibition at the Moore College of Art in Philadelphia entitled Artists' Books, and the phrase stuck. Following this exhibition, bookshops were founded to sell and distribute these unusual publications: Art Metropole (Toronto; www.artmetropole.com/about) in 1974, Other Books & So (Amsterdam) in 1975 and Printed Matter (New York City; www.printedmatter.org/what-we-do) in 1976, among many others.

Since Vanderlip's exhibition, many people have attempted to refine the definition of what constitutes an artist's book. The simplest definition uses the Duchampian prompt: 'It's an artist book if the artist says it is.' In her essay 'The Artist's Book Goes Public' Lucy Lippard described an artist's book as 'neither an art book (collected reproductions of separate art works) nor a book on art (critical exegeses and/or artists' writings), the artist's book is a work of art on its own, conceived specifically for the book form and often published by the artist him/herself' (1985, 45). Lippard was one of the founders of the bookshop Printed Matter, along with Sol LeWitt and others, and she would have seen the Vanderlip exhibition catalogue. Paul Bianchini, the late pop art dealer, is quoted by Anne Moeglin-Delcroix in an epigraph: 'An artist's book is a work solely created by the artist's decisions. It is produced by the best methods to achieve quality in unlimited quantities.

It should be available at a moderate price wherever books are sold' (Moeglin-Delcroix et al., 2004, 26). Bianchini's definition could be applied easily to most publications available at the New York and Los Angeles Art book fairs.

Duncan Chappell's article 'Typologising Artists' Books' (2003, 12–30) further defines related book types. It is important to separate the artists' books published before Diane Vanderlip's exhibition from those that came after. Following her exhibition, artists began using the phrase 'artists' books' to describe an intentional, self-conscious practice of publication and object production.

Collection development

Whether building a collection for the first time or adding to an existing collection of artists' books, defining what to collect (as well as what *not* to collect) is vitally important. An artists' books collection at an art and design school library will support teaching and research; these books may also serve to inspire students and faculty in the creation of new works. The primary faculty and students using the collection will be in the printmaking, book arts and graphic design departments and classes. In addition, faculty and students in other studio, design and area studies departments may request class visits or presentations using and viewing artists' publications.

When building a collection of artists' publications, criteria may include geographic area, book format, published works, book objects, multiples, unique works, student works and binding styles. Additional considerations might be whether or not to include fine bindings, letterpress-printed works, illustrated books with poetry or prose, *livres d'artiste*, *livres deluxe*, commercially printed books and trade edition pop-up books. On the other hand, one may want to consider what to exclude: books with food, animal carcasses, human excreta, sticky books, scented books, toxic materials, tar and damaged books (those that may have been subject to water damage, mildew or mould, stained, torn, dirty, crushed or burned). Should the collection include books with out-of-date media: CD-ROMs, diskettes, cassettes, records or magnetic media? What is the library's ability to offer playback options for visitors? What about Fluxus objects such as *Flux Deck* or *Smile in a Box*, sculptural book objects such as those by Barton Benes or Byron Clerx, or altered books such as those by Melissa Craig or Brian Dettmer? Even though a book is created by an artist, it still must meet the criteria set forth in the library's collection development policy.

An artists' books collection in an art and design school library may be modest in size (500–3,000 titles) primarily due to limited budget, storage, staffing and time limitations associated with specialized care, handling, cataloguing, digitization, preservation and teaching with the collections. However, there are many opportunities within these areas, depending on staff interest and expertise. With its focus on teaching, learning and inspiration, the art and design school library is well positioned to connect with faculty and students through class instruction sessions and individual or small group visits. The

collections should include and make available a wide variety of books by format, binding, printing, structure, content, materials and other unique or significant features.

Acquisition strategies

Prior to the launch of the world wide web, artists' books were available primarily by mail order from brick-and-mortar bookshops or at an occasional book fair. Lucy Lippard suggested, 'One day I'd like to see artists' books ensconced in supermarkets, drugstores, and airports' (1985, 48). This did not come to pass, however, primarily because of the non-standard formats and esoteric content of artists' books, and often the lack of industry-standard features such as dust jackets and ISBN numbers. In addition, early artists' books often included such unusual content that no shops, much less the general public, could easily understand them. This was confirmed by many artists producing books in the 1970s and 1980s – to this day they may experience difficulty even giving their books away.

The most common methods for acquiring artists' books include firm orders (online and in person), approval plans, book fairs and direct orders from artists and publishers. Firm ordering – title by title – is time-consuming but rewarding. In person is best, accomplished when visiting bookshops or book fairs. If buying from a vendor in the USA, an Internal Revenue Service W-9 tax form may need to be completed by any vendor or artist for the initial transaction. Is payment by credit card, PayPal, cash or bitcoin, or will the vendor send the book(s) with an invoice for payment later? The institution may dictate how payment and transportation can be handled.

Buying in the field when representing an art library can be challenging. One may not have immediate access to the online catalogue to check holdings. Not every vendor takes credit cards, and few are willing to send a copy of the book without receiving payment first. In the USA it is customary for a library to insist on receiving books first, then processing payment. Large shops and distributors are accustomed to this, but individual artists or small publishers might not be acquainted with this practice. In addition, when buying for an institution, if using cash or a credit card with individual artists, they need to create an itemized invoice and provide an itemized receipt. It is preferable to request that the artist or publisher ship the book to the library, for if the book is damaged in transit the institution can ask for replacement or reimbursement from the shipper. However, if the book is hand-carried from the point of purchase, the individual is responsible for the book should it be damaged on the way to the library. The best arrangement is to purchase the book online with a credit card so that the transaction does not require the tax form, the payment generates an electronic invoice and receipt and the book is mailed directly to the library.

Many times book artists or dealers contact the library about visiting in person to display books that they have for sale. This can be very time-consuming, and it can be difficult to resist sales pressure in the presence of the artist. Most librarians prefer to work with artists or dealers by visiting a website or by having a paper prospectus sent to them.

If a librarian is then interested in examining the book, he or she can ask to have it sent on approval. If the librarian decides to purchase the book, shipping charges can be added to the bill. Should the librarian decide not to purchase the book, the library pays for packing and return shipping.

A great source for acquisitions is the exhibitor listings for any of the international book fairs. For example, the MISS READ Berlin Art Book Fair and the New York Art Book Fair list their exhibitors online. Almost all of the exhibitors include links to their websites. This sounds obvious, but not all librarians, bibliographers or curators take the time to visit the websites of these publishers, artists and distributors. This review can prove valuable, especially since many titles may sell out quickly.

Another source is the acquisition of artists' books through donations, and especially donations accompanied by funds intended to offset the costs of processing, cataloguing and preservation. Many potential donors ask the library to accept their books or archives without fully realizing that libraries incur significant costs to acquire, catalogue, preserve and make collections available to library patrons. The fact that libraries must consider storage costs for every volume or box they store, on-site or off-site, in perpetuity, often surprises donors. The US Tax Code allows charitable deductions for donations from individual collectors. A collection should be appraised by a qualified appraiser before the donation is made, and donors may be able to take the appraised value of the books as a tax deduction against their annual taxes. When preparing to accept a large donation of books, a library should consider requesting funds to offset costs to preserve and make the books accessible.

Procedures for receiving and processing artists' books

The acquisition, receiving and processing of artists' books is similar to that for other books; however, artists' books present challenges to any library. The staff needs to determine the threshold for treating these publications as artworks or material culture, as opposed to trade monographs. Will the library retain the wrapping material in which a book arrives and/or any ephemera that comes with the book? Should the library house the covering material or ephemera with the book in a special enclosure or store these separately? If the latter, where should they be stored, how should they be catalogued and arranged, and does the library provide enclosures?

Library staff should develop a procedure for digitally photographing books as they arrive to record how a book was packaged, then photograph the covering material and book after opening. If the budget allows, two copies can be purchased and one left unopened.

Staff must decide if artists' books will be catalogued only or if an image management programme such as CONTENTdm (www.oclc.org/en/contentdm.html) should provide visual access to these unique materials. Bookplates should not be used; instead, staff can select a couple of locations in which to write the call number or other identifier in pencil

near the gutter. Barcodes should be placed only on the enclosures or on paper bookmarks, never on the books.

Storage and preservation options

Secure and protective storage is important for housing and accessing artists' books in the library. Locked storage space with a dedicated heating, ventilating and air conditioning system is ideal, but most libraries must do the best with what they have. At a minimum, staff should store books by size on metal shelves in a dust free environment, and where possible make or buy protective enclosures or wrappers that are custom-sized to each title to maximize structural support. As an alternative, a library can store books that are thick or less in call number order in acid-free, lignin-free hanging file folders in a metal filing cabinet, spine side down. The hanging file system has been implemented at institutions such as Pratt Institute, the Maryland Institute College of Art and the School of the Art Institute of Chicago. Oversized books need clamshell or similar custom enclosures that can support the book or object within. Some books need to be stored on folio shelving or in flat files.

While preservation may not be the initial consideration in collection development, it is worth keeping in mind where and how the books will be stored. Any collection development policy must address whether a library has the capacity to collect books or objects of unusual sizes or formats. If they do, then does the library have proper storage areas for these often oversized objects? Is there access to staff who can make protective enclosures for storage and handling? Or can a staff member be sent for training? Can the library preserve and make these materials accessible for the long term? Most libraries collect such books very selectively, or only when they come in as part of a larger donation. For published books that are in the form of a standard codex, storage and access are simplified. Most libraries make or buy enclosures to protect the books, but artists' books do not generally conform to publishing standards. They may have loose elements, non-standard wrapping materials, bags, photographs, non-standard content or pages, toxic materials, food and basically every imaginable material. Enclosing, preserving and making them available for viewing is often a challenge.

Teaching with artists' books

Library instruction and class teaching (or co-teaching with faculty) can be tremendously rewarding, but they are also labour intensive. Artists' books require handling procedures similar to those in special collections libraries; extra care must be taken when providing access to groups and classes.

For example, a faculty member who is knowledgeable about the collection may e-mail a list of books to be shown to a class, typically 30–40 books. The librarian should take time to preview each book, noting any special considerations. Staff must triage the list of books

into those that can be handled in a classroom setting and those that the librarian needs to show or demonstrate to the class at the end of a visit. The handling and use policy, possibly part of the library's special collections use policies, should be shared with faculty and students before their visit to the library. The policy would include items such as requiring library visitors to wash their hands after arriving at the library, disposing of chewing gum, using hair ties to tie back long, unsecured hair, only using pencils (provide them) for notes, and allowing photography with phones. Staff must avoid making exceptions to the policy, even for faculty. Entrance into special collections storage areas should be prohibited, and visitors should be asked to use the catalogue in advance to select and request materials to examine.

Before the class visit, the librarian can pull all of the books and place them on a book truck in their protective enclosures. Extra hair ties, sharpened pencils, notepaper, dust cloths and placemats (11 x 17 pieces of paper) should be on hand. Staff can arrange tables and chairs to avoid crowding, clean the surface of the tables, and set placemats in front of each chair with an artist book on each mat. One or two extra seats with books set out will facilitate student rotation.

When the class arrives, staff should ask students to place jackets and book bags away from the tables and seating areas, prohibit food or drink on the tables, and check to make sure everyone has a pencil for note taking. Students should not handle the books until instructed. The librarian can use this time to talk about the collection in the library, or the history of artists' books, or perhaps the faculty member will want to discuss the history or context of artists' books. The librarian must remain in the room and be available to answer questions and to ensure the books are being handled correctly. Books should stay on the table and not be pulled into a reader's lap, even if that is more comfortable; leaving the book on the table or in book cradles supports and protects the structure of the book. The librarian can take the last 15 minutes of the visit to page through and discuss any fragile or delicate books, then encourage students to return on their own to view the books.

Teaching with such collections may be done by librarians, faculty, teaching assistants, graduate students or any combination. As with any special collection title or volume, artists' books have a special status in that they are publications that serve as research resources as well as art objects.

Considerations for exhibition and display

The primary challenge with artists' books is that they are a haptic medium, meant to be handled and touched, read and experienced. Exhibiting artists' books in library display or exhibition cases is necessarily an exercise in frustration in that the books can be viewed only at a distance. Librarians are encouraged to spend time learning about exhibition best practices – do not overfill the cases, give the books room to breathe and make sure to plan the layout of books and labels in advance. A basic knowledge of making or

purchasing book supports, wedges and appropriate lighting is essential. If one has little or no knowledge of such practices, a consultant can provide suggestions. All exhibitions should be planned at least one year in advance, with clear guidelines on what is allowed in the exhibition space and cases. For planning purposes, library staff should provide measurements of the exhibition cases and spaces to each curator. In turn, curators should provide the layout of the exhibition, accurately drawn to scale showing where books and their adjacent labels will be placed. The plan must also indicate which books need supports and to which pages the books will be open.

The library must develop a loan policy if it is willing to lend artists' books. Will loans be made to campus galleries, libraries or locations off campus? Who will cover the cost of insurance, shipping and display? What if conservation is needed before lending? Who is responsible for damaged or lost books? Consulting colleagues at other libraries may prove useful in developing the policy.

In addition to displays or exhibits of artists' books, the library can explore options for online exhibits. If the institution has a social media policy, there may be opportunities for promoting the artists' books collection using current and relevant applications.

Artists' books collections at art and design schools present tremendous opportunities for librarians to support teaching and instruction, as well as inspiration and discovery for students. Opportunities for exhibition, guest lecture series and social media are all great advantages of building and sustaining a collection of artists' publications in the library.

References and bibliography

Art-rite (1976/77) 14, winter, Art-Rite Publishing Company.

Campos, A. (2011) *Multiple, Limited, Unique*, The Center for Book Arts.

Chappell, D. (2003) Typologising Artist's Books, *Art Libraries Journal*, **28** (4), 12–20.

Desjardin, A. (2001) *The Book on Books on Artists' Books*, Everyday Press.

Di Bello, P., Wilson, C. and Zamir, S. (2012) *The Photo Book: from Talbot to Ruscha and Beyond*, I. B.Tauris & Co. Ltd.

Drucker, J. (1998) *Figuring the Word*, Granary Books.

Goldstein, A. and Rorimer, A. (1996) *Reconsidering the Object of Art: 1965–1975*, Los Angeles Museum of Contemporary Art.

Indiana University Libraries (2016) Enclosure Treatments, Book Repair Manual, www.indiana.edu/~libpres/manual/index.html.

Klima, S. (1998) *Artists' Books, a critical survey of the literature*, Granary Books.

Lippard, L. (1985) The Artist's Book Goes Public. In Lyons, J. (ed.), *Artists' Books: a critical anthology and sourcebook*, Visual Studies Workshop Press.

Moeglin-Delcroix, A., Maffei, G., Liliana Dematteis, L. and Rimmaudo, A. (2004) *Guardare, raccontare, pensare, conservare: quattro percorsi del libro d'artista dagli anni '60 ad oggi*, Casa del Mantegna.

Perree, R. (2002) *Cover to Cover: the artist's book in perspective*, Nai Publishers.
Schraenen, G. (1992) *Ulises Carrion*, Idea Books.

Where to buy artists' books

Book fairs

Artist book fairs (Los Angeles, New York, Seoul, Tokyo, Mexico City, etc.); Codex International Book Art Fair; 8-Ball Zine Fair (Tokyo); I Never Read, Art Book Fair Basel; Libros Mutantes Madrid; MISS Read Artist Book Fair (Berlin); Offprint Art Book Fair Paris and London; Rencontres d'Arles.

Bookshops

Art Metropole (Toronto); Boekie Woekie (Amsterdam); Buchhandlung Walther König (Berlin); Dashwood Books (New York City); Flotsam Books (Tokyo); Motto Books (Berlin); Ooga Booga (Los Angeles); Printed Matter (New York City); Ulises (Philadelphia), among many others.

Online shops

Check out the online listings of exhibitors at any of the book fair web pages.

Cataloguing resources

Art Libraries Society of North America, *Artists' Books Thesaurus*,
 http://allisonjai.com/abt/vocab/index.php.
Thurmann-Jajes, A., Boulanger, S. and Stepancic, L. (2010) *Manual for Artists'
 Publications (MAP): cataloging rules, definitions, and descriptions*, Research Centre
 for Artists' Publications at the Weserburg and Museum of Modern Art.
White, M., Perratt, P. and Lawes, L. (2006) *Artists' Books: a cataloguer's manual*,
 ARLIS/UK & Ireland.

Researching artists' books: online databases

Archive Artist Publications, Munich, Germany, www.artistbooks.de.
Artexte, Montreal (Québec) Canada, http://artexte.ca/research/collection/.
Centre for Artists' Publications, Bremen, www.weserburg.de.
Centre National de l'Édition et de l'Art Imprimé (CNEAI), Chatou, France,
 www.collection-fmra.org.
Library of the National Gallery of Canada, Ottawa, Canada:

- the Art Metropole Collection Database,
 http://bibcat.gallery.ca:81/screens/opacmenu.html
- the National Library's Collection of artists' books and multiples,
 http://bibcat.gallery.ca/.

The Museum of Modern Art Library, DADABASE,
 http://arcade.nyarc.org/search~S8.
Study Center of Museu d'Art Contemporani de Barcelona, www.macba.cat.
Victoria & Albert Museum, London, United Kingdom, V&A Artists' Books Database,
 www.vam.ac.uk/page/a/artists-books/.

Notable collections with artists' books

Indiana University Bloomington
Library of Congress, Washington DC
Museum of Modern Art, New York
Otis College of Art and Design, Los Angeles
Rhode Island School of Art and Design Library
School of the Art Institute of Chicago, Joan Flasch Artists' Books Collection
Stedlijk Art Museum Library, Amsterdam
Thomas J. Watson Library, The Metropolitan Museum of Art, New York
University of California, Los Angeles
University of Washington, Allen Library
Victoria and Albert Museum Library, London
Yale University, Robert B. Haas Family Arts Library, New Haven

Chapter 11

Art documentation: exhibition catalogues and beyond

Gustavo Grandal Montero

Introduction

The literature of the history, theory and practice of art and design has been in continual evolution since Leon Battista Alberti wrote *De Pictura* in 1435 (and *Della Pittura* in 1436), almost contemporaneously with the invention of the printing press in around 1440. A growing range of publications establishing new ways of documenting the work of artists and designers would follow this theoretical treatise: biographies, catalogues and journals. In recent years influenced by new digital tools and methods, this literature is still evolving, and it is central to the resources and practice of art and design librarianship.

Art catalogues are arguably the main form of art documentation today, and a cornerstone of the bibliography of the subject. Widely published by museums, public and commercial galleries, academic and commercial publishers and others – still primarily in print format – their history can be traced to the first art collection catalogues published in the 17th century and to group and solo exhibition catalogues that appear in the 18th century.

This chapter explores the present and potential future of the art catalogue and related formats, their role in the documentation of art, and their management and use in art and design libraries. Exhibition catalogues, collection catalogues, *catalogues raisonnés*, sales catalogues and art ephemera are primary and secondary source materials, documenting artworks and their history, particularly their public presentation in exhibitions and museums. Exhibition catalogues, alongside special formats like recurrent exhibition documentation (e.g. biennials, triennials), auction and sales catalogues, scholarly collection catalogues and *catalogues raisonnés*, present a number of common characteristics, and their management in library collections often requires specialist knowledge, as they can be challenging to acquire and require expert cataloguing. Art ephemera (e.g. invitations, posters, lists of works, press releases) are another important if underrated resource collected by libraries as a complementary source of information on exhibitions

and artworks. These materials and their management, from collection development to facilitating access and use, are the focus of this chapter.

The exhibition catalogue

Originally simply lists of artists and titles of works with dates, exhibition catalogues have added considerable content over time: images (from drawings to photographs), descriptions and analysis of the works, critical essays, chronologies, biographies of the artists, bibliographies and indexes. In the 20th century, particularly since the 1950s, there is an overlap with the role of the specialist monograph, but the main purpose of the exhibition catalogue remains to record an exhibition and the artworks it presented. A wide range of catalogues is published – group and solo artists, single work and retrospectives – each with different target audiences (collectors, scholars, general public), sizes and prices. Often published by the institution that hosts the exhibition, catalogues can also be published or distributed by a commercial publisher.

Modern catalogues are often described as published to 'accompany' or 'on the occasion' of an exhibition. Post-1960s experimentation with the format of the catalogue has become a recurrent theme, both in its content and material qualities as a printed object, and in relation to the exhibition and its audiences. This sometimes results in its hybridization and questioning of the binary nature of the relation between documentation and artwork. An example is *The Consistency of Shadows: exhibition catalogs as autonomous works of art* (Betty Rymer Gallery, 2003), both for its content and as an object.

As the art world continues to expand, and the number of public and private galleries and museums – and subsequently of exhibitions – grows ever larger, the production of catalogues has increased, and a majority of exhibitions publish some sort of catalogue or accompanying publication.

The main art bibliographies covering catalogues and library collection catalogues (in print) are now very dated and of historical interest only. However, the online catalogues of major art libraries and specialist collections, as well as union and other co-operative catalogues, like Art Discovery (http://artdiscovery.net/) or WorldCat (https://www.worldcat.org/), are excellent sources of information on exhibition and other catalogues, both current and past. Listings, particularly online research guides dedicated to this subject, can also offer useful information (see https://community.libguides.com/).

Collection development and management of exhibition catalogues

Given the importance of this material, collecting exhibition catalogues at a research level is essential for many art and design libraries, but this presents a number of challenges. The first step is to identify reasons for collecting this type of material and to define scope.

This information should be part of the library's collection development policy to guide acquisitions staff and inform users. Adequate funding with a dedicated allocation within the acquisitions budget is also required. For a research collection, a level of funding similar to that dedicated to monographs or periodicals would be reasonable as a guideline.

Whether the collecting scope is comprehensive or selective (for instance, by geographical area or subject, according to medium), selection and acquisition are time-consuming. Coverage by bibliographic data suppliers and alert systems is limited, and other sources are partial and multiple: publisher and distributor catalogues, gallery websites, art magazines, art event listings. While true comprehensive collecting of this material is practically impossible, specialization and co-operation between libraries can improve overall availability of resources. This remains a goal, as it was when Anthony Burton wrote 40 years ago: 'complete global coverage . . . [or] comprehensive national collections . . . [are] not yet achieved. Nor do the existing means of bibliographic control catch up' (Pacey, 1977, 74).

Art specialist library suppliers are able to provide a relatively large, international selection of catalogues from major galleries, museums and recurrent exhibitions, within standing orders or approval plans in principle the best way of acquiring material of this kind: Arts Bibliographic, UK (www.artsbib.com), Worldwide, USA (www.worldwide-artbooks.com), Shamansky, USA (www.artbooks.com). Regular review of standing order lists and the criteria for approval plans is important. Specialists also offer substantial lists of new and recent catalogues in stock. Because of the small print runs of most catalogues and their limited distribution (particularly for foreign or smaller institutions), it is essential to acquire this material as it is published. Language and country specialists – e.g. Casalini, Italy (www.casalini.it) and generalist suppliers such as Dawson, Erasmus, Ingram, ProQuest Books – can supplement art specialists.

Publication exchanges offer another acquisition venue for exhibition catalogues, particularly for museum or other libraries associated with a programme of contemporary art publications. This is a relatively time-consuming method but is well suited to this type of material and sometimes more successful than direct acquisition. Direct purchases are the last-resort method for acquiring this material, and second-hand and specialist booksellers can sometimes help to fill gaps retrospectively. Although an option to few libraries, use of local agents (researchers, dealers and so on) provide a way to achieve in-depth acquisitions in areas poorly covered by library suppliers or for rare material. For a particularly interesting example, see Kember et al. (2014, 5–9). Donations can fill gaps in the collection for current and retrospective collection development.

Cataloguing exhibition catalogues requires specialist training, language skills and subject knowledge. Local guidelines should be implemented to achieve consistency in the application of international standards (RDA/AACR2, MARC21, DDC, LCSH) to these materials.

Good selection of access points and subject indexing are important elements in creating catalogue records that facilitate access and use of exhibition catalogue collections.

Consistent use of MARC21 fields 100 (Main Entry – Personal Name), 110 (Main Entry – Corporate Name) and 111 (Main Entry – Meeting Name) are essential to this, including use of authority files (e.g. Library of Congress authorities and local files), as are 600 (Subject Added Entry – Personal Name), 610 (Subject Added Entry – Corporate Name), 611 (Subject Added Entry – Meeting Name) and 650 (Subject Added Entry – Topical Term). Consistent use of notes fields (500, 504, 505) is also critical.

Owing to the international and multilingual nature of this material, there are a number of language-related cataloguing issues. Creating parallel, alternative title field (246) entries when appropriate for these will improve left-anchored title search retrieval. Libraries collecting Japanese, Korean, Chinese, Russian, Arabic, or other non-roman-script language material and with significant use by speakers of these languages may consider the creation of multiscript MARC21 records to allow direct search and retrieval in the original script.

Several excellent sources offer guidance on cataloguing this material. The ARLIS/UK & Ireland Cataloguing and Classification Committee published a revised edition of *Art Exhibition Documentation in Libraries* (2013). ARLIS/NA has made available online *Cataloging Exhibition Publications* (2017), a series of four documents providing guidance and detailed examples (title and statement of responsibility, name and title access points, notes and subjects). The British Library offers guidance on resource description and access (RDA) implementation (2014). The Library of Congress offers RDA Special Topics: art catalogs (James, 2013) and a useful flow chart (Library of Congress, n.d.).

Preservation is also a consideration in the life cycle of these materials. More substantial catalogues are often treated like standard books and kept on open shelves, although in many cases for reference use only. Occasionally rare or fragile material (e.g. small-scale catalogues, experimental formats) are kept in pamphlet boxes or other protective housing – or in closed access – sometimes as part of special collections. Regular reviews of the collections and transfer of individual items as required are advisable. Since much of this often high-demand material becomes rare or irreplaceable over time, sometimes fairly quickly, balancing access and preservation concerns must be carefully considered. Protecting the original material qualities of the catalogue when possible and avoiding irreversible interventions, such as rebinding and covering, should be another consideration so as to preserve artefactual value and allow for use in exhibitions, especially when the artist has been involved in its creation (Grandal Montero, Hirata Tanaka and Foden-Lenahan, 2013).

Biennial, triennial and other recurrent exhibitions

There are currently more than one hundred biennial and other recurring exhibitions of contemporary art. Exhibition catalogues are the main and most authoritative source of information for these important events. The Venice Biennale, for instance, has published print catalogues for all its exhibitions since 1895, but for smaller exhibitions or those with

limited resources, this is not always the case. Websites as documentation of these exhibitions is almost universal, often including podcasts, video and digital versions (usually pdf files) of catalogues, programmes and press releases. As with other digital resources, long-term access is problematic, with retrospective content often not maintained after each exhibition.

Collecting biennial-related material at a research level presents a number of challenges, as library suppliers provide a relatively limited coverage via standing orders and approval plans. In some cases, acquiring the catalogue is possible only by visiting the exhibition.

Both 'biennial' and 'biennale' (an Italian word, but widely used in English to refer to biennial exhibitions) should be used in catalogue records to maximize keyword retrieval. For the same reason, use of Anglicized as well as vernacular forms of the name of the biennial exhibition, individual edition title (or subtitle, parallel title, alternative title) and location name are recommended in all cases, using notes fields when necessary (Grandal Montero, 2012).

Other types of recurrent exhibitions that often produce catalogues are annual exhibitions (including those related to art prizes) and art fair catalogues.

Specialized formats: collection catalogues, catalogues raisonnés, sales catalogues and auction catalogues

These catalogues differ markedly from the exhibition catalogue and among themselves. The oldest type, collection catalogues, have been produced since the 17th century and are still published today, although they have become relatively rare over the last three decades, superseded in part by online collection databases. They belong to a scholarly research tradition, like the *catalogue raisonné*, and are related to museums and the role of the curator, providing technical information on media and materials, exhibition details, historical information and bibliographic references. Some collection catalogues cover the full range of holdings of an institution (often in multi-volume sets with appendices), while others are dedicated to specific subsets or groupings of works by type and period.

Catalogues raisonnés

A standard art reference publication, providing a systematic list of the totality of an artist's work (occasionally limited to work in a given medium or period), the *catalogue raisonné* traces its origins to the 18th century. Essential as a scholarly tool for academic researchers, it is also a source of authoritative provenance and authentication information for dealers and collectors, with an apparatus that includes titles, technical details (medium, size), dates, history (provenance and current ownership information), exhibition details, bibliography and images. *The Art catalogue index (A.C.I.)* (Corboz and de Pebeyre, 2009) lists approximately 1500 *catalogues raisonnés* for about 900 artists born between 1780 and the late 20th century.

Online *catalogues raisonnés* are a fast growing publishing model, with numerous projects currently completed or in progress, and it is possible that they will overtake print editions. However, in this transitional environment, they raise a number of concerns, from preservation, versioning and historiographic issues to image quality and legal questions, such as copyright and licensing. The *Art Libraries Journal* has dedicated a special issue to survey this topic in collaboration with the Catalogue Raisonné Scholars Association (www.catalogueraisonne.org) (2015).

Sales catalogues

Sales catalogues can be found as far back as the beginning of the 17th century and comprise art dealers' catalogues, public sales catalogues and auction house catalogues. A critical tool for those researching art markets, collections and collecting, and the provenance of artworks, they describe each of the items for sale, often in detail (technical information, provenance, condition). Sales catalogues in print can be purchased individually or by subscription (to all or specific series published by each auction house). In recent years these are also available as pdf files or in other digital formats on the websites of all major houses (e.g. Sotheby's, Christie's, Bonhams, Phillips) free of charge. The commercial database *Art Sales Catalogues Online (1600–1900)*, based on Fritz Lugt's *Répertoire des Catalogues de Ventes Publiques*, includes digital facsimiles of about 24,000 historical sales catalogues.

Because of the large volume of catalogues published, their cost, and the range of objects, subjects and periods covered, only some libraries develop systematic collections of this material. A clear scope and inclusion in the collection development policy is important in those cases. Traditionally only catalogued at series level, and sometimes not at all (relying instead on handlists of holdings, or simply on collocation as a discrete reference collection), individual item records have become more common in recent years, and these are recommended for large or specialist collections.

Other forms of printed documentation: ephemera

Art ephemera, sometimes referred to as artists' files, vertical files or information files, consist of small-scale, freely or inexpensively distributed printed material related to artists and their work, made for specific, limited uses (usually to announce an event, such as an exhibition) and are intended to be discarded afterwards. A wide range of formats and types of document can be considered as ephemera: invitation cards, press releases, artists' statements, curricula vitae, listings, programmes, maps and plans, fliers, stickers, leaflets and posters. Ephemera collections may sometimes also include newspaper and magazine clippings, small catalogues, pamphlets and other less ephemeral publications. In addition to artists and other individuals (curators, collectors), they relate to artworks, events (exhibitions, prizes, fairs) and institutions (galleries, foundations, public agencies). Art publisher catalogues, art distributor catalogues, publication catalogues from galleries and

museums and art book fair catalogues are additional types of materials in ephemera collections. Historical sets of these are likely to be rare and of research value.

Collected as primary sources of information (images and historical data) and in many cases the sole existing documents on lesser known individuals or institutions, these ephemera are also valuable as artefacts and are valued for their material qualities. They are often used as such in exhibitions. They share some characteristics with archival materials, but ephemera are not unique in principle. Artists' ephemera, created artists, form a special category often considered part of artistic practice as distributed artworks.

Traditionally received by post, sometimes collected locally by staff and others, ephemeral materials have been replaced by online digital alternatives, such as e-mail and websites. Often relatively difficult to discover and access, normally arranged in personal or institutional files, but not catalogued at individual item level (for practical reasons), art ephemera have relied on collection-level descriptions, finding aids, listings and spreadsheets, and at best file level catalogue records, created by using generic templates. The ARLIS/NA project Artist Files Revealed provides cataloguing guidelines and an online directory of collection-level descriptions for a range of institutions (Artist Files Working Group, 2010).

Digitization has been seen for some time as the ideal way to provide access to these collections, not least with the prospect of OCR allowing full-text search and thus partially compensating for the lack of individual item catalogue records. The twin obstacles of lack of resources and copyright restrictions have to some extent thwarted this development, but recent projects, based on in-house digitization, enlightened fair use and 'take down' policies, show future potential (Art Libraries Journal, 2016).

Websites, digitization and other digital-born material

It is almost universal today for exhibitions to have some online presence, typically a webpage or website, but the range of forms of digital-born documentation related to exhibitions and collections is substantial, from digital publications and databases to e-mail messages and RSS feeds. Sometimes this online content complements that in the printed publication, or it may be the only documentation available. Giving access to and preserving for long-term use this ever-growing amount of digital material has been one of the most pressing issues for art and design libraries over the past two decades.

National libraries, such as the British Library and Library of Congress, have been actively collecting websites for some time, working under the umbrella of the International Internet Preservation Consortium. There has been also engagement from research and special libraries, bringing both diversity and expertise to the effort, particularly through collaborative projects. An example of this is the New York Art Resources Consortium (NYARC) and its web archiving programme, which includes online auction house catalogues (see their web archiving frequently asked questions at www.nyarc.org/content/faq-web-archiving). However, the sheer size of potentially

relevant material, added to the fast pace of technological change, copyright-related restrictions, differences in institutional priorities and availability of technical resources, have contributed to a lack of widespread progress.

Organizers of a range of important projects that emerged in the last few years have begun to rethink and re-invent the documentation of art and artworks for a digital environment. In addition to the examples mentioned in the previous sections, the Getty Foundation's Online Scholarly Catalogue Initiative (www.getty.edu/foundation/initiatives/current/osci/), launched in 2009 to create new models for the publication of museum collection catalogues in the online environment, is of note: eight museums participating in the grant programme have published pioneering online catalogues.

Digitization

Over the last decades an ever larger number of digitization projects have been carried out by individual institutions or as part of collaborative projects. Much of this material is now available online to all, including important historical catalogues, such as the Royal Academy of Arts Winter Exhibition catalogues, the Ashmolean collection catalogues and complete collections of the exhibition catalogues published by the Metropolitan Museum of Art and Guggenheim Museum. The Getty Research Portal (www.getty.edu/research/tools/portal/index.html) provides free online access to an extensive collection of more than 100,000 digitized art history texts from a range of institutions, including many art catalogues.

As art documentation is continuously re-assessed in light of digital media developments and the online information environment, changes and transformations are emerging, albeit less fundamental and at a slower pace than in other subject areas. Art catalogues can be seen as a case study in the singularity of art and design librarianship, and particularly, the importance of printed publications as key resources in the field for the foreseeable future. As we have seen, exhibition catalogues are still produced predominantly in print, as are many *catalogues raisonnés*, sale catalogues and some collection catalogues. Printed art ephemera are also widely produced and circulated. However, online *catalogues raisonnés* are addressing the challenges of transferring the scholarly methods developed by a print culture to a digital one and are a growing trend in art publishing, as are online collection catalogues.

A growing range of digital-born material is being produced to document and disseminate information about artworks and exhibitions, and much historical print content is in the process of being digitized, creating large online collections of digital facsimiles. This is a complex and rich environment where a mix of print and online resources seems likely to stay with us for much longer than may have been anticipated, in contrast with other subject areas and standard information management practices.

References

ARLIS/NA (2017) *Cataloging Exhibition Publications: best practices*,
https://www.arlisna.org/publications/arlis-na-research-reports/147-cataloging-exhibition-publications-best-practices.

ARLIS/UK & Ireland Cataloguing and Classification Committee (2013) *Art Exhibition Documentation in Libraries: cataloguing guidelines*.

Art Libraries Journal (2015) Catalogues Raisonnés, Collection Catalogues and the Future of Artwork Documentation, *Art Libraries Journal*, **40** (2).

Art Libraries Journal (2016) Art Ephemera, special issue, *Art Libraries Journal*, **41** (2).

Artist Files Working Group (2010) Files Revealed: documentation and access, ARLIS/NA,
https://www.arlisna.org/images/researchreports/artist_files_revealed.pdf.

Betty Rymer Gallery (2003) *The Consistency of Shadows: exhibition catalogs as autonomous works of art*, School of the Art Institute of Chicago.

British Library (2014) Special Topics in RDA: exhibition and art catalogues,
www.bl.uk/bibliographic/pdfs/rda-exhibitions-and-art-catalogues-201412.pdf.

Corboz, N. and de Pebeyre, C. (2009) *The Art catalogue Index (A.C.I.): catalogues raisonnés and critical catalogues of artists 1780–2008*, Blondeau Fine Art Services.

Grandal Montero, G. (2012) Biennalization? What Biennalization?: the documentation of biennials and other recurrent exhibitions, *Art Libraries Journal*, **37** (1), 13–23.

Grandal Montero, G., Hirata Tanaka, A. and Foden-Lenahan, E. (2013) Defending the Aesthetic: the conservation of an artist's book, *Art Libraries Journal*, **38** (1), 32–7.

James, K. (2013) RDA Special Topics: art catalogs, PowerPoint presentation, Library of Congress, https://www.loc.gov/aba/rda/source/special_topics_art_catalogs.ppt.

Kember, P. et al. (2014) Asia Art Archive, *Art Libraries Journal*, **39** (2), January, 5–9.

Library of Congress (n.d.) Art Catalogs,
www.loc.gov/aba/rda/source/special_topics_art_catalogs_flowchart.doc.

Lugt, F. (1964) *Repertoire des Catalogues de Ventes Publiques: troisième periode 1861 1900*, Nijhoff.

Pacey, P. (ed.) (1977) *Art Library Manual*, Bowker.

Chapter 12

Tactile libraries: material collections in art, architecture and design

Rebecca Coleman and Mark Pompelia

Phenomena exist in the material world.
Material makes thoughts tangible.
Materials manifest the world. (Viray, 2011, 8)

What is a materials collection?

A materials collection is 'a body of physical items and samples acquired across various industries to be utilised as objects for inspiration and in project specification by architects, designers, artists, and researchers in the practice of those and allied fields' (Pompelia, 2013, 1). Like all library collections, materials collections are as varied and unique as the institutions they serve. While these collections have long been found in design firms, in recent decades their presence in academic settings has increased (Jost, 2011). By offering materials samples for exploration by students, faculty, designers, artists and practitioners, materials collections provide an intimate and tactile means of exploring the physical vocabulary of the built environment.

For patrons, materials collections offer opportunities to engage physically with samples. Tactile interactions can promote creativity and innovation in ways that viewing materials online or in texts cannot. For artists and designers, the experience of an object or space is of paramount importance and is deeply affected by the selection of materials. Through direct physical contact, one can come to better understand a material and be inspired by its possibilities. The browsability of these collections frees visitors from exploring via search boxes and facets and allows for serendipity. Researchers in a materials collection frequently pick up a material because it looks interesting, shiny, bright or translucent. They dismiss labels that indicate that a sample is marketed as flooring, insulation or for erosion control. As they hold, bend or peer through a material, it transforms and inspires – physical contact catalyzes the design process.

The role of materials in design has been well documented in scholarship and theory

(Beylerian and Dent, 2007; Kolarevic and Klinger, 2013; Schröpfer, 2011). Scientific advances have led to a proliferation of new materials that are available for provocation, use and 'misuse' by designers. As Manuel Kretzer notes in his discussion of the changing nature of materiality, 'applying the right materials ... represents a truly demanding task and requires not only knowledge and experience on the various material properties, but also sensitivity and intuition in anticipating their meaning and value over time' (2016, 26). Physical interaction with materials is essential to this process.

The value of materials collections to academic institutions

Academic departments can use materials collections to contribute to the satisfaction of accreditation requirements. For example, the National Architecture Accreditation Board (NAAB, 2014) requires that 'Graduates from NAAB-accredited programs must be able to comprehend the technical aspects of design, systems, and materials and be able to apply that comprehension to architectural solutions.' They further state that knowledge of 'building materials and assemblies' should include 'understanding of the basic principles used in the appropriate selection of interior and exterior construction materials, finishes, products, components, and assemblies based on their inherent performance, including environmental impact and reuse.' The National Association of Schools of Art and Design (NASAD) accreditation standards likewise make multiple references to material literacy. For example, an 'understanding of the possibilities and limitations of various materials' is one of eight competency standards for the bachelor's degree in sculpture (2016, 111).

Material collections provide experiential learning that is critical to success in art, architecture and design disciplines in which a deep understanding of materiality is required. Sourcing and evaluating materials is a routine requirement in associated professions. Graduate students and alumni without access to materials in their education are at a disadvantage as they launch their careers as practitioners and makers. Students who have the opportunity to work with materials collections as researchers or employees can be inspired to pursue alternate academic and career paths. Students have even adjusted the focus of their study to be material based following employment and research assignments using the materials collection (Wagner, 2013).

Beyond contributing to departmental learning outcomes and accreditation standards, materials collections also respond to larger institutional priorities. As administrations look to develop and strengthen pan-university research initiatives and cross-disciplinary centres to foster collaboration across fields of study, materials collections have the potential to connect researchers. The life cycle of a material, from development to its commercial or artistic use, engages materials scientists, engineers, fabricators, designers, marketers and even social scientists. However, the experience of materials is universal and has relevance to nearly every field of study. At the University of Michigan, the Materials Library supported the research of an interdisciplinary course exploring touch-sensitive

colouring technology for children with autism (Michigan Engineering, 2015). A materials collection creates a physical and intellectual space to bring researchers together. As collaborations around design thinking, incubation and entrepreneurship expand, materials collections are well positioned to assist in these endeavours.

Building a materials collection

In *Material Library Research Report*, Kai Alexis Smith (2015) identifies three methods by which material libraries build their collections – through donations, samples obtained by request from manufacturers, and purchases. Each of these methods provides opportunities and challenges.

Many materials collections get their start through donations. The collection at the University of Virginia, for example, was seeded with samples collected from faculty who had been gathering and storing materials for use in their own studio classes. Donated materials can be very welcome additions to a collection – both because they are free and because they are inevitably closely tied to the research and teaching needs of the department or school, having been selected by faculty and/or students. However, donations can also be problematic. Donated materials may not fit within the prescribed scope of the collections policy. A clear review procedure for donations that can be communicated to patrons should be in place and operate in tandem with existing library gift policies.

Material samples can also be acquired by request through many manufacturers. Often seen as a cost of doing business, samples may be sent free of charge or for the cost of shipping, but requesting samples can be a hit-or-miss means of acquisition. Most companies put their resources into large sales of their materials and may not send samples, or else send them after long delays. Other materials are simply not available in this way because of high costs or limited production and therefore must be purchased. In libraries where faculty and students are used to quick purchasing models for text resources, patrons may be frustrated by the indefinite timelines of materials acquired by request.

Material brokers provide an opportunity to purchase samples, sometimes in bulk packages or subscriptions. Material ConneXion is probably the best-known provider of 'out-of-the-box' materials collections. While more costly, using a vendor like Material ConneXion can save a small staff time and effort. With a focus on innovation, Material ConneXion and other such brokers provide access to materials that are on the forefront of design industries. While manufacturers may not understand the mission of academic material collections, or may not prioritize requests from librarians, brokers are often more responsive and timely in fulfilling orders. Brokers are often able to provide materials that individual requests to the manufacturer have failed to secure.

Most importantly, collections should be built through collaboration. Librarians and curators need to involve faculty and students to determine acquisitions that respond to

institutional and curricular priorities. One way this can be achieved is by engaging students in acquisitions as part of a course requirement. Students can research a material, identify a source, and procure a sample for the collection. Assignments of this nature prepare students to source materials successfully for their design work while simultaneously engaging them deeply in the existing collection.

The best method for gathering samples is determined by the unique goals, scope and policies of each collection. In developing acquisitions policies, librarians and curators should consider the information needs and priorities of stakeholder researchers, the space available to hold (and grow) a collection, and whether the collection will house materials no longer in production (or whether those materials will be de-accessioned). Policies should also describe what will be excluded from the collection, such as historic materials, commonly available materials, systems, materials larger than a certain size, or multiple brands of a similar material. The New York School of Interior Design Materials Library, for example, shares its collection development policy online at http://ibrary.nysid.edu/ library/about-the-library/materials-libraries and encourages donations of various materials that are 'current or not older than 3–4 years' and of limited size. Reviewing acquisition priorities and policies frequently ensures that the collection remains highly relevant and highly valued.

The acquisition of books, journals and databases related to materials can facilitate deep research related to material samples. Research guides, such as the one assembled by University of Michigan librarian Rebecca Price (http://guides.lib.umich.edu/c.php?g= 282771&p=1884154), can collocate these information sources virtually with free resources from around the web.

Organizing a materials collection

Art- and design-based materials collections lack a unified controlled vocabulary that can keep pace with innovation and address the various ways art and design users seek materials. They also resist easy organizational and classification schemes. In the art, architecture and design professions in which creativity and inspiration are primary motivators, materials are approached expansively. This is unlike the fields of material science, construction and engineering in which material consideration is focused and exact, and material application legally cannot go beyond intended uses.

Given this unique profile of design-based material collections, the vast majority are organized by composition (metal, wood, glass, etc.) and then subdivided by local needs. A composition-based organizational approach accomplishes many goals: it provides points of access with which users are generally familiar, facilitates discoverability through browsing, and enables collection development. No librarian should expect that composition could satisfy all inquiries, however. Librarians should position the collection to allow for multiple approaches: properties, uses and applications, experiences, personalities and emotions (yes, emotions), and so on.

A material collection in an architecture or engineering department or school will be well served by adopting an organizational scheme based on the Construction Specification Institute (CSI) number, an approach that will prepare the student for employment in those fields. In addition to CSI, a UK-based data model by Granta Material Intelligence can provide an organizational framework.

Material collections that support the fine arts and design disciplines are likely to provide physical and digital access that cuts across compositional categories. For example, a search for wood may actually be an inquiry based on rigidity or sustainability – in essence a search for certain properties that can cut across composition. Investigating the materials collection based on properties such as luminosity or conductivity provides a broad and meaningful set of materials far beyond one material composition.

In addition, artists and designers base their approach to materials on how they make a person feel. Thus, materials are rendered through an emotive and psychological lens. A material can be happy, warm and inviting, or distant, cold and unfriendly. Representing these qualities in physical arrangements or digital search tools can illustrate just how limiting traditional library classification schemes and controlled vocabularies can be when applied to design materials. Browsability is of utmost importance for material collections and the researchers they serve.

Although new materials are being invented and created at an increasing rate, innovative materials use already-existing materials but in new and effective ways. In parallel, most students do not create a new material, but they may use materials in interesting and compelling ways. An architect may repurpose insulation as a wall covering or explore the use of aluminium foam in the design of furniture. The design-based materials collection should allow and encourage this stage of inspiration.

Programming a materials collection

Material collections offer libraries both traditional and innovative opportunities for programming. Whether located in a central or subject library or as part of an academic department or school, material collections can benefit from a combination of programming approaches from both realms. Keynote speaker Chris Lefteri advised at the 2013 symposium Materials Education and Research in Art and Design funded by the Institute of Museum and Library Services (IMLS) that schools should not have a materials collection in a static sense, that they must feature an intentional and forward-thinking approach to activating holdings. Regardless of staff or budget limitations, a programming plan propels collections to new levels of creative and scholarly engagement (cited in Pompelia, 2013).

Because most material collections are organized primarily by compositional categories, librarians have found great success with exhibitions of materials that pull items out of their bins or from their shelves to be presented in a manner and association that was otherwise not apparent. This type of arranging engages patrons through factors such as

properties – colour or translucence, for example. A 'new arrivals' display can present acquisitions before they disappear into their destination bins. 'Recently circulated' can also be a point of discovery and generate interest to know which materials faculty and student colleagues have considered useful. Exhibits of various types may also be displayed outside the space that the collection typically occupies. At the University of Virginia, where the materials collection occupies a windowless room somewhat hidden from view, small exhibits in the library lobby allow patrons to engage with materials in passing, whetting their appetite to explore the broader collection.

Partnering with departments and offices on campus with the goal of supporting or supplementing their programming can be an effective means to reveal the holdings of the materials collection. A lecture on economic supply chains or a symposium on environmental impact can be supported by materials that illustrate the topic, lending hands-on impact to concepts addressed.

Schools with a museum or art gallery can call on the materials collection to stage a supplemental display with items that mimic those contained in the museum object. The exhibition of a fragile 17th-century armoire, for example, could be enhanced with an interactive display from the materials collection of the same wood, silver and inlay process used in the museum piece. This can work also in the contemporary gallery where pieces are more conceptual with the handling of a material that replicates or is reminiscent of a property. Museum education departments and local arts education departments can be among the most enthusiastic of materials collection patrons in their drive to enhance understanding of art through haptic experience.

Vendor or distributor representatives can offer students a discussion panel from their perspective inside industry. Far from being a sales pitch, these speakers have an interest in presenting real world examples of how to approach companies with the most informed questions to minimize wasted time for both company and client. Students and faculty alike may not otherwise keep pace with industries that have faced incredibly rapid changes – with regards to environmental impact, for example – and benefit from this type of programming.

Lectures by designers, including alumni, are another smart way to programme the materials collection. Visiting artists, architects and designers speak effectively from personal knowledge and use of materials, possibly in ways that are not communicated by the collection. Designers, especially alumni, can directly speak to the critical curricular benefits of material collections during their studies because they did – or did not – have one at their institution.

Collaboration opportunities for a materials collection

Surveys conducted in the past decade have been quick to note the lack of shared resources and practices for materials collections (Akin and Pedgley, 2016; Hindmarch and Arens, 2009; Munro, 2016; Smith, 2015). Recent efforts seek to change that. Material libraries are

heterogeneous in nature, reflecting the specific and unique programmes related to the courses and degrees offered by departments at a given institution. The mission and scope for any one materials library may resemble those from other material libraries, but, in effect, each collection presents a different profile from the next. How, then, can collections work together for the benefit of scholars and designers?

Collaboration was a primary motivator for the formation of the Materials Special Interest Group (SIG) under the auspices of the Art Libraries Society of North America (ARLIS/NA). Founded in 2011, the group has met regularly each year at the ARLIS/NA annual conference. The SIG maintains a blog titled material|resource (http:// materialresource.wordpress.com) that offers collection profiles and industry resources and, with its nearly four hundred subscribers, could serve as a locus for collaboration.

This question of collaboration was the focus of a workshop held as part of the 2013 materials symposium; 45 librarians attended thematic presentations by colleagues on taxonomies, collection development, collaborative research and funding, before concluding with an open discussion on next steps that included building community and identifying opportunities for collaboration. The workshop's session on collaboration explored the possibility of partnerships with material science as a model for project or platform development and grant funding. As part of this discussion, Laura Bartolo (2013) highlighted the partnerships that the Center for Materials Informatics at Kent State University has developed with public and private research organizations focused on the advancement of materials development and adoption.

Others see a research-driven partnership with local industry as a collaborative model whereby the academic-based material collection serves the creative and project-specification needs for small- and medium-sized firms that do not have such a collection in-house. The Material Resource Collaborative at the University of Houston co-ordinates programmes and services that appeal to local firms, including offering consultations on LEED (Leadership in Energy and Environmental Design) v4, sustainability and carbon footprint analysis. Collaborative programming has led to grant funding and provided students with real world research opportunities within their local community (Kacmar, 2013).

Co-operation between collections is only recently gaining momentum. Emerging from the IMLS workshop was the desire for collaboratively derived and shared solutions for taxonomy and collection organization. Librarians also lamented the lack of expertise and resources to create unique database platforms at their home institutions and expressed the need for an 'out-of-the-box' solution that could be easily adopted. Already in partnership toward a joint catalogue and shared solution for their collections, librarians from Harvard University Graduate School of Design's Frances Loeb Library and Rhode Island School of Design's Fleet Library were motivated by this collective interest to think beyond their two schools.

The official collaboration, with Harvard University and Rhode Island School of Design as organizing members, has resulted in two outcomes, both called Material Order: a shared, open source, cloud-hosted cataloguing utility via the LYRASIS CollectionSpace

platform for object collection management, and a member-driven consortium among participating schools that provides a current and forward-thinking taxonomy and organizational schema (Pompelia, 2016). Front-end development of the shared file using a Wordpress customization is planned for 2017 and will be on the open web, allowing visitors to see holdings of participating schools and enabling crowd-sourced capture of experiential aspects of materials, in addition to other research-level resources.

Conclusion

Material collections stand at the forefront of future-looking programmes and services for libraries. They assert their post-digital nature through authentic, inspirational and experiential modes of understanding and as haptic learning centres with browsing as a primary mode of discovery. Digital access to material collections cannot serve as a surrogate, but rather expand functionality and augment the physical. Institutional and interdisciplinary collaborations are changing the ways scholars access and interact with materials in an academic setting, and how they interact with the broader community of makers, designers, entrepreneurs and scientists. Materials collections are catalysts. They function in an art–architecture–design sphere that is positioned adjacent to the sciences where dialogue can and will occur, where material selection is a learning process informed by both success and failure, and where critical thinking and making is the hallmark of 21st-century education.

References

Akın, F. and Pedgley, O. (2016) Sample Libraries to Expedite Materials Experience for Design: a survey of global provision, *Materials & Design*, **90**, January, 1207–17, doi:10.1016/j.matdes.2015.04.045.

Bartolo, L. (2013) Librarians' Workshop, *Materials Collection Creation and Administration: a new role for libraries* (white paper), http://digitalcommons.risd.edu/materialseducationsymposium/Publications/Resources/1.

Beylerian, G. M. and Dent, A. H. (2007) *Ultra Materials: how materials innovation is changing the world*, Thames & Hudson.

Hindmarch, L. and Arens, R. (2009) The Academic Library and Collaborative Architectural Education: creating a materials collection at Cal Poly, *Art Documentation: journal of the Art Libraries Society of North America*, **28** (2), 4–12, www.jstor.org/stable/27949517.

Jost, D. (2011) Material Evidence: for hands-on-learning, more universities are establishing materials collections, *Landscape Architecture*, **101** (8), 124–6, 128–32, 134.

Kacmar, D. (2013) Materials Research. In Abbate, A. and Kennedy, R. (eds), *Subtropical Cities 2013: braving a new world; design interventions for changing climates*, papers from conference organized by the Association of Collegiate Schools of Architecture, Florida Atlantic University, ACSA Press.

Kretzer, M. (2016) *Information Materials: smart materials for adaptive architecture*, Springer International.

Kolarevic, B. and Klinger, K. (2013) *Manufacturing Material Effects: rethinking design and making in architecture*, Routledge.

Michigan Engineering (2015) Tactile Art | MichEpedia | MconneX, YouTube video 03:33 posted 30 July, https://www.youtube.com/watch?v=uQU7ZhMvH2k.

Munro, K. (2016) Material Libraries Report, University of Oregon, https://scholarsbank.uoregon.edu/xmlui/handle/1794/20041.

NAAB (2014) *2014 Conditions for Accreditation*, National Architectural Accrediting Board, www.naab.org/wp-content/uploads/01_Final-Approved-2014-NAAB-Conditions-for-Accreditation.pdf.

NASAD (2016) *NASAD Handbook 2016–2017*, National Association of Schools of Art and Design, https://nasad.arts-accredit.org/wp-content/uploads/sites/3/2015/11/NASAD_HANDBOOK_2016-17.pdf.

Pompelia, M. (2013) *Materials Collection Creation and Administration: a new role for libraries* (white paper), paper given at symposium Materials Education and Research in Art and Design: a new role for libraries, http://digitalcommons.risd.edu/materialseducationsymposium/Publications/Resources/1.

Pompelia, M. (2016) Material Order: building collections and creating community, Association of Collegiate Schools of Architecture AASL Column, November, https://www.acsa-arch.org/acsa-news/read/read-more/acsa-news/2016/11/08/material-order-building-collections-and-creating-community.

Schröpfer, T. (2011) *Material Design: informing architecture by materiality*, Birkhäuser.

Smith, K. A. (2015) *Materials Library Research Report*, University of Notre Dame, www.kaialexis.com/wp-content/uploads/2015/12/MaterialsLibraryResearchReport-redact_Redacted1.pdf.

Viray, E. (2011) Why Material Design? In Schröpfer, T. (ed.), *Material Design: informing architecture by materiality*, Birkhäuser.

Wagner, D. (2013) Materials + Process: an exhibition of student-made materials, Academic Commons Program, paper 3, http://digitalcommons.risd.edu/grad_academiccommonsprogram/3.

Chapter 13

Seeing the bigger picture: archival description of visual information

Alyssa Carver

Introduction

One of the most persistent challenges special collections librarians face is how to explain what they do. Casual conversations with strangers – to prevent them from becoming protracted – require omission of the word 'archivist' and the negative definition, 'It's the stuff you can't check out of the library.' This is an oversimplification, of course, but in truth there are not many other commonalities with other occupations to point to when describing archives and special collections. Given the potentially infinite range of collection formats and topics, absolute definitions are elusive. The answer to every archival question accommodates ambiguity and may often be 'it depends'. It is much easier to explain the few tangible qualities, like rules and restrictions, or to characterize special collections by how they differ from 'regular' collections.

This might seem like a rather abstract conundrum, but it becomes very concrete when the job is to describe these materials. Description is an essential library service of which readers may be unaware. The catalogue reveals where the desired item is; the item is retrieved. That seems easy. But the description of materials in special collections is often more complex, and sometimes even the fundamental nomenclature indicating what an item is can be difficult to identify. In a closed-stack environment, the stakes are higher since browsing is precluded, making accurate and detailed description is essential. There are few shortcuts for patrons that bring intellectual serendipity, like determining where an author's work or subject is shelved and then going there to see which book is the one they want. (With the word 'see' we have the linguistic bias toward visuality, the ocularcentric conflation of 'seeing' and 'knowing' [Rose, 2012, Chapter 1.1]). Users might not be aware that manuscripts and unique materials even exist, much less how to look for them in a catalogue search. Thus for cataloguers of special collections, the task is not simply to make known items findable, but rather to describe the uncommon qualities of unknown items to an audience that cannot see them in a way that makes them not only retrievable, but also desirable.

Unfortunately, with visual material this is a complex task. For patrons who are artists, designers and visual thinkers in particular, browsing is the best way to discover image-based resources (Cowan, 2004, 14; Frank, 1999, 447). The lack of opportunity for serendipitous encounters with this material affects these users more than others. And yet, it seems as though there has been little effort within the archives and library professions to solve or even seriously consider this problem. Is this due to a basic misunderstanding of the information-seeking behaviour of artists (Cowan, 2004, 18)? Academic libraries, which are often the locations of archival, manuscript and rare book collections, with their focus on scholarly research, might not understand how artists research when the form of the final product is so unlike a peer-reviewed article. The archives reading room is typically viewed as the site of studious, controlled quiet, rather than of creative activity. But archivists who work with designers and design collections know that artists use their collections for a value form of research as well. Graphic designers often conceive of their projects as problems awaiting solutions and approach their work quite pragmatically, ultimately expressing visual arguments with the same rigour as any verbal rhetoric. Although designers and artists may form a distinct set of library users, the fundamental lesson is that visual information takes many forms and that contemporary media is increasingly image-centric (Rose, 2012, 2–5). The Association of College & Research Libraries recognized this and published Visual Literacy Competency Standards for Higher Education in 2011, stating in the introduction: 'Visual imagery is no longer supplemental to other forms of information.' If this is the case, then all of our patrons stand to benefit from careful reconsideration of the relationship between special collections and visual material.

Definitions

What do we mean by 'visual material'? As a conceptual category, it can encompass almost anything that has an observable form. But limiting the discussion to only the examples that might appear in archives still leaves a sizeable range of material: documentary photographs, product packaging labels, instructional diagrams, maps, architectural plans, fashion sketches, infographics, advertisements, textile samples, typographic compositions, type specimens, calligraphy – essentially every genre of art and illustration. Additionally, most of these items can exist in analogue and digital formats. Each comes from a specific disciplinary context, with its own history and vocabulary, but their commonality is the capacity to convey information nonverbally. If the essential premise behind visual literacy is that certain content can be communicated by nonverbal means only, then there is some irony in the fact that we can only catalogue such content via verbal description. ACRL addresses this complication by acknowledging in the preamble to the standards that 'finding visual materials in text-based environments requires specific types of research skills' (Association of College & Research Libraries, 2011).

Important as it is to help students develop strategies for image research with words,

description, discovery and access are visual activities, too. Are libraries serving the needs of visually literate patrons? If visual literacy is a significant skill set, perhaps there are better systems that support finding and navigating visual information. Accommodating patrons who are artists and designers might require developing a service model beyond simply providing visually rich collections.

The scope of this chapter is somewhat narrower, however, discussing how to make archival description facilitate the discovery of visual material in collections. Without a set of established best practices, the goal of the chapter is to present the tools and frameworks that are available and discuss their utility based on a case study centred on processing a large design collection.

Those who may benefit from reading this chapter include the experienced archivist new to processing image-based collections and the art librarian who is asked to manage a collection of artists' papers. Furthermore, articulating the specific challenges involved with describing visual archives may stimulate new ideas about the practice and suggest areas for future research.

Frameworks

Because manuscripts and archives are so much more heterogeneous than bibliographic materials, there is a striking difference in the level of standardization between the two. Despite their being closely related professions, both with long histories, librarianship has a much more developed body of rules and best practices than manuscript and archival management. The archival community began to codify its own standards and theoretical models only in the past few decades, relying until then on an amalgamation of library values and local policies. The mid-1990s brought the early development of the archival metadata format Encoded Archival Description, most recently updated in 2015. *Describing Archives: a content standard* (DACS) was first published in 2004, with a second edition in 2013 (Society of American Archivists, 2013). While these are huge advances for the profession, archival standards are still less like 'rules' than 'guiding principles', especially when compared with bibliographic cataloguing. Note that the Canadian content standard *Rules for Archival Description* is very similar to DACS, and both are based on the International Council on Archives' *General International Standard Archival Description* (Bureau of Canadian Archivists, 2008; International Council on Archives, 1992). Because DACS supports a broad array of archival descriptions and outputs, it is not heavily prescriptive (DACS, Part I, Introduction). It is designed to work in concert with whichever value standards are appropriate for the collection subject, like the Getty thesauri or Library of Congress authorities. Therefore, much of the guidance provided by DACS is accompanied by the modifiers 'if appropriate', 'when present' and 'optionally'.

The underlying principles are firm, however. Of these, the most fundamental is that archives are always understood as a collective body of material. In archival terminology,

the word *fonds* refers to this greater whole, of which each manuscript is only a small part. It defines not an actual instance of collected material, necessarily, but the conceptual grouping of all documents created or accumulated by the same entity (person or organization) in the regular course of life or business activities (Pearce-Moses, 2005, 173–4). Therefore even if the collection in question consists of only a single piece of correspondence, it is treated with respect to a larger whole for the purposes of archival description. Library cataloguing, in contrast, is concerned with discrete items, and the nature of those items is mostly self-explanatory. (A bibliographic catalogue record does not need to define what a book is, or explain the connection between a book and its author.) To use a more art-specific example: a preliminary sketch for a sculpture, even if the sketch is all that exists, should not be considered an individual product but as a step in an ongoing artistic process. In contrast, an item with a physically identical format (a few lines of graphite on paper) would be considered a work of art in its own terms if that is what the artist intended it to be.

Another core archival value is authenticity, variously expressed as *respect des fonds*, 'original order' or simply provenance. In practice, this dictates that collections from different origins should not be combined, and the sources (creators) of collections should always be documented, along with the entire chain of custody, if possible. Ensuring and maintaining the authenticity of archives is important for several reasons. Sometimes there are legal mandates involved, or claims of historical discoveries that depend on the archives as evidence. But there is also meaningful information to be gleaned from the relationships between materials within a collection. This is another aspect of the authenticity of a collection, closely related to the idea of archives as aggregate mentioned above. An archival collection is not just the sum of its parts. The greater whole can be viewed as a manifestation of processes through time, as slicing through rock strata can reveal layers of geological history. Respecting the original arrangement of a collection recognizes its organic nature. Since rearranging and removing items can destroy the evidential value of an entire collection, if done improperly, archivists are obligated to preserve the logic of the collection's arrangement while they describe it. As an example, if a graphic designer's papers contain a folder full of unfamiliar images labelled with the name of a well known project, the archivist can conclude that they were potential inspirational sources for that project, even if ultimately unused. To impose some other arbitrary filing scheme to these photographs and clippings would break the thread of connection between them.

There are fine distinctions here. Why is the principle 'arrangement and description' if the archivist is not supposed to arrange anything? Various practices of arrangement and description exist and challenge a search for exact standards. Some collections, often business files and institutional records, arrive at the archives with a straightforward, usable arrangement system – whether alphabetical, chronological or by department. If this is the case, the archivist should maintain this arrangement, describe it in the finding aid, and if some portion of material is found lacking order while processing, arrange those items according to the extant scheme. But often, as with personal papers and artists'

collections, the archivist finds no discernible order. The Society of American Archivists glossary of terms states that 'the principle of respect for original order does not extend to respect for original chaos' (Pearce-Moses, 2005, 280–281). How, then, does the archivist proceed? It depends.

The flexibility of archival standards extends to a feature of description that may seem at first glance peculiar: that a detailed inventory need not be present in a DACS-compliant descriptive record. Archivists can choose what level of descriptive detail is appropriate for each collection – or for an individual portion of a collection. Archival description may also be an iterative process, so that publishing an accession record with a physical description that states simply '200 boxes' is quite valued if it includes all other necessary collection-level information. When the collection has been fully processed, the record can be augmented to include a more granular list, including boxes, folders or individual items. This kind of flexibility would be unthinkable in a library catalogue record, which is primarily concerned with managing the locations of items. Archival description has more of an ontological function; the first task is to record *what* exists, then to state where it might be.

Practice

Although daunting, addressing an unprocessed collection – creating order from chaos – is often at the very heart of archival processing. Improbably, this task is discussed less than might be expected, perhaps because there are many valid approaches to arrangement and description, based on the unique contents of each collection. Often the most qualified person to make these decisions is the processing archivist.

Kathleen Roe (2005) provides a concise, yet practical and thorough, overview of the subject. She discusses the essential differences between archives, library and museum cataloguing practices, presents some of their history, and offers guidance on when different levels of descriptive detail are appropriate. Still, her book cannot address different kinds of archival materials at any length. In accordance with DACS, Roe lists a number of relevant data standards and vocabularies. Jane Greenberg's analyses (1993, 2001) address the quality and utility of various descriptive schemas as they relate to image-applicable subject headings and metadata, as do Ascher and Ferris's multi-standard comparison of special collections descriptors (2011). Although it is certainly advisable to use language and terminology that the intended audience will understand and that is at the same time consistent with institutional practices, the utility of authorized headings as access points within finding aids has not been proven to help users find or navigate collections (Chapman, 2010, 16–17).

In fact, the finding aid in general has not been studied thoroughly enough to determine how well it serves the needs of users in our current information climate. As the traditional format for presenting archival description, finding aids have always been text-based documents, although today they are frequently published and displayed.

Considering all the contextual information they need to provide, finding aids become lengthy, especially if they include a detailed inventory. In the time it has taken for archival standards to develop and become widely adopted, the internet has become ubiquitous. For web-savvy library patrons, online finding aids are a confusing oddity. Without an intuitive format – one less familiar than a library's online catalogue – online finding aids also deviate from reader expectations of web design and usability: they are text-heavy and static (Chapman, 2010, 4–5; Daines and Nimer, 2011, 8–9). Told to use a card catalogue to locate material, an undergraduate student would probably leave the library and not return; the student would regard the card catalogue as an unreasonable barrier to access in a contemporary library, even though access to collections in such a way was once usual.

Some in the field of archives and special collections have addressed the importance of the online interface for discovery (Schaffner, 2009). Others have proposed modifications to the finding aid that employ web technologies more effectively and align with users' expectations (Ellis and Callahan, 2012; Krause and Yakel, 2007). Interactive characteristics that seem especially relevant to the finding aid include the capacity to glimpse the entire extent of a collection in one overview, to zoom in from a broad view to a detailed view, and to navigate within a collection without losing a sense of direction (see Discover the Queenslander, www.slq.qld.gov.au/showcase/discover-the-queenslander#/mosaic; Australian Prints and Printmaking, www.printsandprintmaking.gov.au/; and Manly Images, mtchl.net/manlyimages/).

Regrettably, the finding aid has only begun to evolve past its paper origins, and as a tool for discovery and access it still resembles a text-intensive card catalogue more than a search of the web (Ellis and Callahan, 2012; Krause and Yakel, 2007; Schaffner, 2009). Since Michael Whitelaw's (2015) case studies are prototypical web galleries with custom-built interfaces, it may be important to underscore the distinction between a finding aid and a digitized collection. The first functions as a surrogate for material existing elsewhere, with which it has a variable one-to-many relationship; the second is a collection of digital items that also have one-to-one relationships with a set of analogue items. Although there is no simple method for applying one generous interface on top of another collection, perhaps some of the techniques and underlying principles can provide a model for the design of a truly digital archival interface. And since processing archivists understand best the contents and connections within collections, their task is clear.

References

Ascher, J. P. and Ferris, A. M. (2011) Collection-Level Surveys for Special Collections: coalescing descriptors across standards, *Journal of Academic Librarianship*, **38** (1), 33–41.

Association of College & Research Libraries (2011) *ACRL Visual Literacy Competency Standards for Higher Education*, http://www.ala.org/acrl/standards/visualliteracy.

Bureau of Canadian Archivists & Canadian Committee on Archival Description. (2008) *Rules for Archival Description*. Bureau of Canadian Archivists, Canadian Committee on Archival Description.

Chapman, J. C. (2010) Observing Users: an empirical analysis of user interaction with online finding aids, *Journal of Archival Organization*, **8** (1), 4–30.

Cowan, S. (2004) Informing Visual Poetry: information needs and sources of artists, *Art Documentation: Journal of the Art Libraries Society of North America*, **23** (2), 14–20.

Daines, J. G., III and Nimer, C. L. (2011) Re-Imagining Archival Display: creating user-friendly finding aids, *Journal of Archival Organization*, **9** (1), 4–31.

Ellis, S. and Callahan, M. (2012) Prototyping as a Process for Improved User Experience with Library and Archives Websites, *The Code4Lib Journal*, Issue 18, 3 October, http://journal.code4lib.org/articles/7394.

Frank, P. (1999) Student Artists in the Library: an investigation of how they use general academic libraries for their creative needs, *Journal of Academic Librarianship*, **25** (6), 445–55.

Greenberg, J. (1993) Intellectual Control of Visual Archives, *Cataloging & Classification Quarterly*, **16** (1), 85–117.

Greenberg, J. (2001) A Quantitative Categorical Analysis of Metadata Elements in Image-Applicable Metadata Schemas, *Journal of the American Society for Information Science and Technology*, **52** (11), 917–24.

International Council on Archives (1992) *ISAD(G): General International Standard Archival Description*, Secretariat of the ICA Commission on Descriptive Standards.

Krause, M. G. and Yakel, E. (2007) Interaction in Virtual Archives: the Polar Bear Expedition digital collections next generation finding aid, *American Archivist*, **70** (2), 282–314.

Pearce-Moses, R. (2005) *A Glossary of Archival and Records Terminology*, Archival Fundamentals Series II, Society of American Archivists (also www2.archivists.org/glossary).

Roe, K. (2005) *Arranging and Describing Archives and Manuscripts*, Archival Fundamentals Series II, Society of American Archivists.

Rose, G. (2012) *Visual Methodologies: an introduction to researching with visual materials*, SAGE.

Schaffner, J. (2009) *The Metadata Is the Interface: better description for better discovery of archives and special collections, synthesized from user studies*, OCLC Research, www.oclc.org/programs/publications/reports/2009-06.pdf.

Society of American Archivists (2013) *Describing Archives: a content standard*, www2.archivists.org/standards/DACS.

Whitelaw, M. (2015) Generous Interfaces for Digital Cultural Collections, *Digital Humanities Quarterly*, **9** (1), www.digitalhumanities.org/dhq/vol/9/1/index.html.

Part III

Teaching and learning

User education is a vital part of the academic librarian's role. Instruction is often the best way to engage students who may be uncomfortable with visiting a library in person. Because they might be visual or tactile learners – and because visiting the library to examine collections is so essential to skilled use of an art library – users in art libraries present challenges for librarians that may not arise in the course of a standard instruction session at college or university. Like all academic librarians, art librarians work with diverse levels of research expertise, but we must also move fluidly between discussing art with practising artists and designers and discussing art with art historians and educators, bearing in mind the differences in each group's research goals and outcomes. In this section we examine the possibilities and difficulties inherent in art library instruction for artists, designers and art historians. The following chapters explore methods for weaving information literacy instruction into a studio class; the place of the ACRL threshold concepts in the visual context of art and design; how to capitalize on special collections with art history students; metaliteracy as an appropriate perspective for enlarging information literacy for visual and tactile learners; the art history student's particular research and information needs; how to employ instructional design principles; and culturally sensitive art information literacy in societies with religious restrictions on image and media consumption.

Chapter 14

Embedded in their world: moving mentally into the studio environment

Michael A. Wirtz

Introduction

The artist's studio is not a natural environment for a librarian. To the unfamiliar, production in the studio may be disorganized, messy and non-linear. What is being made is often difficult, if not impossible, to classify. Descriptions of the work being created are often vague, couched in metaphors and full of synonymous terminology. To a library professional, trained in a world of classification, organization and controlled vocabulary, the studio environment is a foreign land. As for visitors to a foreign land, there is always the temptation to evaluate an unfamiliar environment based on what is familiar. Librarians of the past thought practising artists 'do not want to learn library systems; some cannot read very well, many cannot verbalise their needs, and frequently cannot evaluate information' (Hemmig, 2008, 349). In an early text on library instruction, the authors stated that they did not include a discussion of fine arts instruction because the fine arts 'depend less on person-to-person communication than they do on talent, inspiration, perseverance, and opportunity – all fragile assets, the successful combination of which is notoriously unpredictable' (Teague, 1987, 99). Art and design practitioners have also noted the disconnection between traditional library services and their creative production. In the essay 'The Culture of Academic Rigour: does design research really need it?' John Wood, former Deputy Head of the Fine Arts Department at Goldsmiths University, states that 'competitive professional practices do not facilitate long periods in the library, and many designers succeed commercially without much contextual reading and writing' (2000, 44).

Although these sentiments might seem dated to a contemporary librarian, there is an element of truth in them. The average art and design student probably does have little interest in learning library systems because most systems rely on a textual or verbal mode of access. Many cannot verbalize their information needs because they often think in the abstract, and their ideas cannot be easily classified. Their needs are unpredictable because

successful art and design is often interdisciplinary and almost always novel. They are not skilled in the rigour of academia because it is not a necessary component of artistic communication.

Essentially, the language commonly spoken by libraries is different from the language of art and design practice. Wood touches on the history of art and design practice within the university in his essay, claiming that academic studio-based practices evolved from medieval craft guilds, whereas the disciplines that are normally associated with 'rigorous' academics evolved from the monastic traditions (2000, 45). He argues that the monastic tradition and its associated rigour could be understood in terms of the perfection, consistency, comprehensiveness, authorial remoteness, linearity, objectivity and explicitness of the traditional academic product: the book (Wood, 2000, 49). He further argues that art and design studios, a relatively recent addition to the traditionally monastic university, do not use the same means or have the same aims in their creative production (Wood, 2000, 52). If art and design studio practice and rigorous academics are two separate paradigms, the traditional library would obviously find itself much more at home in the latter.

None of this is to say that art and design students do not need the library. As an embedded librarian with Virginia Commonwealth University in Qatar's Master of Fine Arts programme in interdisciplinary design for the past seven years, this author's observations lead him to believe that studio-based students are prolific consumers of a wide variety of information. The aforementioned observations may be true but do not preclude librarians from having a place in the studio. The most effective way to serve populations of artists and designers is to shift the point of service and preconceived notions of librarianship into their spaces.

Embedded in a studio cycle

The most common conception of embedded librarianship rose from the working relationships librarians began to form with medical professionals in the early 1970s (Shumaker and Talley, 2009, 8). In these relationships, medical librarians would follow medical professionals on their rounds, using specialized knowledge to provide information.

The term embedded librarianship has since expanded to many disciplines and many different conceptions of what embeddedness means to a librarian. There are numerous accounts in the literature of librarians working in some sort of embedded fashion, but the majority of them focus on the physical location of library services – bringing library services to the patrons' environment (Haines, 2004; Leousis, 2013). According to a 2009 report on embedded librarianship for the Special Libraries Association, embedded library services can be defined by the following eight attributes: 'customer centric not library centric, located in their workplace not our workplace, focused on small groups not entire populations, composed of specialists not generalists, dependent on domain knowledge

not only library skills, aiming for analysis and synthesis not simply delivery, in context not out of context, and built on trusted advice not service delivery' (Shumaker and Talley, 2009, 9).

The author's experience with embedded librarianship began when he was hired at Virginia Commonwealth University in Qatar in 2009 as the librarian for the newly established Master of Fine Arts (MFA) programme. Since the librarian position was new and somewhat loosely defined, the librarian detected an opportunity to integrate himself into the classroom. The programme went through an evolutionary process in the first years of operation, and the librarian began co-teaching several courses with studio-based faculty. The curriculum had a significant writing component for an MFA programme, and the largely studio-based faculty began to rely on the librarian to provide embedded instruction in those areas. Some of the classes could be considered areas in which a traditional mode of librarianship could play a role – the theory-centric design seminar, for instance. However, the librarian was soon embedded in the studios courses as well, integrating work on the written components of the thesis into the studio production. During the same time, he began to serve on thesis committees – most often as the thesis reader, but also as a primary adviser.

About four years ago, the department saw the need to modify the thesis process. When the programme began, the curriculum was administratively designed before the first faculty member was hired. As the programme evolved with the addition of new faculty members, they felt that the original undefined thesis requirements did not serve the students well, and they asked the librarian to develop new guidelines and an outline for the written thesis component. At that point the position of librarian moved beyond the territory of traditional librarianship. Although most of the embedded work in the MFA programme centred on the textual, those texts developed differently than in most other disciplines. The students composed texts that were not linear in nature, but rather often personal, first-person accounts of their explorations. They also wrote the texts as the studio explorations were in progress, so that working on the written component of the thesis focused on a goal in a state of continual change. The time frame for the completion of the MFA degree did not allow students to complete their studio work and then work on the written component. Rather, the studio work had to be developed simultaneously with the written component.

In the early years of the programme, despite having a studio background himself, the librarian tried to introduce a more linear model, one that would more closely resemble the social science research he had worked with as a librarian. But in doing so, he was asking the students to speak in the language of the paradigm to which he was accustomed. By the time he was asked to redesign the written portion of the thesis, he began to see the value in the cyclical nature of the design studio.

Most literature on the design studio (or what is sometimes too broadly termed design thinking) discusses at least three phases of design: exploratory, generative and evaluative (Martin and Hanington, 2012). It is tempting, especially without experience in the studio

environment, to see this as a linear process in which a designer first explores concepts, generates prototypes and evaluates those prototypes for functionality and efficacy, redesigning as necessary. The reality is a more circular process in which each step refers back to the previous one. The exploratory and generative phases are often indistinguishable, and the evaluative phase is often begun and completed within minutes of a generative change. The model in which a student explores a concept, develops a prototype based on that exploration, and then evaluates it using systematic, scientific methodology is a rarity. Students may well encounter all three phases when working on a design, but they cycle through them rapidly, often several times within a few hours.

This is not to suggest that MFA students are unaware designers who rely solely on the unconscious and on artistic instinct to complete their work. Like students of all disciplines, they need information to develop their ideas successfully. It is, however, difficult to predict what types of information students need and when. In teaching a class on thesis development within the programme, the author gives structure to the class so as to work within the students' cycle of production. The assignments begin with a literature review of theories, histories and behavioural research that ground their current work. Next are research precedents – identifying and examining the work of artists and designers working with similar ideas. Finally, students revisit their problem statements – what they are trying to do and why. The class co-ordinates with the students' third-semester studio course, taken simultaneously. By introducing this structure, the librarian brings information into the cycle of production. The codification of abstract concepts generated from the research and writing in the course feeds into studio course explorations. Likewise, the designs generated in the studio course form the basis of the research in the course taught by the librarian, which mirrors the exploratory (what are the big ideas out there?), generative (what have others done with this?) and evaluative (how am I going to use this?) nature of the studio process. Due dates and the evaluation of each of the course units are scheduled in alignment with the studio course so that students can rework previously completed portions as they cycle through the research process.

Information use in the studio

In her article on assessing the needs of studio art students, Hannah Bennett wrote that she viewed her role as evolving from a 'subject specialist and subject librarian into a resource explorer' (2006, 38). This is an apt description of the experience of working with art and design practitioners. Over the past 30 years, numerous articles and studies on the art practitioner's use of information have appeared, but most have focused on how librarians define information and information usage within artistic production. According to William Hemming's extensive review of the literature on the information-seeking behaviour of visual artists, artists require information for inspiration, visual images, technical information and career guidance (2008, 355). He also concluded that the literature shows that artists have highly individualistic information needs, prefer

serendipitous browsing and favour human mediation to searching catalogues or indexes (2008, 356).

Most of these studies centre on the use of information from a library perspective. They look at the types of information that art and design students use and how they prefer to access it. Although this can be helpful for designing library services and collections, to work effectively as an embedded librarian in the studio it is beneficial to look at how art and design students use information in the studio environment. In this regard, the information model put forth by Edward Teague in his 1987 chapter 'A Portrait for the Librarian' is a simple and effective way to conceptualize information use in the studio environment.

Teague breaks down the types of information needed by studio art and design students into three categories: technical, contractive and expansive. Technical information establishes knowledge of a medium or method. This could be information related to a particular piece of software, the composition of ceramic glazes, the steps in a particular printmaking technique, or health and safety considerations in the etching process. It is information a student needs to work effectively within a medium (1987, 100).

Contractive information defines the parameters of a studio exploration. For example, this information might be behavioural research that can help predict the way a product could be used (Teague, 1987, 101). Building codes, geographical data, political information and standards are all examples of contractive information. Although at their cores art and design are aesthetic interactions with audiences, they require knowledge of contractive information for those interactions to be effective.

Expansive information provides sources of inspiration (Teague, 1987, 101). As an information type, this is the most challenging to define because almost any kind of information can inspire. Obviously, visual information on the work of other artists and designers can be sources of expansive information, but so might literature, history, philosophy, science and nature.

The utility of these three categories in traditional librarianship may be limited because of their broad scope. An art librarian can easily evaluate a need for resources in 19th-century French painting, but it is more difficult to evaluate a collection for its expansive capacity for the studio artist. However, for the librarian embedded in the art or design studio, these categories can help evaluate how a student employs a particular piece of information.

Teague's categories are not necessarily intended to classify types of information as a librarian typically classifies resources, but rather they are intended to explain in what capacity a piece of information is being applied. A student could use the same piece of information as technical information in one capacity and expansive information in another. Additionally, the capacity in which a piece of information is used can change. For example, use of information about an unknown medium could initially be considered expansive, but later, as the student begins to work in that medium, it might be used as either contractive or technical information.

The utility of these categories may increase by expressing them as adverbs. Instead of identifying the student's use of information as technical, expansive or contractive, one might more usefully ascertain when a student works with information technically, contractively or expansively. This can allow the librarian to identify opportunities to provide additional information.

In practice, these categories are not mutually exclusive. If the categories are visualized as overlapping circles, then the areas where they intersect demonstrate the possible combinations (Figure 14.1). Although this could be seen as a further complication of an already loosely defined system, the areas of intersection are key places for intervention by the librarian. For example, if students are looking for information on an Arduino microprocessor (technical or contractive), there is the opportunity to introduce them to information on other artists and designers using Arduino technology (expansive).

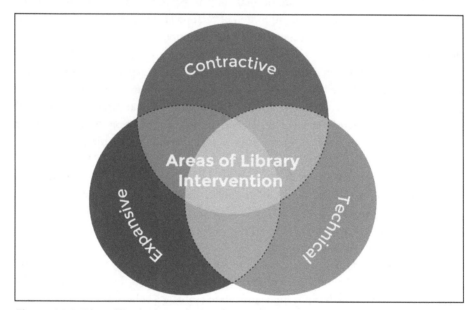

Figure 14.1 *Edward Teague's categories of creative practitioners' information use visualized as overlapping elements that provide opportunities for librarian intervention* (Teague, 1987)

By identifying these possibilities for use of information in the studio, the librarian can direct the students to sources of information. Another method is to structure questions that will open a dialogue for deciphering the information needs. Rarely do art and design students consider how they use a piece of information; rather, they simply have a question and seek out an answer. By understanding the capacities in which art and design students apply information in the studio, a librarian can channel curiosity, direct inquiry and lead students to resources that will enhance their productivity.

Conclusion

In 'A Recent History of Embedded Librarianship', Matthew Brower stresses the necessity of 'long term planning with the customer' as a key element of working successfully as an embedded librarian (2011, 3). In the art and design studio this is critically important. To understand fully where the students are in the cycle of production and how they are using information requires a commitment greater than an hour-long instruction session. A level of embeddedness is necessary to connect art and design practitioners with the information they require. Attending critiques, visiting studios and workspaces and initiating informal conversations are effective ways to establish an embeddedness within studio culture. Moving into the studio space mentally is as important as moving there physically.

References

Bennett, H. (2006) Bringing the Studio into the Library: addressing the research needs of studio art and architecture students, *Art Documentation: Bulletin of the Art Libraries Society of North America*, **25** (1), 38–42.

Brower, M. (2011) A Recent History of Embedded Librarianship: collaboration and partnership building with academics in learning and research environments. In Kvenild, C. and Calkins, K. (eds), *Embedded Librarians: moving beyond one-shot instruction*, American Library Association.

Haines, A. (2004) Out in Left Field: the benefits of field librarianship for studio arts programs, *Art Documentation: Bulletin of the Art Libraries Society of North America*, **23** (1), 18–20.

Hemmig, W. S. (2008) The Information-Seeking Behavior of Visual Artists: a literature review, *Journal of Documentation*, **64** (3), 343–62.

Leousis, K. (2013) Outreach to Artists: supporting the development of a research culture for Master of Fine Arts students, *Art Documentation: Bulletin of the Art Libraries Society of North America*, **32** (1), 127–37.

Martin, B. and Hanington, B. (2012) *Universal Methods of Design: 100 ways to research complex problems, develop innovative ideas, and design effective solutions*, Rockport Publishers.

Shumaker, D. and Talley, M. (2009) *Models of Embedded Librarianship: final report.* Special Libraries Association, http://citeseerx.ist.psu.edu/viewdoc/download?doi=10.1.1.679.8208&rep=rep1&type=pdf.

Teague, E. H. (1987) A Portrait for the Librarian: bibliographic education for students in design disciplines. In *Conceptual Frameworks for Bibliographic Education: theory into practice*, Reichel, M. and Ramey, M. A. (eds), Libraries Unlimited.

Wood, J. (2000) The Culture of Academic Rigour: does design research really need it?, *The Design Journal*, **3** (1), 44–57.

Chapter 15

Teaching with threshold concepts and the ACRL Framework in the art and design context

Alexander Watkins

Introduction

Teaching is at the core of the work of many academic librarians, with information literacy as the focus. But how do we define information literacy? And what skills and dispositions constitute information literacy? The way we articulate the definition of information literacy has a direct effect on how we teach it. The Information Literacy Competency Standards for Higher Education (the standards) from the Association of College & Research Libraries (ACRL) set forward a set of common skills and abilities an information literate student possesses. Now the ACRL *Framework for Information Literacy for Higher Education* (the *Framework*) posits six 'big ideas' or frames that an information literate individual understands (2015a). It represents the culmination of a shifting pedagogical landscape in librarianship. The six frames are intentionally complex and wide ranging in scope. When the frames intersect with research practices within disciplines, they take on different shadings and modulations and are useful in multiple ways. When we apply the *Framework* from an art and design perspective, what might these ideas look like?

The shifting landscape of information literacy pedagogy

The adoption of the *Framework* and the rescinding of the standards in 2016 was the result of a sea change in thinking about information literacy. Despite their usefulness, a simple update of the standards could not solve some of their intrinsic issues nor bring them in line with current teaching practices. The standards are essentially a linear progression of many discrete research skills and steps. By overloading learning objectives and giving all components equal priority, no skills were identified as especially crucial (Hofer, Brunetti and Townsend, 2013, 110). Its prescribed order of steps suggested one way to carry out research and one way to understand information literacy; its prescriptive approach models the workflows of often privileged, high-achieving students whose work process most closely aligns with our own as academics and librarians (Elmborg, 2006, 194). Problematically, the

standards do not address the social and political aspects of information, and they present an essentially positivist construction of information – as absolutes separate from context (Foasberg, 2015). The standards position students as mere finders and users of external and discrete units of information, rather than as critical participants in their communities. This kind of document encourages the 'banking' model of education, where learners are to be filled with predetermined information. The standards ended up limiting library pedagogy by encouraging procedural tool-based training rather than building students' capacity to be critical users and creators of information.

Crucial is the *Framework*'s new definition of information literacy: 'Information literacy is the set of integrated abilities encompassing the reflective discovery of information, the understanding of how information is produced and valued, and the use of information in creating new knowledge and participating ethically in communities of learning' (ACRL, 2015a). It contrasts sharply with the definition provided by the standards that information literate individuals 'recognize when information is needed and have the ability to locate, evaluate, and use effectively the needed information'. Several important concepts are embedded in the new definition, most importantly that of learners as participants in communities and as creators of knowledge. The *Framework* lists six concepts that together constitute key ideas of information literacy and describes the knowledge practices of information literate individuals (the actions that indicate comprehension of the ideas) and their dispositions (the emotional and motivational states that allow students to apply the ideas). These are the six frames:

- scholarship as conversation
- research as inquiry
- authority is constructed and contextual
- information creation as a process
- searching as strategic exploration
- information has value.

The complexity of these concepts elevates library instruction. In acknowledging that information and authority are social constructs, the *Framework* positions learners to take on more agency as participants in the information ecosystem, rather than as passive consumers of information. Rather than listing requisite skills or learning objectives, the *Framework* instead is sufficiently elastic so as to fit local and disciplinary needs. Thus, art and design librarians will be responsible for understanding how students relate to the *Framework*'s concepts and which cognitive skills students will need to work with them. By teaching students a contextualized version of the *Framework*, librarians will not only support students' success in their chosen fields, but also give them the tools to transfer their information literacy capacities to other aspects of their lives (Kuglitsch, 2015).

The *Framework* has not been without controversy or criticism. Some librarians have spoken out in defence of the standards and of standards-based education; however, as

this author's stance on this matter is already evident, he will leave it to others to make this argument. Additional frames have been proposed, such as 'information social justice' and 'information apprenticeship in community' (Hinchliffe and Saunders, 2015).

Threshold concepts

The *Framework* has its roots in the idea of threshold concepts. These are complex and troublesome concepts that are essential to the epistemology of a discipline. They are troublesome because they are hard for learners to grasp and understand. On the other hand, experts have generally internalized the concept, such that it seems so obvious that it often is not stated explicitly. Often called bottlenecks or choke points, thresholds impede students' advancement in a discipline until they are mastered. Meyer and Land (2003), education researchers who developed the threshold concept, liken them to portals that open new vistas of understanding and to liminal spaces that once passed through cannot be re-passed. Thus, the learning of threshold concepts is often permanent. In describing the thresholds, they assign several of these five traits as typical:

- *Transformative*: they change the way the learner views the world, or at least certain of its phenomena.
- *Irreversible*: it is hard to unlearn a new understanding. This also makes it difficult for experts to understand the position of a new learner who has not crossed this threshold, as it is difficult for them to imagine seeing the concept any other way.
- *Integrative*: they involve the interrelatedness of concepts that might have seemed disconnected.
- *Bounded in a conceptual space*: threshold concepts are usually specific to a discipline, and incompatibility among them can suggest disciplinary boundaries.
- *Troublesome*: this knowledge is often alien or counterintuitive but also might be troublesome because it remains tacit and unspoken.

Let us take as an example the frame 'scholarship as conversation' and examine how it aligns with this definition of a threshold concept. Once learners understand this idea, their views of academic discourse and production changes, and they no longer see them as residing in a repository of pure facts, but instead as competing arguments and interpretations that create new knowledge. Once understood, it becomes difficult to think of academic writing as anything other than discourse. It integrates several concepts students struggle with, including why and how they engage with scholarly sources, the importance of an original thesis, permission to disagree with their cited sources, and the purpose of scholarly citation. Finally, this knowledge is troublesome, mainly because it is never explicitly taught or explained to most students and to some may seem counterintuitive. Students may use scholarly sources because they are regarded as reliable, rather than to engage in scholarly conversation.

The use of the threshold concept theory in developing the *Framework* has been debated, with many questioning the value of threshold concepts (Townsend et al., 2015; Wilkinson, 2014). They are not universally accepted, and some consider them essentializing, unverifiable or even hedged to the point of incoherence. This criticism led to the de-emphasizing of threshold theory in the text of the *Framework*, and consequently the concepts are simply called frames (ACRL, 2015b). However they are described, it seems clear that the six concepts in the *Framework* stand on their own as core concepts and are useful organizing principles for information literacy instruction.

Intersections of the frames with art and design research

Scholarship as conversation

Scholarship is a discourse that involves evolving arguments, multiple perspectives, competing schools of thought, and differing interpretations. Novice learners tend to see scholarly sources as stand-alone, nearly infallible and useful by virtue of their authority. In order for learners to become more expert users of scholarly information, they need to understand that 'every scholar is working in a context, and is not the only voice of a discipline, a problem, or a question' (ACRL, 2015a). It is also important to understand that this occurs over long spans of time as scholars negotiate meaning through books, articles, reviews and presentations. Students who have not grasped this concept might take a single scholar's interpretation of an artwork as its one true meaning, as fact rather than merely argument, as a global perspective rather than a single data point in a large discourse. Instead researchers must seek out this conversation and discover its shape, path and history. Asking students to explore footnotes is one way to teach this concept. While students may see the purpose of footnotes as included simply to prove facts, they discover that citations can serve multiple purposes, such as locating works in their disciplines, refuting and arguing, extending and expanding. As they trace citations forward and back, students understand the conversations expressed in footnotes.

This concept can be extended to the visual arts by thinking of the importance of locating an artwork in the ongoing art world conversation. Students writing an artist's statement or undergoing a critique must be able to explain their work's location in ongoing developments and currents in art. They need to be able to explain how their work relates to and is influenced by past and present artists (Peterson, 2017). Garcia and Labatte discuss using this idea to make information literacy more relevant to artists, explaining that artists 'must identify their place in art history and ideology' (2015, 242).

Another key application of this frame is development of students' own voices as scholars and artists. Their essays or artworks will then be their entry into a conversation. Students may be anxious about interacting with established scholars and artists, but it is key that they recognize their work as part of a larger conversation and engage critically with the theories, ideas and arguments of others. Students who have grasped this concept participate in the conversation through an original argument expressed in an essay or artwork.

Research as inquiry

At its core this frame endorses research on unsolved problems or questions and encourages the researcher to contribute original ideas leading to new knowledge. Understanding this frame means moving from summarizing and reporting to analysing and arguing. This frame is often an unspoken expectation in college-level essays. While some students enter college with this understanding, others may not be as acculturated to the norms of academia. Leaving this as an implicit requirement only increases the advantage of privileged students. By making this expectation explicit, information literacy instruction can equalize imbalances in preparation and increase inclusivity.

As students work toward developing original inquiries within the context of a discipline, they gradually develop more complex research questions that create new knowledge. Art history students must learn how inquiry functions in the discipline. Those who have not yet grasped this concept might be researching a work of art, only to become frustrated that there is little to no secondary information on it. They have yet to learn that one of the main goals of research in a discipline is to explain unexplained art, to research context, genre, material, artist, style, period or production, and to make original connections to the specific work under study. This frame is closely tied to 'scholarship as conversation', as students need to understand that new knowledge in art history often comes in the form of a reinterpretation and argument for a different meaning.

In art and design disciplines this frame takes on an important new dimension. Our students are often practitioners who make objects. If they do not write typical research papers, what does research as inquiry mean for them? To understand this frame in such a context, we must see art and design as the results of research that can indeed express new knowledge and meaning (Sullivan, 2004). Logically, practice-based research is also a form of inquiry, one in which 'human understanding arises from a process of inquiry that involves creative action and critical reflection' (Sullivan, 2006). Art can express, embody, and encode new meanings and discoveries, though the path of inquiry is less linear and its means of expression more ambiguous. If we can teach artists and designers that the concept of research as inquiry applies to their work, information literacy becomes essential to the artistic process and enriches it.

Authority is constructed and contextual

This frame asks students to understand two important ideas that affect the concept of authority. The first is that authority is contextual: that depending on the question being asked the appropriate authority will differ. Whether a resource is the right fit depends on what the student's information needs are and in what context they will use this information. The art world contains many authorities from academics to critic, artists, curators and gallerists. Students need to learn whose authority is appropriate in different contexts and for different questions. An authority on one topic and in one situation is not necessarily an authority in another area or situation. For example, an auction house

or gallery might be an authority on the value of a work of art and its provenance but not on its meaning within the culture that created it.

The second idea is that authority is a culturally constructed phenomenon based on a society's knowledge practices and ways of knowing. At issue for art historians is the exclusive nature of scholarly authority, grounded in western ways of knowing, that keeps out knowledge from other cultures (Smith, 1999). This is especially problematic in a discipline that frequently studies the cultural and religious objects of other societies. For example, indigenous knowledge of the arts, often passed down through oral tradition and apprenticeships, is not accorded the same authority as a scholar's textual research on that culture's art. Frequently, indigenous voices are considered primary sources to be analysed as subjects. Alternatively, academic sources are secondary sources to be engaged with as an intellectual equal. The colonial nature of this relationship, in which non-Western societies provide the raw art objects and Western critics appropriate, interpret and give them authoritative meaning, is deeply problematic. To address this, librarians can use this frame to teach that while indigenous and academic authorities are the result of cultural ways of knowing, neither is inherently superior (Watkins, 2017). Rather the authority depends on context and questions the researcher has, so that in many cases indigenous sources are more reliable.

Information creation as a process

This frame assumes that the way research is created and presented determines what it can tell the researcher and avoids a strict hierarchy of sources. Students often have the mistaken impression, not infrequently from instructors, that only scholarly sources are good, while other sources are bad or biased. Rather, students should learn the strengths and weaknesses of source types and creation processes. The process of writing an article in *The New York Times* is different from the process of creating a scholarly article, but both are likely to be reputable and in depth. Understanding their different strengths and the processes that create them allow students to select the type of source most likely to match their information need. In art and design, students encounter various information creation processes, from those used to create art journals and fashion magazines to those that support exhibition and auction catalogues.

Students should consider creation processes, authors, audience and purpose when thinking about a source. For example, the journalistic approach found in magazines and newspapers informs a researcher effectively about the facts of an art event, while the analytical approach in a scholarly article may help interpret the meaning of that event. A trade magazine's audience of practitioners in the field may discuss materials and process. The currency and reporting purpose of art magazines, newspapers and blogs might make them the best source for contemporary artists or to situate their own work in the field. This frame is closely tied to 'Authority is constructed and contextual' because different groups most commonly use particular types of sources. We can help students determine

what each of these communities has to offer. For example, they may consult academics writing in scholarly books and journals for interpretations, critics writing in magazines and newspapers for aesthetic judgements, and curators writing in exhibition catalogues for relationships between objects and artists.

One interesting application of this principle is in images of works of art. Students need to think about how reproductions of artworks are created and manipulated. Images taken by a museum will have quality control processes in place to ensure they provide an accurate representation of the original, while other sources of images may have been cropped, recoloured or otherwise altered. When selecting an appropriate source for an image, students must consider their information need. In some cases, a quick Google image search will suffice. More likely students need reliable colour and cropping as well as good resolution and the ability to enlarge in order to conduct a thorough visual or iconographical analysis. Students may also need to see the artwork in person to understand its true visual impact, materiality and depth.

Searching as strategic exploration

This frame stresses the importance of understanding and using search tools strategically, while also acknowledging the serendipity and discovery so crucial to art and design research. Students who master this frame can select from a wide range of search strategies and match them with their information need and with the affordances of the resource, whether Google or a specialized academic tool. Students who have mastered this frame search iteratively, using their previous results and new knowledge to modify searches as they progress.

In art and design, the librarian's role is often to facilitate serendipitous discovery and bring rigour to student's natural exploration through concept mapping, browsing strategies, discovery tools and search refinement techniques. Peterson discusses the importance of exploration in allowing the research process to be infused with 'curiosity, creativity, and a sense of wonder' (2017). Concept mapping can be especially useful when working with art and design students, as their nebulous research interests cohere through the mapping process and connect to concrete topics like artists, styles or techniques. Working collaboratively to produce concept maps can help students identify new artists who work with related themes. Then the librarian can teach how to turn this wealth of terms into strategic searches. Students also benefit from reflecting on chance discoveries, for example thinking about why a book was in a specific spot or why one search brought up a certain result. Often by questioning these discoveries we learn about the organizational principles that underlie information seeking.

Information has value

This frame focuses on the idea that information has value, both to powerful interests that wish to maintain control over information and profit from its value, and to regular people

that leverage information for social change. That information has monetary value is often very clear to librarians in art and design. We provide our users with costly academic databases, professional resources like trend forecasts or market research reports, lavishly illustrated art books, and access to image databases. The challenge is in getting students to recognize this value. They may not realize that during their time in school they are members of one of the most information-privileged groups in the world. Most students have not considered that this access essentially disappears after they graduate. Students who think critically understand the information inequality inherent in our current information ecosystem and question the morality and sustainability of our current closed access academic publishing system. Understanding this frame also involves knowing that information has not only monetary value, but also social value. Art and design disciplines exemplify how information can be leveraged to effect change for social good. Students can use their access to information to inform the creation of activist art, interventions, posters or designs that solve problems and improve lives.

In art and design the value of information is especially relevant to the use and re-use of images, which clearly have value as they are sold and licensed. Often this value is protected by extended periods of copyright, but in other cases – such as images of public domain artwork – control is maintained by providing limited access to high-quality photography. The shrinking and privatization of our public domain heritage is an example of the influence of powerful interests and its direct effect on artists and designers.

But this frame can teach that artists also have power. Fair use protects their right to appropriate and remix images, allowing them to satirize, parody and critique, using existing images to explore new messages and themes. Indeed, whose work is appropriated and who does the appropriation often mirrors the race, gender and socio-economic hierarchies in our society. It is particularly important that art and design students grapple with the complexities of this frame in order for them to make informed and ethical use of images and information.

Conclusion

This chapter is a brief exploration of how the *Framework* can inform our information literacy teaching in art and design. These concepts can expand and elevate our disciplinary instruction. It is more important than ever that we work to create critical users and creators of information who can participate actively in their communities. We should work to create artists, designers and scholars who understand information systems and who can use their power to transform, advocate and create.

References

ACRL (2015a) *Framework for Information Literacy for Higher Education*, Association of College & Research Libraries, www.ala.org/acrl/standards/ilframework.

ACRL (2015b) *History of the Framework for Information Literacy for Higher Education*, Association of College & Research Libraries, http://acrl.ala.org/framework/?page_id=41.

Elmborg, J. (2006) Critical Information Literacy: implications for instructional practice, *Journal of Academic Librarianship*, **32** (2), 192–9. https://doi.org/10.1016/j.acalib.2005.12.004.

Foasberg, N. M. (2015) From Standards to Frameworks for IL: how the ACRL framework addresses critiques of the standards, *Portal: Libraries and the Academy*, **15** (4), 699–717.

Garcia, L. and Labatte, J. (2015) Threshold Concepts as Metaphors for the Creative Process: adapting the Framework for Information Literacy to studio art classes, *Art Documentation: Bulletin of the Art Libraries Society of North America*, **34** (2), 235–48.

Hinchliffe, L. J. and Saunders, L. (2015) Framing New Frames: expanding the conceptual space and boundaries, https://www.ideals.illinois.edu/handle/2142/88407.

Hofer, A. R., Brunetti, K. and Townsend, L. (2013) A Thresholds Concepts Approach to the Standards Revision, *Communications in Information Literacy*, **7** (2), 108–13.

Kuglitsch, R. Z. (2015) Teaching for Transfer: reconciling the Framework with disciplinary information literacy, *portal: libraries and the academy*, **15** (3), 457–70.

Meyer, J. and Land, R. (2003) *Threshold Concepts and Troublesome Knowledge: linkages to ways of thinking and practising within the disciplines*, University of Edinburgh, https://www.utwente.nl/ces/vop/archief_nicuwsbrief/afleveringen%20vanaf%20okt%202005/nieuwsbrief_17/land_paper.pdf.

Peterson, A. (2017) Mapping the Chaos: building a research practice with threshold concepts in studio art. In Godbey, S., Wainscott, S. and Goodman, X. (eds), *Disciplinary Applications of Information Literacy Threshold Concepts*, Association of College & Research Libraries.

Smith, L. T. (1999) *Decolonizing Methodologies: research and indigenous peoples*, Zed Books.

Sullivan, G. (2004) *Art Practice as Research: inquiry in the visual arts*, SAGE.

Sullivan, G. (2006) Research Acts in Art Practice, *Studies in Art Education*, **48** (1), 19–35, https://doi.org/10.2307/25475803.

Townsend, L., Lu, S., Hofer, A. R. and Brunetti, K. (2015) What's the Matter with Threshold Concepts?, http://acrlog.org/2015/01/30/whats-the-matter-with-threshold-concepts/.

Watkins, A. (2017) Teaching Inclusive Authorities: indigenous ways of knowing and the framework for information literacy in native art. In Godbey, S., Wainscott, S.

and Goodman, X. (eds), *Disciplinary Applications of Information Literacy Threshold Concepts*, Association of College & Research Libraries.

Wilkinson, L. (2014) The Problem with Threshold Concepts, https://senseandreference.wordpress.com/2014/06/19/the-problem-with-threshold-concepts/.

Chapter 16

Teaching by the book: art history pedagogy and special collections

Sandra Ludig Brooke

Introduction

We are now nearly two decades into the new century, and the digital revolution continues to accelerate. Big data, social media and virtual reality – these are just the latest phenomena to push the boundaries of library collections and services. Busy students with expectations of immediate, remote access to content can find the print-dependent art library anachronistic and frustrating. The concept of slow scholarship and the pedagogical strategies of 'deceleration, patience and immersive attention' are a hard sell when faculty must contend with large lecture courses and paper deadlines loom. As academic art libraries strive to be relevant in an increasingly digital world, it is worth reflecting on the character and usefulness of their least accessible yet most distinctive holdings – special collections. For meditations on slow learning and temporal intelligence in art history pedagogy, see Singerman (2016, 73–84) and Roberts (2013) respectively.

Scope and value of special collections

The term 'special collections' is inexact and is interpreted differently by individual libraries. Here it refers broadly to those materials afforded extra physical protection, usually through closed shelving, mediated handling and climate control. Although antiquarian books are a core component – so much so that 'special collections' and 'rare books' are often used interchangeably – it should be emphasized that many modern and non-codex materials are candidates. Criteria for special collections include rarity (survival in limited numbers), fragility (the need for special handling), vulnerability to mutilation and substantial market value. For an extended discussion of the policies and selection criteria used to identify special collections and rare books materials in art research libraries, see Rinaldo (2007).

An individual selection need meet only one of these criteria, and even libraries that supposedly do not collect rare books will find items in stacks or vertical files that merit

added protection. Examples commonly found in art libraries, beyond antiquarian books, are avant-garde journals, broadsides, contemporary artists' books, exhibition ephemera and fine facsimiles. Audiovisual materials are not addressed in this chapter although they are part of special collections in many art libraries and bring with them related security and preservation challenges. At colleges and universities where special collections are concentrated in a central rare books department, they are nonetheless a resource that will benefit from the art librarian's attention.

From an institutional perspective, there are essential values attached to special collections beyond market worth. The documentary significance of these materials is fundamental for research, and the display potential of rare books is prized in museums and libraries with exhibition space. For colleges and universities, they can also serve as potent instructional tools. Rare book curators and archivists continually seek new ways to engage students and persuade faculty to incorporate special collections into courses across the curriculum. Because art history is a peculiarly object-centric discourse, and the study of original works an intrinsic part of art historical training, it is a natural venue for teaching with special collections. For an overview of the contentious history, scope, and state of art history as a discipline, see Preziosi (2009, 7–11).

Faculty point of view

To test this assumption, several art history professors at Princeton University were invited to describe how they incorporate special collections into seminars, lectures and class assignments, and to reflect on what they hope students will take away from these experiences. Are special collections supplemental or central to their teaching, and what barriers prevent them from fully exploiting this resource? How would they compensate if teaching at an institution without such collections? What do they see as the role of digital surrogates, and what kind of digital projects could they envision creating for or with their students? While the group consulted is biased in that participants already use special collections for teaching, they do represent several generations of art historical training and specialize in a wide range of periods, media and cultures. They also employ different approaches and methodologies in their own research. What follows is a summary of their observations – some generally applicable to teaching in the humanities or with museum collections, others peculiar to rare books and art history pedagogy – plus some concluding thoughts for academic art librarians.

Materials and venues

Faculty employ a diversity of special collections materials for teaching. Deluxe to popular items from many periods and cultures are used to introduce not only art, but its transmission and reception, and the development of art history as a discipline. While a particular edition is sometimes essential for pedagogical purposes, faculty are often able

to make effective use of exemplars. Pictorial pieces, especially artists' presentations of their own work, are a core interest. Examples mentioned range from a folio of Piranesi etchings to some of Hanne Darboven's book works. Facsimiles of illuminated manuscripts and scrolls are critical for teaching Medieval and East Asian art. Faculty want to show students works that artists would have consulted – for example, a 17th-century japanning manual or an architectural model book. Items such as maps, early photographic magazines and even children's school primers are employed to place structures, imagery and ideas in historical context. Archival materials and ephemera are another rich resource, and items like mail art that 'fall between' document and artwork may frequently be found in libraries rather than museums.

Because of the impediments of class size, instructors are more inclined to incorporate rare book sessions at the graduate rather than the undergraduate level. Still, increasingly they look for ways to use special collections with undergraduates, including non-majors in introductory surveys. Professors sometimes prepare undergraduates by discussing a print or book from their own collection during a lecture and ask teaching assistants to follow up with tutorials in the rare book room. One professor worked with the library to display a fine facsimile in a large lecture hall and invited undergraduates to step forward at the end of class for a closer look. Graduate students are typically required to do preliminary readings for special collections seminars and are then challenged to examine the works displayed, ask informed questions, and make thoughtful observations. Since classroom handling is restricted to the instructor and library assistant, students are encouraged to follow up with an individual visit to the rare book room, perhaps in connection with a paper assignment.

Pedagogical goals

Several professors recalled their own transformative experiences encountering rare books and original manuscripts for the first time as students. Whether it was in a seminar, archive or a print dealer's shop display, they were inspired by the richness and vulnerability of the materials. As instructors, they believe working with originals is uniquely stimulating, and teaching with special collections is an opportunity to get art history students excited about the scholarly enterprise itself – the process of inquiry, discovery and insight.

When asked what they want students to take away from encounters with special collections, instructors have both concrete and abstract goals. They sometimes see rare books as comparable to museum pieces, but more often they regard the library's collections as different, although equally vital to art historical study. They return to the theme of engagement with original works and the need for this to happen as early as possible in an art history student's career. In contrast to literary and general historical studies, where modern editions and translations may be adequate for undergraduate learning, art historians want students to grasp from the outset that analysing and writing

about original objects is the crux of the discipline. The challenge of creating a research project by working outward from an original object is typically a new enterprise for students. Observing, describing and developing questions on which subsequent research is structured is quite different from starting with a broad theme and working back through the secondary literature. As one professor put it, class rare book consultations are a practicum for doing primary research.

The library is viewed as playing a complementary role to the art museum, which is an indispensable venue for introducing students to original works of art. Rare books tend to be more physically accessible than museum collections, even when museum pieces are in storage rather than on public display. There are practical advantages to having items that students can touch, manipulate and examine with a magnifying glass in full light. In a more oblique way, accessibility can help students overcome what some see as an obfuscating reverence for works of art – what one calls the 'halo effect' that museums tend to confer on objects. Handling special collections in the rare book reading room can help students move from a traditional view of artworks as 'objects of veneration' to one of artworks as 'objects of knowledge'. This conceptual leap can be a critical step in the development of new art scholars. Because libraries are more likely to hold compelling works by anonymous actors as well as major masters, they invite discovery and original analysis or, in the words of one professor, 'If you don't show students the little magazines as well as De Kooning, history will keep repeating itself.'

Professors are also adamant about communicating art's materiality. One describes encounters with special collections as fully sensual experiences that engage sight, touch and even smell. Special collections are valued for embodying the contingencies of history. Imperfections and interventions that might be veiled in a museum setting – abrasions, soiling, annotations – all bear witness to time's passage and close use by a thinking person. In the same way, the imminence of early books can collapse time, making the distant past present and engaging. As one professor observed, early modern books are the means for a New Yorker to access Renaissance buildings directly without travelling to Europe.

Analysis of physical properties

Professors emphasize repeatedly the idea of using special collections to teach what can be intuited from physical objects. Sophisticated observational skills are essential for art historians and are necessary to amend perceptions of art gained through slide presentations and illustrations in secondary literature. Through tactile scrutiny, students can assess such properties as size, weight, orientation and surface. Recognizing different production technologies, especially printmaking techniques and methods of photographic reproduction, is also a focus. Knowing what range of effects was available to artists opens up questions about which were chosen, and why. Materials and methods of construction provide clues to the circumstances of a work's creation. For example,

design students are led through a structural exploration of three editions of Alberti's *De re aedificatoria* and then asked to consider how the physical means of the books as objects affects the meaning of the text, and vice versa. Students of post-revolutionary Russia get a visceral sense of the modernists' situation when they see Malevich's and El Lissitzky's Suprematist philosophy embodied in a distinctly handmade lithographic pamphlet (Malevich, 1919) (Figure 16.1). Such lessons, learned in the rare book room, can be applied to the analysis of any work of art.

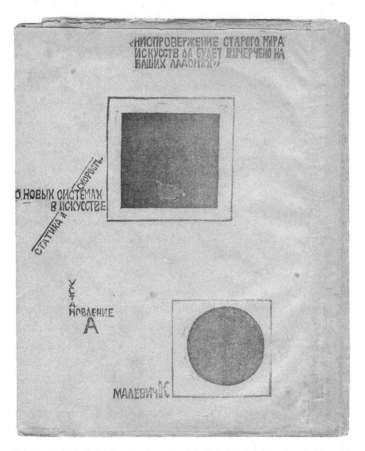

Figure 16.1 *Cover designed by Kazimir Malevich for his O novykh sistemakh v iskusstve.* Image courtesy of Marquand Library of Art and Archaeology, Princeton University

Books as cultural actors

Another recurring theme is fostering the understanding that books are a primary source of cultural and artistic exchange. Close encounters with significant or unusual exemplars

in a seminar or paper assignment can engender respect for the complex roles books play as cultural actors. A string of early editions manifests the truth that every 'primary source' has actually been through multiple intermediaries. With the breadth of examples in special collections, it can be easier to demonstrate artistic and intellectual networks – the truth that no work stands alone.

Professors observe that today's students, who are at ease navigating hypertext and working with packets of data and images, seem to find books ever more unusual (Grafton, 2009, 288–324). Yet the fact that students might experience difficulty contending with rare books – be they incunabula or artist-produced journals of the psychedelic era – is something instructors not only acknowledge but embrace. Moments of estrangement, puzzlement and being off balance are teaching opportunities; the attendant lessons may be straightforward or subtle. For example, students studying an original Renaissance treatise may be motivated to broaden and deepen their language skills. As they notice things like the small format, tight binding, inconsistent typography and lack of an index, they begin to comprehend the difficulty artists of the period would have had using such a book. Other insights – but probably not these – would come from reading the same text in a modern, translated, critical edition.

Recovering contexts

Attentiveness to images' aesthetics, historical development and meaning is another central concern of art history. Examining images within their historical context helps scholars move beyond their illustrative content. Many artworks appear bereft of context in museums, displaying few clues about their original situations. Although library collections are equally susceptible to displacement, books and related materials can carry within themselves a context for images. Emblem books, popular 19th-century news magazines and avant-garde photography books are just a few of the items instructors draw on for this purpose. Students are challenged to look at images in relation to text, other images and a piece's overall format. By unfurling a Chinese hand scroll, one sees how the artist conceptualized narrative so that the viewer both observes and experiences the passage of time. Guided reflection on a facsimile of the *Book of Kells* opens students to a new understanding of the manuscript as a relic and shrine – a sacred container and a holy space through which the reader moves. Special collections materials also embody artworks and buildings that have been altered, no longer exist or were meant to be ephemeral – from an 18th-century landscape garden, a Baroque festival (Gevaerts, 1641) (Figure 16.2 opposite) or a Gilbert and George performance.

Professors use special collections to bring forward art historical concerns about audience, reception and the dissemination of ideas. Students compare plain and luxury editions of an early modern book, and this leads to a discussion about art patronage that resonates with painting production during the same period. Two early illustrated guides to French antiquities – one a scholarly text with elaborate pictorial reconstructions, the

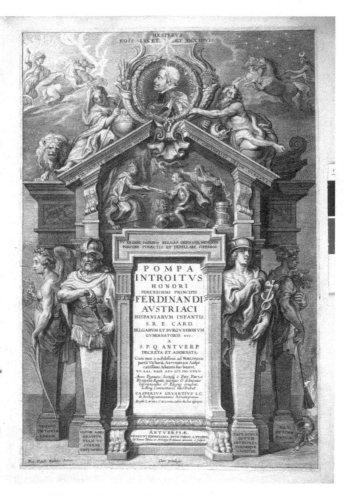

Figure 16.2 *Title page designed by Peter Paul Rubens for Jean-Gaspard Gevaerts's* Pompa introitus. Image courtesy of Marquand Library of Art and Archaeology, Princeton University

other a wistful reflection in sonnet form – epitomize evolving responses to the Roman past (Guis, 1665; Valette de Travessac, 1750) (Figures 16.3 and 16.4 on the next page). Items of any vintage with marks of ownership and use – an annotated treatise, a well worn carpenter's handbook, an issue of an avant-garde journal in its original mailing wrapper – introduce provenance studies and network analysis. Students can be astonished to see the ephemeral become monumental. For example, a popular, early guidebook to the courtesan district of Edo stands today as a landmark – and exquisitely rare survival – of Japanese printmaking (*Yoshiwara makura-e*, 1660) (Figure 16.5, page 165). A modest, staple-bound photo book that was distributed in only a few copies to mourners at Francesca Woodman's 1981 funeral is now a touchstone for the artist's brilliant but tragically brief career.

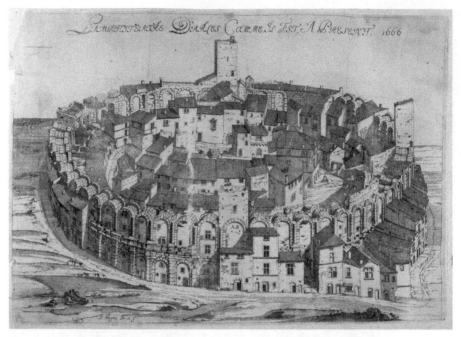

Figure 16.3 *The amphitheatre at Arles as it appeared in 1666, from Joseph Guis's* Description des arènes. Image courtesy of Marquand Library of Art and Archaeology, Princeton University

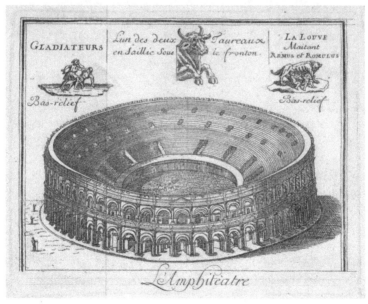

Figure 16.4 *The amphitheatre at Nimes from Valette de Travessac's* Sonnets sur les antiquités. Image courtesy of Marquand Library of Art and Archaeology, Princeton University

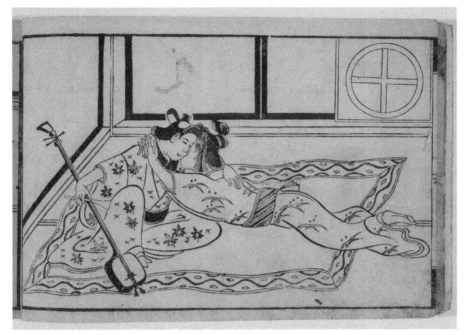

Figure 16.5 *Courtesan and client by the Kanbun Master from* Yoshiwara makura-e.
Image courtesy of Marquand Library of Art and Archaeology, Princeton
University

Access and digital surrogates

Special collections are integral – not supplemental – to the teaching of professors of art history. While quick to recognize the validity of other pedagogical approaches, lack of access to rare books would for them be a serious impediment. When teaching at a school without such resources, their preferred remedy is to arrange class trips to an off-campus rare book library. They also turn to personal collections, ordinary reprints and digital collections. A question about the proper role of digital surrogates drew mixed responses. In some subject areas, mass scanning projects and documentary databases provide valuable raw material for research. Round-the-clock remote access makes digital surrogates a good mnemonic and discovery tool, useful for research and class preparation. Instructors also mention imaginative uses of computer imaging for textual study and visual pattern analysis. Those who have contributed to digital humanities projects, or created digital teaching objects, look forward to enhanced computer display techniques that will capture more of an object's physical presence and allow for more life-like manipulation. Some envision collaborating with students to create digital projects that are more than presentational, incorporating geographic information systems mapping, multimedia and translation tools to provoke discovery and new insights. As a pedagogical tool, digital surrogates are valued chiefly for their potential to pique students' curiosity,

provide leads for their research and inspire them to return to original works in special collections or the museum.

Strategies for art librarians

These professors make a credible case for the unique role of special collections in art history pedagogy. With many competing priorities, academic libraries must always be discerning about how they deploy space, staff and acquisitions funds. If persuaded of the core teaching value of special collections, what steps can art librarians take to ensure such materials are available and used to best advantage?

Whether their schools have deep or limited special collections, art librarians should partner with faculty to develop desiderata and advocate for purchases and gifts that support art history courses. Even with limited funds, the library can build a creditable teaching collection by making choice and targeted additions. While incunabula may be out of reach, pertinent items like artist's book multiples can be purchased at a reasonable cost. Some desirable antiquarian books are also within reach. As has been observed, powerful teaching exemplars are not necessarily the finest collector's editions. To supplement in-house collections, art librarians should apprise themselves of nearby, complementary collections and build bridges with those institutions for their faculty and students. Conversely, caretakers of important collections should accommodate classes from other institutions whenever possible.

Art librarians should use the library's catalogue, finding aids and digital projects to draw attention to local resources. Full and accurate cataloguing for unusual items, augmented perhaps with scans of inscriptions and other unique features, will increase the likelihood of discovery. If the online catalogue does not already facilitate browsing by location, alternate mechanisms for browsing closed stacks virtually should be created. Provision of staff attendants and suitable classroom space for rare book consultations should be a priority, and creative ways should be sought to bring together items from across campus for seminars. Through reference consultations, book lists and show-and-tell sessions, librarians can promote hidden special collections. New and visiting faculty should be approached about teaching materials pertinent to their courses. Physical and online exhibits are another way of eliciting interest, especially when students and instructors act as curators. Opportunities to create digital teaching tools or rare book data sets in partnership with faculty, students, digital humanities specialists and educational technologists allow for new insights to special collections.

Academic art libraries can cultivate special collections without apology. Rare books are not a luxury, but a remarkable pedagogical tool. As one Princeton professor summed it up, 'The aha moments almost never happen in a lecture hall, but before an object. It's the best way to teach.' With effort and imagination, these distinctive library collections will continue to shape future generations of art historians.

References

Gevaerts, J. (1641) *Pompa introitus honori Serenissimi Principis Ferdinandi Austriaci Hispaniarum Infantis*, Ioannes Meursius.

Grafton, A. (2009) Codex in Crisis: the book dematerializes. In *Worlds Made by Words: scholarship and community in the modern west*, Harvard University Press.

Guis, J. (1665) *Description des arènes ou de l'amphithéâtre d'Arles*, F. Mesnier.

Malevich, K. (1919) *O novykh sistemakh v iskusstve, statika I skorost' [On New Systems in Art: static and speed]*, Vitebsk.

Preziosi, D. (2009) Art History: making the visible legible. In Preziosi, D. (ed.), *The Art of Art History: a critical anthology*, Oxford University Press.

Rinaldo, K. (2007) Evaluating the Future: special collections in art libraries, *Art Documentation*, **26** (2), 38–47.

Roberts, J. (2013) The Power of Patience: teaching students the value of deceleration and immersive attention, *Harvard Magazine*, November–December, http://harvardmagazine.com/2013/11/the-power-of-patience.

Singerman, H. (2016) Old Divisions and the New Art History. In Breslin, D. and English, D. (eds), *Art History and Emergency: crises in the visual arts and humanities*, Yale University Press.

Valette de Travessac, A. (1750) *Sonnets sur les antiquités de la ville de Nismes.*

Yoshiwara makura-e [Pillow Pictures of Yoshiwara] (1660) Edo.

Acknowledgements

Grateful acknowledgement is made to the following current and former Princeton University professors who generously shared their time and insights for this project: Esther da Costa Meyer, Rachael Z. DeLue, Brigid Doherty, Christopher P. Heuer, Thomas DaCosta Kaufmann, Beatrice Kitzinger, Anne McCauley, John Pinto, Irene Small, Andrew Watsky, Carolyn Yerkes and Nino Zchomelidse. Thanks are also owed to Kim Wishart who gave the graduate preceptor's point of view.

Chapter 17

Metaliteracy in art and design education: implications for library instruction

Leo Appleton

The concept of metaliteracy

The term 'metaliteracy' is still a relatively new concept since being introduced into the library and information science literature as a 'framework that integrates emerging technologies and unifies multiple literacy types' (Jacobsen and Mackey, 2011, 62). It is therefore still a fairly recent addition to the parlance surrounding library instruction and teaching and learning practice, which this chapter will attempt to expand on. In the first edition of this handbook, there was no corresponding chapter; instead, there was a comprehensive 'teaching and learning' section with chapters covering themes such as visual literacy (Gluibizzi, 2010), embedding information literacy (Mayer, 2010), and using image databases (Roberto and Robinson, 2010). The inclusion of such chapters suggests that as a profession we were still in the habit of regarding individual literacies and talking about them as a group of literacies. However, a later chapter discussed how multiple literacies are best served in the art and design library and how librarians need to accommodate how visual and kinaesthetic learners access, organize and use information (Wilson and McCarthy, 2010).

At the heart of metaliteracy in an art and design context is the acknowledgement that art and design students learn 'differently' and that subsequently, this difference needs to be considered when developing information literacy instruction. Writing in 2008, Halverson suggested that there 'were few, if any, existing formulas in place to create information literacy programmes that adequately address the particular and idiosyncratic needs of arts students' (2008, 34). While there has been much discussion and development within the area of information literacy for art and design students since 2008, there remains a need to acknowledge the 'difference' and to establish learning frameworks accordingly. Greer (2015) considers the notion of art itself within an information literacy context and in doing so reflects on the artistic practices of 'creating meaning from personal experience; forging connections with larger concepts and cultural references; and encouraging the practice of self-reflection' (84).

Metaliteracy models

Within this information literacy context, metaliteracy models lend themselves to arts education and learning, but before expanding on this, it is first useful to identify which component parts go into such a model. In proposing their metaliteracy model to redefine information literacy, Jacobson and Mackey 'envisage a comprehensive model for information literacy to advance critical thinking and reflection in social media, open learning settings and online communities' (2014, 84). Indeed it was the need to demonstrate a different type of information literacy within participatory digital and networked environments which led Jacobson and Mackey to form and develop metaliteracy, in order to address the gaps in existing information literacy models. Further, social media provided the catalyst for addressing this and developing further understanding of the 'complex relationships between researchers, information tools and agency in and through the research process' (2016, 3).

Literacies such as visual literacy, media literacy, computer literacy and network literacy are all implicit in information literacy in the networked age and have been identified as such for some time (Jacobson and Mackey, 2014, 2–3). The link between these related literacies and the influence that technology has had on information literacy practice is very much accepted, and this broader understanding of how students search for and process information within the networked environment is now regarded as metaliteracy in its embrace of a range of other literacies. Within some of the literature it is easy to confuse the term 'metaliteracy' with 'multiliteracy', and in effect the two are linked. However, by definition, 'meta' implies something that is 'referring to itself' or is 'self-referential' (OED, 2017). Jacobson and Mackey define metaliteracy as requiring 'individuals to understand their existing literacy strengths and areas for improvement and being able to make decisions about their learning' (2014, 2), while 'multiliteracy' concerns itself with the 'interconnections of multiple literacies', which involves 'a higher level of cognitive and linguistic capabilities and critical thinking than does focusing on a single approach' (2014, 16). These definitions therefore suggest that a certain level of metaliteracy is required in order to engage in multiliteracies.

The multiliteracies in question for art and design students are numerous and are often discussed and analysed as individual literacies, or within a more holistic information literacy landscape. For example, Daley (2003) recognizes visual literacy, communication literacy and media literacy as resonating with art and design disciplines, with particular attention on media literacy as it addresses a wide variety of formats and media including images and sound. Being able to process information in different formats helps students create meaning, and media literacy often sits within the broader multimedia learning theory, based on the assumptions that there are two separate channels for processing information (auditory and visual) and that learning is an active process of filtering, selecting, organizing and interpreting this information (Mayer, 2009). The cognitive theories associated with metaliteracy and the individual constituent literacies are widely

discussed and provide much of the discourse around the changing information literacy landscape in arts education. For example Beatty (2013) details the cognitive theories that sit behind visual literacy and in doing so combines them with the *ACRL Visual Literacies Standards for Higher Education* (ACRL, 2011), which have become an essential instrument in arts librarians' understanding and teaching of visual literacy in recent years.

Other literacies of particular significance to the art and design environment in that they complement the multimedia elements of sound and vision are object- and artefact-based literacies. 'Objects can be employed in a variety of ways to enhance and disseminate subject-specific knowledge, to facilitate the acquisition of communication, collaboration, practical observation, drawing skills and inspiration' (Chaterjee, 2010, 180). Object-based learning encourages analysis and critical reflection as students are encouraged to read meaning and text within objects and discuss how they can be interpreted. Such activity not only tests students' visual literacy but also incorporates sensory elements, such as touch, as students explore how objects relate to them (Hardie, 2015). The impact of tactile learning, haptics (grasping hold of things physically as well as figuratively, rather than simply touching) and somatic and sensory learning are all key attributes of object-based learning (Chaterjee, 2008). They subsequently require a high degree of metaliteracy from participating students.

Historically, however, the rise of digital and networked information led to a different understanding of critical information skills and the cognitive behaviours behind them. Godwin (2008, 3–5) attests that the rise of social media and Web 2.0 technologies at the start of the 21st century transformed the information landscape as exposure to these technologies revolutionized how people find, access and use information. In effect this also fundamentally changed how librarians needed to approach the teaching of information literacy. In their book *Information Literacy in the Digital Age*, Welsh and Wright (2010) suggest that information literacy should now be considered a liberal art which extends from knowing how to use computers and to access information to being able to reflect critically on the nature of information, including its technical infrastructure and its social, cultural and philosophical context (3).

Significantly, media literacy addresses the idea of the learner as a producer of information and content, a characteristic which comes through strongly in much of the discussion around metaliteracy. In discussing digital literacies around social media and Web 2.0, Godwin (2008) and Welsh and Wright (2010) identify how user-generated content and information is at the heart of Web 2.0 and therefore completely changes users' understanding of information literacy.

As has been established in this section, the meta-perspective is distinct from acknowledging multiple literacies (although the two are linked). In establishing their metaliteracy model, Jacobson and Mackey illustrate how the 21st century learning environments are social, multimodal, interactive and open, requiring an integration of visual, textual, aural, media, digital and collaborative competencies. It is therefore essential that the fundamental elements of information literacy (determining, accessing

evaluating, incorporating, using and understanding information) are acknowledged within the literacy types which are now recognized within a metaliteracy framework: visual literacy, media literacy, digital literacy and cultural literacy (2013, 85).

What does metaliteracy mean for learning?

Metaliteracy provides an overarching framework that builds on the core information literacy competencies while addressing the revolutionary changes in how learners communicate, create and distribute information in participatory environments. Central to the metaliteracy model is a metacognitive component that encourages learners to reflect continuously on their own thinking and literacy development in these fluid and networked spaces (Jacobson and Mackey, 2013, 84). While the focus of this chapter is not on learning theories, it is difficult to discuss metaliteracy without acknowledging some theoretical frameworks that pertain to it. As already discussed, metaliteracy places an emphasis on technology, networked information and multiple literacies, culminating in knowledge acquisition instead of just skills development. Metaliteracy therefore requires a high level of understanding of one's own knowledge and cognitive abilities. This is metacognition, which Hartman (2002) argues 'is generally defined as cognition about cognition, or thinking about one's own thinking, including both the processes and the products', which in turn has a significant impact on 'acquisition, comprehension, retention and application of what is learned, in addition to affecting learning efficiency, critical thinking and problem solving (Hartman, 2002, xi).

Fundamentally, metaliteracy requires an understanding of one's own literacies and how they interlink, and in doing so acknowledges the existence of multiliteracies. Metaliterate individuals demonstrate metacognition in how they critique, analyse and read meaning into sources. The complexity of applying this understanding of one's own learning and thinking processes and interrelated competencies is presented by Gardner (1983) in his theory of multiple intelligences, which differentiates intelligence into specific 'modalities' rather than seeing intelligence as dominated by a single general ability. Gardner identifies the following different intelligences: musical-rhythmic, visual-spatial, verbal-linguistic, logical-mathematical, bodily-kinaesthetic, interpersonal, intrapersonal and naturalistic. He opposes the idea of labelling learners to a specific intelligence but maintains that his theory of multiple intelligences should empower learners and not restrict them to one modality of learning (McKenzie, 2005).

Applying metacognition and multiple intelligence theories to metaliteracy practices helps us better understand metaliteracy and what it means for learning, and in effect this is a continuation of the existing discussions around information literacy and learning styles theories. Discussing this in relation to information literacy instruction, Blanchett, Powis and Webb (2012, 19) suggest that learning styles theories are linked to discussions of personality and individual difference, including theories of multiple intelligence. They also highlight that critics of learning styles theory suggest there is limited evidence of

their actual impact on teaching and learning. Such a stance is difficult to justify in an arts education environment where visual and kinaesthetic learning styles have proved to be dominant and, along with the theories of metacognition and multiple intelligences, learning styles need to be accommodated when developing the metaliterate learner. This is even more the case in the arts, and while it is important not to stereotype arts students and practitioners to these specific learning styles, there is evidence to suggest that they need to be taken into account.

To consider fully what metaliteracy means for learning in an art and design environment, it is useful to look at discussion of how it is taught. Elkins (2001) points out that there is a long history within western thought, stretching back as far Plato and Aristotle, that contends art cannot be 'taught' at all. He identifies four things that can be taught in art classrooms, including art criticism and theory, professional skills, and visual acuity and technique, but he also highlights that these fall short of expressing either what actually happens in art instruction or what is deemed most important.

In a study looking specifically into art and design teaching, data was collated from a series of interviews with tutors across four subject areas to identify a set of 'signature pedagogies' associated with art and design education (Shreeves, Sims and Trowler, 2010). Using Shulman's definition, signature pedagogies describe the fundamental ways in which future practitioners are educated across three dimensions: operational acts of teaching, assumptions about best ways of imparting knowledge and know-how, and underlying beliefs about attitudes, values and dispositions (Shulman, 2005). In their study, Shreeves and colleagues identified the following key aspects of art and design teaching and learning:

- Learning has a material and physical dimension, requiring engagement with material and development of ideas through media such as sketchbooks or performance, and also 'whole person' engagement including mind, emotions and senses.
- Learning involves living with uncertainty and unknown outcomes and is challenging to students and sometimes to tutors who have to support their uncertainty.
- Learning has a visible dimension and its products exist as artefacts and are often open to public scrutiny, which enables dialogue about the learning process.
- Aspects of learning take into account the audience, and the creation and performance of work is carried out with an audience in mind.
- The intention is to develop independent creative practitioners, and the tutor's role is to foster individuals who understand where they and their work fits within a practice.
- Learning is fundamentally social in that practice is visible and discussed.
- Process is important and developmental, and student and tutor interaction often centres on work in progress.

These features of art and design teaching and learning validate the requirements for art and design students to demonstrate high levels of metaliteracy in order to navigate through their varied learning environments and understand how their learning is working and evolving.

Teaching and learning in art and design is ultimately about supporting students to find their own way to be an artist or designer. Similarly, students' understanding of how they themselves learn feeds into this. Winters introduces the concept of 'meta-learning' (learning about learning) and 'how it can be used to make subject characteristics and expectations of the art and design teaching and learning context more explicit to students' (2011, 91). Meta-learning is concerned with developing an awareness of oneself as a learner and using this knowledge to improve as a learner. This is in keeping with the features identified above by Shreeves and colleagues and reinforces how metaliteracy enables art and design students to develop as independent, critical, creative, reflective and connected metacognitive learners.

What does metaliteracy mean for art and design librarians?

'Expert teaching includes mastery over a variety of teaching techniques, but unless learning takes place, they are irrelevant' (Biggs and Tang, 2011, 20). It is essential, therefore that art and design librarians understand how their students learn, how metaliteracy and meta-learning impact on their learning, and how to adapt their own teaching practices to accommodate this. There is an evolving concept of the information literacy landscape, as introduced by Lloyd (2010). This helps to frame how librarians might approach their library instruction and information literacy teaching in the digital and metaliterate age, which can be particularly helpful to art and design librarians. Secker and Coonan (2013) discuss the different strands that make up A New Curriculum for Information Literacy (ANCIL) and cover the development of academic literacies in students and mapping and evaluating the information landscapes. ANCIL involves developing a reflective learning framework for students, and it is reflection on the multimodal elements of their learning that requires art and design students to develop metaliteracy skills.

Art and design librarians now need to immerse themselves in the application of metaliteracy within the very broadest of information literacy frameworks. Lloyd suggests that 'the focus is not only on text, but also on visual, audio, spatial and electronic mediums . . . and this has challenged the autonomous and technical views of literacy' (2010, 14). The librarian must take into account the multimodality of information and how students make meaning from different sources through their reflection. Rockenbach and Fabian describe how this participatory and interactive learning 'forces information professionals to rethink their role in the flow of information and suggests responsibility for nurturing a new range of skills and literacies such as higher level critical thinking skills, problem-based enquiry and visual literacy' (2008, 28).

In brief, art and design librarians need to approach metaliteracy in the same way in which any arts educators would. 'Using a broad range of exploratory, connective and experimental modes in a continuous process of finding out, trying out and evaluating is a central component in studio teaching and learning and echoes the nature of art and design as a field, where no fixed methodology for inquiry exists' (Winters, 2011, 93). Librarians must adopt the same flexibility and approach to their teaching, ensuring that the focus is on students' experimenting, discovering meaning and reflecting in order for learning to take place.

The critical thinking, reflective and communication skills associated with metaliteracy have led to an environment in which librarians are now encouraged to share successes in visual literacy and digital literacy strategies, collaboration models, object-based teaching practices, creative approaches to information literacy and professional development opportunities in general.

Conclusion

This chapter has introduced the concept of metaliteracy in an information literacy landscape framework and alongside a number of learning theories. Being able to understand one's own literacies and learning practices is essential for art and design educators and students. In embracing arts education, art and design librarians must fully exploit their position of being at the heart of student learning and ensure that the needs and requirements of their highly metaliterate students are accommodated and considered at all stages of their interaction with library services, support and resources. This is particularly important in the development and design of teaching and instruction sessions as metaliteracy becomes increasingly dominant within the information literacy landscape.

References

ACRL (2011) *Visual Literacy Competency Standards for Higher Education*, Association of College & Research Libraries, www.ala.org/acrl/standards/visualliteracy/.

Beatty, N. (2013) Cognitive Visual Literacy: from theories and competencies to pedagogy, *Art Documentation*, **32**, Spring, 33–42.

Biggs, J. and Tang, C. (2011) *Teaching for Quality Learning at University: what the student does*, 4th edn, Society of Research into Higher Education.

Blanchett, H., Powis, C. and Webb, J. (2012) *A Guide to Teaching Information Literacy: 101 practical tips*, Facet Publishing.

Chaterjee, H. (2010) Object-Based Learning in Higher Education: the pedagogical power of museums, *University Museums and Collections Journal*, **3**, 179–81, http://edoc.huberlin.de/umacj/2010/chaterjee-179/PDF/chaterjee.pdf.

Chaterjee, H. (ed.) (2008) *Touch in Museums: policy and practice in object handling*, Berg.

Daley, E. (2003) Expanding the Concept of Literacy, *Educause Review*, March/April 33–40.

Elkins, J. (2001) *Why Art Cannot Be Taught*, University of Illinois Press.

Gardner, H. (1983) *Frames of Mind: the theory of multiple intelligences*, Basic Books.

Gluibizzi, A. (2010) Visual Literacy for Highly Literate Viewers. In Glassman, P. and Gluibizzi, A. (eds), *The Handbook of Art and Design Librarianship*, Facet Publishing.

Godwin, P. (2008) Introduction: making the connections. In Godwin, P. and Parker, J. (eds), *Information Literacy Meets Library 2.0*, Facet Publishing.

Greer, K. (2015) Connecting Inspiration with Information: studio art students and information literacy instruction, *Communications in Information Literacy*, **9** (1), 83–94.

Halverson, A. (2008) Confronting Information Literacy in an Academic Arts Library, *Art Documentation*, **27** (2), 34–8.

Hardie, K. (2015) *Wow: the power of objects in object based learning and teaching*, Higher Education Academy.

Hartman, H. (ed.) (2002) *Metacognition in Learning and Instruction: theory, research and practice*, Kluwer.

Jacobson, T. and Mackey, T. (2011) Reframing Information Literacy as Information Literacy, *College and Research Libraries*, **72** (1), 62–78.

Jacobson, T. and Mackey, T. (2013) Proposing a Metaliteracy Model to Redefine Information Literacy, *Communications in Information Literacy*, **7** (2), 84–91.

Jacobson, T. and Mackey, T. (2014) *Metaliteracy: reinventing information literacy to empower learners*, Facet Publishing.

Jacobson, T. and Mackey, T. (eds) (2016) *Metaliteracy in Practice*, Facet Publishing.

Lloyd, A. (2010) *Information Literacy Landscapes: information literacy in education, workplace and everyday contexts*, Chandos.

Mayer, J. (2010) Embedding Information Literacy into a Studio Art Course. In Gluibizzi, A. and Glassman, P. (eds), *The Handbook of Art and Design Librarianship*, Facet Publishing.

Mayer, R. E. (2009) *Multimedia Learning Theory*, Cambridge University Press.

McKenzie, W. (2005) *Multiple Intelligences and Instructional Technology*, International Society for Technology Education.

OED (2017) Meta, Oxford English Dictionary Online, https://en.oxforddictionaries.com/definition/meta.

Roberto, R. and Robinson, R. (2010) Incorporating Image Databases into Teaching and Learning. In Gluibizzi, A. and Glassman, P. (eds), *The Handbook of Art and Design Librarianship*, Facet Publishing.

Rockenbach, B. and Fabian, C. (2008) Visual Literacy in the Age of Participation, *Art Documentation*, **27** (2), 26–31.

Secker, J. and Coonan, E. (eds) (2013) *Rethinking Information Literacy: a practical framework for supporting learning*, Facet Publishing.

Shreeves, A., Sims, E. and Trowler, P. (2010) 'A Kind of Exchange': learning from art and design teaching, *Higher Education Research & Development*, **29** (2), 125–38.

Shulman, L. (2005) Pedagogies of Uncertainty, *Liberal Education*, **91** (2), 18–25.

Welsh, T. and Wright, M. (2010) *Information Literacy in the Digital Age: an evidence-based approach*, Chandos.

Wilson, H. and McCarthy, L. (2010) Touch, See, Find: serving multiple literacies in the art and design library. In Gluibizzi, A. and Glassman, P. (eds), *The Handbook of Art and Design Librarianship*, Facet Publishing.

Winters, T. (2011) Facilitating Meta-learning in Art and Design Education, *International Journal of Art and Design Education*, **30** (1), 90–101.

Chapter 18

The art of evidence: a method for instructing students in art history research

Catherine Haras

Introduction and rationale

Within various disciplines, contextual sources such as history, theory and criticism are used to support knowledge claims. However, the discipline of art history assigns the undergraduate a particular challenge with regard to secondary source use. There is specific information that must be closely read and decoded before it can be researched and interpreted – the work itself. 'Reading' an artwork requires an entirely different type of literacy, one that is non-textual. Images use a unique syntax (Dondis, 1973; Yenawine, 2014). Art has its own grammar and demands visual literacy – the ability to observe, negotiate and interpret images (Yenawine, 2014). Visual literacy must be learned (Avgerinou and Ericson, 1997; Sinatra, 1986), and learning to see is itself an art (Berger, 1977; Taylor, 1981). Visual literacy is also important for learning: it develops metacognition (Perkins, 1994; Sinatra, 1986) – the awareness of one's own thinking, a precondition for achieving expertise (Zimmerman, 1990).

We live in a visual world. While visual literacy has come to be associated with an almost overwhelming set of skills and abilities (ACRL, 2011; Avgerinou and Pettersson, 2011; Bamford, 2003; Hattwig et al., 2013), there are several statements we can make with regard to teaching and learning them. Visual analysis is an active social process (Bruner, 1989), iterative (Housen, 2001) and takes time (Acton, 1997). This chapter argues that visual literacy may begin simply with the act of observation.

Problems arise, however, when untutored viewing meets an almost oppressive body of art historical scholarship. On the one hand, the student should come to a work with a fresh eye (observation); on the other, the student must acknowledge precedent in secondary sources (research). If curiosity is lacking, the student will be overwhelmed by and disengaged from information when it is time to do the research. Lack of curiosity may be a function of assignment design. Any assignment that minimizes the discovery process yet demands second source treatment risks failure. It is tempting for students to plagiarize meaning when research outcomes are sketchy. A student may glance at the art object,

skim an art book that tells who the artist is or was, what the artist intended based on his or her political views, or what colours mean, all without making essential connections. The product of such an assignment is the typical student essay that cannot address with authenticity the important questions the art object raises. The student remains unengaged with the process.

Visual responses deepen when a student repeatedly encounters a work of art (Hubbard, 2006). These informal observations can inform research discovery powerfully. This chapter discusses a unique method of engaging undergraduates in a series of guided research steps, and these enlighten student observations of an artwork. In teaching students art history, often formal analyses and theory or criticism are either/or approaches. Here, observation and research occur in tandem and report to each other. Librarians focus the search process within the observation process. Students are able to practise their observation skills by returning to the work. Contextual information is employed as a kind of codebook, teaching students how to read and confirm visual information. The student's relation to the work deeply matters. The disciplinary treatment fortifies and eventually objectifies the emotional response to a work. The quality of student observations should deepen progressively, as these are reinforced or challenged by history and criticism, giving students pause for reflection. This approach trains students to become art detectives, locating visual clues (evidence), decoding them (secondary sources), making statements about purpose and functionality, and then reflecting on the process. At heart it is a metacognitive activity, using guided discovery to challenge and encourage students to think about what and how they see.

This method is written to the instructor but intended for the librarian – and art librarians can and should advocate for research pedagogy and collaborate in developing research agendas for library-dependent art curricula. It is the librarian's responsibility to negotiate the process. The author, a librarian who leads a university teaching and learning centre, has used this design in a course, as well as in collaboration with instructors in various settings. An art museum, a community college, and a master's-degree-granting university have all used it. This approach does not demand a robust library, but it does make good use of the library.

Redefining the art history assignment

Designing an assignment with research in mind

Librarians can offer consultation or collaborate designing any project that involves research, as they are expertly familiar with their collections as well as with the information-seeking process.

Successful art history assignments have less to do with analysing specific artworks and the scholarship behind them than with guiding an unfolding process. The instructor's main concern is to structure the assignment, including its research activity, so as to be meaningful to the student (Freedman, 2003; Hubbard, 2006). This process is time-

intensive. The instructor should specify research objectives and be prepared to devote time to teaching them or having a librarian teach them. The quality of the research should be graded with a writing rubric. Interestingly, if students maintain a research journal, they need not write a paper. If the course instructor is agreeable, librarians might consider offering their services (or devise a rubric) to evaluate the quality of the research component of the assignment.

It is the author's experience that the project works best if students are responsible for portions of the assignment incrementally. Scaffolding, or breaking the assignment into manageable portions so that student work is authentic, best accomplishes this. It helps to make several parts of the project due at regular intervals so that students do not rush to complete the project at once. For example, the observation journal entries might be due weekly, and the entire journal along with a paper (if assigned) toward the end of the term. Students should have to justify their use of secondary sources. Students also should take clues away from course readings and lectures, which might be themed to give context to the art selected. Students should spend at least one class session in the library. The librarian could be available to students as a consultant in the process.

In the assignment the student is asked to analyse a single work of art in depth. Students will observe the work in sequential visits. They should initially describe what they see, then use their observations to make inferences from initial viewings (what they think they see). The student's own ideas and reactions to the piece are key to eventual discovery of appropriate contextual information as this creates intrinsic interest. Next, the student should ask questions based on what is observed about the piece but not yet understood.

Any lingering questions students have will demand art historical treatment. Research prompts should invite relevant searches for appropriate sources, and even these can be scaffolded so students gradually define their research needs. Questions will require contextual sources and a library to answer these, so that the treatment of the object is finally scholastic. The sequence of practised observation, collection of evidence, and reference to scholarly sources should be repeated until an individualized analysis emerges. This evolution will be reflected in the journal if followed correctly.

Librarians can influence the ways the art historian frames a research assignment. What should an assignment involving the library achieve? Ways of thinking about art and ways of thinking about search and discovery are not always congruent. Foremost should be the development of critical thinking in students. Since discovery is also an iterative process, librarians can help create a transparent assignment with attention to the quality of questions they ask of students and when they ask them.

A good assignment ultimately asks students to reflect on the process itself:

- 'How does the work function?'
- 'How does the piece act on its viewer—you?' or 'What are you supposed to understand or believe based on this piece?'

- 'What did the painter intend to depict?' and 'Does this resonate with your experience being near it?'
- 'What is your relationship to this work now that you have spent time observing and researching the piece?'

For upper-division students, challenging questions can help a student address meaning by analysing the piece in its former and current spaces:

- 'Where did the artist originally conceive placement?' and 'Was the art installed in a public or private space?'
- 'What is the original purpose of the piece based on the space?'
- 'How would the original installation act on a viewer of its time?'
- 'How does the piece act in its current space?' and 'What has changed with the space?'

The journal need not be long. In previous versions of the assignment, students have turned in work from 5 to 15 pages long. The point is to record changing responses to art and to the meaning of an artwork as influenced by repeated viewings and information seeking. The result should be an intensely personal document reflecting changed points of view.

The work to be observed

To begin to answer these questions, students must first meet the work. Students are learning to 'activate' the object in their own ways. Instructors should choose carefully the types of art their students may select in anticipation of student ability, since aesthetic development occurs in predictable patterns (Housen, 2001). The choice of art has an impact on impact secondary source selection. Librarians are in a good position to advocate for certain artworks given their knowledge of the library's collection on the artist or era. The instructor can decide whether the class will observe just one work or whether students will select individual works to work on alone or in groups.

The piece must be physically observed. Instructors should be encouraged to take advantage of local museum collections. The work of little known creators, old portraits, work of various local schools and movements, and regional art provide good opportunities. Students can visit the physical work more than once, and area libraries and museums can thereby support the project. Ideally the work lives close by.

The art being observed need not be famous. In some ways the method works best using rather anonymous art, as this motivates thoughtful interaction without the distraction of numerous secondary sources. Famous artists and their best-known work present challenges. Their cult of personality and body of scholarship may overpower honest investigation and distract the student.

Student observation as a kind of evidence

Students are asked to approach their art like detectives. Students hone their visual sense with the knowledge that their own perceptions are a valuable form of evidence. These will provide the groundwork for future analysis, since the quality of their observation determines the next questions they ask and the secondary sources they require. Students need to observe the artwork more than once, and should meanwhile obtain an image for reference from the web, a postcard or a bookplate. Students record their changing relationship with the work as well as their use of and interaction with secondary sources by keeping a journal. Librarians can be aware of the following visual grammar students may use to structure their thinking:

- medium (sculpture, painting, photograph, video)
- colour: hue, saturation, brightness
- black and white: tonality and grey scale
- texture: dot, line
- composition:
 — movement
 — direction
 — placement: sequencing, alignment, emphasis
 — framing or visual splits: horizontal, vertical, diagonal
- perspective (angle, dimension)
- scale
- objects:
 — type or kind
 — placement
 — interaction with figures
- figures:
 — nonverbal gestures (arms, hands, fingers)
 — facial expression (head, eyes, mouth)
 — body language (distances, code matching)
 — people (age, gender, ethnicity)
 — clothing (type, colour)
- background (objects, setting)
- presence or use of words: which words? where are they located?
- title of piece.

The secondary source as a type of codebook

Outstanding questions generated by physical observation will be satisfied by a visit to the library. Secondary materials should supplement the emotional experience of observation. In other words, sources can only be used as they directly answer, confirm or refute student

observation. Secondary sources include museum descriptions that accompany a piece, guidebooks and web pages, and reference art books and periodicals. Students may consult secondary sources during the observation process. Journal entries will reflect this interchange. Students should record all their searches, even unsuccessful ones. Again, both the process of observation and research as informed by observation are formative.

A secondary source should address artistic influences. However, for the purposes of this project (especially in the case of very old or relatively unknown works), it might be more helpful for the student to explore cultural and historical context:

- the time period the art was made
- the medium or format (e.g. painting, sculpture, film)
- the category or school of art
- the spirit of the age in which the piece was created
- the meaning of certain visual quirks – symbols in the work explicit in art of the time.

Secondary sources and the use of the library

Although this approach is not necessarily dependent on an art library, students usually need training on how to use a library. The discovery process should be taught as a form of critical thinking, not as a finding exercise. Emphasis should be given to source evaluation over locating information. Instructors might plan ahead:

- Think about whether your library can accommodate the art in question. It helps enormously if the instructor carries out the assignment in advance in order to have a sense of what the student may face when seeking information. Frustrated searches dampen curiosity.
- Incoming students have been using Google for years by the time they get to college. The project should respect casual search engine use early in the process but encourage sophisticated searches as a mark of progress.
- Think about how many sources students are required to use and their levels. Some sources are only available in academic languages other than English, such as German and French.
- Discourage students from using scholarly journal articles unless you are certain your students understand academic writing conventions.
- Do not penalize students for using the many print and online subject encyclopaedias available in a library. Reference literature is designed for the novice researcher and builds research skill. Subject encyclopaedias introduce students to the literature within a theme and are useful for overall treatment of topic.
- Think about what learning outcomes you have for a library session. What will students be able to do as a result of instruction? Students need time to think about

what they need to find, to identify search terms and appropriate sources, to search and retrieve information, and to evaluate sources. For the student, each of these is a different step.

- Consider whether students are sufficiently capable of searching a library catalogue and scholarly databases or whether they need instruction.
- The students' journals include their experiences of information seeking and discovery. Students should come to the library with their journals prepared to use terms and concepts they have recorded from museum visits.
- It is inevitable that some students will seize on obscure works of art. Work with them and encourage them to use interlibrary loan. Consider a research clinic for students and review discovery strategies and sources with them.

The process and a real world example

In the following real life example, a first-year history major with studio art experience visited the Getty Villa in Los Angeles. The student, Maria, chose a marble head of the Roman emperor Augustus (Figure 18.1).

Figure 18.1 Unknown, *Portrait Head of Augustus*, 25–1 BC, marble, 15¾ x 8¼ x 9⁷/₁₆ in, © The J. Paul Getty Museum, Los Angeles

The assignment outline is written in bullet points, with excerpts from the student's journal in italics.

- Look at the piece and write down your primary reactions to it.
 — Journal entry: record name of piece and medium.
 — Entry: what do you feel is happening as you look at the piece. Does it grab you? What do you feel? Record your first thoughts. Be specific! This will also help determine if the piece is of interest to you.
 — If you feel unmotivated, find another work to focus on.

 The head of Augustus immediately caught my eye. He has presence. He's kind of beat up. He doesn't look like he's even made of marble. His imperfections give him a hard look. His eyes are intelligent/searching. The portrait is next to a bust of Caligula. Next to Caligula (flabby): Augustus looks determined, sharp and handsome.

- Observe the work closely.
 — Entry: observe and write down all visual clues you notice. No detail is too small. Inferences may be made only as supported by physical observation.

 Augustus' head faces forward, his gaze directed proper right. His head is slightly turned. There are clear signs of damage to the nose, ears, lips and outer sides of the eyebrows. A furrow runs across the forehead, most prominent on the left and right sides above the eyes. Hints of vertical lines originating from the inner corner of the eyebrows are visible. The cheekbones are extremely defined, as are strong naso-labial lines. A prominent Adam's apple can be seen in profile. The features gave the impression of a hardened yet elegant and noble man (elongated, vertical facial lines, high and prominent cheekbones). A thick neck and upright head – makes the head seem intense and dominating. The features are well proportioned, so that face seems to me both rational and dignified. The softness, blurred shadows, and slight furrows create a humanistic, empathetic portrait while the severe features give authority.

- Look at the museum record or panel that accompanies the piece.
 — Entry: Write down the record and any relevant information if there is a lot of information. What questions are unanswered for you? What would you ask the artist if s/he were present? What other evidence do you need to back up your observations? No detail is too small!

 The piece measures 15¾ inches. The Getty museum artifact description suggests it was actually once a portrait of the unpopular emperor Caligula, re-carved after both emperors' deaths. Why would they bother to re-carve a minor bust in a far-off province? How much stock did they put in portraiture? Obviously a serious element of Roman political vocabulary. I'm inferring that any physical features displayed by the head must be very purposeful, or the artist would not have included them.

- Follow the museum record to books and references about the piece. Write these down. The museum library should have a record of the piece. Do not be shy about contacting a curator if you are stuck. Otherwise, save for the library visit.
 — Entry: record all new terms you read in the museum description. You will use these for research.

I wanted to research re-carving methods, so that I would know which features derived from the original Caligula, and which were additions. Helpful terms: Augustus portraiture, re-carving. I contacted the Getty Villa via accession number and asked them to send me a list of citations for the head of Augustus. Next, I searched for each of the citations in the university's art databases. Every citation provided was for an article in German. I can't read German(!) Anyway they weren't available through my library. The only source available to me from the Getty's list was a book on mutilated and re-carved Roman portraits (Mutilation and Transformation – see bibliography) that I located in electronic form through the library catalog [sic]. The book interprets my object as a re-carving of Caligula's portrait – the profile is deeply undercut, displays wide eyes, hollow temples, and re-worked sideburns. Interesting. But this did not tell me much about the piece except that the artist worked hard to cover up the image of Caligula and that some imperfections were due to the re-working. I need to judge the work and intention of the second (re-carver) artist.

• Art books on the time period will shed light on context, style and spirit of the period in which the piece was created, as well as on a school of art and the artist, if known. Remember that none of the supporting information you uncover will answer the essential questions of purpose, function, and action. They will only provide footwork. You must do the thinking.
 — Entry: record your catalogue searches. Include Library of Congress subject headings and all keywords you used. Record your dead ends and successes. All searches should be recorded.

• You can follow other sources that will not necessarily be about your piece, but about the time period, style, or artist. For example, works of history.
 — Entry: record any sources that have helped you to answer questions of history or culture. Write down the titles of books or web pages that could tell you more about the artist or the time. You may also include class notes if these are relevant to your understanding.

I knew [from class] that Roman portraiture was used as political propaganda. Also, there were certain styles of portraiture developed for and devoted to Augustus himself, each expressing certain characteristics. I thought researching them would be a good place to begin. I searched for books about Augustan portraiture in my library, keywords: 'Roman portraiture,' 'Roman sculpture,' 'Roman art,' 'Augustan sculpture,' 'Augustan portraiture.' Subject heading: Sculpture – Mutilation, defacement, etc. – Rome. I thought the most authoritative book about Augustan portraiture was: Roman Sculpture by Diana Kleiner (see bibliography). Certain classes of Augustan portraiture: prima porta, pontifix maximus, forbes or imperator.

None of these types looked like the Getty Augustus. They are smooth and 'godlike,' while the Getty Augustus is rough and uneven. The Getty Augustus clearly was not one of the above genres. Yet, in Roman Sculpture, it also mentioned another less known type, the Actium type. This type of propaganda depicted Augustus as a seasoned war hero. The Actium type portrays a determined man of action. His face is youthful but creased, his head of curls in complete disarray, as if he has just returned from battle. The coarse quality suggests that Augustus earned respectability and responsibility.

I was able to identify the Getty Augustus as something like the Actium type because I was so familiar with my piece. When I discovered a photo of Actium portraiture, I could immediately identify certain characteristics the two had in common. However, the book Roman Sculpture stated that the Actium type existed during only a narrow period of time during Augustus' reign. I determined that the Getty Augustus, therefore, could not be directly classified as part of the minor Actium type, given that it was produced after

the emperor's death. Still, the similarities made me examine the bust for features that encouraged a war-hero persona.

● Go back to the piece and examine the physical aspects that your secondary accounts discuss.
 — Entry: look for the visual clues that are mentioned in your secondary source. If none are mentioned, think about the artist and his intentions and influences. Figure out if you think that the spirit of the piece contains the spirit of the artist as described.
 — Your new viewing should be informed by this new knowledge.

After reading Roman Sculpture, *I went back to my image of the Getty Augustus (post card). I was able to recognise a certain artistic vocabulary in Roman portraiture. There is a whole system of classification used for these portraits. The second artist drew heavily from the 'Actium' line of propaganda. Elements such as the slope of the cheek, the neck, forehead, and lips are strikingly similar. However, I didn't want to label the head yet. The Actium type is clearly a foundation by the re-carving artist. Maybe the artist suggested Augustus as strategic, wary and charismatic man.*

● With each new source, re-evaluate your piece of art. Look at your piece as much as possible. If you can, go back and observe it under different types of lighting. Walk around it. Remember, you are still using your senses as a source of evidence.
 — Entry: write down each new insight in light of what your sources say about the work. The goal is not to form your visual perception around those of the critics, but to approach your piece informed and educated about certain technical elements and styles. Do you agree? If not, you must defend your observation. You can also look for another source to confirm your own claim.
 — Entry: record any new sources your questions have directed you to.

The Getty Augustus had a quality that made it come alive to the viewer. I returned to an article from class ('How to read a Roman portrait') for more clues about how to decode it (see bibliography). Sheldon Nodelman discusses a conflict in Roman portraits between 'the act of willful self-presentation and the action of the inner world glimpsed behind it.' With the notion of a 'hidden mindscape' in mind, I took another look at the Getty Augustus.
 As I walked around the piece, the longer I looked at it, each feature morphed, making the piece look alive. I observed that Augustus comes off as very thoughtful. His mind seems to have wandered off somewhere, as Nodelman suggests about Roman portraits. The interior quality makes the Augustus bust seem honest and unguarded, like someone we're supposed to trust. Still, the hard quality of the face and slanting gaze gives the impression that the portrait is expectant and wary. So while the Augustus does have a 'hidden mindscape,' he comes off as ready for action.
 I made a number of observations about the Getty Augustus based on the Kleiner and Nodelman writing. I noticed in the portrait a timeless quality – the piece is caught in a very singular, very real specific moment in time. The face expresses tension (the neck stretches in certain places, the mouth is twisted closed, the jaw is strong and sweeping). I thought that these facial tensions brought vitality and energy to the portrait – making it seem alive . . .

● Compare your piece with a piece that is contemporary (from the same time).
 — Entry: describe any contrasts or similarities you observe. Does the comparison inform your piece at all? How?
 — Entry: what do your sources say about contemporary work of the time?

I found a statue of Caligula and another portrait of Augustus, both from the Metropolitan Museum of Art. I compared Getty Augustus to them. The portrait of Caligula has exaggerated/disproportionate features. He looks stupid and unhinged. This helped me to see how the Getty Augustus' artist carved a balanced face. Augustus comes off as sane by comparison. The Met portrait of Augustus has smooth skin and perfect features – much more perfect than the Getty Augustus. This perfection gives the Met Augustus a very imperial look. Based on this I thought that the two artists had different intentions. The Met Augustus was trying to portray royalty and elevation, while mine was trying to portray humanity and rationality . . .

- Now bring your work together: answer the tough questions that will help to animate the piece (entries):
 — Entry: what is the purpose of the piece? Make your case based on the image, your observations, and the secondary sources you used to discover the artist's technique, the piece's historical context, etc.
 — Entry: where did the artist originally conceive placement of the piece? Was it installed in a public or private space? Consider how the piece was supposed to act on a viewer of its own time. How does the piece act in its current installation space?
 — Entry: who do you think was the audience for this work? Where did it fit in culturally? Is it high or low art?

I believe that the piece was 'acting' in several ways. First – it was trying to seem worthy and battle hardened – hence the use of Actium type features. Second, it was trying to come off as rational and intelligent –the balanced features and contrast with the Caligula portrait. Third, it was trying to seem trustworthy, humane, and gentle – hence the interior gaze. Finally, I thought that the portrait tried to come alive to its viewers by showing tension and imperfections in the face. A perfect kind of leader is being described.

I thought that the portrait was a very effective form of propaganda that made Romans remember Augustus as the Roman ideal. It seemed that the piece would have been displayed in some public forum in the outer provinces to communicate a message about leadership to Romans living far away. The portrait implies that Augustus was the ideal commander – and that his spirit and legacy lived on in Rome. In the Getty space the portrait looks like an artifact. It looks fancy at the villa, which is a luxurious re-creation of that ancient world. The Getty Augustus is not beautiful. But the piece still has political meaning. Augustus is still strong, ready, trustworthy, intelligent, powerful.

Conclusion

This method takes advantage of two iterative processes: observation and search. Although time-intensive, it combines the two by engaging students in their own thinking; students become part of the discovery process. This approach situates libraries squarely within the project and develops a research sensibility. Students must take ownership of the quality of their sources as they relate to their lived experience. The method also helps learners synthesize information, an outcome elusive in the library competency (information literacy) literature. The method develops self-awareness, which increases learning (Zimmerman, 1990). Students will most likely remember the project, if not remain mindful about the influence of observation. The method can be adapted for use in any coursework in which there is visual involvement, such as history, anthropology, communications, liberal studies and political science.

In 2011 the Association of College & Research Libraries (ACRL) created the first visual literacy standards for American librarians, perhaps in response to rapid incursions of digital and other media into everyday life. The ACRL standards acknowledge a vibrant and challenging area of practice for those who teach with images. The importance of studying, negotiating and knowing what images are and do (Elkins, 2008, 3) now migrate to the centre of a college education. Art history has a significant contribution to make to higher education because of the increasingly visual nature of knowledge – one in which the collaborative role of the librarian is the key to its attainment.

References

ACRL (2011) *ACRL Visual Literacy Competency Standards for Higher Education*, Association of College & Research Libraries, www.ala.org/acrl/standards/visualliteracy.

Acton, M. (1997) *Learning to Look at Paintings*, Routledge.

Avgerinou, M. and Ericson, J. (1997) A Review of the Concept of Visual Literacy, *British Journal of Educational Technology*, **28** (4), 280–91.

Avgerinou, M. D. and Pettersson, R. (2011) Toward a Cohesive Theory of Visual Literacy, *Journal of Visual Literacy*, **30** (2), 1–19.

Bamford, A. (2003) *The Visual Literacy White Paper*, Adobe Systems, wwwimages.adobe.com/content/dam/Adobe/en/education/pdfs/ visual-literacy-wp.pdf.

Berger, J. (1977) *Ways of Seeing*, Penguin Books.

Bruner, J. (1989) *Thoughts on Art Education*, Getty Center for Education in the Arts.

Dondis, D. (1973) *A Primer of Visual Literacy*, MIT Press.

Elkins, J. (2008) *Visual Literacy*, Routledge.

Freedman, K. (2003) *Teaching Visual Culture: curriculum, aesthetics, and the social life of art*, Teacher's College Press.

Hattwig, D., Bussert, K., Medaille, A. and Burgess, J. (2013) Visual Literacy Standards in Higher Education: new opportunities for libraries and student learning, *Portal: Libraries and the Academy*, **13** (1), 61–89.

Housen, A. (2001) Voices of Viewers: iterative research, theory and practice, *Arts and Learning Research Journal*, **17** (1), 2–12.

Hubbard, O. M. (2006) We've Already Done That One: adolescents' repeated encounters with the same artwork, *International Journal of Art & Design Education*, **25** (2), 164–74.

Perkins, D. N. (1994) *The Intelligent Eye: learning to think by looking at art*, J. Paul Getty Trust.

Sinatra, R. (1986) *Visual Literacy Connections to Thinking, Reading and Writing*, Charles C. Thomas.

Taylor, J. C. (1981) *Learning to Look: a handbook for the visual arts*, University of Chicago Press.

Yenawine, P. (2014) Thoughts on Visual Literacy. In Flood, J., Heath, S. B. and Lapp, D. (eds) *Handbook of Research on Teaching Literacy through the Communicative and Visual Arts*, Routledge, 845–6.

Zimmerman, B. (1990) Self-Regulated Learning and Academic Achievement: an overview, *Educational Psychologist*, **25** (1), 3–17.

Acknowledgement

I am grateful to Maria for her excellent insights and generous permission to use her journal entries.

Chapter 19

'I want students to research the idea of red': using instructional design for teaching information literacy in the fine arts

Katie Greer and Amanda Nichols Hess

Despite the different contexts in which art librarians serve – in universities, museums, special collections, auction houses – information literacy instruction occurs in all of them. The librarian as educator is a common enough paradigm in the 21st century, although that role often brings discomfort to practitioners with no formal training in teaching. Instructional design models provide structure and support to the librarian while creating and implementing lessons. These models engage the librarian in a systematic process, scaffolding the steps needed to create user-centred, effective instruction, whether the target audience is museum docent volunteers or graduate students. This chapter provides a brief introduction to the discipline of instructional design and some of its resources and then explores the use of a library-centred instructional design model in an undergraduate studio art classroom.

What is instructional design?

Instructional design represents both a unique discipline and an approach that all librarians designing learning experiences can integrate into their practices. Instructional design as a field grew out of the programmed instruction movement of the mid-20th century (Skinner, 1954), and the need to use new media (e.g. slides, images, film) in training settings (AECT, 2001). As technology and media have developed, instructional design as a field has similarly progressed. Today, scholars refer to the discipline as 'the principles and procedures by which instructional materials, lessons, and whole systems can be developed in a consistent and reliable fashion' (Molenda, Reigeluth and Nelson, 2003, 574). The idea of a systematic approach is key to instructional design because it reflects the intentional, reflective process that individuals should adopt in creating meaningful learning environments (Smith and Ragan, 2005).

Importantly, though, instructional design also represents a way of thinking about teaching and learning that individuals creating diverse educational interactions can adopt

to inform their practices. Ritchey, Klein, and Tracey (2011, 3) call instructional design 'the science and art of creating detailed specifications for the development, evaluation, and maintenance of situations which facilitate learning and performance', and this definition of the field addresses how it can be integrated into other disciplines. Importantly, this integration needs to follow a series of steps or guidelines (take a systematic focus) so that the resulting instruction's effectiveness is consistent for all learners and measurable through assessment or evaluation.

Why should librarians consider instructional design?

As librarians' instructional responsibilities evolve to reflect 21st century learning environments, instructional design represents a useful approach to develop teaching. In the past, librarians at art and design schools, colleges or universities collaborated with faculty only on individual instructional sessions or in developing resource lists for students. Now, though, they may be engaged in designing learning opportunities that connect visual literacy and the *Framework for Information Literacy for Higher Education* through online resources (Tewell, 2010), flipped instruction (Loo et al., 2016), and multiple instruction sessions in a single course (Zanin-Yost, 2012) or potentially in a course-level partnership. Ritchey, Klein and Tracey's (2011) definition of instructional design presents opportunities for librarians to create new kinds of 'detailed specifications' for how learners develop and demonstrate their knowledge in a digital environment. In creating these specifications in a more diverse array of formats, academic librarians serving art and design instructors and students may act as what Shank and Bell (2011, 106) call 'facilitators [and] navigators' as well as instructors. The result is that art and design librarians can foster environments in which exploration, knowledge creation and discovery happen in collaborative and meaningful ways.

How can art librarians use instructional design in their practices?

Perhaps the most effective way for art and design librarians to integrate instructional design into their teaching practices is to use one of the disciplines many design frameworks or models. These structures provide detailed specifications on how practitioners can develop and assess learning situations, and they can be applied in many different instructional environments. Perhaps the most famous instructional design framework is the analysis, design, development, implementation and evaluation (ADDIE) model (Branch, 2009; Molenda, 2015), which has five phases:

● analysis of an instructional problem or need
● design of learning objectives or outcomes to address the identified instructional issues

- development of resources to help learners meet those objectives or outcomes
- implementation of the learning resources with the intended learners
- evaluation of learners' attainment of outcomes or the effectiveness of learning resources.

This model has been applied by librarians in different learning scenarios (Davis, 2013; Easter, Bailey and Klages, 2014; Nichols Hess and Greer, 2016). Moreover, the ADDIE model has been adapted to reflect librarians' specific instructional needs, such as in the USER (understand, structure, engage and reflect) instructional design model (Booth, 2011) and the interview, design, embed and assess (IDEA) model (Mullins, 2014), which will be explored in this chapter.

There are also other design frameworks that librarians working in the arts could consider integrating into their practices. Dick and Carey (1985) present a tightly scripted instructional design model in which the learning designer begins by identifying instructional goals and from these goals conducts an instructional analysis, determines learners' characteristics or entry behaviours, sets performance objectives, designs instructional strategies, creates instructional materials, engages in formative evaluation, and performs summative evaluation. In contrast, Merrill (2002) advocates a more flexible series of principles, rather than a fixed structure, in his first principles of instruction model. The first principles framework asserts that instructors promote learning by engaging learners in solving real world problems, using and activating existing knowledge as a basis for new learning, demonstrating new learning to the learner, asking learners to apply their new knowledge, and assessing learners' integration of their new knowledge into their world (Merrill, 2002). And Kirkpatrick's (1994) evaluation model focuses on measuring learning effectiveness at four different levels: learners' reactions, learning, behaviour and broader results, such as organizational outcomes. This structure may be a useful resource for librarians focused on assessing their learning designs.

Because there are several instructional design frameworks, librarians may find that different approaches work in particular instructional settings. To that end, they should explore instructional design-focused resources as they consider integrating this approach into their teaching. First, professional organizations such as the Association of College & Research Libraries (ACRL) and the Association for Educational Communications and Technology (AECT) offer content on instructional design. ACRL regularly provides instructional design-focused learning opportunities through webinars, e-courses and conference programmes; AECT is the primary organization for instructional design scholars and can provide academic librarians with more in-depth information on the field's practices and scholarship. Art librarians interested in instructional design may also find practitioner-focused blogs, such as Amanda Hovious's Designer Librarian (https://designerlibrarian.wordpress.com) or the Blended Librarian Online Community (http://blendedlibrarian.learningtimes.net) to be instructive. As these librarians develop their instructional design knowledge, they may also find more scholarly content

instructive. AECT offers a number of publications on instructional design. *Tech Trends* (http://link.springer.com/journal/11528) focuses on practically-grounded scholarship, while *Educational Technology Research and Development* (http://link.springer.com/journal/11423) shares more in-depth research on instructional design issues. AECT's *Educational Media and Technology Yearbook* (www.springer.com/series/8617) offers a regularly updated guide to the field's tools, developments and trends, especially for designing technology-rich learning environments.

Instructional design in practice: using the IDEA model

Librarians used to teaching individual instruction sessions may recognize some of the steps in instructional design models as typical preparatory activities, although they may undertake some of these in an *ad hoc* manner rather than as a systematic progression of instructional design. For the remainder of this chapter we will outline the steps of the IDEA model proposed by Kimberly Mullins (2014; 2016) and present an example of information literacy instruction development for a studio art class which used that model. Although Mullins proposed the model with a traditional academic audience in mind, describing it as 'an instructional systems design approach that specifically addresses the skills, criteria, and design issues of library instruction within content disciplines' (2014, 339), its steps can easily be applied to the art school, docent training or a special library environment. The IDEA model includes four phases: interview, design, embed and assess. The steps included for each of the four phases were created by Mullins and can be found in her (2014) paper, along with further explication of each.

The interview phase

Similar to the 'analyse' phase of the ADDIE model, this step prioritizes information-gathering about the learners and the instructional setting, and emphasizes the use of interviewing stakeholders in order to ensure that all instructional goals are met. These are the steps of the interview phase:

- Step 1: Perform a syllabus analysis.
- Step 2: Interview the instructor.
- Step 3: Receive feedback and revise.

Ask yourself:

- Do I have a copy of the most recent documents (syllabus, docent training materials, etc.)?
- What do I know about this course or session and how it fits into the larger curricular goals?
- What has been done previously (if at all) for these learners?

- What is the typical demographic makeup of this group?
- What do the stakeholders want the learners to get out of a library instruction session?

A professor scheduled a library instruction session for his studio art course. By examining the syllabus, the librarian noted that students were expected not only to produce art grounded in conceptual, theoretical and art historical concepts, but they were also required to produce an artist statement discussing the application of those concepts. The syllabus analysis provided several entry points for information literacy instruction, which could be tailored to the students' assignment and needs. Since the course was required of all studio majors but not a prerequisite, the students would be at different stages of their academic careers and have a mixture of information literacy skills – some more advanced, some still beginners.

For the interview portion of this stage, the librarian needs to connect with the primary stakeholder – in this case, the professor – and discuss the information literacy goals for the learners. At this stage, expectations can be shared by both parties – and new ideas brought into play. In this example, although the syllabus analysis suggested a more traditional research approach, the discussion centred on the wide range of projects and the professor's wish for reluctant students to browse resources for inspiration. 'I'd really like them to start very broad and just explore,' he noted, 'for example, maybe I want them to research the idea of red, and then go from there to find what interests them.' Such a request, although vague, illustrates the wide-ranging nature of the art studio; librarians may often find themselves faced with such broad, indefinable goals and need to find a way to ground the open-ended goals of creativity in the more prosaic skills of information literacy.

For those who use the interview form Mullins provides in her article, Step 3 of the interview phase is to send a draft of the form to the professor for feedback before moving on to the next stage. In our scenario, because the discussion itself was so wide ranging, the librarian typed up the results of the meeting and sent an e-mail message to confirm that all involved were in agreement.

The design phase

During this phase, the librarian uses the interview notes and feedback to design the instructional goals and content for the course session. These are the steps of the design phase:

- Step 1: Perform a gap analysis.
- Step 2: Develop an information literacy goal.
- Step 3: Create information literacy objectives and identify assessment items.
- Step 4: Identify relevant information literacy content.

Ask yourself:

- Have these students had information literacy instruction prior to this course?
- What are the most critical information literacy skills that will be needed for the course and the relevant assignment(s)?
- What are effective tools or assignments that could measure attainment of the information literacy goals?
- Do resources (online tutorials, library guides) exist that could be used for this instruction?

Students in the course had widely varying degrees of prior knowledge. Some had experienced library sessions before, while others had never set foot in the library or used its online resources. The session, therefore, needed to be flexible enough to meet the needs of novices as well as more experienced learners. From the discussion in the interview phase, the librarian developed broad information literacy goals for the class: students effectively browse for and retrieve images according to interest, and then apply keyword search strategies to narrow and refine their information-seeking within library resources.

To support these goals, the librarian created objectives and assessments (Table 19.1). The professor's interest in a broader-to-narrower progression of research had led to a loose structure for the assignments: students would first conduct a very broad keyword search for images that relate to the concept of 'red' and send an Artstor image group of at least 30 items to the librarian and the professor for evaluation. From there, the list would be winnowed down until each student had a cohesive set of images and conceptual ideas. A guided worksheet assignment would then lead the students through formulation of a keyword search strategy that matched their interests as defined by the images. At that time, students would begin the text-based portion of the research, finding books and

Table 19.1 *Aligning broad goals with defined objectives and proposed assessment items*

Broad goal	Objective	Assessment
'Research the idea of red' – use library tools to browse images and surreptitiously find artistic inspiration	Students will create and share an inspirational image group using Artstor	Artstor image group
Keyword searching strategies	Students will develop a list of keywords relevant to their interests that can be used in research	Concept mapping or brainstorming worksheet
Keyword searching strategies	Students will progressively refine their keyword searches using broadening or narrowing	Annotated bibliography
Library familiarity	Students will know who the art librarian is and how to contact	Follow-up e-mails; research consultation statistics

articles using the library catalogue and either *Art Full Text* or *ARTbibliographies Modern*. An annotated bibliography would be submitted for assessment. At the end of the semester, the final research papers would also provide a summative assessment checkpoint.

The embed phase

The embed phase sets this instructional design model apart from others, in that it exists to facilitate the work of subject librarians who must integrate themselves into classes in order to reach students. Mullins includes sequencing and scaffolding planning in this phase. As part of the larger IDEA model, these steps consciously build on the two previous phases while also anticipating the final. The embed phase goes beyond the classroom time allotted and asks the librarian to consider how students will meet the research objectives when not with the librarian. These are the steps of the embed phase:

- Step 1: Identify effective embedding strategies.
- Step 2: Create an implementation plan.
- Step 3: Implement the plan.

Ask yourself:

- At what point in the course materials will students need library resources?
- How are they accessing instructional materials? How can they access library resources from those with a minimum of distraction?
- Where are links to research resources or tutorials being placed, and why?
- What is the most effective way that students could access and get assistance with the resources that they will need for their assignments?
- What is the timeline for each embedding strategy?
- Which documents or guides need updating?

To support the objectives and the assessments, the librarian created an online research guide which included relevant resource and support links and short tutorials for the critical resources. The library guides created at Oakland University can be added to the course learning management system in the form of widgets that exist permanently in the frame of the course page when a student accesses the course online (Hristova, 2013). This allows for quick 'point of need' access to library resources and services. Librarians who do not have this technology could work with a professor to provide targeted links to embed in assignment descriptions, online syllabi and other relevant documents.

Mullins stresses not all instructional content need be original or wholly customized. Open access tutorials or already created resources fitting the needs of instruction can and should be repurposed for use when available. For example, the link to the Purdue University Online Writing Lab citation guide for the Chicago Manual of Style was

provided for students as they worked on the annotated bibliography assignment (https://owl.english.purdue.edu/owl/resource/717/01/).

The assessment phase

Mullins recommends the use of formal rubrics in order to assess quantitatively each formative objective and how the course plan as a whole met summative goals related to library, regional and national (or professional) overarching information literacy goals. Numerous online resources can assist in the construction of rubrics; one example is a guide from the University of Wisconsin-Stout, which includes rubrics for creative activities as well as traditional research assignments: www.uwstout.edu/soe/profdev/rubrics.cfm. These are the steps of the assessment phase:

- Step 1: Implement formative assessments.
- Step 2: Implement summative assessments.
- Step 3: Implement modification plans.

Ask yourself:

- How effective (on a measured scale) were students at achieving each objective?
- Do the implemented assessments provide useful data?
- Did the instruction meet or contribute to larger administrative goals?
- What measurable changes could be made to make the information literacy session even more effective in the future?

Formative assessment occurred throughout the class session as students used image searching and submitted image links, and then continued as they built their research bibliographies. These assessments indicated that some students could use more guidance with the technology, and some needed further assistance with the conceptual portion of the assignment. The subject faculty member conducted the summative assessment using the finished projects. The student papers showed evidence of progression with research and inquiry, but there were questions on citation styles. Future iterations of the course session used these assessments as a starting point for additional or modified content with the IDEA model.

Conclusion

Although many of these steps are intuitive to the practising instructional librarian, the use of instructional design models such as IDEA lends a systematic approach to the occasionally daunting task of creating and delivering instruction. In the creative fields, the information needs are often far less concrete than in other disciplines, with the result that the librarian may experience instructional dilemmas requiring a more creative, open-

ended approach. The use of an instructional design model can help ground the instruction within the more formal discipline of information literacy. 'Librarians as educators' need not be the parlance of the day; rather, through the use of instructional design and other best practices from the field of education and the scholarship of teaching and learning, the profession can collectively shift to 'librarians: educators par excellence'.

References

AECT (2001) *AECT in the 20th Century: a brief history*, Association for Educational Communications and Technology, http://aect.site-ym.com/?page=aect_in_the_20th_cen.

Booth, C. (2011) *Reflective Teaching, Effective Learning: instructional literacy for library educators*, American Library Association.

Branch, R. M. (2009) *Instructional Design: the ADDIE model*, Springer.

Davis, A. L. (2013) Using Instructional Design Principles to Develop Effective Information Literacy Instruction, *College & Research Libraries News*, **74** (4), 205–7.

Dick, W. and Carey, L. (1985) *The Systematic Design of Instruction*, Scott Foresman.

Easter, J., Bailey, S. and Klages, G. (2014) Faculty and Librarians Unite! How two librarians and one faculty member developed an information literacy strategy for distance education students, *Journal of Library & Information Services in Distance Learning*, **8**, 242–62.

Hristova, M. (2013) Library Widget for Moodle, *Code4Lib Journal*, **19**, http://journal.code4lib.org/articles/7922.

Kirkpatrick, D. L. (1994) *Evaluating Training Programs: the four levels*, Berrett-Koehler.

Loo, J. L., Eifler, D., Smith, E., Pendse, L., He, J., Sholinbeck, M., Tanasse, G., Nelson, J. K. and Dupuis, E. A. (2016) Flipped Instruction for Information Literacy: five instructional cases of academic librarians, *Journal of Academic Librarianship*, **42** (3), 273–80.

Merrill, M. D. (2002) First Principles of Instruction, *Educational Technology Research and Development*, **50** (3), 43–59.

Molenda, M. (2015) In search of the Elusive ADDIE Model, *Performance Improvement*, **54** (2), 40–42.

Molenda, M., Reigeluth, C. M. and Nelson, L. M. (2003) Instructional Design. In Nadel, L. (ed.), *Encyclopedia of Cognitive Science*, Wiley, http://search.credoreference.com/content/entry/wileycs/instructional_design/0.

Mullins, K. (2014) Good IDEA: instructional design model for integrating information literacy, *Journal of Academic Librarianship*, **40** (3), 339–49.

Mullins, K. (2016) IDEA Model from Theory to Practice: integrating information literacy in academic courses, *Journal of Academic Librarianship*, **42** (1), 55–64.

doi:10.1016/j.acalib.2015.10.008.

Nichols Hess, A. and Greer, K. (2016) Designing for Engagement: using the ADDIE model to integrate high-impact practices into an online information literacy course, *Communications in Information Literacy*, **10** (2), 264–82.

Ritchey, R., Klein, J. and Tracey, M. W. (2011) *The Instructional Design Knowledge Base: theory, research, and practice*, Routledge.

Shank, J. D. and Bell, S. (2011) Blended Librarianship: [re]envisioning the role of librarian as educator in the digital information age, *Reference & User Services Quarterly*, **51** (2), 105–10.

Skinner, B. F. (1954) The Science of Learning and the Art of Teaching, *Harvard Educational Review*, **24** (2), 86–97.

Smith, P. L. and Ragan, T. J. (2005) *Instructional Design*, Wiley.

Tewell, E. (2010) Video Tutorials in Academic Art Libraries: a content analysis and review, *Art Documentation: Journal of the Art Libraries Society of North America*, **29** (2), 53–61.

Zanin-Yost, A. (2012) Designing Information Literacy: teaching, collaborating and growing, *New Library World*, **113** (9), 448–61.

Chapter 20

Cultural differences and information literacy competencies

Nancy Fawley

Design students can pose multiple challenges for librarians. Their information-seeking behaviours are often less linear than those of their university colleagues. Developing library initiatives and instruction becomes even more challenging when working with international students who bring different cultural backgrounds and language competencies to their college programme. They also have varying degrees of experience with and knowledge about libraries. These obvious barriers, in addition to more subtle obstacles such as cultural background and academic history, all affect their expectations and use of a library (Curry and Copeman, 2005, 410). Librarians working with English as a Foreign Language (EFL) design students need to address both the information-seeking behaviours of design students while also being aware of the unique needs of an international student population.

A diverse student body

According to the Institute of International Education's *Open Doors Report on International Educational Exchange* (IIE, 2016b), there were over 1 million international students studying in the USA in the 2015/16 academic year, an increase of 2.4% from the previous year. Of these students, approximately 60,000 studied fine and applied arts, a 5.2% increase from the previous year. Chinese students made up almost a third of the total with an increase of 8.1% from the previous year. Other top countries sending students to the USA are India, Saudi Arabia and South Korea (IIE, 2016b). With such diversity, librarians need to be aware of the cultural differences of their student body, specifically in how they affect their information-seeking behaviours.

Many institutions have developed gateway programmes for international students, which offer language support and help with cultural adjustment along with academic courses, and they serve as a pathway into a degree programme. These initiatives fulfil two purposes. International students bring diverse backgrounds and social values to their

academic experience and can contribute to the university's diversity initiatives. At the same time, international students are an important source of revenue because they pay full tuition fees, or out-of-state tuition fees for public institutions.

Cultural considerations in learning and education

Language difficulties are by far the biggest challenge facing international students in the classroom. A study of how international students in the creative arts at the University of the Arts (London) experience stress found that problems related to language were the most common. Students said they had trouble conversing, responding to questions during critiques, and reading at the speed necessary to keep up with class assignments (Sovic, 2007, 151). Understanding discipline-specific art and design terms adds another layer of difficulty to language acquisition.

English language proficiency is arguably one of the main reasons EFL students plagiarize or unintentionally misuse sources. Many librarians are asked to instruct students on academic integrity, and it is worth understanding some of the differences in learning styles of international students. In many countries in the Middle East and Asia, teaching is by rote and memorization and imitation. In a study to assess the extent to which art and design pedagogies in practice aid or hinder international students, it was found that previous education experiences such as rote learning with a high respect for authority were a challenge (Caldwell and Gregory, 2016, 120). Memorizing text in one's native language does little to prepare a student to think critically. Furthermore, good students do not challenge their teachers or authorities, but instead faithfully copy and reproduce them (Sowden, 2005).

International students also face challenges in transitioning to a different system of teaching and learning. An understanding of the educational system of students' home countries is helpful when developing outreach and information literacy instruction for international students. For example, many libraries in Asia and the Middle East have closed stacks, while some libraries are reserved for scholars to use, not students (Leki, 1992, 74). Not all countries require librarians to have a terminal master's degree, and some library staff may have a high school diploma or a bachelor's degree and little formal training in public services and information literacy. As a result, they play more of a 'keeper of the library' role, discouraging students from touching the collection, rather than engaging and instructing them in the use of the library and its resources.

Common active learning strategies, such as class discussions and small group work, are at odds with many international students' previous education experiences. Answering a question in class may be considered bad form as it humiliates their peers who did not know the answer (Leki, 1992, 30). Group work is also a source of stress and may lead to a lack of integration in the class. A student who is silent and does not participate in group activities is effectively excluded (Sovic, 2007, 153).

Awareness of social customs

An awareness of students' customs and social traditions is important and can provide a base for instruction and outreach. For example, in many Muslim countries men and women who are not related are traditionally segregated; the university may be their first experience interacting with members of the opposite sex. For the most part, students self-segregate according to their comfort level. Group activities encourage students to engage with class content, but take care not to dictate who works with whom.

Be cognisant when interacting with students of the opposite sex as well. Gestures that mean one thing in the USA may indicate something else in another culture. A firm handshake as a greeting, a squeeze on the arm for encouragement, or direct eye contact during conversation may have a disrespectful (albeit unintentional) meaning. In Sri Lanka, for example, shaking one's head left to right means 'OK' or 'I agree', not 'no' as it does in Western countries. Furthermore students from countries where women are not as highly respected as men may have trouble accepting the authority and expertise of a female librarian (Wayman, 1984, 337).

Students from conservative Muslim countries where women wear *hijab* may be shocked or offended when their textbooks and lectures feature images of Greek and Roman statues and models in revealing clothes. The key is to treat the issue matter-of-factly, and then move forward with the instruction.

Using cultural difference as an advantage

These cultural differences do not have to be obstacles to library instruction; an awareness can also enhance the class. Students from group-oriented societies base their achievements on the success of a group, rather than the individual. As a result, there is also pressure to help the weaker member succeed. In this instance, helping a friend or a relative is not considered cheating but a moral obligation (Leki, 1992, 72). Hands-on group work is a way to acknowledge the importance of groups and engage visual learners, while students with weaker English language skills can benefit from working with their colleagues.

For those who were raised in cultures that prize individualism and accountability, the importance of saving face, and its link to honour and reputation, may be hard to grasp. Saving face is a way to avoid shame, which in group-oriented cultures includes the extended family as well. Any offence that causes shame is taken as a humiliation that needs to be retaliated against immediately to regain the group's honour (Patai, 2002, 107). Situations that can lead a student to 'lose face' can range from class discussions to the more serious situation of accusing a student of academic dishonesty. When instructing a class, be conscious of not singling out students who may be struggling with the material. Here again, this is a situation where group work could be beneficial.

Design students' information-seeking behaviour

Design students in particular have been referred to as 'pariah(s) of library instruction' (Teague, 1987, 99), stumping text-focused librarians who do not know how to assist students doing research for studio classes. Student designers in particular need information on technique and the assigned project, plus information to stimulate and motivate (100). It is finding the information to inspire creativity, the 'expansive data' as Teague calls it (1987, 101) that commonly bewilders librarians. In a survey of the information needs and information-seeking practices of students at the Hong Kong Design Institute, it was found that traditional library services and print collections were unable to fulfil all the information needs of art and design users, which included walking around aimlessly and visiting shopping malls as sources of inspiration (Lo and Chu, 2015, 109).

A further challenge for librarians is convincing students of the benefits of using the library for their studio classes. Many make a distinction between using the library for their general education and text-based classes and do not consider it necessary for their design course. Promoting the library's and librarians' services to students across disciplines is key.

Curriculum mapping to integrate information literacy instruction strategically

Curriculum mapping is a process used by educators in elementary, high school and higher education to evaluate a curriculum for proper sequencing and identify gaps, inconsistencies and redundancies in the programme by aligning learning objectives with course content. It provides educators the opportunity to look at a curriculum in a holistic manner.

Librarians can adapt a curriculum mapping process to evaluate how library instruction and outreach supports an existing curriculum. Those with specific liaison roles to departments, such as the design arts, can use it to identify gaps and redundancies in their information literacy instruction in the programmes they support. It can be used as an opportunity for conversations with faculty or can be conducted internally as a planning device (Buchanan et al., 2015, 110). It helps guide librarians to introduce skills and concepts strategically at the point of need throughout a student's college career and to create a plan to support this. It is also a tool to help librarians be strategic with their time and efforts and determine when face-to-face instruction is necessary, or when a research guide or digital learning object is appropriate.

This is a beneficial way to span the various ways a design student may be exposed to information literacy and library instruction in required general education classes and disciplinary studio work. Many first-year students, and especially international students, also have a tour and orientation to the library when they arrive at campus prior to the start of their first semester. This is a key time to reach out to international students with

carefully conceived activities to introduce an academic library and its resources and services, while also alleviating library anxiety. In focus groups formed to determine how student artists used the library, a small number mentioned the library instruction they received as part of a first-year composition class or freshman orientation. These students found, however, that the sessions did not cover information relevant to their needs for their art and design courses (Frank, 1999, 453).

When creating a curriculum map, be sure to include learning outcomes from library orientations and information literacy instruction in required, general education courses, such as freshman composition. At many institutions, library instruction for first-year composition is part of a large-scale initiative in which most or all librarians in a department or library participate. If this is the case, it is simple to include the learning outcomes as part of a grid, or reach out to colleagues who are teaching the classes to find out what students are learning. In subsequent interactions with students in design classes, these outcomes can be reinforced or enhanced while also making a connection between concepts taught in general education courses and those in design classes.

International students who are part of a gateway programme and take additional reading and writing classes provide another opportunity for information literacy skills and concepts to be mapped. These are additional opportunities for reinforcing these skills and concepts beyond what native language learners may require. Targeting required courses in the design curriculum, if possible, also ensures that librarians are reaching the widest possible group of students.

Using the Framework for Information Literacy for Higher Education

The Association of College & Research Libraries (ACRL) *Visual Literacy Competency Standards for Higher Education* are currently under five-year review as prescribed in the *ACRL's Guide to Policies and Procedures*. The *Framework for Information Literacy for Higher Education* (ACRL, 2015), adopted by the ACRL Board in 2016, is a cluster of related core concepts. They allow for flexible implementation and can provide a guide for developing a curriculum map that could include international student orientation, general education or language and writing competency courses, along with design courses. Two of the six frames are highlighted in Figure 20.1 on the next page (ACRL, 2015, 9).

The creative design process also starts with exploration, then continues to incubation, insight and execution (Teague, 1987, 105). Library instruction that highlights browsing, and the serendipitous discovery that can ensue, supports this open-ended exploration. A handout of subjects, their corresponding Library of Congress call numbers, and their location in the library assists users who want to browse. Do not limit your list to only art and design subjects, as exploration may be multidisciplinary and expand beyond the design arts.

Sample curriculum map				
I = Introduce; R = Reinforce; E = Enhance				
OUTCOME	**INTL. STUDENT TOUR**	**FIRST-YEAR COMPOSITION**	**ART FOUNDATION**	**ART HISTORY**
Students will seek appropriate help when needed	Students will be introduced to the unique aspects of a US academic library in order to effectively use the library and its resources **(I)**	Students will know who their liaison librarian is and how to contact them and make an appointment with them **(R)**	Students will know how to make an appointment with their liaison librarian **(R)**	Students will know how to make an appointment with their liaison librarian **(R)**
Students will recognize the value of browsing for discovery	Students will be introduced to the library's print collection and the way it is organized and used **(I)**	Students will develop keywords and use limiters to refine a search in a discovery tool **(I)**	Students will search a discovery tool or OPAC to identify call number ranges to browse for creative inspiration **(R)**	
Students will use various research methods based on their information needs		Students will identify and use different types of tertiary resources to develop keywords and expand vocabulary **(I)**	Students will differentiate between image and article databases and use according to their information need **(I & R)**	Students will use advanced search techniques in a subject database to identify relevant articles **(R & E)**

Figure 20.1 *Sample curriculum map based on two of the six frames in the ACRL Framework for Information Literacy for Higher Education*

Browsing library stacks, however, as simple as it may sound, may be intimidating to students with little or no library experience. Those accustomed to closed stacks are often surprised when they learn they are allowed to touch the books, take them off the shelves and handle them. Furthermore, keep in mind that library books are arranged in alphabetical order and shelved from left to right. It sounds straightforward, but imagine how students, whose first language does not use the Latin alphabet and is read from right to left, may be challenged in understanding and locating call numbers on the shelves.

The frame 'Research as Inquiry' states, 'Research is iterative and depends on asking increasingly complex or new questions whose answers in turn develop additional questions or lines of inquiry in any field' (ACRL, 2015, 7). Inquiry in the creative process extends beyond the library and includes a diverse set of sources that can serve as a starting

point for inspiration. The 'process is more "intuitive" than "systematic"' (Lo and Chu, 2015, 116). A variety of research techniques and resources are needed to search and synthesize information from images, scholarly information, and professional literature on galleries and auctions, for example.

International students benefit from instruction that reinforces these concepts. Identifying keywords and synonyms, in particular, is a struggle when language competency is developing. Using tertiary sources with more accessible language, such as dictionaries and encyclopaedias, helps them formulate search terms while also obtaining background information on their subject. These skills can be reinforced in both general education and design classes as students develop the skills to search and read scholarly materials.

Conclusion

International design students succeed because of their talent, perseverance and hard work. When working with students from other cultures, librarians must account for the cultural differences that may affect their library usage and information-seeking behaviours. Successful outreach and information literacy instruction delivered strategically across general education and design classes encourage scaffolded learning of skills and concepts but also acknowledge the cultures of a diverse student body.

References and bibliography

ACRL (2011) *Visual Literacy Competency Standards for Higher Education,* Association of College & Research Libraries, www.ala.org/acrl/standards/visualliteracy.

ACRL (2015) *Framework for Information Literacy for Higher Education*, Association of College & Research Libraries, www.ala.org/acrl/standards/ilframework.

ACRL (2017) *ACRL's Guide to Policies and Procedures*, Association of College & Research Libraries, www.ala.org/acrl/resources/policies.

Buchanan, H., Webb, K. K., Houk, A. H. and Tingelstad, C. (2015) Curriculum Mapping in Academic Libraries, *New Review of Academic Librarianship*, 21 (1), 94–111.

Caldwell, E. and Gregory, J. (2016) Internationalizing the Art School: what part does the studio have to play?, *Art, Design & Communication in Higher Education*, 15 (2), 117–33.

Curry, A. and Copeman, D. (2005) Reference Service to International Students: a field stimulation research study, *Journal of Academic Librarianship*, 31 (5), 409–20.

Frank, P. (1999) Student Artists in the Library: an investigation of how they use general academic libraries for their creative needs, *Journal of Academic Librarianship*, 25 (6), 445–55.

Hattwig, D., Burgess, J., Bussert, K. and Medaille, A. (2011) *Visual Literacy Competency Standards for Higher Education*, Association of College & Research Libraries, www.acrl.org/ala/mgrps/divs/acrl/standards/visualliteracy.pdf.

IIE (2016a) International Students by Field of Study, 2014/2015 – 2015/16, *Open Doors Report on International Educational Exchange*, Institute of International Education, www.iie.org/opendoors.

IIE (2016b) Open Doors Fast Facts, *Open Doors Report on International Educational Exchange*, Institute of International Education, www.iie.org/opendoors.

Leki, I. (1992) *Understanding ESL Writers: a guide for teachers*, Boynton/Cook.

Lo, P. and Chu, W. (2015) Information for Inspiration: understanding information-seeking behaviour and library usage of students at the Hong Kong Design Institute, *Australian Academic & Research Libraries*, **46** (2), 101–20.

Patai, R. (2002) *The Arab Mind*, Hatherleigh Press.

Sovic, S. (2007) Coping with Stress: the perspective of international students, *Art, Design & Communication in Higher Education*, **6** (3), 145–58.

Sowden, C. (2005) Plagiarism and the Culture of Multilingual Students in Higher Education Abroad, *ELT Journal*, **59** (3), 226–33.

Teague, E. H. (1987) A Portrait for the Librarians: bibliographic education for students in design disciplines. In Reichel, M. and Ramey, M. A. (eds), *Conceptual Frameworks for Bibliographic Education: theory into practice*, Libraries Unlimited.

Wayman, S. G. (1984) The International Student in the Academic Library, *Journal of Academic Librarianship*, **9** (6), 336–41.

Part IV

Knowledge creation

Gone are the days when the library was considered simply a physical storage facility for the research and writings of scholars. In the same vein, the role of librarians has changed from being the 'keeper' of collections to being an active creator and research colleague. Specialized skill sets position librarians at the forefront of knowledge creation and dissemination. New models of publishing have opened opportunities for alternate methods of information distribution. While the fields of art and design have embraced digital publishing and new media, traditional print still constitutes a large percentage of knowledge delivery. In response, art and design librarians have become active partners in digital art history initiatives while still facilitating access to print formats. The authors in this section explore the ways in which art libraries and librarians navigate through the numerous channels of scholarly communication to support research in all of its manifestations. The areas of digital art history, digital map-making and professional opportunities for art students receive close attention.

Chapter 21

The ever-shifting landscape: mapping the present and future of digital art histories

Colin Post

Introduction

This chapter provides an overview of the practices, approaches and discourses that make up the diverse field of digital art history. The author first describes the general discourse around digital art history, exploring how art historians and arts information professionals have defined digital art history and positioned digital art history practices in relation to the broader field of art history. He then outlines specific tools and methods, offering examples of projects. Finally, he considers the role that art and design libraries, archives and museums can play in supporting scholars, students and the wider public in pursuing, creating and sharing digital art history projects.

Art and design librarians and other arts information professionals have a critical role to play in the future of digital art history. Identifying what this role might be is especially difficult, as digital art history is a moving target, developing in relation to dynamic technologies that promise an increasing range of possibilities. However, by mapping out the past and present of the field, information professionals will be better equipped to respond strategically to technological developments and work together towards a future of strong digital art historical scholarship.

The digital in art history

Digital technologies undeniably occupy a prominent position in nearly all aspects of current art historical research activities, teaching and knowledge production. Although relatively few in the field self-identify as 'digital' art historians, essentially all art history scholars depend on digital technologies to carry out their work, including such ubiquitous tools as PowerPoint and online library catalogues. The digital image repository, though, is perhaps the most significant digital resource to date for art history scholarship. Drucker (2013) refers to this phase of building up repositories of digital resources as *digitized* art history, work that has included scanning analogue images and crafting metadata

descriptions. This work has also laid the foundation for what Drucker distinguishes as *digital* art history: the application of digital methods and computational analysis to the study of artworks and other art history research materials. With this still-growing infrastructure of digital resources, art historians can use computational tools to investigate objects of art historical research to new ends.

Drucker frames digital art history as still very much in the making, and in the present discourse many lament that art historians have been slow to embrace digital humanities approaches, lagging behind other fields like history and literary studies (Zweig, 2015). However, Zweig (2015) demonstrates that there is a rich history of art historians engaging with computational technologies, dating back to the early days of computing. Early on, art historians and information professionals realized the potential for computational technologies to both grow collections of art history research materials and to open up new possibilities for research. Ellin (1969) describes fervent early activity by a number of museums to develop collection databases, noting some 50 ongoing projects in 13 countries, the largest of these a significant collaborative undertaking facilitated by the Museum Computer Network. Then as well as now, scholars have recognized the transformative power of these efforts – databases are not just updated slide libraries, but provide new means to share and access resources and lay the foundation for wider scholarly collaboration (Bailey, 2015; Zweig, 2015). Through the 1980s and 1990s, art historians began to seize on the new affordances provided by these growing databases, such as the activity of the Computers and the History of Art (CHArt) working group (Bentkowska-Kafel, 2015; Getty Art History Information Program, 1994).

Art historians today have even more opportunities to use digital resources and apply computational methods. However, as Zorich discusses in an expansive report on the changing nature of art historical practice, scholars remain split on the value of digital methods. While many affirm that digital art history opens up 'new avenues of inquiry and scholarship', others 'remain unconvinced that digital art history will offer new research opportunities or that it will allow them to conduct their research in new and different ways' (2012, 6). The critical question posed to the field at large persists: do digital methods truly enable researchers to ask new kinds of questions?

Advocates of digital methods have addressed this question, arguing that digital approaches do afford scholars new research methods, such as information visualization and network analysis, and also expand the scale and scope of research (Drucker, 2013). Scholars can ask questions not of a few artworks, but across entire corpora of materials, a boon to research recognized early on (Ellin, 1969). As Manovich (2015) emphasizes, working with data entails not only new research methods, but also wholly new objects of study, constituting a shift in paradigm as well as method. Just like a painting, data are particular and constructed representations of the world, requiring critical interpretation. As digital data are increasingly central to the expression and circulation of global culture, data-driven art history represents an opportunity to better understand not only cultural history, but also the cultural present and future (Schich, 2016).

Even as we can make the argument that digital tools and approaches constitute a new set of methods for art historical research, scholars urge that digital art history still be seen as part of the broader field of art history. As Bailey (2015) observes, art historians do not need to take an either/or approach to digital tools, suggesting that art historians stand to benefit from using both analogue and digital resources. Bentkowska-Kafel (2015, 59) argues that art history has been a rich and interdisciplinary field of intellectual inquiry from its beginnings, and digital approaches only further enrich the field. Schich advances this point even further, outlining a 'perspective for a systematic science of art and culture that integrates qualitative inquiry with computation, natural science, and information design' (2016, 58). For Schich, the study of art and culture needs to integrate both humanistic and scientific modes of inquiry. Coupled with the power of digital technologies, this methodological inclusivity promises to enable scholars to broach cultural and art historical research questions that are novel in kind, scale and scope.

Summary of digital approaches and projects

Cultural analytics

As mentioned above, one of the most significant changes posed by digital art history is the capacity to work with large corpora of data. Manovich (2009) has termed this study of large sets of cultural data 'cultural analytics', and Manovich and his research team have pioneered this approach through the Software Studies Initiative (SSI) at the University of California San Diego and the California Institute for Telecommunications and Information. SSI has developed a number of freely available tools for analysing and visualizing large data sets of images and has applied these tools to study both traditional art works as well as the exponentially expanding body of user-generated social media content (Hochman and Manovich, 2013). While current computing power facilitates the analysis of ever-growing data sets, there are important precedents for the use of computational quantitative methods in art history. Prown (2001) describes an effort in the 1960s to use computer tabulation and calculation to analyse over 300 paintings by John Singleton Copley, arriving at a more thorough understanding of the character and pattern of Copley's patronage over time. Zweig (2015) posits the work of William Vaughan, and the Morelli project in particular (Vaughan, 1987), as a key forbearer to cultural analytics.

Hristova (2016) makes use of cultural analytics approaches and tools developed by SSI to analyse Panel 45 of Aby Warburg's *Mnemosyne Atlas*, focusing specifically on the meaning of colour in the images collected on this panel. Hristova demonstrates that cultural analytics provides a new means to analyse images as data, and integrates this analysis with traditional art historical methods to draw out the cultural and historical context of Warburg, the historical images of Panel 45 and the data under study. As Hristova (2016, 129) explicates, even the smallest unit of information, a pixel of colour, has complex and polysemous cultural significance.

As data – especially large data sets – are difficult to comprehend without the aid of a

computer, scholars depend on information visualization techniques to produce images about the data, or what Klinke (2016) terms 'meta images'. For Klinke, creating visualizations is a human-driven, interpretive process, a means for scholars to make sense of large data sets. Visualizations illustrate findings of data analysis, but the creation of these also constitutes part of the method. As interpretive summaries of large data sets, visualizations are themselves informatic and epistemic objects, constrained by assumptions or prerogatives of the creator, and communicating a particular message about the data set. Drucker (2014) offers an expansive history of information visualizations, from ancient charts and tables to contemporary computational methods, explicating the variety of means by which these graphics function as a communication media.

Modelling cultural heritage objects

Related to the visualization of large data sets is the digital modelling of cultural heritage objects. Foni, Papagiannakis and Magnenat-Thalmann (2010) lay out a typology of methods for modelling cultural heritage objects, classifying these according to four dimensions: precision, visual consistency, interactivity and automatism. Some representation approaches include restitution drawings, scale models, panoramas, annotated images and computer games. As the authors note, all of these representation approaches have different advantages and disadvantages, depending on the intended purpose and user of the digital object.

One particular approach that is increasingly valuable to scholars, students and the general public is virtual reality, especially as virtual reality technologies become more prevalent through smartphone add-ons like Google Cardboard. Reflecting on work modelling ancient Roman architecture at the University of California Los Angeles Cultural Virtual Reality Laboratory, now the Experiential Technologies Center (Figure 21.1 opposite), Favro (2006) discusses the great potential of virtual reality technologies for scholarship, especially for architectural historians and archaeologists. Virtual reality enables scholars to re-create buildings, cities and sites that have either been significantly transformed over time or have been destroyed altogether. Virtual reality models allow for users to enter into an immersive and kinetic experience of these spaces, effectively creating new objects of study that would not be possible without this technology. The affordances of virtual reality technology are inspiring for both scholars as well as knowledge consumers, making architectural and archaeological research more accessible and appealing to a wider public. However, Favro cautions that virtual reality models cannot be taken as wholly accurate replicas of the original site. Rather, virtual reality models are knowledge representations, objects communicating a current understanding of historical architecture and archaeological sites, but like a journal article, these scholarly objects are still very much artefacts of knowledge-in-process, adding to an ongoing discourse and sparking further experimental inquiry. Unlike static journal articles, however, virtual

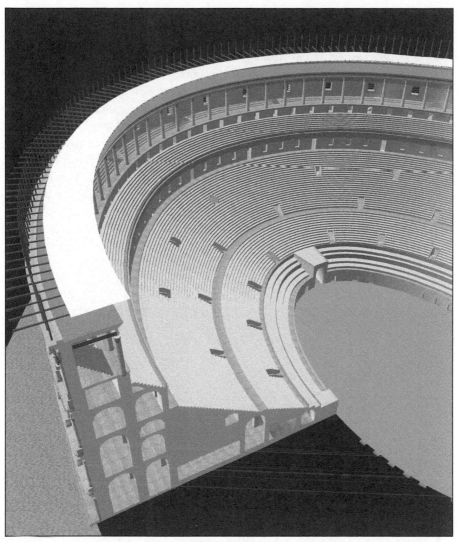

Figure 21.1 *Virtual reality model of Roman Coliseum, Experiential Technologies Center*
© University of California Regents, 2003

reality models provide an interactive means to disseminate existing knowledge, test theories and gain new perspectives on objects of research. For more detail on the process of developing and carrying out a virtual reality project, see Snyder (2012).

Mapping

White (2010) remarks on a growing interest in the study of space in the humanities, and particularly in the field of history. While scholars have previously studied phenomena in

relation to space, digital technologies greatly augment spatial research methods, enabling scholars to analyse geographic information systems data more readily and generate maps and other visualizations that approach scholarly research questions from new angles. Fletcher and Helmreich (2012) present a good example of the potential for mapping and the use of geographic information systems tools for art historical research. This project is really a complementary pairing of two related geographic information systems-driven research projects. In one, Fletcher and contributor David Israel map the location of commercial galleries in London from 1850 to 1914 (Figure 21.2). As the authors describe, this period was formative for the commercial gallery system, which today constitutes the basis for the exchange and circulation of artworks. The map shows these galleries in relation to other significant locales, such as artists' residences; by interacting with the map, viewers can see where galleries sprouted and diminished over time. In the second project, Helmreich and contributor Seth Erickson create a network visualization that tracked the global activity of the prominent gallery Goupil & Cie/Boussod, Valadon & Cie.

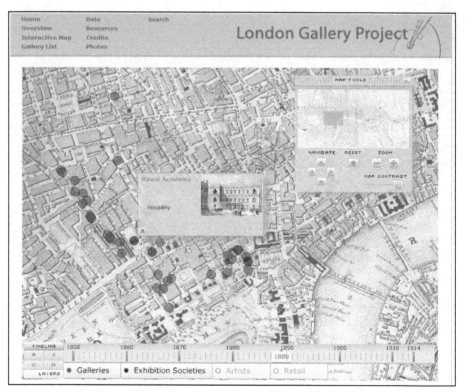

Figure 21.2 *The location of commercial galleries in London, 1850–1914, Pamela Fletcher and David Israel, London Gallery Project, 2007; revised September 2012, http://learn.bowdoin.edu/fletcher/london-gallery/*

Taken together, these two projects make a historical argument about the relationship between the local development of gallery spaces in the prominent city of London and the global influence of these spaces in the circulation and exchange of artworks. The visualizations illustrate the authors' art historical arguments, but they also crystallize and demonstrate their methodological approach. Creating the map and network visualizations were the primary research activity and not just illustrations created after the fact. As White (2010) asserts for the scholarly use of visualizations in general, these knowledge objects are not just a means to communicate research results, but also 'a means of doing research; it generates questions that might otherwise go unasked, it reveals historical relations that might otherwise go unnoticed'. This project challenges existing models of authorship and scholarship, necessitating interdisciplinary project teams and active collaboration among many parties instead of the lone scholar sifting through primary and secondary texts. These observations hold true for many other kinds of digital art history research described in this chapter as well, such as the virtual reality models discussed above.

Network analysis

Network analysis is the modelling and study of networks, which can consist of people, locations, materials or other data points. As the example of Fletcher and Helmreich (2012) above demonstrates (Figure 21.2), network analysis can often be used in conjunction with geographic information systems and mapping projects. While network analysis can be done through analogue means, digital tools make it possible to study large data sets quickly, such as the project discussed by Schich et al. (2014), in which the team constructed a network of the birth and death locations of over 150,000 notable individuals spanning over two millennia (from 1 CE to 2012 CE). This network provides a large-scale overview of cultural history, illustrating trends in the processes of global mobility.

Network analysis has significant potential to address new kinds of art historical research questions. Lincoln (2016) offers a great example of the power of network analysis to bring new insight to art historical research. Drawing on the prints databases at the British Museum and the Rijksmuseum, Lincoln constructs networks of the print-making industry in the Low Countries in the 16th and 17th centuries (Figure 21.3 on the next page). Lincoln states, 'network analysis can illuminate dimensions and scales of historical events that are otherwise difficult for art historians to conceptualize' (2016, 153). For this study, Lincoln characterizes structural changes in the print-making industry over time, and also identifies highly central print makers that have otherwise been overlooked by art history.

The role of libraries and information professionals

In a wide-ranging report on the changing practices in the field of art history, Long and Schonfeld (2014) emphasize the development of digital art history among their primary

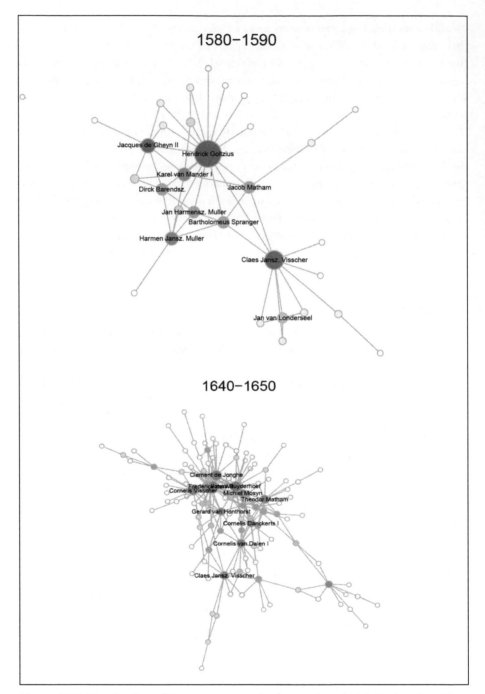

Figure 21.3 *Visualizations of the core components of network analysis in the Low Countries, 1580–90 and 1640–50, Lincoln (2016)*

findings. At this critical phase, information professionals play a significant part in fostering these emerging practices, even as this is likely to involve envisioning and embracing changing roles (Zorich, 2012). Undergirding this shift is the importance of collaboration between information professionals and art historians (Bailey, 2015). Regardless of the technology, scholars and information professionals share the complementary goals of producing, preserving and making accessible art historical knowledge. With the growing importance of digital technologies, information professionals can continue to advance these goals by supporting digital art history efforts.

Foremost, information professionals can provide training and access to digital tools. Many scholars lack formal training with digital technologies, including in specific software applications as well as general personal information management skills (Long and Schonfeld, 2014; Zorich, 2012). Librarians are especially poised to equip scholars with these skills through workshops or other training sessions. These authors also emphasize the importance of younger scholars and students gaining these skills, as digital technologies will become even more important to the field in future. As an example, Bruzelius (2016) describes the activities of the Wired! Group at Duke University, including the Visualising Venice summer programme, a two-week intensive workshop that has been held since 2010 in collaboration with the Architectural University of Venice and Venice International University. Participants collect data on-site and use a variety of digital tools to create dynamic, multimedia presentations.

For the benefit of students as well as faculty, information professionals can develop collaborative projects that integrate digital technologies into the classroom and curriculum. Bailey (2015) discusses a case study at Providence College in which librarians, art and art history professors and undergraduate students produce an annual journal in both analogue and digital formats, featuring work by senior art and art history students. This project affords students professional experience with analogue and digital publishing processes, helping them to learn about important issues like copyright and image use.

In addition to actively promoting the use of digital art history tools, information professionals need to preserve and provide long-term access to products of digital art history scholarship. As many of the above examples make clear, digital art history scholarship rarely results in traditional publication formats, but instead often generates dynamic and interactive products. Snyder (2012) identifies preservation as a critical challenge for complex digital art history research products like virtual reality models, noting that the burden of preservation often remains on the researchers. Art and design libraries can act as repositories for digital art history research products, and librarians can serve as stewards to ensure that these special research products are preserved and made accessible to future users. This audience is not limited to other scholars – these products appeal to a wider user base and hold the potential to engage students and the general public in new ways. Reflecting on an interactive map of ancient Rome, Meeks and Grossner (2012) remark on the potential for this project to be used as a pedagogical resource, both in the classroom and for a broader public.

Finally, art historians and information professionals need to collaborate with technologists and computer scientists to be an active voice in the development of tools (Klinke, 2016; Promey and Stewart, 1997). As discussed throughout this chapter, digital technologies hold enormous promise to advance the field of art history in exciting trajectories, but arts professionals need to assert themselves in developing these technologies to ensure that these tools will meet the needs of art historians, art librarians, curators and students. Computer scientists and technologists can also become valuable assets to art historical research projects, as is the case in many of the projects discussed above. Information professionals can facilitate these conversations and collaborations as they move between both worlds (Zorich, 2012). Art historians and information professionals have fostered a dynamic and vital diversity of digital practices, and continued efforts will serve only to strengthen the field of art history as a whole.

References

Bailey, D. (2015) Creating Digital Art History: library, student, and faculty collaboration, *International Journal of New Media, Technology & the Arts*, **10** (2), 1–10.

Bentkowska-Kafel, A. (2015) Debating Digital Art History, *International Journal for Digital Art History*, **1**, 51–64.

Bruzelius, C. (2016) Graduate Workshop on Digital Tools for Art Historians: the Visualizing Venice summer program, *International Journal for Digital Art History*, **2**, 219–21.

Drucker, J. (2013) Is There a Digital Art History?, *Visual Resources*, **29** (1–2), 5–13.

Drucker, J. (2014) *Graphesis: visual forms of knowledge production*, Harvard University Press.

Ellin, E. (1969) Museums and the Computer: an appraisal of new potentials, *Computers and the Humanities*, **4** (1), 25–30.

Favro, D. (2006) In the Eyes of the Beholder: virtual reality re-creations and academia. In Haselberger, L. and Humphrey, J. (eds), *Imaging Ancient Rome: proceedings of the Third Williams Symposium on Classical Architecture, 2004*, Journal of Roman Archaeology, http://introtodh2016.web.unc.edu/files/2016/11/Favro_2006.pdf.

Fletcher, P. and Helmreich A. (2012) Local/Global: mapping nineteenth-century London's art market, *Nineteenth-Century Art Worldwide*, **11** (3), www.19thc-artworldwide.org/index.php/autumn12/fletcher-helmreich-mapping-the-london-art-market.

Foni, A., Papagiannakis G. and Magnenat-Thalmann, N. (2010) A Taxonomy of Visualization Strategies for Cultural Heritage Applications, *Journal on Computing and Cultural Heritage*, **3** (1), 1–21.

Getty Art History Information Program (1994) *Humanities and Arts on the Information Highways: a profile.*

Hochman, N. and Manovich, L. (2013) Zooming into an Instagram City: reading the local through social media, *First Monday*, **18** (7), http://firstmonday.org/ojs/index.php/fm/article/view/4711.

Hristova, S. (2016) Images as Data: cultural analytics and Aby Warburg's Mnemosyne, *International Journal for Digital Art History*, **2**, 117–33.

Klinke, H. (2016) Big Image Data within the Big Picture of Art History, *International Journal for Digital Art History*, **2**, 15–37.

Lincoln, M. (2016) Social Network Centralization Dynamics in Print Production in the Low Countries, 1550–1750, *International Journal for Digital Art History*, **2**, 135–57.

Long, M. and Schonfeld, R. (2014) *Supporting the Changing Research Practices of Art Historians*, Ithaka S+R.

Manovich, L. (2009) *Cultural Analytics: visualizing cultural patterns in the era of 'more media'*, http://manovich.net/content/04-projects/063-cultural-analytics-visualizing-cultural-patterns/60_article_2009.pdf.

Manovich, L. (2015) Data Science and Digital Art History, *International Journal for Digital Art History*, **1**, 13–35.

Meeks, E. and Grossner, K. (2012) Modeling Networks and Scholarship with ORBIS, *Journal of Digital Humanities*, **1** (3), http://journalofdigitalhumanities.org/1-3/modeling-networks-and-scholarship-with-orbis-by-elijah-meeks-and-karl-grossner/.

Promey, S. and Stewart, M. (1997) Digital Art History: a new field for collaboration, *American Art*, **11** (2), 36–41.

Prown, J. (2001) *Art as Evidence: writings on art and material culture*, Yale University Press.

Schich, M. (2016) Figuring out Art History, *International Journal for Digital Art History*, **2**, 41–67.

Schich, M., Song, C., Ahn, Y., Mirsky, A., Martino, M., Barabási, A. and Helbing, D. (2014) A Network Framework of Cultural History, *Science*, **345** (6196), 558–62.

Snyder, L. (2012) Virtual Reality for Humanities Scholarship. In Nelson, B. and Terras, M. (eds), *Digitizing Medieval and Early Modern Material Culture*, Iter.

Vaughan, W. (1987) The Automated Connoisseur: image analysis and art history. In Denley, P. and Hopkin, D. (eds), *History and Computing*, Manchester University Press.

White, R. (2010) *What is Spatial History?*, Stanford University Spatial History Lab, http://web.stanford.edu/group/spatialhistory/cgi-bin/site/pub.php?id=29.

Zorich, D. (2012) *Transitioning to a Digital World: art history, its research centers, and digital scholarship*, Samuel H. Kress Foundation and the Roy Rosenzweig Center for History and New Media.

Zweig, B. (2015) Forgotten Genealogies: brief reflections on the history of digital art history, *International Journal for Digital Art History*, 1, 39–49.

Chapter 22

Critical cARTography: mapping spaces for dialogue about identity and artistic practices

Andy Rutkowski and Stacy R. Williams

Introduction

One of the most exciting aspects of digital mapping projects is their ability to speak to users and facilitate discussion. In many ways, printed maps can do the same thing. If you take a historical map of a city that shows population density and place it in front of a group of students or community members, it will not be long before a discussion begins on neighbourhood change, migration patterns, or visualization techniques and methods. In her introduction to *Infinite City: a San Francisco atlas*, Rebecca Solnit writes that 'every place is if not infinite then practically inexhaustible' (Solnit, Pease and Siegel, 2010, 2). As a result, maps provide a framework for interpretation, discussion and reflective thinking. In many ways, academic librarianship, much like a map, is rooted in providing information to an audience. The mechanism for this exchange of information is multi-faceted, and it can occur in a classroom, within collection development policies, at the reference desk, in a research guide, or during an online chat. This chapter asks, 'Why not use a map?'

The digital map-making process is one method for librarians to experiment in providing access to information and sharing that information to a wide audience of users. As digital humanities-based research becomes more prevalent in academia, how can librarians leverage some of the methods and tools used to create our own digital projects to advance emerging literacies and reframe our library collections for new audiences? Moreover, as we develop partnerships with faculty in the classroom, how can we become engaged in pedagogy that helps not only add value to, but also shapes a syllabus? The results of a recent international survey that asked questions of art and design librarians in higher education pointed to emerging tasks that 'relate to online communication and services' and concluded that 'librarians might serve as guides who create original information and direct users to supplemental resources' (Carpenter et al., 2010, 22, 27).

In the following pages, we hope to expand on this finding by discussing two mapping

projects that point to and highlight existing resources and offer a way for users to reinterpret these collections for their own research.

Some background or mapping it out

The following projects emerged from different opportunities but share in the conviction that librarians can help shape conversations around collections through direct and simple digital projects. An emphasis was placed on using free, open source, and easily accessible tools and software. One of the challenges facing digital projects is how to store and make accessible related data. In this area the project favoured using resources that are either available at our respective institutions or widely and freely available on the web. As a result, the authors stress the ephemeral nature of the digital and present their work not as a final document of record but as a starting point – one that brings to relief an issue or a problem and then points to other sources and ways of looking at the problem. Much like a conversation, the projects encourage questioning, engagement and reinterpretation. Digital maps can bring principles of information to visual and kinaesthetic learners effectively by offering them ways to 'physically engage with ideas' through the process of critical cartography (Wilson and McCarthy, 2010, 185).

The Los Angeles mural project

The Los Angeles mural project began in an urban humanities course at the University of California Los Angeles. Students were conducting research about downtown Los Angeles and were prompted to create their own maps of the area incorporating archival materials, census data, oral histories and other sources. One team began researching murals and sketching out an alternative history of radical art in Los Angeles. Part of their research process led them to different archival sources of murals in Los Angeles, including the Robin Dunitz Collection at the University of Southern California (USC) and the Nancy Tovar East LA Mural Collection at the University of California Los Angeles (UCLA). The difficulty encountered by the students resulted from how each institution provided access to the murals. Since they were not indicated on a map, the murals were not easily explored by their locations. The start of this project then was to take available metadata from each collection and develop a simple map viewer that displayed the murals. From this initial research interaction a larger project developed with several themes and goals:

- Co-locate murals on one single map from multiple sources.
- Improve metadata for each collection, especially location data.
- Provide a template and basic instructions so that users can either replicate this project or create their own selected map of murals.

Scope of the mural project

The initial scope of the project was limited by the availability and depth of the metadata associated with the collection. Key metadata in the Robin Dunitz collection for a selection of murals were latitude and longitude, which allow any item to be located precisely in space. However, more and more collections have benefitted from adding geographic co-ordinates to records during metadata creation. With this data mural locations were plotted so that a sample of the collection was viewable on a map.

After plotting the location for each mural, the authors, working with Yoh Kawano and Albert Kochaphum from UCLA's Institute of Research and Education, encountered a design challenge. Rather than a traditional marker (e.g. circle, star, flag) that showed where each mural was located, the authors experimented with embedding a thumbnail image at each location. The goal was to stir the imagination of the viewer multiple times with expressive icons, rather than simply offer a gallery of uniform 'image' icons requiring yet another click for the final image of an individual record. The solution offered users not only the visual sense that the map provided information on murals, but also glimpses of all unique records. Once this was complete the authors shared the map with students, who were able to use it as a tool to navigate through the collection.

The simple process of providing access to these murals on a map created the opportunity for spatial thinking about each mural's location and its respective relationship to the larger urban environment and other murals. The map helped shape dialogue on where murals were concentrated, where they were absent, and when they were created and documented. Moreover, it allowed students to consider the process of how the murals were documented initially, leading them directly to the Robin Dunitz Archive for further research.

The future of the mural project

What started as a simple project has slowly developed into a more comprehensive digital mapping project that considers space, identity and community, as murals are social and political statements giving voice to marginalized communities and individuals. Using basic mapping methods and technology, the project now aims to provide a better understanding of the neighbourhoods surrounding murals and the visual nature of the urban landscape overall. For example, given the saturated level of messages from advertisers, stores, street signs, fliers and other media, students can ask how these visual stimuli compete with the message of a mural. What does it mean if liquor stores surround a block with a mural about social justice issues? How can students learn to quantify and qualify aspects of the urban environment? Is it possible to analyse the frequency of foreign languages used in advertising to observe demographic shifts in a neighbourhood? The next step for the LA Mural Mapping project is to provide a model for archiving a neighbourhood with a mural in order to provide greater context and meaning for understanding its culture.

The Los Angeles County Art Museums Project (LA Muse)

The starting point for this project began with a list of 16 nearby museums in the resource section of the USC Department of Art History website. Orienting new students to the art history academic environment, this section also included information on local libraries for students to find research materials and professional organizations that they could join. When the authors first saw the list of museums, they thought they could easily improve it by placing the locations on a map and at the same time develop their skills in digital humanities. Questions from students who attended outreach events at USC Libraries' Helen Topping Architecture and Fine Arts Library also influenced the project. Besides asking questions related to library policies, spaces and research, students also had questions about where to explore the cultural and architectural history of Los Angeles.

The project evolved as new technological tools for instruction, for visualizing collections and for digital scholarship created new roles for librarians. In particular, digital scholarship allows for collaboration across disciplines and relies on collections of information and data (Cox, 2016, 133). With these possibilities, the project launched with the additional goal of developing new skills for art librarianship with tools that generate, gather and present visual information using maps, images and text.

Scope of the art museums project

The project began by identifying 21 art and cultural centres located in Los Angeles County. Many of the selected locations came from the list of art museums created by USC's Department of Art History. Other museums were chosen because of their neighbourhoods or the collections they contained. In *Discover Los Angeles: An informed guide to LA's rich and varied cultural life*, Kevin Starr wrote in the introduction 'every organisation in Los Angeles seems to want a museum' (1997, 10). The museums in the project represent the cultural diversity of Los Angeles as documented in the California African American Museum, The Getty, the Los Angeles County Museum of Art, the Hammer Museum and USC Fisher Museum of Art, among others. Initial preparation included using guidebooks on Los Angeles architecture, museum websites, historic newspapers, government documents, online city planning resources for Los Angeles, and library collections to find out more about museum development in Los Angeles. In assessing how to visualize the data, the project used Stanford's web-based data visualization tool Palladio, which, along with JuxtaposeJS, is a powerful and easy tool for use by art librarians with collections. Next, a CSV file in Google Sheets with metadata on each museum was run through Palladio, which allowed for plotting the data on a map, creating a timeline, or viewing images. Palladio forged a better understanding of the data and provided a bridge to other tools. The next step was to create a map using the location intelligence software CARTO with museum coordinates and to create timelines using TimeMapper and Timeline JS. By using JuxtaposeJS's image slider tool for

comparing two images, the project could reveal how museum buildings transformed public spaces (e.g. the sites of The Broad and The Getty) and show their development over time. The final step incorporated a LibGuides platform to create a guide that serves as a landing page for the project and provides access to each component.

The future of the art museums project

The goal of the LA Muse project is to adapt and collaborate with faculty, students and colleagues in creating an interactive space for using some of this location data in a positive way. While much of the project consisted of compiling background information on the museums for harvesting metadata and images, the greatest challenge is to create an audience for the project in the university community. The continuation of the project will require a deeper focus on communicating its potential impact on pedagogy in the classroom and on assignments. To this end, the project will explore open source network analysis tools to show relationships between organizations, collections and artists.

Digital infrastructure and ecosystem: lessons learned

The two projects use many overlapping software and technologies. Some common themes emerged, including the need to develop a stable and simple infrastructure requiring little maintenance and having minimal operating costs. The most essential tool for the projects is a website at which users can interact with the content on multiple levels: project background, an interactive map and access to data files. The projects differ in the locations of their content: one features the library content management system LibGuides, while the other uses GitHub, a web-based version control repository and internet hosting service. Although LibGuides is a subscription product, it has become part of the web infrastructure in many academic libraries. Both platforms provide easy organization of and access to digital content.

Another challenge is managing the creation, storage and exchange of data. Google Sheets is now widely available via academic Google accounts and through Google's public Gmail service. It provides the flexibility and features needed to administer most digital projects. In addition, for some of the tools used, such as TimeMapper and TimeLine JS, Google Sheets is fully integrated and must be used for creating a visualization. For others tools, such as local intelligence software CARTO, Google Sheets is one of several data management options for integration into the platform. The strongest recommendations for Google Sheets are a short learning curve and its collaboration feature.

A variety of user-friendly, replicable and accessible tools and software support the creation of maps, timelines and other visualizations. The authors recommend an approach focusing on how the tool impacts communicating a question or problem visually. For example, the challenge of telling a narrative history of museums in Los

Angeles could be met with a static web page with a traditional essay organized by dates and topics; or, it could be addressed with TimeMapper, which connects the narrative to a geographic location seamlessly. Each project met the objective of providing access to the data and methods for the sake of enabling others to reproduce, enhance or customize those data to fit their own needs.

Conclusion

Digital mapping projects have the potential to transform how we understand our roles as librarians. They offer meaningful engagement with academic communities by providing methods and resources, and provide a space for discussion and collaboration on a topic or research question. They fundamentally alter traditional roles in the process by shifting the emphasis towards active roles for librarians.

Visit the two projects LA Muse (http://libguides.usc.edu/lamuse) and Mapping Los Angeles Murals (https://muralcartographies.github.io/MuralsofLA/).

References and bibliography

Carpenter, C., Essinger, C., Bliss, L. and Resnick, A. (2010) Surveying Trends in Art Librarianship: evolving roles. In Gluibizzi, A. and Glassman, P. (eds), *The Handbook of Art and Design Librarianship*, Facet Publishing.

Cox, J. (2016) Communicating New Library Roles to Enable Digital Scholarship: a review article, *New Review of Academic Librarianship*, **22** (2–3), 132–47.

Houston, D. and Ong, P. (2013) Arts Accessibility to Major Museums and Cultural/Ethnic Institutions in Los Angeles: can school tours overcome neighbourhood disparities?, *Environment and Planning A*, **45** (3), 728–48.

Solnit, R., Pease, B. and Siegel, S. (2010) *Infinite City: a San Francisco atlas*, University of California Press.

Starr, K. (1997) Introduction. In O'Connor, L. B., *Discover Los Angeles: an informed guide to LA's rich and varied cultural life*, J. Paul Getty Trust.

Wilson, H. and McCarthy, L. (2010) Touch, See, Find: serving multiple literacies in the art and design library. In Gluibizzi, A. and Glassman, P. (eds), *The Handbook of Art and Design Librarianship*, Facet Publishing.

Chapter 23

More than just art on the walls: enhancing fine arts pedagogy in the academic library space

Rachael Muszkiewicz, Jonathan Bull and Aimee Tomasek

Introduction

Much attention has been paid in the academy to creating active learning environments both within and outside the classroom. This focus on experiential and problem-based learning has become widely adopted or at least attempted by many in a relatively short period of time. While active learning in the fine arts has long been part of curricula (studio art, sculpture), little attention has been paid to creating a complete picture of the fine arts industry, specifically introducing the students to the juried selection, finishing and purchasing processes. Many times, collegiate artists leave their institutions with degrees but have never sold a piece of art nor know how even to approach this process.

Similarly, academic libraries' spaces have become more collaborative in recent years, reflecting ever-changing curricula. However, with new technologies and collaboration areas, outreach and space design for scientific, social science and professional disciplines sometimes overshadow what the library could do for fine arts, specifically as exhibition space as well as curricular space.

This chapter outlines one initiative to include fine arts in the academic library space through a library-led and faculty-advised juried selection and purchasing process for fine arts students. The annual Student Art Purchase Award at Valparaiso University not only enhances fine arts students' business acumen through experiential learning, but also increases the versatility of the library as multidisciplinary learning space.

Experiential learning as pedagogy

While art in the library is not a new concept, experiential learning in the form of independent undergraduate research is, comparatively. As a pedagogy, undergraduate experiential learning has gained much momentum in recent decades across the academy, but until recently has been largely absent from the library (Chandra, Stoecklin and Harmon, 1998; Kremer and Bringle, 1990; Russell, Hancock and McCullough, 2007).

Previously, librarians concentrated instruction efforts mostly on course-related research with little differentiation between undergraduate research and traditional curriculum-based research (Stamatoplos, 2009, 239). In fact, because these undergraduate researchers do not adhere to a traditional curriculum, 'they can fail to recognise the potential value of interaction with librarians' (Stamatoplos, 2009, 239). Even if librarians have started outreach to independent undergraduate researchers, little has been done to examine the library as an experiential learning space, particularly for fine arts pedagogy.

Library as fine arts pedagogical space

Student fine arts pedagogy and student artwork in the libraries, especially academic libraries, has also become commonplace in recent years, but with only sporadic emphasis on creating experiential learning – a mixing of pedagogy and practice – for fine arts students. In one instance, visual arts students used scientific materials for inspiration to create artwork for one college's science library. This resulted in a rare case of art and science collaboration within a library setting, helping visual arts students study scientific material for practice purposes (Merolli, 2009).

For example, citing Dana's (1913) influence on artwork in the library, librarians at Rutgers University set up a multi-faceted arts programme, rotating a permanent collection of professional works of art and other fine arts pedagogical exhibits (Mullins and Watkins, 2008). They argue that this type of programme reinforces Dana's vision of a 'vital intellectual and cultural centre' for students and other library patrons. This scheduled shifting of professional artwork 'overcomes any language, cultural or economic barrier to provide the students an opportunity to interact with the art and learn about themselves', although the authors say little about the inclusion or exclusion of student artwork in their programme (Mullins and Watkins, 2008, 86, 84).

The library juried exhibition has become the most common instance of mixing pedagogy and practice within the library for fine arts students; however, few libraries have documented their processes. University of Tennessee Knoxville librarians started a competition specifically as a 'venue for the students, as opposed to staff or artists in the community', judged by library personnel (Beals, 2007, 56). The competition was open to all enrolled UT Knoxville students but was designed as only a temporary exhibit. While this public display of student artwork is an established practice, the students received practice in a juried submission process in addition to receiving greater exposure for their artwork (Beals, 2007, 58). Another example of using a juried submission process is an annual student art competition as a partnership between the Art Department and Reed Library at Fort Lewis College. The jury consisted of library personnel, while the art faculty members advised the students and the process (Oliver, 2012). This 'remarkably easy' collaboration between art and library personnel resulted in students gaining experience in the proposal writing and competition yet did not result in a permanent sale of the work (Oliver, 2012, 94).

Case study: the Student Art Purchase Award

The Christopher Center for Library and Information Resources (CCLIR) is a four-storey building at Valparaiso University, housing primarily Christopher Center Library Services (CCLS), including the University Archives and Special Collections and four other departments. It is a popular space on campus, with an average annual gate count of over 370,000. The building caters well to students' needs, providing natural light and evolving study spaces and furniture, but lacks original art. Apart from occasional CCLS and University Archives and Special Collections displays, the walls in the CCLIR are either blank or house framed low-cost art prints.

With the desire for original art, the Library could have reached out to Valparaiso University's Art Department to obtain faculty work or to the campus art museum, but it was important to library faculty to involve undergraduate students, as Valparaiso University is primarily a teaching university. But how does an academic library go about seeking art from current undergraduate students who are taking various art classes? Without a stable infrastructure for collection, would this collection be piecemeal and dependent on the students themselves? How could this be maintained beyond a one-time art procurement, perhaps deepening a connection with both the students and the Art Department? Library faculty decided to cement the process of acquiring student art by creating the Student Art Purchase Award.

An initial meeting in fall 2013 with the chair of the Art Department to discuss a possible annual award determined the high level of interest from both departments and established a timeline, requirements and pedagogy. The goal was to emulate a professional experience for these art students along with enriching the library facility. Both parties decided that an art award open to art majors and minors would be mutually beneficial. Applicants would present their artwork to a library selection committee; the presentation would detail the art itself and the plan and cost of framing the art, if selected. CCLS would provide funding to purchase the art as well as a committee of faculty and staff, permanent placement and storage of the art, an opening reception for the artists, and an online gallery to display digital images of the art via the CONTENTdm platform (http://collections.valpo.edu/cdm/landingpage/collection/studentwork).

The Art Department would put out the call for submissions, manage the applicants by counselling them on art pricing and finishing and how to present art professionally; it would also supply electronic copies of all art to the library committee. CCLS would hold the copyright to the artwork. The Dean of Library Services agreed to $1000 of annual funding, equal to endowing another library research award. Rather than using the funds to select only one art piece, the committee could purchase multiple pieces, as long as the budget was not exceeded.

Having received administrative approval, an entry process was created to mirror the practices of most juried art exhibits, with an expectation that students would learn this set of procedures, making them familiar and experienced with the professional entry process.

In the typical professional juried application process, it is rare that artists get to present their work in a public presentation, as would happen in a client–artist relationship. The Art Department and CCLS faculty felt it was in the students' best interest to make the presentation process a requirement. These few adjustments in professional practices were created to better suit the pedagogical mission of both departments as well as that of Valparaiso University.

A major component of this presentation hinged on revealing a budget for the potential purchase of the work. The student established the value of the actual piece of art along with the specific costs for framing, mounting and/or professionally finishing each individual piece. The details of anticipated finishing materials were expected in every presentation. Requiring this logistical budgeting component forced students to think about art creation in a way that was not being addressed in the classroom. Other elements of these presentations dealt with addressing dimensions, materials and explanation of content. These presentations were designed as an attempt to sell artwork to a potential buyer: CCLS. Although the Art Department has in place other venues to address each student's development as an artist, this event was created to expose participating students to a more commercial application of producing artwork.

The selection committee looked at various policies from other academic libraries and museums and crafted a student art collection policy that exemplifies the student experience at Valpo. This policy was deliberately broad so as to include many diverse works. In the second year of the award, the committee added a requirement for the students to address this diversity in their presentations.

Adding artwork to Valparaiso University buildings requires the approval of the University Space Planning Committee (USPC). For the first year, award winners' art pieces are displayed in the second floor fireplace lounge, a high traffic area on the main floor of the library (Figure 23.1 opposite). Initial permission for the lounge was granted by USPC per an e-mail request, but the permanent placement of the art pieces required further consideration. The Art Department chair assessed the CCLIR facility in regards to the long-term placement of the art pieces, considering the amount of space needed to keep the annual collections together, the lighting of the areas selected and how the space would fit the art and vice versa. After relaying this information to the USPC, the committee did not grant the library carte blanche for the project as it continues, but their continual permission is granted once a year with updated information.

Long-term storage of the art pieces was something that had to be considered by CCLS when implementing the award. While the chair of the Art Department's building assessment determined that the CCLIR has enough blank or replaceable wall space to house between 15 and 20 years of the art award winners, long-term success of the award would require storage planning. The CCLIR has an automatic storage and retrieval system on-site – with environmental protections – that is used to store books not currently in the stacks and other archival material. With storage bins that measure 8 sq ft, the majority of art pieces would fit easily and would be stored with archival supplies to avoid damage.

Figure 23.1 *Students assess the second group of Library Student Art Purchase Award winning artwork at the 2015 Student Artist Reception © 2015 Valparaiso University*

Benefits of the award from an art faculty member's perspective

The benefits to art students from the perspective of the art curriculum are numerous. Every art major learned about the entry process by observing their peers, even if they chose not to participate. These student observations support growth simply by creating an awareness of professional protocol. The selected students are held to the highest standards when it comes to finishing their art works. They are forced to acquire all of their finishing materials as well as the actual framing and matting of each piece. The quality of this framing was equal to that of any professional framer; this experience in finishing skills will prove to be beneficial in the long term for each student.

The art majors and minors applying for the award attended every presentation and had the opportunity to learn from their peers. The goal was to foster critical thinking about how students can speak more articulately about their work. Refining confidence and establishing clarity in a presentation about any creative work is an important component in understanding what drives any artist to make the work in the first place. University student learning outcomes are addressed specifically in this process for every participating student. Students whose art works were not accepted into the collection were notified and then had the opportunity to meet the Art Department chair to discuss and learn what improvements should be made in presenting their work and selecting works for future opportunities.

Ultimately this collection will serve as an important component in professional development for every one of these young artists. Students gain valuable experience concerning the application process, production and presentation of their own art works. Additionally, students can link to the online gallery as part of their CV or portfolios. The university community benefits as well. The CCLIR is a frequently used facility that draws the widest variety of faculty, staff and student interaction, along with members of the surrounding community, inviting a wide audience to comment on the work, which might never have a chance for a sizeable audience if housed in a traditional art gallery.

Benefits of the award from a library faculty member's perspective

This award has resulted in art students having a greater awareness of what the library can do for them, as fine arts students often do not use the library for research related to their creative work. The entire juried and purchasing process echoes the Association for College and Research Libraries (ACRL) threshold concept that information has value: 'Information possesses several dimensions of value, including as a commodity, as a means of education, as a means to influence, and as a means of negotiating and understanding the world' (2015). In this case, students' art is their information, and the library shows that information's value by exhibiting it on the walls of the CCLIR. It also demonstrates to students that their work can be a commodity and an influence; the finishing and invoicing process brings this from abstract to practical.

The student work is seen by much of the campus population as well as the external community. Having their artwork permanently displayed also gives the artists a life-long connection to the building, institution and local community. The celebration of student artwork during the reception brings attention to the collection and offers an equivalent celebration for these fine artists to the end-of-the-year research event associated with experiential learning in other disciplines, such as a research symposium or design expo. The student art in the CCLIR also shows, in a physical way, that the library is interested in students and their creative work.

Valparaiso University's role as a teaching institution is reflected in the library's relationship to and reputation among students. As Kam (2001, 14) states, 'By collecting art objects, we exercise our role as key cultural players in society while also reinforcing our institutional identities.' An art piece in the library is viewed differently in its intended purpose than it would be viewed in the student union or in the university chapel. Each observer sees this visual representation as one way the library affects student lives.

Benefits of the award from an art student's perspective

The students who participated in the award process were asked about their experiences in an anonymous survey. The responses showed that the award is beneficial, including positive comments about the framing, selling and finishing of the pieces. When the students were asked about their views on the CCLIR and if they had changed after their

art award experience, the consensus was that their views had changed for the better, with one stating they have 'a deeper relationship' with the library, while another commented on the library's 'pursuit of quality' and 'diversifying the education experience' not offered elsewhere on campus.

Students were also asked if they felt that this award was a real collaboration between the library and the Art Department to make the library a more beautiful place. The responses were unanimously positive, with one student elaborating that 'more departments should follow the example and work with the Art Department and the library'. The Valparaiso University student newspaper *The Torch* echoed this in its story covering the first year's reception: 'This new award has proven to be an exciting opportunity for aspiring artists and good for the library and the community to show their support for what these students do' (Crapitto, 2014, 9).

Future plans

Currently the award is limited to two-dimensional art so it fits the available display and storage space. The challenge of obtaining and displaying three-dimensional or digital art on-site will be evaluated continually by CCLS and the Art Department. The department offers several courses that give students experience in creating three-dimensional works that are not currently considered for selection. There should be a commitment to display electronic media and to obtain the proper equipment necessary to showcase such work. These limitations need to be resolved in an effort to better accommodate all art majors. As wall space becomes limited and art pieces go into storage in the automatic storage and retrieval system, CCLS will also need to develop a policy for the rotation of the art.

Conclusion

While this project has difficult aspects, and the funding challenge may be prohibitive to many libraries, the overall experience is beneficial for all stakeholders. The Art Department and its students benefit equally from the experiential learning, which was not covered previously within the curriculum. CCLS is able to support a group of students in a new and unique way and obtains original art for its walls. It also 'invite[s] attention, inquiry, study', as Dana articulated (1913), for all library patrons. All who view the art in the CCLIR are made aware that the library and the Art Department hold student work in high esteem. This partnership can be modelled in any academic library that has display space, a source of some funding, art majors and minors, and the willingness to collaborate between departments.

The Student Art Purchase Award allows CCLS to show that its interest in pedagogy goes beyond a more narrow view of information literacy to the new, broader threshold concepts. Academic libraries are about all forms of information, including creative expressions. After four successful years, the Student Art Purchase Award is already a

permanent fixture for art majors and minors, and CCLS continues in its role as client and an intrinsic part of a collaborative pedagogy.

Within a traditional classroom setting, students may be taught the process of developing a client–artist relationship, finishing a piece of art, presenting in a juried environment, and creating invoices and bills. They may even observe their fine arts instructors go through the process. But unless students experience it for themselves, outside class, interacting with real clients, this knowledge remains theoretical. An approach such as the Student Art Purchase Award is experiential learning that has positive implications for the art students' professional readiness.

References and bibliography

ACRL (2015) *Framework for Information Literacy for Higher Education*, Information Literacy Competency Standards for Higher Education Task Force, Association for College & Research Libraries, MW15 Doc 4.1, http://acrl.ala.org/ilstandards/wp-content/uploads/2015/01/Framework-MW15-Board-Docs.pdf.

Beals, J. (2007) Student Art in the Library Juried Exhibition Program, *Art Documentation: Bulletin of the Art Libraries Society of North America*, **26** (1), 56–8.

Chandra, U., Stoecklin, S. and Harmon, M. (1998) A Successful Model for Introducing Research in an Undergraduate Program, *Journal of College Science Teaching*, **28** (2), 113–16.

Crapitto, P. (2014) Library Celebrates Student Artists, *The Torch*, 2 May, 9, www.valpotorch.com/features/article_fd5866f8-d242-11e3-86ed-0017a43b2370.html.

Dana, J. (1913) Print Collections in Small Libraries, *The Print Collector's Quarterly*, **3** (1), 61–9.

Kam, D. V. (2001) On Collecting and Exhibiting Art Objects in Libraries, Archives, and Research Institutes, *Art Documentation: Bulletin of the Art Libraries Society of North America*, **20** (2), 10–15.

Kremer, J. and Bringle, R. (1990) The Effects of Intensive Research Experience on the Careers of Talented Undergraduates, *Journal of Research & Development in Education*, **24** (1), 1–5.

Merolli, B. (2009) Student Art as Construction Beautification, *Library Journal*, **134** (9), 22–3.

Mullins, L. and Watkins, A. (2008) Using Art to Promote Student Learning and Build Community Partnerships, *Urban Library Journal*, **15** (1), 83–7.

Oliver, A. (2012) Strengthening On-Campus Relationships via an Annual Student Art Commission, *Journal of Library Innovation*, **3** (2), 89–104.

Russell, S., Hancock, M. and McCullough, J. (2007) Benefits of Undergraduate Research Experience, *Science*, **316** (5824), 548–9.

Stamatoplos, A. (2009) The Role of Academic Libraries in Mentored Undergraduate Research: a model of engagement in the academic community, *College & Research Libraries*, **70** (3), 235–49.

Valparaiso University (2016) *University Student Learning Objectives (USLOs) Task Force – Fall 2015–Spring 2016*, www.valpo.edu/provost/files/2014/06/University-Student-Learning-Objectives-Final-Report_Spring-2016.pdf.

Chapter 24

Beyond the monograph? Transformations in scholarly communication and their impact on art librarianship

Patrick Tomlin

Introduction

The Association of College & Research Libraries (ACRL) defines scholarly communication as 'the system through which research and other scholarly writings are created, evaluated for quality, disseminated to the scholarly community, and preserved for future use' (ACRL, 2006); it is the bedrock of the academic enterprise. Encompassing both formal and informal channels for the exchange of information, it extends across disparate disciplines and bridges distinct areas of expertise. It is the means by which existing scholarly knowledge is consumed, interpreted and reciprocally transformed through new scholarship.

The academic library's role in this process is substantive. By providing access to published scholarship, whether in print or electronic form, library collections increase the potential points of contact between authors and their audiences. In doing so, the library acts as a seedbed for the research of other scholars, thereby furthering the creation of new scholarship and perpetuating the scholarly communication life cycle. It thus occupies a critical point along the scholarly communication chain.

Over the past 30 years, however, scholarly communication has become unmoored from the institution it serves. This phenomenon was initially masked by the rapid expansion of academic specialization and an overall growth in library budgets in the decades after World War 2 (Henderson, 2002). Today the effects of that detachment are more readily apparent. Trends in scholarly publishing, particularly the adoption of for-profit business models, have made the library's ability to provide access to the ever-expanding volume of scholarly material increasingly problematic. Scholarship has taken on the unique identity of a commodity, one in which universities frequently invest twice: once when funding the research of faculty and students, and again when their libraries purchase that research on publication. At the same time, the proliferation of digital technology and informal internet-based networks for communication has led to

powerful new models, cheaply maintained and freely accessible, for conducting and disseminating research beyond conventional academic channels, many of which bear little resemblance to the book or article format. Indeed, it is in part the wide-ranging properties of the digital environment – its capacity for inexpensive, fast and decentralized reproduction of information – that has thrown many of the less attractive aspects of traditional scholarly publishing into relief.

This chapter examines the changing nature of scholarly communication and the burgeoning impact of those changes on the art and design library. It focuses specifically on the traditional system of scholarly publishing and the alternatives that are now challenging it. Throughout, it situates art librarianship, which has thus far remained on the margins of discussion about scholarly communication, within the broader economic, institutional and technological of producing, disseminating and preserving scholarly content. While developments such as open access have their origins in disciplines seemingly far removed from the sphere of the arts, they nonetheless pose pressing questions for the profession about access and ownership, authority and professional identity. Their gravitational pull has already begun to exert a subtle but undeniable influence on everyday practice.

This chapter introduces the various components of the scholarly communication debate and suggests how art librarians might best contribute their particular skills and knowledge to shaping the course of that debate.

Art libraries and the crisis in scholarly publishing

Any introduction to scholarly communication would be incomplete without some discussion of the 'serials crisis', a term used to encapsulate a nearly four-decade-long process in which library funding has consistently failed to meet the rapidly rising costs of journals. Although stemming from the pricing and licensing habits of specific commercial publishers in the fields of science, technology, engineering and maths (STEM), the economic effects of the serials crisis now reach across all disciplines, and it has framed library-based discussion of scholarly communication reform from the beginning (Panitch and Michalak, 2005).

Much attention has been paid to the contradictory economics of academic publishing. On the one hand, most scholars give away their research when they publish it. In place of immediate monetary compensation, they reap the benefits attendant with having one's ideas circulate in the academic sphere: the work is cited and built on by other scholars, which leads to professional prestige, career advancement and potential salary increases, in addition to whatever broader societal recognition of the intellectual or historical value of that work might accrete. In theory, then, the more avenues that exist for increasing access to an author's scholarship, the more that author benefits.

On the other hand, scholarly publishing has grown increasingly corporate in its structure and purpose, with all the drive to maximize profit and minimize investment loss

that such an identity suggests. Once the domain of scholarly societies and universities, the infrastructure for the formal publication of research has been gradually absorbed by the consolidated sphere of commercial publishing. Through gradual but continual mergers and acquisitions of society publishers, four corporate publishers – Reed-Elsevier, Springer, Wiley and Taylor & Francis – publish and own approximately 45% of all peer-reviewed journals, most of them in the STEM disciplines (Crow, 2006; McGuigan and Russell, 2008). In 2006 these publishers accounted for more than half of the $16.1 billion in revenue in periodicals in the USA, and produced more than 60% of materials indexed by the Institute of Scientific Information, the world's most comprehensive citation index (Willinsky, 2009). The consolidation of corporate academic publishing has proven a formidable challenge to society and university publishers unable to draw on the same level of capital and marketing and has repeatedly resulted in rising subscription prices. In fact, according to scholar Peter Suber, journal prices have increased four times faster than the general rate of inflation for nearly two decades (2004). Data prepared by the Association of Research Libraries (ARL) shows that journal prices per subscription rose 215% between 1986 and 2003, while the number of serials purchased by libraries decreased by 6% (Association of Research Libraries, 2004). In 1994, journal subscriptions comprised 51% of university library expenditures for information resources in the USA. By 2012, this number had increased to 69% (Publishers Communication Group, 2015).

Coupled with the dominance of licensing practices such as the so-called 'Big Deal', in which commercial publishers offer steeply discounted but heavily regulated online access to a large number of their journals and electronic resources, a mounting number of librarians now find themselves with limited funds for a system over which they have less and less control. Unable to cancel individual subscriptions to journals of low use or marginal relevancy to their institution's research programmes, and having in many cases already cancelled other print subscriptions to reduce expenses, many libraries are now bound to accept publishers' terms simply to maintain access to the materials their researchers need (Blecic et al., 2013; Frazier, 2001).

The STEM disciplines have inarguably shouldered the greatest consequences of these conditions. But although cost escalation has not been distributed equally between the disciplines – art journals are still far cheaper than their counterparts in the sciences – the general rate of inflation in the arts has remained comparable. In 2016 the average annual subscription price for a physics journal was $4508, an increase of 58% from 2006; the average annual subscription price for a chemistry journal was $5105, an increase of 56% in the same period. In marked contrast, the average annual subscription price for an art or architecture journal in 2016 was $496. Nevertheless, this figure represents a 168% increase in cost over art journal subscriptions for 2006, and a 6% rise over art serials prices for the previous year (Bosch and Henderson, 2016; Van Orsdel and Born, 2006). Library budgets strapped by increases in core serial prices in the STEM disciplines invariably result in a reduction in other expense areas, including the acquisition of generally less expensive art and design materials.

Perhaps more importantly, discussion so heavily framed by serials costs also ignores the different value the STEM disciplines and the arts and humanities have historically placed on their various forms of scholarly communication. Critical differences exist in their disciplinary cultures, which have in part shaped the arts' response to the serials crisis and to the newer models of scholarly communication discussed in the following section. Art and design scholarship remains deeply invested in the printed monograph in particular, both as a model of exhaustive research and sustained argumentation and as a means for professional advancement. But because the 'crisis' has been viewed principally through the lens of serials, disconcerting trends within arts publishing have been almost entirely overshadowed and subsequently unaddressed even by those arts scholars and librarians most engaged in the current system of scholarly communication.

Lawrence McGill of the Center for Arts and Cultural Policy Studies at Princeton University, for example, has demonstrated that the rate of art history monographs published annually by university presses has slowed dramatically over the past decade, and now faces a long-term decline for the first time since the early 1990s. As indicated in his 2006 study of scholarly publishing in art and architecture, the number of titles in the arts published by university presses declined by 16% (from 565 titles to 472) between 2000 and 2004 and has since shown little sign of changing. In addition, art historical monographs account for a mere 3% of all university press publications, and eight university presses have constituted 57% of that figure over the past 50 years (McGill, 2006).

Although different in many respects, scholarly publishing in the arts mirrors its counterpart in the sciences in at least one crucial respect: commercial publishers now sustain the very product formerly subsidized by universities, whose presses are now forced to act as autonomous financial units and whose libraries are unable to maintain the quantity of purchases they once did.

The two-decade sequence of progressive growth followed by measured decline in scholarly art publishing parallels an overall slowing of scholarly publishing in the humanities. But it also speaks pointedly to the high costs associated with producing an illustrated book. Art books require illustrations, and illustrations incur costs that do not exist for books in other disciplines. Press editors surveyed by Ballon and Westermann (2006) put the total cost of a standard 300-page hardcover art history title, from proofs to publication, at approximately $41,400. This figure stands in stark contrast to the estimated $23,000 that a university press invests in publishing a hardcover book without illustrations. As a result, many presses are turning to monographs with less specialized topics and broader commercial appeal in an attempt to increase revenues. As Herman Pabbruwe, chief executive officer of Brill Publishing, has succinctly stated,

[Y]ou need to be very good in art history publishing to make a living without subsidies and without really going belly up. It's dangerous stuff. Art historians love photography; they love the book as an object. We're all used to colorful, big, fat

books, museum catalogues at low prices. It remains to be seen if more parties can step in and do all this work – the preparation of an art history book can easily take three to four years – and then still come out whole. So it is a challenging field, much more challenging than text-based humanities publishing in general.

(Cited in Holly et al., 2006, 44)

Still other points of stability for the scholarly art book are eroding. Commercial booksellers stock fewer academic art history texts. Some large-scale museums have, with some controversy, replaced shelf space once designated for books with exhibition-related merchandise (Lyon, 2006; McDermott and Dunigan, 2013). On average 300 copies of a university press art book can now be expected to sell, less than half the amount from a decade ago (Howard, 2006).

Illustrations are costly for more than the publisher, of course. An author needing high-quality images for a book-length study might pay up to $10,000 in permissions fees – the publisher very rarely covers image-associated costs – and that figure can easily double for a heavily illustrated text (Indianapolis Museum of Art, 2015, 204). Securing permissions for reproductions frequently entails navigating a landscape populated by an unusually varied ensemble of copyright holders and image providers: museums, galleries, artists, their estates, artists' rights societies, collectors and dealers. Scaling the terrain of art publishing involves entering a daunting thicket of intellectual property law and proprietary preoccupations (Bielstein, 2006). Arguably more insidious are the costs to access this culture. Although copyright law is justly designed to protect the intellectual and commercial interests of the artist, the pseudo-copyright control of reproduction use that many museums and individuals assert over authors necessarily restricts the circulation of scholarship using images (Bielstein, 2006). It treats research that does not generate profit as if it did, fostering a climate that obligates authors to seek permission for any use, including some that exist squarely within the domain of fair use, and inhibiting the potential to reach wider audiences.

In short, while much has been written about an omnipresent serials crisis, of greater concern to scholars and librarians in the arts is an imminently pressing 'monograph crisis'. The decisions of a small but powerful number of commercial publishing entities now play a strikingly significant role in shaping the collections of libraries and quite possibly the composition of academic departments. When academic presses and commercial publishers are forced to ask whether the manuscript will find a market to justify the mostly unrecoverable expense of its production, the resulting decision invariably, if invisibly, shapes the direction of the field itself. If all this sounds a bit conspiratorial, consider that the number of PhD degrees conferred in art history has risen by more than 66% since 1990, or about 8% per year (McGill, 2006). Despite the ease with which information is now disseminated in the digital age, the points of contact between a growing community of scholars and their audiences seem to be diminishing rather than increasing. What began as an issue of financial cost for libraries has evolved into

something more: a question of access and of who controls the production and dissemination of research.

Open access

If scholarly communication has faced its share of obstacles impeding the circulation of research over the past four decades, it has also witnessed unparalleled opportunities for advancing the processes of research and learning. From the beginning, the corporatizing of scholarly publishing has coincided with the efforts of an international array of academic and cultural institutions engaged in creating tools to expand access to knowledge. The subsequent emergence of these resources – digital archives, full-text collections and e-books, online data sets, search engines and multimedia websites – has transformed not only where research can be conducted, but also who can conduct it (Maron and Smith, 2008). By using the networked functionality of the web to extend access to research materials around the world, in many cases enhancing that content with customizable and interactive features in the process, these tools present substantial counterpoints to the ongoing erosion of scholars' access to the traditional infrastructure of academic publishing.

Among the most promising alternatives to the traditional system of scholarly publishing is open access. Simply put, open access entails permanent access to online scholarly literature that is free for readers and free of most restrictions limiting use (Suber, 2004). While the open access movement acts on a scholarly tradition that has long been concerned with extending the circulation of knowledge (Gúedon, 2001), the concept itself received formal expression only in 2001, during the first meeting of the Open Society Institute, an international organization of scholars, librarians and publishers. Convening in Budapest, the Institute characterized open access scholarship by:

> its free availability to the public internet, permitting any users to read, download, copy, distribute, print, search, or link to the full texts of these articles, crawl them for indexing, pass them as data to software, or use them for any other lawful purpose, without financial, legal, or technical barriers other than those inseparable from gaining access to the internet itself. The only constraint on reproduction and distribution, and the only role for copyright in this domain, should be to give authors control over the integrity of their work and the right to be properly acknowledged and cited. (Budapest Open Society Institute, 2002)

This description neatly delineates the unique intersection of technological, economic, legal and scholarly concerns that gave rise to the open access movement. The Budapest convention produced two strategies for achieving open access to scholarship that have since remained central. The first (often called the 'gold road') entails two possible actions: new open access peer-reviewed journals are created, performing the same function as

traditional journals but shifting costs associated with publication away from the subscriber, or existing subscription-based journals make the switch to open access, becoming freely accessible. In the second option (referred to as the 'green road'), authors 'self-archive' electronic copies of preprints or peer-reviewed postprints by depositing them in online institutional or disciplinary repositories. The first strategy alleviates the barriers to access erected by the existing system of scholarly publishing while simultaneously preserving its principal element, the journal. The second relies on the interoperability of the networked digital environment to provide access to archivable materials representing the full spectrum of scholarly literature.

Open access focuses on scholarship produced without expectation of payment, a fact that results in numerous additional benefits. For libraries and universities, the most immediate advantages of participating in open access – whether by linking to open access content in library catalogues, hosting institutional or disciplinary repositories, or publishing open access scholarship – are related to reducing prohibitive materials costs and eradicating restrictive licensing arrangements like the 'Big Deal'. Because open access content is available to all, libraries do not face the burden of licensing negotiations and publisher contracts that effectively minimize circulation in order to maximize profit. Because open access content is hosted online, distribution of copies takes place at a cost proportionate to the initial digitization of the document and the fractional costs of server space and site maintenance. And because access is perpetual – admittedly a shifting concept online – libraries can provide or link to content without worrying about violating copyright or licensing agreements, future subscription cancellations, access embargos or inflation. Through open access the academy can once again leverage its central place in the scholarly communication cycle without having to worry about the bottom line (Bailey, 2006; Suber, 2016). Put differently, the open access movement turns the dominant economic model for scholarly publishing on its head: the more that libraries invest in increasing access to scholarship, the less they will have to spend for that access.

For scholars, open access provides immediate access to a potentially global storehouse of knowledge while, as multiple studies have proven, increasing the visibility and potential impact of their own work as much as 50% to 250% (Antelman, 2004; Harnad and Brody, 2004). It accomplishes this in large part by returning control over access to authors. Although most publishers require the signing of a copyright transfer agreement before publication, thereby relinquishing the economic and use rights inherent in authorship, the majority of open access journals allow authors to retain those rights. To this end, a number of organizations have developed practical, easily implemented 'open' alternatives to existing copyright and licensing structures. The international Scholarly Publishing and Academic Resources Coalition (SPARC), developed by the Association of Research Libraries, offers a licence addendum, which modifies publishers' agreements to grant authors retention of non-commercial re-use rights to their published work. Similarly, the multiple licences developed by the non-profit Creative Commons organization provide a variety of options whereby authors and artists can regulate use of

their work by others while still enabling free access to it. Both have already been used by the two largest open access publishers in the sciences, the Public Library of Science (PLoS) and Biomed Central.

The open access movement has experienced extraordinary successes in the STEM disciplines, where the negative ramifications of the corporatizing of scholarly publishing have been most obvious. Self-archiving of articles in astronomy and several other STEM fields, for example, approaches 100%, with little effect on subscription-based journals (Corbyn and Reisz, 2009). Adoption of open access practices in the arts and humanities, by comparison, has been much slower. There are various reasons for this resistance, many of them, again, stem from differing disciplinary cultures. For one thing, the open access movement's historical focus on the journal as the principal vehicle for scholarly communication reform is less immediately relevant to disciplines like art, art history and design, in which the monograph fulfils that function.

As anyone who has attempted to weed an art library's collection well knows, the information found in art books can remain relevant to scholars for decades, even centuries, resulting in a 'shelf-life' far lengthier than scholarship in most other disciplines. Author-paid publishing fees, the dominant funding model for major open access science publishers like Biomed Central and PLoS, are almost wholly absent in arts and humanities scholarly publishing, as is submitting preprints to online repositories, also a common practice in the hard sciences (Jöttkandt, 2007). For that matter, few government agencies fund humanities research and can therefore stipulate public access to the results. That open access content is made freely accessible on the web, where it is subject to the (potentially limitless) copying, duplication and redistribution inherent in digitization, further complicates the already complex intellectual property system currently regulating art reproductions in publications.

Perhaps harder to dispel is a lingering suspicion of digital publishing, which many faculty in the arts still consider less scholarly than its print counterpart, even as they have begun to rely heavily on digital resources to meet their research and teaching needs (Whalen, 2009). But because online-only academic journals are still a relatively new phenomenon, they have been frequently characterized by critics as falling short of existing standards for editing and peer-review. As Steven Harnad, one of the movement's founders, makes clear, the latter misgiving is particularly unfounded: 'Peer review is medium-independent, but the online-only medium will make it possible for journals to implement it not only more cheaply and efficiently, but also more equitably and effectively than was possible in paper' (Harnad, 2000). Despite these hurdles, open access in the arts is undeniably gaining momentum.

Still, the growth of peer-reviewed open access journals in the arts is undeniable. At the time of writing there are roughly 9400 peer-reviewed journals listed in the Lund University Libraries' *Directory of Open Access Journals*, the most comprehensive global index of peer-reviewed open access journals. Of these, 97 belong to its fine arts category. (History, by comparison, contains 129 journals.) This number points to the sheer diversity

of publications that have managed to thrive in the open access environment. The majority of these open access journals pass no publication costs to contributors. They are peer-reviewed and free for the reader. Authors retain the copyright to their articles and thus the ability to archive, distribute and re-use postprints on their personal or departmental websites. Notable examples include *Nineteenth-Century Art Worldwide* (www.19thc-artworldwide.org/), one of the first open access journals in art history, and *British Art Studies* (www.britishartstudies.ac.uk/), jointly published by the Paul Mellon Centre and the Yale Center for British Art.

Additional open access models have succeeded in other disciplines. Several long-standing academic presses have successfully experimented with open access, either transitioning existing toll-access journals (Oxford, MIT) or creating new, completely open access journals (University of Michigan). Many other publishers make online copies of articles or entire journals freely available while retaining print copies available for purchase or subscription. Disciplinary archives such as The Kultur Project (http://kultur.eprints.org), based in the UK, also provide artists and authors opportunities to circulate and preserve examples of their work electronically. As of 2016, more than nearly 600 universities and research institutions around the world have introduced policies recommending or requiring scholars to deposit copies of published articles in institutional repositories, ensuring that open access can co-exist with traditional scholarly publishing and that it will remain an important talking point in scholarly communication debates. The Registry of Open Access Repository Mandates and Policies provides a unified source for policies adopted by universities and other centres of scholarship (ROARMAP).

Nevertheless, the bulk of open access activity in the arts looms on the horizon, more as tantalizing possibility than certain bet. From an art historian's perspective, open access does not require a radical alteration of established practice; many already research, edit and referee articles, nearly always for free as a service to the field. But because the present system appears to provide adequate levels of access and impact, and because most art historical research is not government funded and therefore not bound by the mandate of public access, the adoption of open access practices seems less urgent there.

Movement is occurring, however, and as more of those involved in arts scholarship comes to understand the issues, progress will continue. For example, a growing number of museums have made high-resolution images of public domain works in their collections free for scholarly use. A 2007 partnership between the Metropolitan Museum of Art and the digital art library Artstor led to the creation of Images for Academic Publishing, a service developed to meet the museum's desire to supply images to scholars for publications without fees; the partnership now includes ten institutions, and Artstor itself makes its images available for free for non-commercial, scholarly and teaching purposes.

A 2013 Mellon Foundation survey of 11 museums with open access image policies found that, while approaches to open access varied from one institution to the next, all

viewed providing fee-free images as essential to their educational and cultural mission. The decision to provide open access to reproductions of works is often less a technological, financial or even legal decision than a philosophical or civic one, though such considerations certainly come into play (Shulman, 2014). Ken Hamma (2005), former Executive Director for Digital Policy and Initiatives at the J. Paul Getty Trust, notes that many museums:

> assume that an important part of their core business is the acquisition and management of rights in art works to maximize return on investment. That might be true in the case of the recording industry, but it should not be true for nonprofit institutions holding public domain art works; it is not even their secondary business. Instead, restricting access seems all the more inappropriate when measured against a museum's mission – a responsibility to provide public access.

Just as scholars, publishers and academic institutions are rethinking their place in the scholarly communication ecosystem, so too are museums redefining their relationship to, and responsibilities for, the production of art and design scholarship.

New measurements of impact

If emerging forms of scholarly communication have broadened the possibilities for access to scholarship, measuring the impact of that scholarship in the digital age raises its own set of questions. The web obviously has the potential to expand the reach of scholarship far beyond, and far more quickly than, that of print. Yet how might scholars track and gauge the reach of their research in this environment? If an art historian writes a blog post relaying a newly discovered painting by Leonardo Da Vinci that is then read by thousands around the world in a matter of days, how might its influence as scholarship be properly evaluated?

Altmetrics presents at least a preliminary answer to such questions. Coined in 2010 by doctoral student Jason Priem, 'alternative metrics' track scholarly content on the social web via its inclusion in tweets, social bookmarking sites, mainstream media sites, journal websites and reference-sharing applications, as it is downloaded, viewed, liked, tagged, shared, posted and cited (Priem, Piwowar and Hemminger, 2012). As an alternative, or at least complement, to traditional bibliometrics based principally on the standards of citation counts and academic journal impact factor criteria, altmetrics allows for the collation and comparison of both article-level data and information about non-article forms of scholarship existing only on the web. Much like open access, altmetrics is predicated on the degree of openness and accessibility of information made possible by the internet.

In practice, altmetrics can take a variety of forms. Altmetric (www.altmetric.com), one of the leading providers of altmetrics data, employs a scoring system based on aggregated usage data from existing online repositories and citation management applications. Other models, such Impactstory (https://impactstory.org/), allow individual scholars to create

their own profiles for monitoring interest in their scholarship. Still other advanced altmetrics tools such as Plum Analytics (http://plumanalytics.com/) track and compare the impact of entire research centres, academic departments and institutions around the world, going beyond the individualized scope of other services. Moreover, recent acquisitions of existing services by commercial publishers like Elsevier and EBSCO – the latter acquired Plum Analytics in January 2014 – provide further integration of altmetrics into subscription-based databases and resources and point to the normalization of altmetrics as a recognized counterpart to bibliometrics. They paint a broader picture of the footprint of scholarship online – if not necessarily measuring its quality, nonetheless giving an indication of the attention devoted to it (Crotty, 2014).

Like open access publishing, these and other altmetrics services initially arose to meet the needs of STEM scholars; accordingly, they focus heavily on those disciplines and their specific forms of scholarly communication, particularly journal articles and preprint and postprint repositories. But altmetrics also holds unique potential for the research output of arts and design disciplines. Although the monograph and journal article is likely to continue to serve as the principal mechanism for disseminating research in fields such as art history, it has long been obvious to those in contiguous arts and design disciplines that citation counts and journal impact factors do not easily apply to 'non-traditional' scholarly or creative works such as paintings, videos, performances and built works. Because of the diversity of formats that artists and designers use to disseminate their work and their reliance on indicators of impact other than citations, they stand to benefit uniquely from the insights on impact offered by altmetrics.

Although a subject beyond the scope of this chapter, it bears pointing out that the emergence of altmetrics necessarily coincided with the concurrent growth of collaborative scholarly communication networks on the web that allow for the posting and sharing of both formally and informally published research. These resources, ranging from Mendeley (www.mendeley.com/) and Academia (https://www.academia.edu/) to Google Scholar (https://scholar.google.co.uk/), allow researchers to build profiles for themselves and internet users to discover their work. And altmetrics and scholarly networks have been enabled by a third development: the creation of persistent, unique scholarly identifiers for scholarship on the web. Attached to and managed by individual scholars, identifiers reduce errors introduced by changes in authors' names or different versions of articles, allow authors to track the citation of their scholarship, and facilitate linkages between scholars and their professional activities. Examples of persistent scholarly identifiers include ORCID (https://orcid.org/), ResearcherID (www.researcherid.com/) and Scopus (https://www.elsevier.com/solutions/scopus).

The role of art librarians in emerging models of scholarly communication

How might the fields of art and design come to play a greater part in alternatives to the

present system of scholarly communication? And what role should the art and design librarian play in that process?

It seems certain that traditional publishing models will continue to co-exist alongside new models of scholarly communication for the foreseeable future in art and design disciplines. In a report for the Kress Foundation, Diane Zorich revealed the uneven contours of scholarly communication in disciplines such as art history. Although digital art historical scholarship has existed since the 1980s, the field has been consistently marked by what she terms a 'disciplinary introversion': art historians face multiple obstacles to adopting digital publishing formats and research tools, ranging from a long-standing paradigm of solitary, individual scholarship and a privileging of print publication to an entrenched scepticism about the actual impact digital scholarly tools are capable of making (2012).

No digital publication models currently exist that enable free and global access to scholarship while simultaneously shielding scholarly publishers from charges of copyright infringement. As Susan Bielstein has made clear, there is evident urgency to strike a balance between the interests of rights holders, image providers, publishers and authors so opportunities are ripe for art librarians and other art information professionals, who have long been at the forefront of the fair-use argument for access to copyrighted works, to create venues in which open communication between arts scholars, libraries, scholarly societies and cultural institutions can take place (2006).

Even as digital repositories, collaborative scholarly networks and open access publishing lead to new formats for scholarship, it appears likely that the monographic format will continue to have a role in shaping authors' commitments to future scholarly communication endeavours, given its long history in arts scholarship. In 2008 the electronic-only Open Humanities Press committed to a monograph series continuing the broad critical theory focus of its journals. UK-based Bloomsbury Publishing has projected more than 50 open access monographs in the humanities and social sciences over the next few years. And at least one open source monograph publishing platform, the Public Knowledge Project's Open Monograph Press, is available (Willinsky, 2009). Multiple academic presses, including Cambridge University Press and Oxford University Press, have initiated open monograph projects.

The print art book is itself a material artefact that, because of the images it contains, frequently possesses value for scholars – aesthetic, symbolic and thus perhaps unquantifiable – quite separate from the informational significance of its content. Art historian Catherine Soussloff makes a case for the continuing relevance of the print art book in the digital age, but in doing so she sheds light on art scholars' implicit expectations for new models of digital scholarly communication (2006). Regardless of whether art history adheres to the traditional monographic form, the need remains for high image quality, seamless integration of text and image, robust bibliographic control, and a technical infrastructure that, together, ensure the material relationship present in the art book is carried over, if not enriched, in the digital environment. This need has gone virtually

unaddressed by current scholarly communication initiatives, which have focused with few exceptions on creating a sufficient infrastructure for the preservation of text-based scholarship (e.g. Lynch, 2003; Pinfield and James, 2003). To rectify this omission, art librarians and scholars will have to take a larger role in ensuring that open access publications, institutional repositories and other emerging models of scholarly communication are flexibly designed to serve the media-rich fields of art and design, fulfilling the specific needs of researchers rather than predetermining the terms of the encounter.

Although art librarians share with artists, art historians, architects and designers a multi-dimensional relationship to the diverse forms of art information, more insight into the habits of art historians as authors is needed. Little attention has been paid to the attitudes of arts and humanities authors who have chosen to publish (or not) in open access journals or other alternative publishing models (e.g. Coonin and Younce, 2009). To date, only Ballon and Westermann (2006) and Zorich (2012) have focused on the viewpoints of authors and publishers – sometimes overlapping, sometimes at odds – active in traditional scholarly publishing in the arts. If art and design libraries are to play a greater role in scholarly communication initiatives in the arts and humanities, understanding the disciplinary pressures and publishing expectations that hinder or encourage scholars' exploration of new models of scholarly communication will only grow more critical. Art librarians occupy an advantageous position to begin such conversations.

Frank discussion with faculty about scholarly publishing and advocacy for the potential of emerging models of scholarly communication are the only certain ways to ascertain the needs and concerns most important to them. Being able to identify and promote relevant resources is a critical way to initiate that conversation: a 2004 survey by Alma Swan and Sheridan Brown discovered that when 'presented with a list of reasons why [authors] have not chosen to publish in an open access journal and asked to say which were important . . . (t)he reason that scored the highest (70%) was that authors were not familiar enough with open access journals in their field' (Swan and Brown, 2004, 220). *The Directory of Open Access Journals* is browsable by discipline, and open access journals are easily indexed in a library's online catalogue and e-resource management systems. International directories of institutional and disciplinary archives are maintained by OAIster (www.oaister.org/) and OpenDOAR (www.opendoar.org/). According to SHERPA/RoMEO (www.sherpa.ac.uk/romeo/) an index of publishers' copyright and archiving policies, roughly 70% of publishers are already amenable to postprint archiving, an opportunity that scholars in the arts have largely failed to pursue. Many other publishers permit self-archiving after a limited embargo period. Librarians can also assist faculty in archiving their materials in their institutional or disciplinary repository if needed – a task that takes, on average, ten minutes the first time, and less thereafter (Harnad and Carr, 2005).

Most importantly, art and design librarians are capable of leading by example, as

participants in new scholarly communication and as agents of change within existing publishing networks. This might just entail a change in our attitudes since, historically, librarians have not always practised what they promoted. A 2005 survey of ten academic research libraries, for example, found that nearly half of the 140 library faculty respondents 'indicated that their primary concern was the publication of their articles and that a publisher's copyright and intellectual property policies were not considered in selecting a journal for article submission . . . few respondents had self-archived any of their published articles in an institutional repository or on a personal or departmental Web site' (Carter, Snyder and Imre, 2007, 77).

Art librarians can engage new approaches to scholarly communication in direct ways, by publishing work in open access journals or creating entirely new ones; by harnessing altmetrics data of their own work; keeping or negotiating copyrights through modified licensing resources such as Creative Commons, the SPARC Author Addendum or the Scholar's Copyright Addendum Engine, which gives authors non-exclusive rights to reproduce, distribute and create derivative works from articles to presentations, lectures and other scholarly and professional activities; and by depositing their own scholarship in their institution's digital repository or a disciplinary repository such as E-LIS: E-prints in Library & Information Science (http://eprints.rclis.org/). Art librarians can also participate in indirect ways, by donating funds to open access journals or their publishers or by assisting in the preservation of existing open access materials in their subject areas (Bailey, 2006).

Finally, there is no substitute for an informed advocate. A list of frequently updated scholarly communication resources, including blogs, organization home pages and tutorials, has been included at the end of this chapter to expedite the often time-consuming task of remaining knowledgeable of current trends and emerging developments.

Conclusion

The high cost of acquiring academic journals and books, the growing over-regulation of licensing, and the shrinking market for specialized literature have all contributed to an environment that is, at best, ambivalent toward the production of scholarship in the arts and to those who are invested in it. Yet these same conditions have also produced an atmosphere ripe for change.

Doubtless, the practical and conceptual challenges of transforming scholarly publishing are enormous. Emerging models of scholarly communication force the art librarian, perhaps more than any of our colleagues in the library, to reassess the relationship between old and new media. For if traditional scholarly publishing represents an unsustainable model, as it increasingly seems to be, how does that inform the work art librarians do? What does it signify for our relationship to the publishing system that has, however problematically, sustained libraries for centuries? Creating and fostering new

means for conducting research and circulating knowledge will require serious reflection from the profession about the unique, scalable contributions it can make to the advancement of arts scholarship in the digital age. It will require the acquisition of new skills, particularly those related to publishing and preserving scholarship, if the university library assumes greater responsibility in these areas. It will almost certainly entail the careful recalibration of what defines an art library collection.

Expanding access to scholarship will demand transcending the institutional and disciplinary borders that have historically separated the work of librarians and that of faculty and presses, as we assume the interlocking roles of advocates and participants. Librarians have long recognized that scholarly communication is approaching a crossroads, but change can only occur in concert with those who produce the scholarship. Only by working collaboratively alongside other stakeholders in arts scholarship will we have an impact on the future shape of scholarly communication.

References and bibliography

ACRL (2006) *Principles and Strategies for the Reform of Scholarly Communication*, Association of College & Research Libraries, www.ala.org/acrl/publications/whitepapers/principlesstrategies.

Antelman, K. (2004) Do Open Access Articles Have a Greater Research Impact?, *College and Research Libraries*, **65** (1), 372–82.

Association of Research Libraries (2004) *Marketplace & Licensing*, http://www.arl.org/focus-areas/scholarly-communication/marketplace-licensing#.WXkbboQrKig.

Bailey, C. (2006) *Open Access and Libraries*, www.digital-scholarship.org/cwb/OALibraries2.pdf.

Ballon, H. and Westermann, M. (2006) *Art History and its Publications in the Electronic Age*, http://cnx.org/content/col10376/latest/.

Bielstein, S. (2006) *Permissions, a Survival Guide: blunt talk about art as intellectual property*, University of Chicago Press.

Blecic, D. D. et al. (2013) Deal or No Deal? Evaluating big deals and their journals, *College & Research Libraries*, **74** (2), 178–93.

Bosch, S. and Henderson, K. (2016) Periodicals Price Survey: fracking the ecosystem, *Library Journal*, 21 April, http://lj.libraryjournal.com/2016/04/publishing/fracking-the-ecosystem-periodicals-price-survey-2016/.

Brown, M. A. and Crews, K. D. (2010) Control of Museum Art Images: the reach and limits of copyright and licensing, http://dx.doi.org/10.2139/ssrn.1542070.

Budapest Open Society Institute (2002) *Budapest Open Access Initiative*, www.budapestopenaccessinitiative.org/.

Carter, H., Snyder, C. and Imre, A. (2007) Library Faculty Publishing and Intellectual Property Issues: a survey of attitudes and awareness, *Libraries and the Academy*, **7** (1), 65–79.

Coonin, B. and Younce, L. (2009) Publishing in Open Access Journals in the Social Sciences and Humanities: who's doing it and why. In Mueller, D. (ed.), *Pushing the Edge: explore, extend, engage*, American Library Association.

Corbyn, Z. and Reisz, M. (2009) Learning to Share, *Times Higher Education*, November, www.timeshighereducation.co.uk/story.asp?sectioncode= 26&storycode=409049&c=2.

Crotty, D. (2014) Altmetrics: mistaking the means for the end, https://scholarlykitchen.sspnet.org/2014/05/01/altmetrics-mistaking-the-means-for-the-end/.

Crow, R. (2006) Publishing Cooperatives: an alternative for non-profit publishers, *First Monday*, **11** (9), http://firstmonday.org/ojs/index.php/fm/article/view/1396.

Frazier, K. (2001) The Librarian's Dilemma: contemplating the costs of the 'Big Deal', *D-Lib Magazine*, **7** (3), www.dlib.org/dlib/march01/frazier/03frazier.html.

Gúedon, J. (2001) *In Oldenburg's Long Shadow: librarians, research scientists, publishers, and the control of scientific publishing*, Association of Research Libraries, www.arl.org/storage/documents/publications/in-oldenburgs-long-shadow.pdf.

Hamma, K. (2005) Public Domain Art in an Age of Easier Mechanical Reproducibility, *D-Lib Magazine*, **11**, www.dlib.org/dlib/november05/hamma/11hamma.html.

Harnad, S. (2000) The Invisible Hand of Peer Review, *Exploit Interactive*, **5**, http://users.ecs.soton.ac.uk/harnad/nature2.html.

Harnad, S. and Brody, T. (2004) Comparing the Impact of Open Access (OA) vs. Non-OA Articles in the Same Journals, *D-Lib Magazine*, **10** (6), www.dlib.org/dlib/june04/harnad/06harnad.html.

Harnad, S. and Carr, L. (2005) *Keystroke Economy: a study of the time and effort involved in self-archiving*, http://eprints.soton.ac.uk/263906/.

Harnad, S. et al. (2004) The Access/Impact Problem and the Green and Gold Roads to Open Access, *Serials Review*, **30**, 310–14.

Henderson, A. (2002) The Growth of Printed Literature in the Twentieth Century. In Abel, R. and Newlin, L. (eds), *Scholarly Publishing: books, journals, publishers, and libraries in the twentieth century*, Wiley.

Holly, M. A., Ledbury, M., Armato, D., Bielstein, S., Brown, A., Conover, R., Constantinopoulos, V., Fay, S., Pabbruwe, H., Soussloff, C. and Wissoker, K. (2006) Art History and its Publishers, *Art Journal*, **65** (4), 41–50.

Howard, J. (2006) Picture Imperfect, *Chronicle of Higher Education*, August, http://chronicle.com/weekly/v52/i48/48a01201.htm.

Indianapolis Museum of Art (2015) *Rights and Reproductions: the handbook for cultural institutions*, The Museum and the American Alliance of Museums.

Jöttkandt, S. (2007) *No-Fee OA Journals in the Humanities, Three Case Studies: a presentation by Open Humanities Press*, https://core.ac.uk/download/pdf/11885312.pdf.

Kaufman, C. and Wills, A. (2005) *Variations on Open Access: a study of the financial and non-financial effects of alternative business models for scholarly journals*, www.sspnet.org/documents/65_Kaufman.pdf.

Kelly, K. (2013) Images of Works of Art in Museum Collections: the experience of Open Access, Council on Library and Information Resources, https://www.clir.org/pubs/reports/pub157/pub157.pdf.

Lynch, C. (2003) Institutional Repositories: essential infrastructure for scholarship in the digital age, *Libraries and the Academy*, **3** (2), 327–36.

Lyon, C. (2006) The Art Book's Last Stand?, *Art in America*, **94** (8), 47–50.

Maron, N. and Smith, N. (2008) *Current Models of Digital Scholarly Communication: results of an investigation conducted by Ithaka for the Association of Research Libraries*, www.arl.org/storage/documents/publications/digital-sc-models-report-2008.pdf.

McDermott, I. and Dunigan, E. (2013) Art Book Publishing: past, present, future, *Art Documentation: Journal of the Art Libraries Society of North America*, **32** (2), 239–52.

McGill, L. (2006) *The State of Scholarly Publishing in the History of Art and Architecture*, Houston, Rice University Press, http://cnx.org/content/col10377/latest/.

McGuigan, G. S. and Russell, R. D. (2008) The Business of Academic Publishing: a strategic analysis of the academic journal publishing industry and its impact on the future of scholarly publishing, *Electronic Journal of Academic and Special Librarianship*, **9** (3), http://southernlibrarianship.icaap.org/content/v09n03/mcguigan_g01.html.

Panitch, J. M. and Michalak, S. (2005) *The Serials Crisis*, white paper, www.unc.edu/scholcomdig/whitepapers/panitch-michalak.html.

Pinfield, S. and James, H. (2003) The Digital Preservation of E-prints, *D-Lib Magazine*, **9** (9), www.dlib.org/dlib/september03/pinfield/09pinfield.html.

Priem, J. (2010) Altmetrics: a manifesto, http://altmetrics.org/manifesto/.

Priem, J., Piwowar, H. A. and Hemminger, B. M. (2012) Altmetrics in the Wild: using social media to explore scholarly impact, http://arxiv.org/abs/1203.4745.

Publishers Communication Group (2015) *Library Budget Predictions for 2015*, http://www.pcgplus.com/wp-content/uploads/2015/01/Library-Budget-Predictions-for-2015.pdf.

ROARMAP: Registry of Open Access Repository Mandates and Policies (2017) *Welcome to ROARMAP*, https://roarmap.eprints.org/.

Shulman, J. (2014) Sustainable Free: lessons learned from the launch of a free service supporting publishing in art history, *Liber Quarterly*, **24**, 84–111.

Soussloff, C. (2006) Publishing Paradigms in Art History, *Art Journal*, **65** (4), 36–40.

Suber, P. (2003) Removing the Barriers to Research: an introduction to open access for librarians, *College & Research News*, **64**, 92–4.

Suber, P. (2004) Creating an Intellectual Commons Through Open Access, https://dash.harvard.edu/handle/1/4552055.

Suber, P. (2005) Promoting Open Access in the Humanities, *Syllecta Classica*, **16**, 231–46.

Suber, P. (2016) *Knowledge Unbound: selected writings on open access, 2002–2011*, MIT Press.

Swan, A. and Brown, S. (2004) Authors and Open Access Publishing, *Learned Publishing*, **17** (3), 219–24.

Van Orsdel, L. and Born, K. (2006) Periodicals Price Survey 2006: journals in the time of Google, *Library Journal*, April, http://lj.libraryjournal.com/2006/04/publishing/periodicals-price-survey-2006-journals-in-the-time-of-google/#_.

Whalen, M. (2009) What's Wrong with this Picture? An examination of art historians' attitudes about electronic publishing opportunities and the consequences of their continuing love affair with print, *Art Documentation*, **28**, 13–22.

Willinsky, J. (2009) Toward the Design of an Open Monograph Press, *Journal of Electronic Publishing*, **12** (1).

Zorich, D. (2012) Transitioning to a Digital World: art history, its research centers, and digital scholarship, www.kressfoundation.org/uploadedFiles/Sponsored_Research/Research/Zorich_TransitioningDigitalWorld.pdf.

Scholarly communication resources for art librarians

ACRL Scholarly Communication Toolkit
(http://acrl.libguides.com/scholcomm/toolkit/)
Launched in 2005, the ACRL Scholarly Communication Toolkit is intended to support librarians and information professionals in integrating scholarly communication efforts into institutional operations and programmes. The toolkit contains useful resources for preparing presentations and handouts on scholarly communication topics for administrators, faculty, students and other stakeholders.

Create Change (www.createchange.org/)
 Developed by the ARL and the SPARC, and supported by the ACRL, Create
 Change is an educational initiative that provides succinct overviews of the
 scholarly communication environment, updated news items, and resources to
 facilitate campus programmes on the topic.
Creative Commons (http://creativecommons.org/)
 Creative Commons, established by law professor Lawrence Lessig in 2001, is a
 non-profit organization that provides free, standardized licences and other legal
 tools to give creators a variety of ways to grant permissions for the public use and
 re-use of their works.
Directory of Open Access Journals (DOAJ; www.doaj.org)
 The DOAJ is an online community-curated directory of open access, peer-
 reviewed journals.
OAIster (http://oaister.worldcat.org/)
 A union catalogue of digital resources, including a comprehensive index of
 institutional and disciplinary repositories around the world.
Open Access Archivangelism (http://openaccess.eprints.org/)
 Steven Harnad is a leading voice in open access. His blog contains frequent
 updates of current open access developments as well as an archive of his own
 articles and essays concerning open access issues.
Open Access Scholarly Information Sourcebook (OASIS; www.openoasis.org)
 Developed by Alma Swan and Leslie Chan, OASIS highlights international
 developments and initiatives in the open access movement. It is designed for
 researchers, librarians and administrators alike, providing links to briefing papers,
 videos, aggregated news digests and case studies in open access publishing.
OpenDOAR (Directory of Open Access Repositories; www.opendoar.org/)
 More than 1400 digital archives are listed in this directory. Contents are searchable
 by subject area, country, language and repository type.
Peter Suber (https://cyber.harvard.edu/~psuber/wiki/Peter_Suber)
 A leading advocate of the open access movement, Peter Suber has archived his volu-
 minous collection of papers devoted to the subject on a personal home page. The
 website offers a wealth of information about open access principles and practices.
Scholarly Publishing and Academic Resources Coalition (SPARC;
 http://sparcopen.org/)
 Created in 1998 by the ARL, the SPARC is an international alliance of academic
 and research libraries working together to promote open access scholarship. The
 Coalition's website provides news about open access as well as a number of
 resources for publishers and authors, including the SPARC Author Addendum, a

document that allows authors easily to modify publisher agreements to keep key rights to their works.

SHERPA/RoMEO (www.sherpa.ac.uk/romeo.php)

An index of publisher's policies on self-archiving of preprints and postprints.

Stanford Copyright & Fair Use Center (http://fairuse.stanford.edu/)

The Center includes examples of copyright and fair use policies, a frequently updated blog and news items, and numerous copyright-related educational resources.

Part V
The physical environment

As the virtual library becomes increasingly imaginable, many libraries are assessing the value of their physical spaces to determine how they can be allocated for optimal use. The space may be even more central to the mission of art and design libraries, since art and design students and faculty presumably bring a visual sensibility and environmental awareness to their engagement with the library. Browsing through print materials is an activity that requires the physical library, and it endures as an important activity for art and design library users, who appreciate the potential for serendipitous discovery, inspiration, and understanding that open-ended searching offers. Although many databases and online resources offer browsing modes, leafing through print publications remains a critical step in the design and ideation process. Libraries have also begun to understand the value of the library as place – as a destination for users seeking an environment conducive to study, contemplation and the exchange of information. Beyond those activities, dedicated classroom space for user education is more frequently a planning priority, as accrediting agencies encourage information literacy as a campus-wide learning outcome. The utopian condition for the library stems from its essential nature as a third place, an academic town square, a neutral zone that enables dialogue, and a space that nurtures productivity.

Chapter 25

New, renovated and repurposed library spaces: responding to new demands

Leo Appleton, Karen Latimer and Pat Christie

Changing typologies in contemporary library design

The 21st century has been a challenging and exciting time in library building design. At the turn of the century there were doom-laden predictions that the physical library would cease to be important in the new electronic age as users would want everything delivered to their desktops at home or at work, and funders would be unwilling to invest in potentially redundant buildings. Instead, libraries embraced technology, shifting from largely collection-based spaces to more flexible ones that encouraged interactions and connections between library users and resources in all formats, between library users and each other, and between library users and library staff. Library design was 'no longer largely governed by the storage and display of resources or by the need for space-consuming issue and service desks but rather by the needs of users. And the creation of exciting and attractive library space has been shown to bring people into the physical library to use virtual resources' (Latimer, 2011, 126).

The challenge is to create attractive, functional library spaces that support new ways of learning and digital literacy and take advantage of technological advances. The classic library building that housed predominantly print collections so successfully for many centuries does not necessarily provide a model for today's library learning spaces. Many of the basic tenets still hold true, however. The quintessential purpose of the library as a gateway to knowledge and as a centre for resources and ideas remains the same, and the trend towards expanding that principle to include creating knowledge and making physical prototypes is, in fact, something that art libraries have long embraced. In his overview of library evolution Brian Edwards points out that 'there was not much difference in the architectural arrangement between the Renaissance art gallery and that of the library' (2009, 4). Although that difference is more marked today, exhibition space remains important in the modern library, especially if linked to the curriculum, and has been made more feasible through the freeing up of space as a result of compact and

collaborative storage and through collection management through the digitization of resources. As we look at designing libraries, and at art and design libraries in particular, in the 21st century it is increasingly important that librarians communicate effectively with funders, architects and, most crucially, users. We need to dispel the myth that 'full libraries are on our smartphones' (Van Susteren, 2016) and demonstrate that libraries continue to be at the heart of our campuses, providing added value and well maintained places to carry out scholarly and creative work with expert help and a range of services on hand.

It is generally agreed that user behaviour has changed, reflecting new pedagogies, the increase in informal, participatory and collaborative learning, and the acknowledgement that people learn in different ways. Much has been written about learning and learning spaces (Watson, 2013) and *The UK Higher Education Learning Space Toolkit* 'explores pedagogical principles and their place in learning space design and considers how universities and colleges might take a truly holistic, institution-wide approach to the development of learning spaces' (UCISA, 2016). The concept of blended learning with the classroom, flipped or otherwise, the laboratory and the library working together to improve the learning experience is a powerful one. Too many of us only pay lip-service to user consultation, however, carrying out occasional surveys and focus groups. More evidence is needed, and data needs to be collected from the full range of users including postgraduates, researchers, academic staff and library staff in order to inform fully the design of new or refurbished spaces.

In the early 21st century, discussion on library spaces focused on the need for information technology and service-rich spaces. McDonald (2010), for example, noted that libraries, rather than being threatened by technology, were embracing it, thereby raising their profile. People wanted to use the latest technology but they wanted to do so in well designed, efficiently managed spaces with expert help on hand from both information technology specialists and information professionals. The freeing up of space previously required for collections was seen as an opportunity to develop new services, to provide more group study spaces, dedicated teaching spaces and sometimes learning cafés.

In the second decade of the century the debate has moved on to topics such as the needs of postgraduates with specially designated spaces in many libraries, such as the David Wilson Library at the University of Leicester. And learning spaces (also known as learning commons or library learning spaces) are taking centre stage with the Diamond Learning Centre at the University of Sheffield being seen as the next stage in the evolution from its earlier information commons. In turn, many university libraries, such as the Sir Duncan Rice Library at Aberdeen University, are providing spaces for outreach activities as universities seek to increase their contribution to the local community.

The Hunt Library at North Carolina State University and the Ryerson Learning Centre in Toronto (Figure 25.1 on the next page), both designed by *Snøhetta*, have received much attention recently. These libraries encapsulate trends, such as creating varieties of study and group spaces, repurposing space through the use of robotic storage, introducing makerspaces (facilities for making, learning and exploring with technology

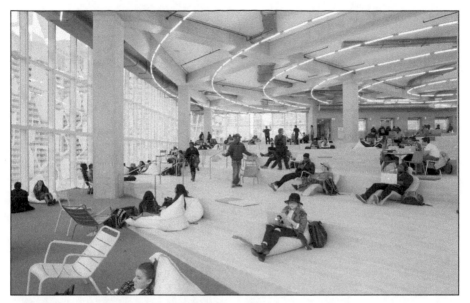

Figure 25.1 *The Ryerson University Students Learning Center, Toronto*
© Photographer: lornebridgman.com

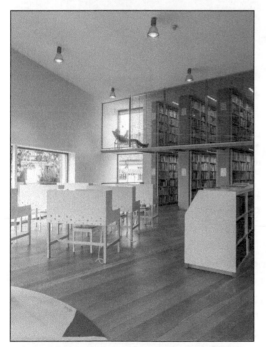

Figure 25.2 *The Swedish Centre for Architecture and Design Library*
© Photographer: Matti Östling

tools from 3D printers to sewing machines) and technology-rich environments for experimentation. Among art libraries, a notable example is the Swedish Centre for Architecture and Design Library (Figure 25.2). In some countries sustainability is a *sine qua non* not only for environmental reasons, but also because library users identify with the concept and are highly supportive of it (Edwards, 2011; Latimer, 2013). Similarly, spaces for staff members – 'the forgotten army' (Purcell, 2013) – have come under scrutiny, with the debate about open plan versus individual offices, as well as hot-desking, central to many building projects.

Library design results not only in new building, but also in renovation, refurbishment and reordering of space. Liverpool and Manchester

Central Libraries, the Weston Library at the University of Oxford (Figure 25.3), the Brynmor Jones Library at the University of Hull, and the continuing adaptation of Edinburgh University's 1960s Basil Spence Library are among notable examples in the UK. The first joint university and public library in the UK, The Hive in Worcester, opened in 2012, and further collaborations among libraries in various sectors will likely develop in the future.

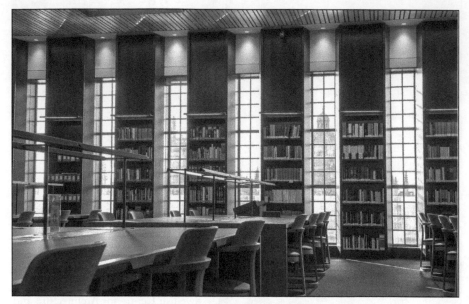

Figure 25.3 *The David Reading Room, Weston Library, University of Oxford*
Photographer: John Cairns © Bodleian Libraries, University of Oxford

Design considerations for art and design libraries

Ideally, art and design libraries are hybrid spaces that combine features of a gallery and a studio with the characteristics of a contemporary academic library. In doing this they fulfil their function as places for information and inspiration – where research and scholarship fuse with design and practice in a manner that encourages creativity, experimentation and innovation. They also act as community hubs where students come together in a stimulating and supportive environment. Hidemi Kondo, Librarian of Tama Art University Library in Japan, designed by Toyo Ito, describes the library as 'a place where people come to relax, contemplate, to search for materials and ideas . . . and [it] provides space for art and design exhibitions' (Shaw, 2013).

In the design of any new library, the relationship of the library to other learning spaces within the building needs to be considered, so that the library is an integral part of the wider learning environment and a key contributor to the academic mission of the university. The design of the library should reflect creative arts pedagogy and be

responsive to the learning preferences of art and design students. The importance of enquiry-based and self-directed learning is core to the studio way of working and often subverts rigid boundaries between theory and practice. Exploration of identity and engagement with risk-taking is facilitated through understanding and critiquing disciplinary and interdisciplinary knowledge, traditions and practices. In turn, the social model of learning encourages peer-to-peer collaboration through group work. In this post-digital age, students expect to move seamlessly between the digital and physical for communication, research and creative practice. All these factors influence the design characteristics of the contemporary art and design library. Skidmore, Owings and Merrill's 2014 library in the University Center at The New School in New York (Figure 25.4) is at the heart of a vertical campus where learning and teaching spaces co-exist with social and living spaces. Physical adjacencies and visual connections achieved through a vertical configuration encourage conversations and interdisciplinarity (Frearson, 2014).

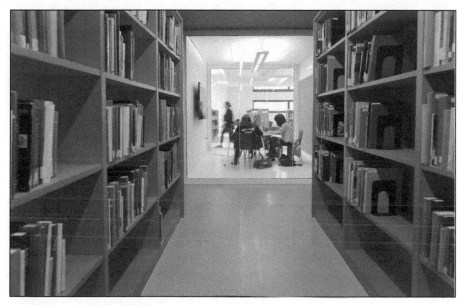

Figure 25.4 *The University Center Library at the New School, New York*
© Photographer: Martin Seck

The role of the library as a visually stimulating and inspirational space is of vital importance within the creative arts. Libraries should provide physical and digital spaces where collections can be showcased alongside creative works. Exhibition cabinets and digital screens with changing displays located near the entrance, in addition to artworks dispersed throughout the library, provide a welcoming experience and signify the library's link with studio practice. The hybrid gallery, library and events space of the Wellcome

Collection's Library and Reading Room in London (Figure 25.5), designed by AOC Architects with Wilkinson Eyre Architects and completed in 2015, is a role model for libraries in any sector.

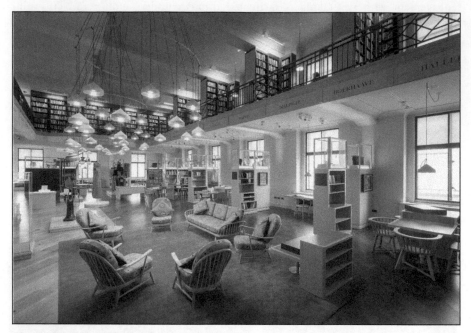

Figure 25.5 *The Wellcome Collection Reading Room, London*
© Wellcome Collection

Library collections represent a significant cornerstone of any university's research infrastructure and a critical teaching resource. While many libraries are transitioning to exclusive purchase of electronic materials and prioritizing study spaces over storage for collections, the book as artefact within the creative arts has special importance. Further, as serendipitous discovery remains an important consideration within an art and design library's collecting policy, it affects the design of new library spaces. Recently, two American art librarians noted, 'In part, the hard work of art libraries is to marry much needed print with the access of digital for researchers' (Falls and Hathaway, 2015, 186). Indeed, art and design libraries are likely to prioritize the accessibility and visibility of their collections more than other libraries. An example of this is the Musashino Art University Library in Tokyo (Figure 25.6 opposite), completed in 2011 and designed by the architect Sou Fujimoto, whose design concept was a series of independent rectilinear book stacks to create a 'forest of books' (Gregory, 2010, 44).

The variety of shapes, sizes and formats of art and design collections needs to be considered when thinking about storage solutions and library floor plans. In addition to the standard book collection requiring shelving that is sufficiently deep and sturdy to

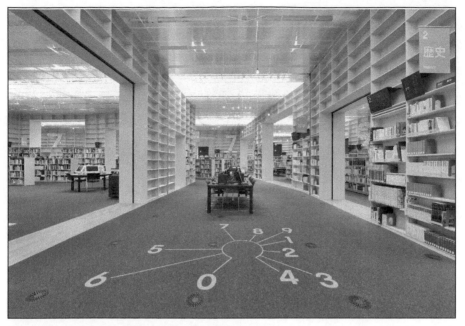

Figure 25.6 *The Musashino Art University Library, Tokyo*
Photographer: Yuichiro Tanaka © Musashino Art University Museum &
Library

hold large, heavy art books, display shelving is often used for current journals and new
books to invite browsing. Many art and design libraries also hold special collections,
ranging from historical manuscripts to contemporary artists' books, that require storage,
display and handling conditions compliant with archival standards. Some libraries
contain ephemeral materials, such as materials collections (samples of textiles, finishes
and hardware) that are stored in a manner allowing students to handle the items freely
and replicating the working environment of a professional design practice, as at the
Central Saint Martins Library, University of the Arts London (UAL) (Figure 25.7, page
270). Whatever the range of collections, the floor plan of the library should embrace
principles of inclusive design, particularly taking account of people with dyslexia, as the
incidence of this disability is higher than average within the creative arts. Care should be
taken with wayfinding to minimize difficulties with orientation and numerical navigation
that many people experience when using libraries. The use of colour coding, subject
names to supplement classification numbers and the provision of maps act as valuable
tools that improve accessibility.

Since art and design libraries typically function as learning environments for creative
practice as well as academic research, study furniture needs to support students switching
between library materials, personal sketchbooks and digital devices. Art and design
libraries also act as community hubs where peer-to-peer collaboration and group working
takes place alongside more traditional independent study. This requires careful attention

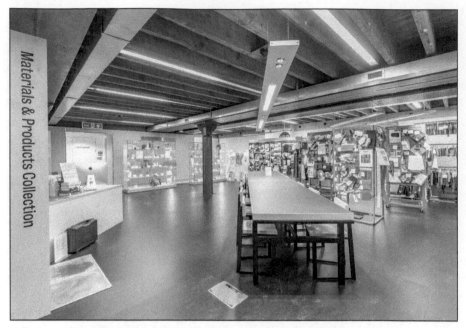

Figure 25.7 *The materials and products collection of Central Saint Martins at UAL*
Photographer: Ideal Insight © University of the Arts London

to the study space configuration, acoustic management, lighting levels and environmental conditions, so that all learning activities can be accommodated successfully. The contemporary art and design library is greatly enhanced by the inclusion of a 'makerspace' with large layout tables, up-to-date art technology and basic studio equipment. This combination of study facilities ensures that students can read and write, draw and paint, cut and paste, access e-learning tools and use digital technologies, including mobile devices, without leaving the library. A prime example of this is the Central Saint Martins Library and Learning Zone, UAL. Designed by architects Stanton and Williams and opened in 2011, the college's new campus library provides study facilities to support individual quiet study along with group work. When the learning zone (Figure 25.8 opposite) was co-located with the Library in 2013 as an innovative and flexible makerspace, this combination of a digital laboratory with traditional research spaces increased usage levels by over 50%.

Student engagement in space planning and design: user experience methodology

One way to ensure that library space is planned and designed responsively, making it fit for its users, is to engage them in the planning and design process, whether through discussion at the initial stages of the project or by regular consultation meetings in the

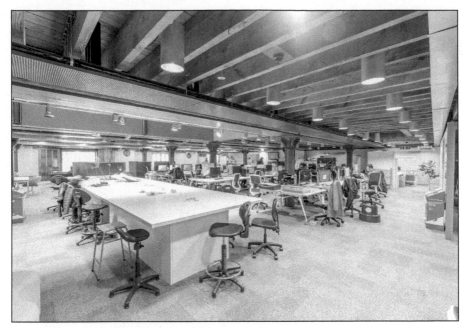

Figure 25.8 *The learning zone of Central Saint Martins at UAL*
Photographer: Ideal Insight © University of the Arts London

project planning cycle. Beyond such consultative approaches are the more investigative and empirical methods. Recent examples of these include student diary mapping for finding out how they currently use learning spaces (Appleton, 2014; Ramsden and Carey, 2014) and observational studies before discussing user requirements as part of a focus group (Oddy, 2015).

However, an increasingly popular method of user engagement in space planning, particularly in the higher education sector, is that of user experience methodology. In libraries, this involves a suite of techniques for first understanding and then improving the experience of library users. One of the fundamental principles of user experience methodology is the use of ethnographic methods. Ethnography, when deployed as a research methodology in an educational setting, is 'a way of studying cultures through observation, participation and other qualitative techniques with a view to better understanding the subject's point of view and experience of the world' (Priestner, 2015). When applied to the library sector, ethnography allows librarians to conduct user research that goes beyond the traditional and largely quantitative library survey methods, with a view to obtaining a richer and more detailed picture of user needs. Subsequently, many academic libraries have begun to show an enthusiasm for applying user experience methodology and now increasingly use ethnographic methodologies when exploring user experience in their physical spaces (Bryant, Matthews and Walton, 2009).

UAL recent employed user experience methodology as a student engagement tool and

research method to inform library space planning. UAL is a specialist provider of art, design, fashion, and communication and performance education from foundation through to doctoral level. It comprises six colleges: Camberwell College of Arts, Central Saint Martins, Chelsea College of Arts, London College of Communication, London College of Fashion and Wimbledon College of Arts. Library Services at UAL manages the libraries and learning zone spaces in each of the colleges. As part of its commitment to continual service improvement, Library Services has always been proactive in consulting and engaging with its students.

During 2015 UAL announced several facilities projects, all of which have major implications for library services, including the building of three new libraries between 2016 and 2020. The UAL user experience project, carried out during 2015, aimed not only to engage students in the design and planning of these new buildings, but also to redesign the learning spaces that they currently occupy. Student surveys and library staff's observations of service and user behaviour within particular spaces have regularly informed space planning decisions. However, until the implementation of user experience methodology, there had been no dedicated initiative related to student behaviour and usage within the library and learning zone spaces to inform such decisions.

The user experience methodology uses a range of methods often described as anthropological and ethnographic in encouraging objective observation and reflection on user behaviour within a given environment or system. The UAL Library Services user experience project used the following methods for gathering intelligence within the overall methodology:

- observation of student movements within library spaces
- observation of static spaces within the libraries
- touchstone tours (gathering subjective views on library space by accompanying users on walk-throughs)
- focus groups
- reflective journals.

The project assembled and employed a team of 12 students to carry out the critical mass of observations and tours in all of the college libraries and learning zones over a two-week period. The team was trained in observational techniques, and their time was divided evenly among the different observational methods. Some members of the observation team were employed for a further period to undertake data analysis for the final report.

There were numerous implications of the project for space planning and future library design at UAL (Appleton et al., 2016). Each of the six college libraries received a report detailing key themes and suggested short- and long-term recommendations for improvements. These varied from small-scale solutions, such as ensuring consistent and clear signage to installing more power, data hubs and desk lamps. Changes to the number

and plans of various types of learning spaces in all six of the UAL libraries have resulted. These include the provision of more quiet study areas and the repurposing of some spaces into group study spaces. Access to digital resources improved as a result of recognizing the need for additional desktop and laptop computers, as well as specialized computer-aided design software packages. The project also helped managers identify in which libraries students were more likely to want makerspaces. For the long term, the UAL user experience project informed the articulation of the 'inspirational environment' vision for the Library and Academic Support Strategy (UAL, 2016), contributed to the University Strategy (UAL, 2015) and informs the design of all three new libraries.

Conclusion

There is no shortage of information and guidance available to those embarking on a library building project. In addition to a substantial body of literature, a number of helpful websites include Designing Libraries (www.designinglibraries.org.uk), The Architecture Group of LIBER (Ligue des Bibliothèques Européennes de Recherche) (http://libereurope.eu/architecture-forum/) and IFLA's Art Libraries and Library Buildings and Equipment Sections pages (www.ifla.org/art-libraries and www.ifla.org/library-buildings-and-equipment). Still lacking, however, is good comparative post-occupancy evaluation. We need formal evaluation metrics to measure impact and value that inform future building projects and ensure continuous improvement. Rather than technical evaluations, librarians are interested in qualitative evaluation, such as of user satisfaction and the impact of a design on user experience and delivery of services.

Post-occupancy evaluation studies also address the allocation and actual use of space, maintenance and serious defects: 'Critically, and to be truly useful, post-occupancy evaluations should measure both the successes and failures inherent in the building performance. The information generated can then be used to identify and solve problems, better inform decision making, raise efficiency and justify future actions and expenditures' (Latimer, 2015).

Not all art and design librarians have the opportunity to oversee a new or renovation library project but most are involved at some point in repurposing library space. In recent years the distinction between libraries and other spaces has become less demarcated as universities seek to create integrated and space-efficient learning environments, as well as to explore the potential of a porous campus both physically and philosophically (Boys, 2010, 157–75). This is particularly important in art and design institutions, where because of the growing pressures on studios, students seek out alternative spaces for their work. Long library hours, sometimes around the clock, may accommodate student lifestyles better than studio opening hours. The library is becoming the preferred place for both scholarship and creative practice, as well as a place to occupy as part of a vibrant community. Good design, high-quality collections and a strong service ethos, based on an understanding of creative arts pedagogy and user needs, ensure that today's art and

design library is at the heart of the student experience and that it remains integral to the academic life of the university. As Les Watson (2013, 6) quoting Stewart Brand on the impossibility of predicting the future (1995) has pointed out, perhaps the biggest challenge of all is to design a library that meets the brief on the day of opening but is also flexible enough to cope with an unknown future. Robust evaluation combined with continuous monitoring processes and underpinned by agile design will address this challenge successfully.

References, bibliography and website

Appleton, L. (2014) Tell Us What You Think: engaging with students in library space planning, blog, #UKAnthrolib,
https://ukanthrolib.wordpress.com/2014/08/19/tell-us-what-you-think-engaging-with-students-in-library-space-planning/.

Appleton, L., Batch, J., Olsson, T. and Reed, S. (2016) Engaging Students through User Experience at the University of the Arts London, *SCONUL Focus*, **67**, www.sconul.ac.uk/sites/default/files/documents/14_20.pdf.

Bennett, H. (2013) The Psyche of the Library: physical space and the research paradigm, *Art Documentation*, **32** (2), 174–85.

Boys, J. (2010) *Towards Creative Learning Spaces: re-thinking the architecture of post-compulsory education*, Taylor and Francis.

Brand, S. (1995) *How Buildings Learn: what happens to them after they are built*, Penguin.

British Standards Institution (2012) *Guide for the Storage and Exhibition of Archival Materials*, PD 5454:2012.

Bryant, J., Matthews, G. and Walton, G. (2009) Academic Libraries and Social Learning Space: a case study of Loughborough University Library, UK, *Journal of Librarianship and Information Science*, **41** (1), 7–18.

Christie. P. and Everitt, R. (2007) 'No Rules': managing a flexible learning space, *Library and Information Update*, **6** (6), 32–5.

Delcore, H. D., Mullooly, J., Scroggins, M., Arnold, K., Franco, E. and Gaspar, J. (2009) *The Library Study at Fresno State*,
www.fresnostate.edu/socialsciences/anthropology/ipa/thelibrarystudy.html.

Duke, L. M. and Asher, A. D. (eds) (2012) *College Libraries and Student Culture: what we now know*, American Library Association.

Edwards, B. (2009) *Libraries and Learning Resource Centres*, 2nd edn, Architectural Press.

Edwards, B. (2011) Sustainability as a Driving Force in Contemporary Library Design, *Library Trends*, **60** (1), 190–214.

Falls, S. and Hatheway, H. (2015) The Art of Change: the impact of place and the future of academic art library collections, *New Review of Academic Librarianship*, **21**, 185–94.

Frearson, A. (2014) *SOM Completes Campus Building for the New School in New York*, www.dezeen.com/2014/02/11/the-new-school-university-campus-som-new-york/.

Gregory, R. (2007) Reading Matter, *Architectural Review*, **222** (1326), 46–55.

Gregory, R. (2010) Musashino Art University Library, *Architectural Review*, **228** (1364), 43–8.

Head, A. (2016) *Planning and Designing Academic Library Learning Spaces: expert perspectives of architects, librarians, and library consultants*, http://projectinfolit.org.

JISC Learning Spaces, www.jisc.ac.uk/guides/learning-spaces.

Latimer, K. (2010) Redefining the Library: current trends in library design, *Art Libraries Journal*, **35** (1), 28–34.

Latimer, K. (2011) Collections to Connections: changing spaces and new challenges in academic library buildings, *Library Trends*, **60** (1), 112–33.

Latimer, K. (2012) Library Buildings. In Bowman, J. H. (ed.), *British Librarianship and Information Work, 2006–2010*, Lulu.com, 360–79.

Latimer, K. (2013) Sustainability in All Phases of the Building's Life-Cycle: a case study of The McClay Library, Queen's University Belfast. In Hauke, P. et al (eds), *The Green Library*, Walter de Gruyter.

Latimer, K. (2015) Introduction. In Latimer, K. and Sommer, D. (eds), *Post-Occupancy Evaluation of Library Buildings*, Walter de Gruyter.

Latimer, K. and Niegaard, H. (2007) *IFLA Library Building Guidelines: developments and reflections*, K. G. Saur Verlag.

Lushington, N., Rudorf, W. and Wong, L. (2016) *Libraries: a design manual*, Birkhäuser.

Macken, M. E. (2006) The Art Library as Place: the role of current space planning paradigms within the academic art and architecture library, *Art Documentation*, **25** (2), 18–25.

Manton, M. (2015) AOC Combines a Reading Room with a Gallery for London's Wellcome Collection, www.dezeen.com/2015/03/26/aoc-reading-room-gallery-space-london-wellcome-collection-museum/.

McDonald, A. (2010) Libraries as Places: challenges for the future. In McKnight, S. (ed.), *Envisioning Future Academic Library Services: initiatives, ideas and challenges*, Facet Publishing.

Oddy, E. (2015) Embracing the Student Voice, *SCONUL Focus* 64, www.sconul.ac.uk/sites/default/files/documents/10_14.pdf.

Pollock, N. R. (2011) Musashino Art University Museum and Library, *Architectural Record*, **199** (3), 60–7.

Priestner, A. (2015) UXLibs: a new breed of conference, *CILIP Update*, May, 31–3.

Purcell, J. (2013) University Library Staff Accommodation: why space matters for the forgotten army. In Matthews, G. and Walton, G. (eds), *University Libraries and Space in the Digital World*, Ashgate.

Ramsden, M. and Carey, C. (2014) Spaces for Learning? Student diary mapping at Edge Hill University, *SCONUL Focus* 62, www.sconul.ac.uk/sites/default/files/documents/3_13.pdf.

Shaw, C. (2013) *Library Futures: Tama Art University, Japan, Guardian*, 7 August, https://www.theguardian.com/higher-education-network/2013/aug/07/library-futures-tama-art-university.

Suarez, D. (2007) What Students Do When They Study in the Library: using ethnographic methods to observe student behavior, *Electronic Journal of Academic and Special Librarianship*, **8** (3), 1–19, http://southernlibrarianship.icaap.org/content/v08n03/suarez_d01.html.

UAL (2015) *Strategy 2015–22: Transformative Education for a Creative World*, University of the Arts London, www.arts.ac.uk/about-ual/strategy-governance/ual-strategy-2015-22/.

UAL (2016) *Library and Academic Support Strategy 2016–2022*, University of the Arts London, https://issuu.com/artslondonlibraries/docs/ual-library_strategy-6_issuu.

UCISA (2016) *The UK Higher Education Learning Space Toolkit: a SCHOMS, AUDE and UCISA collaboration*, Universities and Colleges Information Systems Association, www.ucisa.ac.uk/bestpractice/Copy_of_publications/learningspaces.

Van Susteren, G. (2016) Colleges should stop building vanity projects like huge libraries and billing students – full libraries are on our smartphones!, Twitter, 31 October, https://twitter.com/greta/status/793052011386265600.

Varley, G. (ed.) (2011) The Architecture and Space Planning of Art Libraries, special issue, *Art Libraries Journal*, **36** (1).

Walton, G. (2015) What User Experience (UX) Means for Academic Libraries, *New Review of Academic Librarianship*, **21** (1), 1–3.

Watson, L. (ed.) (2013) *Better Library and Learning Space: projects, trends, ideas*, Facet Publishing.

White, C. T. (2009) *Studying Students: the ethnographic research project at Rutgers (part 2)*, www.libraries.rutgers.edu/rul/staff/groups/ethnography/reports/ERP_FinalReport_Phase_2.pdf.

Worpole, K. (2013) *Contemporary Library Architecture: a planning and design guide*, Routledge.

Chapter 26

Why is that column in the middle of the room? Success in creating classrooms for library instruction

Paul Glassman

Introduction

As hands-on instruction becomes essential in the information literacy curriculum, librarians and library administrators may find themselves planning or proposing spaces that support their instructional goals and nurture those needs through responsive design decisions. To be effective, libraries are with increasing frequency moving toward locating, designing, equipping and furnishing functional, flexible and comfortable electronic classrooms (Primary Research Group, 2008). Whether or not an architect is available for assistance, considering essential criteria and making responsive design decisions results in spaces that are functional, flexible and forgiving.

This chapter is based on experiences with spaces at Hofstra University, Felician University and Yeshiva University, all in the metropolitan New York region. It proposes a set of guidelines for ensuring greater success in the realization of the library instruction classroom. The chapter title derives also from experience at those institutions, where the spaces available contained structural columns almost in their centres, serving not only to support the floors of the spaces above, but also, on a metaphorical level, to suggest the occasional impediments and constraints that confront planners and designers of any interior volumes. Creative problem solving requires accommodations to inherent obstacles, and planners and designers who expect the unexpected are more likely to be able to surmount those obstacles and achieve their goals.

Several questions are likely to emerge in the early stages of the planning process:

- What is the right space for library instruction?
- How do we propose a project of that magnitude?
- What happens if the architect doesn't listen to us?
- Can we do this on our own, without an architect?
- Do we want fixed seating?

- What type of equipment is needed?
- What should the capacity be?

With the increasing demand for electronic classrooms and the measurable benefits smart classrooms have in effective information literacy instruction, librarians are being asked to provide improved learning environments for their students. This chapter illustrates prototypes for shaping learning spaces to respond to changing learning needs and takes the shape of a set of practical guidelines for managing design and construction projects of this type.

Developing a proposal

A strong proposal to those who make decisions on capital improvement projects can result in approval for a good idea and make the difference between inadequate and adequate funding. After presenting the guiding rationale for the project, strong proposals outline the benefits of designing and constructing the new space, and identify the users, as well as the planning group. This group should involve all who need to play a role, such as a sampling of students and faculty, information technologists who supervise computer equipment and networks, and physical plant personnel, who may employ standards for equipment replacement, such as lamps and other consumables. Identification of the client or clients is essential: to whom will the architect or contractor report? Whose approval is needed for the design to move into construction? Whose approval is needed for changes or for additional funds?

The project team

Although not customary in all institutions when the plan is modest, project teams are fundamental in ensuring implementation of the plan. The project team assembles the decision makers, as well as those on whose success the project depends. Although the planning group may reconstitute itself as the project team, it may bring its work to completion by asking the project team to supersede it. Even if the institution has little precedent for a project team when there is not an architect, designer or external contractor, there are benefits to regular, brief, well documented meetings by those most involved. At minimum, the team should include the architect or designer (if there is one for the project), at least one representative from the library, including the librarian who works most closely with the instruction programme, a member of the internet technology office, a representative of housekeeping or building maintenance, key personnel involved with audiovisual equipment, and the institutional purchasing agent. Weekly meetings are optimal for tracking progress, and a written record circulated to team members serves as documentation of decisions agreed to, as well as of responsibilities taken by team members and others.

The programme

Often overlooked is the design or architectural programme, which is essential for reaching an understanding of, and agreement on, the scope and parameters of the project. Beginning with the overarching goals for the project, the programme is a list of its functional requirements. Not a recommended solution, it is rather a statement of the problem. Rather than qualifying the problem, it quantifies it by providing numbers of users, square footages and other specific requirements.

Benefits of employing an interior architect

Although the final cost of the project will be greater – perhaps as much as 15% higher – there are benefits to employing an interior architect. The architect or designer may ask key questions the client may not think of; and the architect co-ordinates the construction schedule, based on knowledge of the optimal sequence of construction components, such as electrical, structural or millwork. The architect or designer also supervises construction and identifies problems or omissions on the part of the contractor(s). Experienced not only in providing accurate cost estimates, these practitioners are also familiar with sources for equipment and materials and may be able to acquire more durable and stylish furnishings than those available through standard library suppliers. Finally, the design practitioner can develop specifications for equipment and materials, ensuring that the proper selections are made from an endless set of options.

Space inventory

Although in many cases there will be a specific space available for the project, in some environments there may be several options from which to choose. It is wise to identify all potential spaces for the project, and based on an inventory of those spaces, their features can be listed: square footage; geometry; structural and spatial intrusions, such as columns and doors; natural and artificial lighting; ceiling heights; level of heating, ventilating and air conditioning; and condition of surfaces (floors, ceilings, walls). The interior architect will be a resource for identifying the space that best matches the programme.

Essential components of the smart classroom

The smart, or intelligent, classroom is a learning space equipped with electronic equipment giving all students access to technological resources, such as the internet, course management software, an intranet, databases and other electronic resources. It allows the instructor to communicate with students not only orally, but also by means of the technology. Its basic components are computer work stations for each student, a proctor station for the instructor, projection equipment, speakers, a projection screen, storage for supplies, perhaps a multimedia cart for portable systems, printers and printer

stands, and that most atavistic of teaching tools, the white board, which the interactive whiteboard may supersede.

The floor plan

Whether or not the project team includes an interior architect, developing a floor plan is indispensable. A scale no smaller than quarter-inch is desirable, and the components of the plan are all fixtures and furnishings. If a professional is unavailable to draft the plan, quarter-inch graph paper may ease the production of the drawing. It is helpful to indicate locations of power, data jacks, light switches and other controls, such as thermostats. New lighting requires a parallel plan, known as a reflected ceiling plan.

Standard projection option

Liquid-crystal display (LCD) or data projectors can enlarge and direct digital media onto a screen. Although it might seem simpler to keep the projector on a media cart, permanent installation is preferable. Suspending the projector by means of a ceiling mount allows for better sight lines, a direct projection angle, and less need for calibration with devices such as an interactive white board. Be sure to budget for replacement bulbs, which are costly.

Alternate projection option

Some campuses now favour LCD television monitors, which boast minimal maintenance costs, in place of data projectors and screens; however, if the screen size is small, it is suitable for small classrooms only. Often the aspect ratio needs adjustment, and with some settings background images are erased. If kept on a media cart, it is essential that there be a separate lectern for the keyboard, so that the instructor does not block the monitor.

Four spatial prototypes

The first and most familiar model is fixed seating in rows illustrated in Figure 26.1 opposite. The structural columns necessitated narrower rows, and the glass storefront prevented lateral orientation, which would decrease the distance of rear rows from the projection screen. Laptop computers stored in a charging cabinet are distributed as needed. If this is your option, be sure to allow adequate space between rows for easy passage by the instructor.

The second option, and one recommended by many library instructors, is a flexible arrangement of clustered seating, which allows students to work in smaller groups and which may facilitate discussion; this formation may be achieved through selecting trapezoidal tables on casters (Figure 26.2). Wireless laptop computers allow for table rearrangement to enable small group assignments.

The third option is stadium seating; the advantages of this option are better sight lines for students; be sure to insure adequate space between rows here, too, and remember that

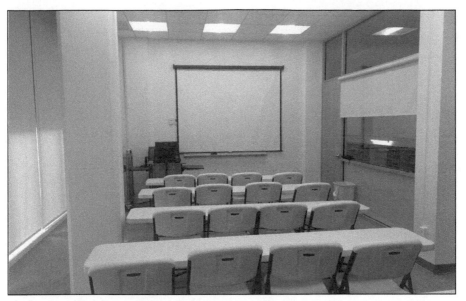

Figure 26.1 *The column intrusion in Yeshiva University's instruction laboratory in the 2015 renovation of the Pollack Library in the Gottesman Library Building*

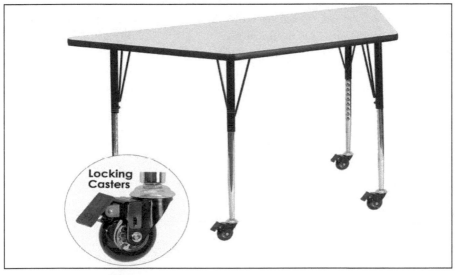

Figure 26.2 *A trapezoidal table on casters*

compliance with the Americans with Disabilities Act (ADA) does not permit stairs. In the classroom shown in Figure 26.3 on the next page, stadium seating creates excellent sight lines and is ADA-compliant by virtue of the location of the first row at the room's entry level.

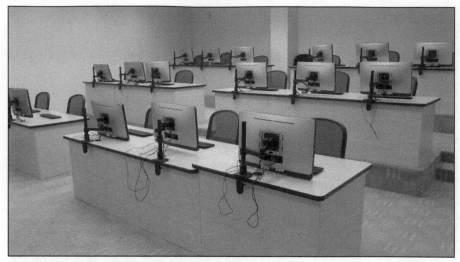

Figure 26.3 *Stadium seating in Dickinson College's Waidner-Spahr Library* (courtesy of James Gerencser, Dickinson College)

If there are stairs, as included in most stadium seating arrangements, a work station at the entry level of the classroom will be necessary and bring with it the liability of separating the student who uses it from the remainder of the class. In some smart classrooms, rows of students face each other; this is not recommended as some students will always have their backs to the instructor.

The fourth option consists of peninsula tables, each with a flat-panel screen (Figure 26.4). This adaptive solution to a space with multiple columns (in the former book stacks

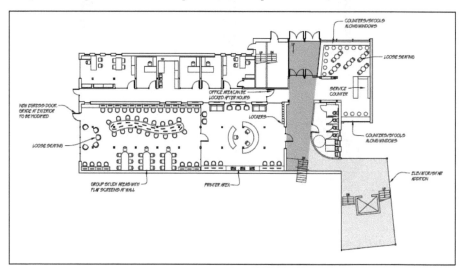

Figure 26.4 *Floor plan of computer laboratory in Felician University's Education Commons illustrating the instruction node at the lower left* (courtesy of Arcari + Iovino Architects)

wing of Fairleigh Dickinson University's Messler Library, now Felician University's Education Commons) provides each student proximity to a screen controlled by the instructor and allows the instructor to move easily among small groups of students.

White boards

White boards are the descendants of dusty and trusty chalk boards. Their relative cleanliness necessitates dry erase markers and the occasional use of a cleaner solvent. Since the instructor may well need the white board and the projection screen at the same time, the white board ought not to be, as it often is, located behind the projection screen. A hybrid solution, in which the image is projected onto the whiteboard, allows for mark-up but requires good housekeeping if previous instructors' mark-up is not to obscure the images.

You may wish to consider interactive white boards, which energize presentations with touch-sensitive displays and notemaking with digital ink. There are three types of projection manufactured by SMART Technologies: font, rear and flat-panel.

There are assets and liabilities to these types of screens: although they allow the instructor to leave the lectern and emphasize teaching material in front of the class at the screen, these screens may be relatively small. Some SMART boards have integral projectors, which cantilever from the interactive white board, thereby simplifying installation. An alternative, also manufactured by SMART Technologies, is the Symposium interactive pen display, which connects to the computer directly and, with an attached pen, allows the instructor simply to touch the monitor for applications and notemaking. It employs the standard projection screen, which can be larger than that of the SMART board, but impedes instructor movement by fixing activity to the lectern. A 2009 survey concluded that some instruction librarians dislike SMART boards because of inadequate image resolution (Wasielewski).

Lecterns

The location of the lectern should be considered carefully. If it is not to block the projection screen, it will be positioned toward the side of the room, causing considerable movement between lectern and projection screen. Some prefer to locate the lectern at the centre of the classroom; this may block sight lines as well, but it focuses attention on the instructor. Many lecterns contain touch screens that control all of the equipment; many also feature awkward designs, such as insufficient space for notes and keyboard drawers that require uncomfortable hand positions. Some instructors prefer a wireless mouse and portable keyboard.

Classroom management software

Also known as classroom control systems, these are essential tools for teaching in smart classrooms. They allow instructors to control the hands-on experience by broadcasting

information to individual work stations or to the entire class. As online public access catalogue (OPAC) and database text on projection screens may be difficult to read, these tools bring the presentation to each computer. Some allow for access to the individual student's work station to see who is having difficulty. Perhaps most useful is their fundamental disciplinary capability of preventing 'off-task' activity when a presentation occurs.

Lighting

Whether natural or artificial, the quality of light has a perceptible impact on the experience of space. There are two kinds of light, and a blend of the two may increase the quality of the environment: ambient, which provides general, or mood, lighting, and task lighting, applied to specific activities. Optimally, the light will be adequate for the task without adding glare, and the pattern of lamps will follow the pattern of activities. The interior architect should provide a reflected ceiling plan, which is the inverse of a floor plan; rather than looking down, the reader looks up. You should match the ceiling plan to the floor plan to determine whether the lighting has been positioned correctly. The placement of light switches is important, especially if the space was previously used for other purposes. Light switches should be positioned at each entry, as well as near the lectern. Rheostatic controls (dimmer switches) for adjusting light levels are essential, as are separate controls for ambient and task lighting.

Power

Unless you are willing to rely on battery-powered computers, which require ongoing maintenance, you need to install power outlets within reach of each work station. Customized furnishings for workstations often integrate power outlets within their designs, placing them on the tabletop. Wi-fi signals should be sufficiently strong so that data jacks for student computers are optional. Printer(s) need sources of power as well.

Heating, ventilating and air conditioning

Most spaces designed before the digital era managed lower heat loads. Computer equipment adds measurably to the head load of the space, and ventilating and air conditioning need to respond to those loads. The project may well require adding a compressor or duct work, which will add to the scope and expense of the project.

Computer equipment

There are arguments in favour of both desktop computers and laptop computers. The advantages of desktop computers include their modularity, so that if a keyboard wears out or has coffee spilled onto it, only that component need be repaired or replaced. Lower prices also contribute to their popularity. The chief argument against them is the amount

of area they consume, in addition to the size and height of obtrusive monitors, which can block visual communication between students and instructor. That obtrusiveness is absent in newer monitors that feature screens with adjustable height. Recessed monitors, which rest below the table surface, are not recommended because of the difficult viewing angle that results (Grafstein, 2008).

Those who prefer laptop computers mention their smaller footprints, fewer cords and opportunities they provide for reconfiguring the space. If a classroom control system is unavailable, the lids of the laptops can be closed to focus attention onto the projection screen. The arguments against them include reliance on batteries that limit the duration of their use, and the concern that limited battery life may require unforeseen expenditure. Internal mice may be unfamiliar to some users, and laptop computers may require a non-standard desk height so as to position the keyboard at the proper level, simultaneously lowering the screen to a level that for some is difficult to read. Furnishings should therefore be designed or selected with great care in relation to ergonomics. The Occupational Safety and Health Administration of the US Department of Labor has a helpful purchasing guide checklist (OSHA, n.d.).

Furnishings

Computer tables may be basic, although grommet holes in tabletops for cables prevents tangling and improve the appearance of the space. If the floor surface is not carpeted, caster chairs may be preferable, so as to reduce sound as students move in them. Although unnecessary, arms for chairs, if selected, are easily abraded when pushed underneath tabletops. Stacking caster chairs are available and provide flexibility.

Maintenance

Co-operation from technology services for the maintenance of the computer equipment, in addition to housekeeping for the space, is often omitted from the planning equation. New spaces require additional assignments or personnel. It is sensible to enrol managers of those areas in the planning process from the start.

Conclusion

Increasingly, library administrators engage in space planning and design. This uncharted territory can yield unanticipated results, both satisfying and problematic. The key is to gather as much information as possible in advance, to work with the best practitioners possible, and to allow at least twice as much time as you would ever imagine needing.

References and bibliography

Brown, C. R. (1995) *Planning Library Interiors: the selection of furnishings for the 21st century*, Oryx Press.

Byrne, E. D. (2003) Space Planning for Art and Architecture Libraries: do's and don'ts from lessons learned. In *Association of Architecture School Librarians Conference Proceedings*, 13–16 March, Louisville, KY, www.architecturelibrarians.org/Resources/Documents/2003/aasl-2003-byrne.pdf.

Domermuth, D. (2005) Creating a Smart Classroom, *Tech Directions*, **64** (6), 21–2.

Grafstein, A. (2008) Recessed Monitors in Electronic Classrooms, e-mail, on the Information Literacy Instruction Discussion List. Professor Grafstein (Hofstra University) solicited advice on acquiring recessed monitors to improve visibility in the classroom.

Murphy, C. (2002) ABCs of Smart Classrooms, *Syllabus*, **16** (2), 24–6.

OSHA, US Department of Labor (n.d.) Computer Workstations eTool, Occupational Safety and Health Administration, www.osha.gov/SLTC/etools/computerworkstations/checklist.html.

Primary Research Group (2008) Academic Library Building Renovation Benchmarks. One-third (33.33%) of libraries in the sample added or improved classroom space in the library, whether or not there had been a major renovation in the previous ten years.

Wasielewski, A. (2009) Classroom Technology – summary, e-mail, on the Information Literacy Instruction Discussion List. Ms Wasielewski (Eastern Kentucky University) requested feedback on the types and amounts of technology respondents had access to and employed in library instruction classrooms.

Chapter 27

Finding common ground: creating library spaces for collaboration

Beverly Mitchell

Introduction

Far from the image that libraries are staid and static places, the academic library of the 21st century is a site of continuous evolution in an attempt to stay current with the needs of its users. To be relevant, libraries must keep pace with users' research, learning and technology needs. Users continue to come to the library to access its scholarly resources, but as these resources increasingly move online and print materials are shifted to other areas of the library or remote storage, the library's building no longer serves primarily as a space for housing materials. In addition, acquisitions budgets continue to shrink, and more resources are shared among libraries either through interlibrary loan or acquired through patron-driven acquisitions. The newer model of collections is point of need. Signalling this trend, the Association of College & Research Libraries (ACRL) lists one of its 2016 top ten trends in academic libraries as collections assessment to promote 'rightsizing' of collections.

There is an increasing need to establish more holistic and agile approaches (qualitative and quantitative) to manage budgetary constraints while ensuring that collections are 'responsive' and committed to institutional research and curricular requirements and needs (ACRL, 2016).

These combined changes and pressures on collections are also freeing up space in libraries. As shelves for under-used collections move out with their volumes and yield more space, libraries are embracing the opportunity to respond to their users' desire for more space. Libraries are repurposing this space for studying, meeting and learning, often alongside these materials. This shift in library use and service is what Megan E. Macken refers to as the 'learning-centered model of library space planning' (2006, 23). Learning is central to the purpose of creating new, collaborative spaces for users, and this manifests in a variety of ways.

Creating spaces: individual, collaborative and social

The information commons is a well established space within most academic libraries. Generally a large and open space, the information commons can provide study space with tables and chairs, or adjacent carrels. For technology needs, it can have computers or outlets for connecting laptops to a power source. Alternately, it can serve as a social space. While this type of space is useful for students working on their own or with a partner, its openness limits it for other purposes. Groups meeting to work on a project or practise a presentation often need a quieter space unimpeded by conversation or other users studying around them. Conversely, users may need a space where they can play music or a performance video. There are also individuals who need a very quiet space for focused concentration. The new spaces created in the library should address these diverse scholastic needs.

Individual spaces

This chapter focuses on group spaces, yet individual spaces are important to retain or create in a renovation. Carrels are an established study space in many academic libraries. Partitions, outlets for laptops and lighting make these spaces valuable for offering the quiet and privacy required by individuals who wish to focus on studying or a project. Carrels will continue to be used in libraries if they are placed in an area designated as quiet and set apart from other occupied areas. When planning a renovation, one should observe how often the carrels are used. If they are not in use, is it because the location lacks quiet and privacy? Or perhaps the carrels need to be updated with a material that offers light, such as a Plexiglas product, but still gives privacy.

Individual study rooms are often in demand in libraries. Graduate students in particular need to book these rooms for extended periods during the semester or over the course of an academic year. Converting smaller rooms, such as storage or copier rooms, to individual study rooms is a way of using this space productively.

Although this chapter addresses study and social spaces chiefly in academic libraries, it is helpful to look to museum libraries, which must also fulfil the need for their staff and members of the community to have a quiet and inviting space to read. In museum libraries, these spaces tend to be reading rooms or areas. Margaret Culbertson's essay 'Artful Architecture: the challenges of renovation' describes the reading room as the space where design features must be given careful consideration, exploiting natural light and using aesthetics. Her description of this space in the Hirsch Library at the Museum of Fine Arts, Houston, demonstrates the importance of a welcoming space for users:

> The highlight of the new Hirsch Library design is the public reading room, an elegant and serene space that looks onto a small walled garden. The view includes sculpture from the museum's collection, a fountain, and the shifting shadows of a trellised vine above the garden. Inside, white walls and gray carpet conform to the

modernist aesthetic of the original Mies building, and the pale blond wood shelving and desks add visual warmth. The bookshelves in the center of the room were kept low to preserve the open effect, allowing views to the garden from the entryway and across the room and maximizing the natural light.

(Culbertson, 2007, 85–6)

Culbertson skilfully describes how these architectural elements have been used to their best effect, and the design elements such as the wood finish or the bookshelves' height all serve the aesthetics. A sense of quiet and calm, which can be enhanced by good design, is paramount in an individual study or reading area.

Collaborative spaces

Collaborative spaces are work spaces. Users need a space where they can talk openly without disturbing others while practising presentations or holding seminars. Whatever the specific activity, users should be able to book a space that suits their plan.

Some of the elements that make for a successful collaborative space are flexible furniture, whiteboards, and easy-to-use audiovisual technology in an inviting space. Mobility and flexibility are now two key features of any workspace furniture, enabling users to rearrange a space for their immediate needs. Durable but light furniture or whiteboards on casters make any space adaptable to a classroom, lecture or seminar setting, and they encourage users to feel welcome and settle into it for their activity.

Two other elements in space renovation should be comfort and design. Art and architecture libraries can use their natural affinity with design to create an aesthetic enhancement of spaces throughout the library. Students, faculty and staff in art, architecture and performing arts libraries often look forward to innovation, which allows librarians to take a risk with design and technology, but both design and technology should be uncomplicated and functional. If users encounter a challenge with heavy or uncomfortable furniture, or the technology does not work with their own devices, the situation will frustrate them, and they will soon find other, more adaptive spaces.

Social spaces

As mentioned above, the information commons can serve both as a study and social space. Paired with a café or adjacent to an art gallery, it can extend the space use. Installing coffee bars, cafés or galleries, which are outside the traditional mission of libraries, is not without controversy. Jeffrey T. Gayton strongly cautions that these non-traditional spaces can compromise a library's unique position as a quiet place for study. He distinguishes two types of group spaces as the 'communal' or collaborative space over the social space in libraries:

> Implicit in this view is a confusion between 'social' and 'communal.' There is a profound difference between a space in which library users are engaged in social activity and a space in which they are engaged in communal activity. Social activity in a library involves conversation and discussion among people, about either the work at hand or more trivial matters. Communal activity in a library involves seeing and being seen quietly engaged in study. (Gayton, 2008, 61)

Gayton believes social spaces can work at odds with the communal spaces in a library, providing a distraction from study. He urges a preference for communal spaces. Heeding Gayton's words, a balance between the two types of spaces is necessary to create a democratic atmosphere, which does not compromise group meeting or study space at the expense of a social space. The quiet, academic environment of a library is an asset that students value in their scholastic lives.

Silas M. Oliviera also references students' high value of quiet study areas. His article (2016, 355–67) offers a meta-survey of studies on the types of spaces students seek in a library. Oliviera conducted space use studies for the James White Library, Andrews University, in Michigan. His studies are a mix of qualitative and quantitative methods. He breaks down his research findings by gender, programme level and other criteria. In his discussion, he concludes that the top priority for students is having individual study space while social space ranked as the fifth main concern.

Design: creating functional and inviting spaces

In a renovation or a new building, much focus is placed on updating the technology or enhancing specific areas, but it is important to consider the design, which should be in keeping with users' expectations for comfortable and flexible furniture, pleasing colour schemes, and spaces with good scale. Closed individual study spaces should create a feeling of privacy, and closed group study spaces should have a sense of adaptability and room to move furniture or a whiteboard.

Ideas for clean lines and contemporary design are available from websites or in design books, and ideas do not need to come from the library field. Marquis et al. wrote an inspiring article about four Canadian colleges converting existing spaces into individual and collaborative spaces (2014, 116). At the new library entrance of the Cégep Édouard-Montpetit in Montégérie, the architectural firm borrowed the idea of display from retail and placed new monographs in front of the patron's view. A series of cascading acrylic stands, much as one would see in the lit window of a book store, promotes an offering of the latest publications and creates a clean look beckoning the user to browse.

In Québec, the library Charlesbourg du Cégep Limoilou took a modular approach by designing a group study area within its larger open space (Marquis et al., 2014, 116). In what appears to be a room within a room, this study area is furnished primarily in red with cushioned, upholstered chairs and desktop computers at a bar with high-backed

stools. In addition to its innovative appeal, this design solution is clever in intentionally defining space for users who can decide how they wish to use it, whether for individual research at a computer or group conversation for a project.

Other libraries that have recently completed a new building project or renovation are excellent sources of information about design and function, and site visits can yield good ideas. Texas Christian University in Fort Worth recently remodelled its Mary Couts Burnett Library, adding more square footage and a significant number of seating areas. There are several spaces with group study rooms walled in with glass and chrome, giving it a contemporary and open look, while still providing a quiet space.

Interpreting the results from his user studies at James White Library, Oliviera concludes that students perceive the library as 'old' and unattractive with uncomfortable furniture (2016, 364). But old does not necessarily mean out of date. Rather, much of the original design of a library can be updated for the 21st century.

Many academic libraries renovate their decades- or centuries-old grand rooms, keeping the integrity, beauty and history of the design. Fondren Library at Southern Methodist University recently renovated its Centennial Reading Room. Moving stacks out of the long and wide 1940s reading room of over 5100 square feet enabled the natural light from the floor-to-ceiling windows to open and illuminate the space. Lights were added to enhance the view of the ceiling's bas relief sculptures by Texas artist Harry Lee Gibson. Using straight-lined, attractive Thomas Moser wood tables and chairs created a feeling of intimacy and warmth in a space where users may work alone or in groups.

In 2008, the Van Ingen Art Library, Vassar College, renovated its library. Built in 1937, the library is modernist, and the architects Paul Byard and Charles Platt of Platt, Byard, Dovell and White chose to restore much of the original design. Librarian Thomas Hill describes the thought behind this plan as 'to formulate spaces for the group study of physical materials as well as texts, which the renovating architects saw would translate well to the requirements of the 21st-century library' (2017). Indeed, the renovation created spaces for individual or group study with tables and chairs, along with a browsing space defined as a separate area with low shelves for print periodicals and period seating in chrome and leather chairs.

Technology

Providing or enabling the use of technology is essential for making a study or collaborative space successful. Whether library staff plan to have technology, such as desktop computers, in a specific space or provide power and data ports, the renovation team should plan which of these scenarios will be executed early on in the planning process. Notably, in older libraries, floor plugs in the right locations are frequently in short supply. Adding these outlets in key areas where students study or where new furniture will be placed can increase the use and success of these spaces.

One technological trend is to bring one's own device, and thus power outlets must be

conveniently located under a table or by a comfortable chair. The 2016 report by New Media Consortium, *NMC Horizon Report*, cites the trend of students bringing their own device in the classroom as access to technology is becoming more integrated within the learning environment of higher education. The report states that students are familiar with their own devices and therefore prefer them (NMC, 2016, 36). However, Oliviera's observational study of student use in the library found that 40% of the time students sat and used the computers available to them (2016, 364). Students do not necessarily want to depend on their own devices all of the time. While this trend suggests there is less need for desktop computers, Oliviera's research suggests that a blend of providing some public computers and outlets conveniently placed for charging or connecting devices serves students best.

Planning a user space renovation: user studies

In one of Oliviera's studies, he invited students to express their preferences in a design charrette by placing symbols representing specific types of spaces, such as 'closed individual study areas', on a blank sheet of paper. In other studies he questioned a student focus group. Oliviera's thorough effort at assessing user preferences in the library is common of other user studies, but his article is a good, thought-provoking overview of studies that can be adapted to gather ideas and information before renovating. Oliviera includes an extensive list of articles about types of spaces – for informal spontaneous meetings, group study or individual study with computer facilities (2016, 355–67).

Several other academic libraries have used similar assessment methods to those of Oliviera. Rachel Applegate writes about an observational study of existing seating areas without computers (2009, 341–6). Khoo et al. used several methods and combined their results to assess how spaces and technology were being used in an academic library (2016, 51–70). When planning even a small renovation, assessment is vital to the project's successful outcome.

In addition to surveying students and staff, valuable input can be obtained from faculty. The semester before the author's library staff began talking to the project team working on a large audiovisual system in a new bookable space, they held a series of meetings with faculty to learn how and when they would use this space. Alternately, in museum libraries, Milan Hughston vouches for curators as key supporters for a renovated library: 'One can almost always count on the curatorial staff to be the library's strongest advocates in ensuring that the new space is suitable' (2007, 82).

Implementation: plan and revision

When there has been careful assessment and thoughtful planning before the first meeting with a project manager, architect, IT staff, interior designer or other members of the project team, librarians have greater confidence in their vision for the library. While the

construction details of a renovation may be unfamiliar to librarians, the behaviour of users, daily traffic and library use are not. The librarian heading the renovation project should ask many questions of the team and not hesitate to follow up with e-mails to all team members when clarification is needed. It is critical that plans are reviewed and there is good communication so that everyone involved in the renovation is aware of the plans and any changes to the project.

During project meetings, the plans may change according to budget, feasibility or simply finding a better solution to a particular problem. The library staff should be flexible as these changes develop. In the design phase, two guiding principles may help librarians stay on track with the project. First, simple design usually serves everyone well. If using the audiovisual set up is complicated, or the mobility of furniture is impeded in some way, it creates frustration and discourages use. Making the design of the space and technology easy to use ends in good results.

A second principle is to plan for the future. While it is hard to foresee how a space may be used in several years' time, if the budget allows, it is generally a good idea to install extra optional components for potential future use. Although data ports may have no immediate use now, retrofitting them may be more expensive, and usually the later installation will be less aesthetically appealing. Alternately, temporary or mobile components may serve just as well as built-in components. As space needs change, the less needing to be reconfigured, the easier and cheaper small updates will be in future.

Conclusion: making the best use of the new spaces in the library

Once the new study and social spaces are completed, additional steps may be needed, such as setting up a booking system for closed group study or an audiovisual meeting space, or updating the signage. Users may immediately flock to these new spaces, though marketing can help this transition. A blog or other social media should get attention from users who do not regularly come into the library or who use another campus library. Fliers and a reception to thank donors helps to publicize a renovation.

Newly opened spaces should be monitored: if there is low use try to find out the reason. Perhaps a different user group from the one originally intended might make better use of the space, or there may be inadequate technology. Consult faculty members, who might have new ideas for developing a space. In short, if the space is not being used as originally intended, staff should opt for a new strategy.

As libraries continue to change in the future, adapting space needs to users' research and learning styles will help to ensure that the library remains a relevant resource in the academic life of its users. A mix of spaces with flexible furniture and technology will likely address multiple types of use in libraries – individual, collaborative and social – and be an investment in patron services for years to come.

References

ACRL (2016) 2016 Top Trends in Academic Libraries: a review of the trends and issues affecting academic libraries in higher education, *College and Research Libraries News*, **77** (6), http://crln.acrl.org/content/77/6/274.full.

Applegate, R. (2009) The Library is for Studying: student preferences for study space, *Journal of Academic Librarianship*, **35** (4), 341–6.

Culbertson, M. (2007) Artful Architecture: the challenges of renovation. In Benedetti, J. M. (ed.), *Art Museum Libraries and Librarianship*, Scarecrow Press.

Gayton, J. M. (2008) Academic Libraries: 'social' or 'communal'; the nature of academic libraries, *Journal of Academic Librarianship*, **34** (1), 60–6.

Hill, T. (2017) E-mail message to author, 30 January.

Hughston, M. (2007) A Primer on Space Planning Based on Experiences at the Amon Carter Museum and the Museum of Modern Art. In Benedetti, J. M. (ed.), *Art Museum Libraries and Librarianship*, Scarecrow Press.

Khoo, M. J., Rozalkis, L., Hall, C. and Kusunoki, D. (2016) A Really Nice Spot: evaluating place, space, and technology in academic libraries, *College and Research Libraries*, **77** (1), 51–70.

Macken, M. E. (2006) The Art Library as Place: the role of current space planning paradigms within the academic art and architecture library, *Art Documentation*, **25** (2), 18–25.

Marquis, D., Haché, N., Julien, M. and Lamontagne, N. (2014) Bibliothèques collégiales: quatre examples d'espaces adaptés au travail individuel et collaboratif, *Documentation et bibliothèques*, **60** (2–3), 115–18, doi:10.7202/1025520ar.

NMC (2016) *NMC Horizon Report: 2016 higher education edition*, New Media Consortium, http://cdn.nmc.org/media/2016-nmc-horizon-report-he-EN.pdf.

Oliviera, S. M. (2016) Space Preference at James White Library: what students really want, *Journal of Academic Librarianship*, **42** (4), 355–67, doi:10.1016/j.acalib.2016.05.009.364.

Part VI

Promotion and sustainability

Social media and electronic communication are ubiquitous in the 21st century, and they have transformed the way that libraries reach out to their patrons, especially students. At a time when many people question the relevance of libraries since so much information is available immediately on the internet, it is especially important for libraries to have a strong presence where students are already spending their time to remind them of the resources, services and other great reasons they should visit. Art and design libraries in particular can make their electronic communications visually stunning with the rich images available in their collections. However, for a message to be received and understood effectively, repetition through multiple channels is always the best strategy. For that reason, libraries need to have customized and well conceived marketing plans to engage target audiences using numerous methods. The chapters in this section offer strategies and recommendations to promote the library to art and design students through marketing, social media and websites as an integral resource for their research and art practice.

Part VI
Promotion and sustainability

Chapter 28

Marketing plans made simple

Paul Glassman

Why pursue a marketing plan?

Typically, definitions of marketing tell us what it is not: it is not advertising; it is not publicity; it is not outreach. But marketing does allow us to understand our audiences: our readers, our users, our constituents – however we refer to the people we hope to serve. And as we learn more about the people we hope to serve, we can communicate the value of academic libraries in a shared language. We can describe the benefit rather than the feature. For example, rather than boasting of the quality of cataloguing, we can offer the promise of finding what our patrons are looking for easily and quickly. Thus, a marketing plan is an exercise in showing empathy for our patrons. It is an opportunity to connect with users, to share the value of library services, and to tell a story that resonates. People take interest in propositions that relieve pain points and thereby make their lives easier. A marketing plan helps us intersect with our patrons' needs. It helps us communicate value and evangelize.

Change management

With the cosmic changes the digital universe has brought to the place of libraries in the academic enterprise, adopting an entrepreneurial approach to change is essential for the successful organization, which adapts its core competencies to support innovation (Thota and Munir, 2011). And that innovation should centre on the expectations of users.

The most compelling reason to create a marketing plan is to help the library change, help it grow as an organism and ensure sustainability for the future. To envision change, we need first to understand the organization: its personality, culture and behaviour. In their theory of change management, Bolman and Deal established four frames – metaphorical lenses – through which organizations and their leaders picture themselves: structural, human resource, political and symbolic. The greater the number of frames through which an organization is viewed, the more comprehensive the understanding of its culture. Each 'captures a vital slice of organizational reality' (2014, 9):

- The *structural frame* highlights goals, strategy, roles and co-ordination. Structural leaders focus on co-ordination and implementation.
- The *human resources frame* centres on relationships, group dynamics, reactions to authority, resistance to the task and response to leadership (Green and Molenkamp, 2005).
- The *political frame* acknowledges the internal competition for power and scarce resources.
- The *symbolic frame* gathers rituals, ceremonies, stories and heroes and is likely to represent the most natural opportunity for communicating the need for change.

Executive summary

The executive summary begins with the mission of the institution or agency – its essential purpose. How will you go about creating a mission statement that resonates with your constituencies, rather than one they ignore? One way is to interview a cross-section of the constituents – current students and faculty, employees, alumni(ae), trustees, administrators – and allow them to assess and critique the current mission statement.

The results of the interviews may contradict your assumptions about what you are doing well and how the library should change. But according to John Kotter (2008), the interview process and its risks demonstrate precisely how to avoid 'dangerous complacency' and to express urgency in the need for change:

- Listen to customer-interfacing employees to gain a deeper understanding of needs and transactions.
- Use the power of video to send the message.
- Do not protect people from troubling data; present it as an opportunity, not a problem.
- Send people out to bring back new information.

You can include the vision for the future – not only what the institution is now, but also what it intends to be. The marketing plan sets out how the institution will move from its current position to the latter one, and those you interview may have solid ideas about what the future should include.

The first part of the marketing plan comprises the table of contents with a short (ideally one-sentence) summary of each section. The table of contents clarifies the analytical process that supports the plan.

Service description

Continue with an outline of the services you offer and a brief summary of how your audiences might use those services. Rather than describe features of the services, be sure

to state what the benefits are to the constituents of engaging with the library and its services. In our efforts to quantify and embrace data-driven decision making, we may over-describe features in detail (numbers of volumes, hours of operation, types of programmes) rather than show what the reader will be able to accomplish with those services (succeed in a course, become a life-long learner, acquire skills for graduate school).

Provide a few examples of initiatives that have been successful and met expectations. Describe their benefits to constituents. For example, a discovery layer may aggregate, re-index and search thousands of sources, but explaining how the discovery layer provides a sizeable set of results with one search is more meaningful. Similarly, be sure to use language that communicates the value proposition of each of those services. Rather than state 'We can search full-text databases and get relevant results', use the emphatic 'Ask us! We'll get you the information you need, when you need it.'

Situation analysis

The analysis of current conditions begins with strengths, weaknesses, opportunities and threats (SWOT). It is a tool for assessing the organization by identifying issues, suggesting solutions, and identifying opportunities (Harmon, 2016). It can identify areas of strong performance and uncover areas in need of improvement. As with the interviews before revising the mission statement, a wide selection of constituents, from employees to trustees, should construct the SWOT analysis so as to gather as many perspectives as possible.

You might begin the conversation by considering the questions proposed by the American Library Association shown in Figure 28.1.

STRENGTHS	WEAKNESSES
What are your library's strongest contributions to your community? What does your library do that no one else does? What do your users like best about your library?	In what areas does your library have fewer resources than you need? What else needs improvement? What do your users wish you did better?
OPPORTUNITIES	WEAKNESSES
What could you do if only your library had the resources to do it? What is happening in the world now that you would like to take advantage of? How can your strengths open doors to opportunities for your library?	In what areas does your library have fewer resources than you need? What else needs improvement? What do your users wish you did better?

Figure 28.1 *SWOT analysis for a library marketing plan* (American Library Association, (2017) http://www.ala.org/advocacy/swot-analysis-your-librarys-strengths-weaknesses-opportunities-and-threats)

Target markets

Nearly all libraries have multiples constituencies, and you may regard each as a distinct market. An understanding of each target market forms the core of a strong marketing plan. First-year students constitute a market, as do doctoral students in art history, studio artists, external researchers, visiting scholars and faculty members. Each group represents a segmentation variable based on demographics, geography, behaviour and culture. Therefore, surveys and focus (interview) group questions need to be tailored to the characteristics of each target market.

 Each market needs to be identifiable, measurable, sustainable, accessible and reachable. An elementary school student may be an avid library user, but if no other elementary school students make similar use of the facility, they are neither a measurable nor sustainable market for that institution. Rather than starting with the most difficult market segment to define (for example, late-registering summer session students), look for a readily identifiable segment (for example, fourth-year film majors).

Competitive analysis

Based on the identification of multiple threats in the SWOT analysis, identify two top competitors (for example, a lively student centre that serves as a magnet for groups that study together, or a writing centre that hosts highly successful end-of-semester open houses). Remember, however, that understanding the competition is critical. You will not overcome the competition without understanding it first.

Service delivery

Thankfully, most academic libraries are direct-channel service providers. They have direct contact with their audiences and constituents and usually do not rely on intermediary distribution channels. Nevertheless, state how delivery occurs. Is a solid percentage of students asking questions via live chat, text messaging or e-mail? Does instruction take place via web conferencing as well as in person? Can books be mailed to online students who live outside the institution's geographic area?

Integrated marketing communications

In this section list the various media through which you plan to promote services and programmes. The public relations effort may include print materials with introductory content and contact information. Events and programmes may be promoted and targeted to specific audiences via news releases, online bulletins, carefully segmented e-mail lists, posters, blogs, broadsides and electronic LED (light-emitting diode) displays. Use language and communication channels your constituents already know and use. Otherwise, your message will be lost. For example, if your students do not really know

what an information literacy workshop is, announce it instead as a term paper clinic or as 'Last-Minute Help'. If first-year students dismiss campus e-mail but check Twitter frequently, concentrate your message to them through the latter channel.

Design the graphic image of the library to be clear and recognizable. Use it consistently on all material, in print or online, such as worksheets in user education, online pathfinders and newsletters. Imagine a variety of distribution channels for print materials. If a semi-annual newsletter is of particular interest to faculty, consider distributing it at a faculty meeting. If a calendar of workshops is of interest to graduate students, explore whether there is a graduate student centre or lounge with a bulletin board. Many of the distribution channels offer high-impact, low-effort approaches.

Composing messages for social media requires a particular set of skills: writing concisely and briefly, using clear punctuation, employing the second person liberally and including visual material whenever possible. Equally important is knowing in which media to invest time. Focus groups and surveys will yield critical information about which constituents are reachable with particular media. The free tool Survey Monkey (https://www.surveymonkey.com/r/LMWLMLS) has an online social networking questionnaire that will serve as a prototype.

Informal exchanges are effective as well. A good 'elevator speech' to an influential dean or faculty member may yield the perfect contact in a department with which you were unfamiliar. Evangelizing and serving as an enthusiastic advocate are at the core of word-of-mouth public relations.

Integrated marketing communications budget

Develop a budget for the first year and two subsequent years. Although much of the dissemination of marketing materials can be achieved at little or no cost, the human resource requirement can be a key expense. Larger libraries hire communication managers, and graphic designers, whether employed within the institution or engaged as consultants, are sound investments for creating well designed and suitably branded templates for web-based and print material.

Other costs to consider are printing, sign holders, A-frame sandwich boards, digital displays, photography and promotional items, such as flash drives, pens, pencils, water bottles and mouse pads.

Establish measurable goals

Include an assessment component by setting achievable and measurable goals first. How many audience members for book talks would you like to attract? How many more assignment-based classes would you like to see?

Make it easy! Provide simple ways for target markets to provide feedback, whether through suggestion boxes, short online or written surveys, usability testing or

interpersonal exchange. Look at data you are already collecting, such as circulation statistics and website analytics. Direct conversation, even if it is improvisational and yields anecdotal feedback, has the benefit of being contextual.

Creating change

You can view your marketing plan as a condensed, programmatically grounded strategic plan. Both are predicated on managing change to sustain a healthy, evolving organization. As a reflection of change theory, your plan may naturally incorporate all of John Kotter's eight steps for accelerating change (2012):

- Create a sense of urgency. Be a champion of the plan.
- Build a guiding coalition. Invite a small, committed set of constituents to participate.
- Form a strategic vision and initiatives. Work toward a unified set of goals.
- Enlist a volunteer army. Engage a larger group of advocates who will evangelize.
- Enable action by removing barriers. Establish a budget with sufficient financial resources. Leave naysayers behind.
- Generate short-term wins. Pick the 'low-hanging fruit' first. Build on successes; address greater challenges later.
- Sustain acceleration. If it works the first time, do it again.
- Institute change. Position your library at the centre of the academic enterprise.

Why pursue a marketing plan?

This chapter ends with the question it asked at the beginning. A marketing plan is a vehicle for directing action toward measurable goals. It is the change agent's tool. But it need not be a Sisyphean task. Rather, your marketing plan can be the crucible that launches the library into a dynamic future.

References

Bolman, L. G. and Deal, T. E. (2014) *How Great Leaders Think: the art of reframing*, Jossey-Bass.

Green, Z. G. and Molenkamp, R. J. (2005) The BART System of Group and Organizational Analysis: boundary, authority, role, task, https://www.it.uu.se/edu/course/homepage/projektDV/ht09/BART_Green_Molenkamp.pdf.

Harmon, A. (2016) SWOT Analysis. In *Salem Press Encyclopedia*, Salem Press.

Kotter, J. P. (2008) *A Sense of Urgency*, Harvard Business School.

Kotter, J. P. (2012) *Leading Change*, Harvard Business Review Press.

Thota, H. and Munir, Z. (2011) *Palgrave Key Concepts: key concepts in innovation*, Macmillan.

Further reading

Dempsey, K. (2009) *The Accidental Library Marketer*, Information Today.

Hallmark, E. K., Schwartz, L. and Roy, L. (2007) Developing a Long-Range and Outreach Plan for Your Academic Library, *C&RL News*, February, 92–5.

Mathews, B. (2009) *Marketing Today's Academic Library: a bold approach to communicating with students*, ALA Editions.

McDonald, M., Frow, P. and Payne, A. (2011) *Marketing Plans for Services: a complete guide*, Wiley.

Potter, N. (2012) *The Library Marketing Toolkit*, Facet Publishing.

VanDuinkerken, W. and Mosley, P. A. (2011) *The Challenge of Library Management: leading with emotional engagement*, ALA Editions.

White, L. L. and Molaro, A. (2015) *The Library Innovation Toolkit: ideas, strategies, and programs*, ALA Editions.

Chapter 29

Engaging with social media

Ken Laing and Hillary Webb

Introduction

Library marketing expert Nancy Dowd published an article in 2013 titled 'Social Media: libraries are posting, but is anyone listening?' (Dowd, 2013). Dowd points out that although the majority of libraries use social media to disseminate information to their communities, many do not keep track of their efforts or claim success in getting followers to interact. With this in mind, libraries that want to create or revitalize their social media presence should consider devising a plan. This chapter presents highlights from a social media case study carried out at the Emily Carr University (ECU) of Art and Design Library in Vancouver, British Columbia. Through the experience of the study, the authors outline ways in which organizations can develop objectives for their social media usage, strategies to increase online presence and interaction with their communities and methods to assess their presence. They also discuss some innovative ways libraries use social media, focusing on the visually rich field of art libraries.

Emily Carr University of Art and Design Library: social media case study

In spring 2013, the ECU Library made a push to energize and bolster its social media presence and formed a social media committee to support this project (Webb and Laing, 2015, 137–51). The committee met to discuss why social media was being used, what goals would be achieved by its use, who would be responsible for each platform, the type of content that would be posted, and how success would be measured. These were some of the goals set out by the committee:

- Raise the online profile of the Library by increasing the number of followers.
- Inform users of special events and programming.
- Help define the Library's role within the broader university community.

● Gain overall support for the Library from the community in general.

A social media policy was drafted to reflect the needs of the Library and to provide concise guidelines for staff to follow when representing the Library on its social media platforms. Each committee member took responsibility for a social media platform, posting content and keeping track of metrics and anecdotes of usage.

Before the goals were set, the social media committee developed and administered a survey that was used to better understand the Library's social media followers and their motives for interacting with the Library's social media channels. A mix of students, staff, faculty and people outside the ECU community answered the survey, and the results showed that both ECU-affiliated and non-ECU users generally follow the Library on social media to find out about events and new arrivals in the collection. Of the platforms on which the Library posted, Facebook and Instagram were the two most popular.

In addition to surveying the Library's followers, the use of analytics was introduced to gauge the effectiveness of the social media strategy and to determine possible ways to boost engagement with posts. For Instagram analytics, the Library used Iconosquare, which showed which hashtags were the most popular overall on Instagram as well as which hashtags the Library used that were among the most popular. Over time, the committee developed a list of hashtags with which to tag the photographs in order to increase the number of likes and the number of followers. Between June 2013 and June 2014 the Library increased its monthly likes from below 100 to over 500, and the follower base grew rapidly. As of January 2017, the Library had 1235 followers and an average of ten likes per post.

The Library's goal for Facebook was to double its followers within five months of May 2013. Although this goal proved unrealistic at the time, the Library was able to increase its follower base by 151, bringing the number of followers to 494 (in January 2017 the Library had 725 followers). Facebook analytics gathered in 2013 showed that Facebook posts shared by institutions that had large follower numbers were the most successful. One of the key findings was that when the Library wished to reach a wider audience for certain posts, it was most effective to ask the ECU Communications Department to share the Library post on the university's Facebook page, leveraging its large audience.

The third social media platform the Library sought to promote and analyse was Twitter. Up until May 2013 the Library hardly used Twitter. Although the Library easily met its goal to double the number of followers by the end of summer 2013, after comparing the names of followers against the Library's integrated library system's patron database, it was determined that out of 170 followers only 12 were students, staff or faculty. Over the course of the Library's 13-month study, engagement from followers was better than expected. The most successful tweets were those that contained links to news stories, events or items in the catalogue. In the end, it was decided that although tweeting requires minimal staff effort and time, the Library wanted to focus its social media efforts on Facebook, Instagram and Pinterest, platforms that allow for more visual content.

The ECU Library found that creating a library social media committee and setting goals and strategies collaboratively were important for building and maintaining an active presence online. The process of setting goals and benchmarks, analysing data and hearing from the community through a survey helped to determine what success on social media looks like. A thorough investigation revealed meaningful connections forged with students, alumni, university staff and community members, resulting in the circulation of, and excitement about, library materials and attendance at library events.

Developing social media objectives

Be intentional

When considering an organization's social media presence, one should be mindful and purposeful about the intentions. Forming a committee is an inclusive way to do this work. The committee can discuss the reasons for using social media, what the goals and objectives are, how to measure success, who is responsible for each platform, and the type of content that should be posted. The organization should recognize that certain platforms are better suited than others for the different types of content it wants to share.

What are you aiming for?

Set goals for social media usage. These are two possible goals that supplement those listed in the ECU Library case study:

- Increase follower engagement and forge community connections with alumni, faculty and other local art and design institutions.
- Determine which platforms work best to disseminate different types of information.

There should be a high rate of return on goals in relation to the amount of staff time and effort put into social media.

Present meaningful and interesting content

Together as a committee, brainstorm the type of content to share to generate interest and gather followers. Content should promote the library and demonstrate the multi-faceted nature of art libraries in general, including:

- new arrivals in the collection
- archival images of the institution
- art exhibitions happening in the library
- library events
- contests

- sharing stories that relate to libraries and the arts
- selected events hosted by the university, especially if the library is participating in some way.

Strategies to increase social media presence

First steps

In order to raise the library's online profile and increase followers within the university library community, the social media committee can devise and implement a series of promotional strategies, such as:

- linked icons for social media platforms on the library website, blogs and research guides
- links to select social media platforms on all staff e-mail signatures
- signage at the circulation desk
- icons on the hours cards
- social media URLs on the lock screens of public computers and audiovisual equipment (iPads, TV screens, media stations).

Keep social media beautiful

If starting out without a social media presence or with accounts that need refreshing, it is important to consider the overall aesthetic of the account if it is a visually based platform like Instagram, Pinterest or Tumblr. Having attractive and cohesive imagery will help gain and keep followers. Think about developing a visual brand for the library. As part of the initial planning conversations, discuss the brand to present to the community. The ECU Library started out in Instagram by posting different types of content such as photographs of art exhibitions in the library, staff book recommendations and promotions for upcoming library events, then started to focus on book covers, mostly of new arrivals (Figure 29.1 opposite). The use of hashtags increases photo findability, as does tagging other user accounts (for example, tag the publisher's account if posting an image of its book).

Stay true to yourself and stay engaged

A key to success on social media is to remain as genuine as possible and to strive for meaningful engagement. At the ECU Library, the staff that manage accounts maintain an active presence by finding new accounts to follow, liking and commenting on media posted by other accounts, replying to any comments made about the library's media, and sharing between platforms (for example, pushing posted media from Instagram to Facebook and Twitter).

Figure 29.1 *Screenshot from Emily Carr University of Arts and Design Library's Instagram account (@ecuad_library), 28 January 2017*

Promote social media presence

Identify key times for the library to promote its social media presence. In educational institutions, the beginning of the school year is an ideal time to do some promotion. Concentrate on reaching a specific audience type, like first-year students. At ECU Library, social media platforms are introduced during tours and classroom instruction sessions, and an Instagram contest is held to correspond with the start of the school year. Hosting contests can increase engagement and follower numbers; students will ask their networks to like their images on the library account, leading to potential new followers. The photographs that students post of the library lend a new perspective on what they find interesting and exciting.

Use assessment tools

Consider the definition of engagement before examining analytics if a high level of engagement is something the organization has decided is important for successful social media efforts. When the ECU Library was analysing its initial social media attempts, it was looking for a high level of follower engagement as determined by the number of likes and comments made about the posts.

Instagram has several ways to assess engagement. Iconosquare is a tool that allows measurement of the growth of followers, the likes and comments on posts, and how the filter and hashtags being used help influence follower engagement. Unfortunately, Iconosquare is no longer a free tool, but if funds are available, a basic account can be

created for a modest fee. Squarelovin is a free tool that offers analytics and measures the same types of information that Iconosquare measures. It has an intuitive interface with a visual display of analytic information about the account (Figure 29.2). Instagram has built-in analytics for business profiles. Its tool is designed for marketers trying to sell products and promote brands; although it is not the traditional way that libraries approach promotion, it is more forward-thinking.

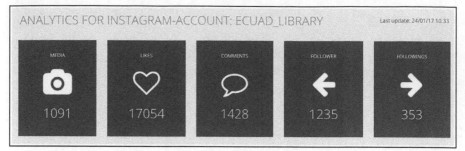

Figure 29.2 *Screenshot of squarelovin analytics of the Emily Carr University of Arts and Design Library Instagram account, 24 January 2017*

Organizations that have set up Facebook business pages have access to Facebook Insights. With Insights, 'page views', 'page likes', 'reach' and 'post engagement' can be viewed. The quick view default displays the last seven days' worth of data, but specific time periods can also be viewed (Figure 29.3). In addition, there is data available for all posts for both 'reach' (how many people received impressions of a post) and 'engagement' (reactions, comments, shares).

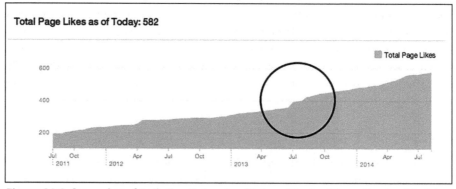

Figure 29.3 *Screenshot of Emily Carr University of Arts and Design Library Facebook Insights highlighting a jump in followers, 21 August 2014*

Twitter has its own analytics site where it tracks data for individual tweets (impression, engagement, engagement rate) and audience data (interests, demographics, region). Twitter analytics are free, intuitive, and cover a wide range of dates. Simply log in to the Twitter analytics site (https://analytics.twitter.com/about) with the Twitter user name and password associated with an account to access the data.

In addition to relying on the analytics data provided by social media sites and through third party providers, it may be worthwhile to explore some creative means of self-assessment. For example, when an organization uses social media and other outlets (posters, word of mouth, etc.) to advertise an event, it can be difficult to determine whether or not social media had a positive effect on attendance. A quick survey can be conducted as attendees arrive to determine how people heard about the event. Another self-assessment suggestion for libraries, albeit more involved, is a study to see if social media posts have any measurable effects on collections. For example, a dedicated campaign to promote an under-used collection or database may be undertaken. Posts to promote that collection can be made over a specific time frame. Reports on the circulation statistics of the collection can then be run and compared against historical statistics.

Innovative uses of social media

Developing image content for websites and LibGuides

Each fall semester the ECU Library holds an Instagram contest in order to engage with students, to promote its Instagram account, and to develop a collection of photographs that can be used on the library's website and research guides. Each contest period draws anywhere from 10 to 20 entries, with some participants submitting multiple photographs. The library announces its contest over Instagram and Facebook, through posters, and during first-year students' library orientation. The contest encourages students to take creative photographs of the library and then hashtag them with #ecuadlibrary. Prizes are given for images that are the most liked and range from gift cards for nearby coffee shops or the art supply store to books. One of the stipulations of the contest is an agreement that all photographs submitted can be used with attribution on the library's online platforms. The feedback the library has received about the contests has always been positive, and the contests encourage students to visit the library and engage with the collections (Figure 29.4 on the next page).

Using Pinterest as a content management system (of sorts)

The Ringling Art Library in Sarasota, Florida, uses Pinterest to display items in its rare book collection (Figure 29.5). In January 2017 there were 669 Pins on the rare books board and the Library had 984 followers. Images on the board consist of covers of rare books that are linked from the Ringling Library's Flickr account. Using Pinterest to display the cover of items in a rare book collection is a simple, effective way to open up a collection that is usually hidden from view or under lock and key. Libraries without a content management platform can use Pinterest to organize digital images. Even when libraries have content management platforms, these systems are often locked so that only those affiliated with an institution have access to them, limiting potential public engagement with collections.

ECU Library uses Pinterest to showcase its artists' book collection. Boards have been created for various publishing formats (accordion-folded books, artists' vinyl, zines, unbound) as well as new arrivals and staff picks. The boards are used as curriculum support for book media classes and are especially useful as a way to explore the collection visually.

Figure 29.4 *Winner of the September 2015 ECUAD Library Instagram Contest*

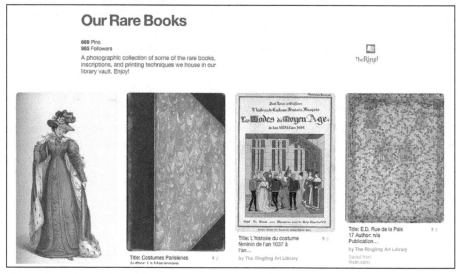

Figure 29.5 *Screenshot of the Ringling Art Library Rare Book Pinterest board, 24 January 2017*

Using Instagram to display rare books and the libraries in which they are housed

Rare book collections are notoriously difficult to access and can be intimidating places to visit. The Thomas Fisher Rare Book Library at the University of Toronto opens itself up via Instagram and does so in a very lighthearted manner (Figure 29.6). In January 2017 the Fisher had 16,700 Instagram followers and posted 1159 times. Its posts contain images of books from its small books collection, time-lapse videos of artists' books, and interior shots of the library itself. Judging by the number of likes it receives and the number of followers it has, the library's collection is broadly viewed.

Figure 29.6 *Screenshot from The Fisher Rare Book Library Instagram account (@fisherlibrary), 24 January 2017*

Conclusion

Social media is a powerful tool that can be harnessed by art libraries and archives to promote collections, events and activities. Visually based platforms such as Instagram and Pinterest can be particularly effective in art and design organizations, especially when used in innovative ways. The key to success for library social media is to spend time developing a plan of action: determine the organization's objectives for using social media, create strategies for increasing social media engagement, and know the tools and methods to assess engagement. Develop a plan of action for using various platforms that will best suit the needs of what the organization is trying to achieve. Without initial planning and staying engaged with audiences, the time devoted to social media may be wasted effort.

References

Dowd, N. (2013) Social Media: libraries are posting, but is anyone listening?, *Library Journal*, May, http://lj.libraryjournal.com/2013/05/marketing/social-media-libraries-are-posting-but-is-anyone-listening/.
Webb, H. and Laing, K. (2015) Engaging with Social Media: the Emily Carr University of art and design library experience, *Art Documentation: Journal of the Art Libraries Society of North America*, **34** (1), 137–51.

Chapter 30

Website strategies for art and design libraries

Judy Dyki

Introduction

Art and design libraries are in the enviable position of having visually stunning collections with which to create websites that appeal to their visually oriented clientele. Since websites are almost always the starting point for students seeking information, it is particularly important for art libraries to take full advantage of their online presence. The sky is the limit when it comes to website design and content, and the more innovative and visual the site is, the more it will resonate with students.

The reality, however, is that website options may be limited for art and design libraries. In many cases, the library's site is part of a larger website for a university or independent art and design school. The library may be required to use the organization's platform, design and sometimes even the website template. Library staff may view this as an unfortunate restraint that necessitates a mundane library website. Staff should instead consider the psychology of limitations and embrace the design philosophy that rules and constraints can benefit one's creativity rather than constrict it (Allsopp, 2013). This creativity is vital for connecting with art and design students. *The Five Obstructions*, a film in which Danish filmmaker Lars von Trier challenges his colleague Jørgen Leth to remake the same film five times – each time with a different set of restrictions and rules – should be required viewing for any team preparing to plan a new website (von Trier and Leth, 2003).

First impressions and a lasting relationship

Since web users are an impatient group – the average time spent on a page is 15 seconds (Mineo, 2014) if the site is not compelling or the information is not readily available – the website of an art and design library must immediately hold visitors' interest and entice them to explore further. The website is the most important vehicle to introduce students to the resources and culture of the library, so the first visit that students make sets the tone for their ongoing relationship with the library and the library staff. Students need to

see immediately that the library has extensive resources that will support their research and/or studio work. If the website is rich in images and perhaps just slightly quirky in design and character, studio art students will sense immediately that the library is an inviting place that understands their needs and that the library staff are creative and fun individuals who enjoy working with artists. Many studies (Cobbledick, 1996; Cowan, 2004; Hemmig, 2009) have shown that artists are reluctant library users; the website is an easy first step in helping them discover the relevance and value of libraries.

Once students are convinced that the library's website is worth exploring, all pages must continue to deliver the message that the library has services and collections that are tailored to their specific needs, whether they are art historians, art educators, artists or designers. Information must be easy to find through logical navigation. Regular updates to and fresh content for the site will give students a reason to return often. For a generation that uses the web for everything from banking to ordering groceries, the more functions that students can complete online (renewing books, paying fines, requesting interlibrary loan books, making acquisitions recommendations), the more often they will be back. The use of social media – Facebook, Instagram, Twitter and blog posts – to link to the library website will also help to drive traffic and draw attention to the resources and collections.

Content: beyond the basics

When approaching a library website, users anticipate that certain basic elements will be present on the site: a link to the online catalogue, library hours, collection information, contact information and location. More fully developed sites will offer resources such as a gateway to electronic resources, tutorials, virtual reference, new acquisitions displays and library blogs (Burke, 2016, 87–90). In 2006, Mychaelyn Michaelec conducted a study of the websites of 82 art libraries to analyse their content, design, placement of elements within the site, colours and graphics, and the simplicity of the library's URL. Although websites have transformed dramatically in the 11 years since the study was completed, Michaelec (2006) makes valuable observations about the importance of design and images to art library websites in particular, while still paying attention to navigation, readability and accuracy of information and links.

Art and design libraries have an advantage with their visually oriented collections. If a library has the ability to create online guides with images for special collections, students will be drawn in to visit the library to explore them. The web-based representation of the Joan Flasch Artists' Book Collection at the School of the Art Institute of Chicago's John M. Flaxman Library (http://digital-libraries.saic.edu/cdm/landingpage/collection/jfabc) is an excellent example of an eye-catching digital presentation. The Royal Academy of Art Library (https://www.royalacademy.org.uk/collections-and-research) uses attractive graphics to introduce each of its special collections. The Book Arts Collection at the Maryland Institute College of Art's Decker Library (https://danube.mica.edu/library/ABCat/site/index.cfm) has a searchable, image-rich interface.

Many art and design libraries have an exhibition space within the building to feature items from their special collections. Providing an online version of these exhibitions is another way to introduce students to the library's collections and resources. The Fleet Library at the Rhode Island School of Design includes documentation and images from its exhibitions along with subject guides to its special collections (http://risd.libguides.com/specialcollections).

If the library building itself is historically significant or architecturally interesting, images will add to the online representation of the institution's unique character. Photographs of activities that take place in the library can bring to life the personality of the facility. Many art and design students like to create installations and stage performances in the library. Documentation of these events will help to establish the library as an integral space for students. The Minneapolis College of Art and Design uses Flickr to post images of the library's activities and collections (https://www.flickr.com/photos/69184488@N06/collections); the library's website provides a prominent link to this image collection.

Library blogs and/or news posts are a great way to provide current information on activities, new acquisitions, featured collections, playful images or fascinating facts about the library and its resources. However, this type of feature is labour-intensive and requires the full commitment of the library staff to keep it active and interesting. There is nothing worse than a blog with outdated posts; staff must consider the workload carefully before introducing this feature.

Technical considerations

If an art and design library is required to use the website of the parent organization, many of the technical decisions will already have been made. However, if the library has some independence in developing its own website, there are many options for constructing a site that attracts the creative audience for which it is intended yet can be maintained successfully by the library staff. The temptation may arise to hire a web designer to craft a spectacular site, but if the library staff do not have the skills needed to refresh the information, the site will quickly become out of date. Websites need to change and evolve to keep current with the shifts in libraries and technology and to incorporate developments in contemporary art. Website planners would do well to paraphrase and evoke S. R. Ranganathan's fifth law of library science: 'The library [website] is a growing organism':

> It is an accepted biological fact that the growing organism alone will survive. An organism which ceases to grow will petrify and perish. The fifth Law invites our attention to the fact that the library [website], as an institution, has all the attributes of a growing organism. A growing organism takes in new matter, casts off old matter, changes in size, and takes new shapes and forms.
>
> (Ranganathan, 1931, 382)

There are myriad manuals available to guide website development. The topics listed below outline just a few of the decisions to be made during the early stages of planning.

Platform

If developing a website from scratch, the options for creating the site can be overwhelming. Using a content management system such as Drupal or WordPress may be the best answer. Drupal is a high-end system that is difficult for non-specialists to learn. Unless the library has permanent access to a web developer, Drupal should probably be avoided. WordPress is friendlier for those who have limited web development skills and may be a better choice.

Other options exist, including developing the site with HTML; the use of LibGuides as the website; the use of the discovery layer of a library management system as a website; or an all-in-one website builder such as Squarespace or Sitebuilder.com. The more customized and flexible a site is, the better it will serve the library's purposes.

Navigation

Logical menus and links that allow users to move around a website and find what they need are critical for a successful web design. Even before the design process begins, it is good practice to create a site map or flowchart of the primary and secondary menus so staff can visualize the structure of the site and ensure there is a logical place for each piece of information. Menus may be placed at the top and/or sides of the page, and additional quick links can be placed at the bottom. Avoid the temptation to use fun and creative labels for the menus, as it is always better to opt for clear, descriptive titles so users do not need to pause and guess what they mean. Although it is impossible to anticipate all future sections that may be added to the site, thinking ahead a few years will result in flexibility and capacity for expansion.

Responsive design

More often than not, a library's website will be accessed on a smartphone or tablet rather than a full-sized computer, so the site must look great and function well on any size of screen. Responsive design allows the site to scale itself to fit the device. As a site is being developed, it is imperative to pause constantly to see how it displays on different sizes of screens.

Accessibility

Although a website created for art students should rightly have a creative design and be rich in images, it is also necessary to consider accessibility and compliance with the Americans with Disabilities Act (ADA). The site should work well with assistive technologies, use alternative text tags and provide descriptive text descriptions that do

not rely on the viewer being able to distinguish particular colours. Keyboard navigation should be available for viewers unable to use a mouse.

Analytics

To determine the success and effectiveness of a website, it is beneficial to know how many visitors access each page, how long they stay on the pages, the path they took to arrive at the page (typed in a search engine, linked from another web page, directed from a social media site), the web browser they are using and much more. Some analytic tools are normally built into a web platform, but the most common add-on tool is Google Analytics. This can be embedded into any website and provides very specific, page-level statistics. This information may then be used to make adjustments to the site to increase its value for students.

Search engine optimization

Search engine optimization is a process that allows a website to be ranked higher than other search engines in results lists. It consists of adding words and phrases to the site's text and the meta tags that describe the content. Since search engines cannot read text embedded in images, it is important to provide descriptive alternative text for any graphics included in the site.

Linked open data

Staff working in art and design libraries that place their special collections online should stay informed about the advances in metadata, linked open data, BIBFRAME (Bibliographic Framework) and other tools for sharing information and linking collections (Jones and Seikel, 2016; van Hooland and Verborgh, 2014). Although much of the development is taking place in the museum world, libraries are gaining leadership status in prototypes and testing. The concept of separate silos of information is giving way to data shared among all types of cultural institutions: libraries, archives and museums.

Web archiving

If the library's website changes drastically in a redesign effort, or if there is web content to which the site links that may be ephemeral and at risk of disappearing (a frequent occurrence with contemporary art sites), library staff should consider web archiving to preserve the sites. Many tools are now available to libraries for this purpose. Staff would need to create a plan and methodology, including the selection criteria for the sites to be archived, collection methods, cataloguing, preservation and data storage (Brown, 2006, 163–83).

Conclusion

A website can represent the heart, soul and personality of an organization. In addition to providing basic information about collections and services, well designed art and design library websites have the potential to create excitement and curiosity on the part of visually oriented students. Website platforms, functionality and design aesthetics change at a lightning pace, but keeping the library site current and fresh is well worth the time and effort. A compelling website is the first step in drawing in reluctant art students who have yet to discover that the library has valuable resources to support their practice and career – and staff who understand and celebrate the artistic personality.

References and bibliography

Allsopp, A. (2013) Why Placing Limitations on Yourself is the Key to Creativity, *DigitialArts*, 13 May, http://www.digitalartsonline.co.uk/features/creative-business/why-placing-limitations-on-yourself-is-key-creativity.

Brown, A. (2006) *Archiving Websites: a practical guide for information management professionals*, Facet.

Burke, J. J. (2016) *Neal-Schuman Library Technology Companion: a basic guide for library staff*, 5th edn, Neal-Schuman.

Clark, J. A. (2015) *Responsive Web Design in Practice*, Rowman & Littlefield.

Cobbledick, S. (1996) The Information-Seeking Behavior of Artists: exploratory interviews, *Library Quarterly*, **66**, October, 343–72.

Cowan, S. (2004) Informing Visual Poetry: information needs and sources of artists, *Art Documentation*, **23** (2), 14–20.

Felke-Morris, T. A. (2016) *Basics of Web Design: HTML5 & CSS3*, 3rd edn, Pearson.

Fons, T. (2016) *Improving Web Visibility: into the hands of readers*, ALA TechSource.

Haefele, C. (2015) *Wordpress for Libraries*, Rowman & Littlefield.

Hemmig, W. (2009) An Empirical Study of the Information-Seeking Behavior of Practicing Visual Artists, *Journal of Documentation*, **65** (4), 682–703.

Jones, E. and Seikel, M. (eds) (2016) *Linked Data for Cultural Heritage*, ALA Editions.

Michaelec, M. (2006) A Content Analysis of Art Library Web Sites, *Art Documentation*, **25** (2), 46–54.

Mineo, G. (2014) 55% of Visitors Spend Fewer than 15 Seconds on Your Website: should you care?, *HubSpot*, 14 March, https://blog.hubspot.com/marketing/chartbeat-website-engagement-data-nj#sm.00001mzg0bnfr8e0lu0hwgmztdazs.

Ranganathan, S. R. (1931) *The Five Laws of Library Science*, Madras Library Association.

Tidal, J. (2015) *Usability and the Mobile Web*, ALA TechSource.

van Hooland, S. V. and Verborgh, R. (eds) (2014) *Linked Data for Libraries, Archives and Museums: how to clean, link and publish your metadata*, Neal-Schuman.

von Trier, L. and Leth, J. (2003) *The Five Obstructions*, film, Zentropa Real ApS.
Wittmann, S. A. and Stam, J. T. (2016) *Redesign Your Library Website*, Libraries
 Unlimited.

Appendix: library profiles

Beth Morris

Art and design libraries provide support for research, instruction and study through a multitude of resources, collections and spaces. Ranging from department-based collections to a corpus of materials located within main campus libraries, art and design librarianship varies by institution, and its mission and constituents. Librarians are responsible not only for identifying, selecting and gathering the most pertinent resources, but also for providing access to these materials and enabling discovery through enhanced records, catalogues, digital interfaces and, more often, direct instruction.

Supporting academic curricula through library collections involves understanding the scope and extent of an institution's programme, specific areas of emphasis or specializations of faculty, as well as the needs of constituents in accessing and using materials. By understanding the intended audience and the full scope of the academic curricula, art and design librarians can draw across collections while also developing unique and special resources that are critical for student and faculty development. The notion of the 21st-century collection is boundless and complex; materials extend from the physical and contextual to the digital and visual.

Four categories of art and design libraries and collections are profiled to provide a closer examination of the range of libraries in which curricula support for art and design students and researchers can be met. This chapter describes the diversity of potential opportunities for art and design librarianship in higher education. The four categories are art and design school libraries, academic branch libraries, academic department-based libraries and main academic libraries supporting art and design curricula. Each profile provides basic information on size, hours, circulation and staffing, as well as facilities, access and collections.

Art and design school libraries

Cranbrook Academy of Art Library

Web: http://cranbrookart.edu/library
Size: 7000 sq. ft
Weekly operating hours: 60 hours
Visitors yearly: 14,000
Circulation yearly: 20,500
Integrated library system (ILS): SirsiDynix Horizon
Staffing: 2 professional librarians (head: Library Director); 1 part-time
 paraprofessional; 12 student assistants; the Library Director reports to the Director
 of Cranbrook Academy of Art.

Facilities and access

Designed by Eliel Saarinen, Cranbrook Academy of Art Library opened in 1942 and is
currently listed on the National Register of Historic Places. The library provides four
work stations with printing, photocopying and scanning capabilities; 25 study spaces
without work stations; and one multi-purpose room for conferences, meetings or group
study. The main constituent groups are graduate students, faculty and staff at the
Academy, curatorial staff at the Cranbrook Art Museum and the general public.

Collections

The extensive collections of Cranbrook's library are focused on the ten visual arts
disciplines offered at the Academy and also provide contextual works in art history,
criticism, artists' writings, performance art and other related fields. Special collections
includes materials on student theses and masters' statements, images of student work,
fine art folios and Cranbrook Press books. The library contains approximately 30,000
print volumes, 7000 bound serials, 4200 masters' theses, 1700 DVDs, 1300 VHS tapes, 195
current serial subscriptions, 52 research databases and 70 linear feet of vertical files.

Emily Carr University of Art and Design Library

Web: www.connect.ecuad.ca/library
Size: 10,677 sq. ft
Weekly operating hours: 70 hours
Visitors yearly: 139,000
Circulation yearly: 26,100
ILS: Evergreen
Staffing: 5 professional librarians (head: University Librarian); 7 paraprofessionals;
 student assistants; the University Librarian reports to the Vice President Academic
 and Provost.

Facilities and access

The Emily Carr University of Art and Design Library includes 15 computer workstations, 2 study rooms, 3 flatbed scanners, 1 book scanner, 5 media stations, a light table, an interactive table, 10 study carrels and 30 iPads for loan. The main users of the library are students, staff, faculty, alumni and community members. The library will move to a new campus in summer 2017.

Collections

The mission of the library's collection is to support the teaching and learning curriculum of the University, with an emphasis on visual arts and design. The collection includes 37,630 print volumes, 225 serial subscriptions and 6100 print serial volumes, 4378 video and films, 725 audio resources, 111,000 slides, 32,780 electronic books and 11,000 streaming electronic media. There is a growing collection of approximately 1800 artists' books.

Rhode Island School of Design, Fleet Library

Web: https://library.risd.edu
Size: 55,000 sq. ft
Weekly operating hours: 88 hours
Visitors yearly: 220,000
Circulation yearly: 98,000
ILS: Sierra
Staffing: 6 professional librarians (head: Dean of Libraries); 10 paraprofessionals; 1.5
 full-time equivalent (FTE) paraprofessionals; 8 FTE student assistants; the Dean
 of Libraries reports to the Provost.

Founded in 1878, Fleet Library is one of the oldest independent art college libraries in the country and occupies the former Rhode Island Hospital Trust Bank building, with the grand banking hall serving as the library's main reading room. The focus of the library is to provide tangible collection resources on the fine arts, architecture, photography, and decorative arts and design, with an emphasis on modern and contemporary art, design practice, and art and design research.

Facilities and access

Fleet Library provides 25 computer workstations, 200 additional seats, conference and group study rooms, and a café, in addition to the main reading room and additional reading room for Special Collections and Archives. There is also a materials resource library, picture collection, graphic design archive and shared faculty computer lab. Fleet Library serves the teaching and research needs of the RISD faculty, RISD Museum

curators and staff, and provides service to all RISD undergraduate and graduate students, alumni and staff, as well as the larger public.

Collections

The collections consist of approximately 160,000 print volumes and 327 serial subscriptions with 17,984 volumes located on-site. Electronic content numbers over 794 electronic journals with subscriptions to 48 electronic databases, 145,000 electronic books, 10,366 media recordings, and access to 14 million digital images. Other physical collection items include 3144 cubic feet of archives, over 32,000 lantern slides, 34,000 circulating design material samples, and 535,306 visual resources from picture clippings, prints, posters, maps and postcards. Special collections include approximately 16,000 special periodicals and 3028 artists' books.

University of the Arts London, Libraries

Web: www.arts.ac.uk/study-at-ual/library-services
Size: 99,210 sq. ft
Weekly operating hours: 106 hours, varies by location
Visitors yearly: 1.3 million
Circulation yearly: 340,000
ILS: Koha, supported by PTFS Europe
Staffing: 130 staff across 6 college libraries (head: Director of Libraries); the Director of
 Libraries and Academic Support Services reports to the Deputy Vice Chancellor,
 Academic.

University of the Arts London (UAL) is the largest specialist art and design university in Europe and consists of six renowned colleges: Camberwell College of Arts, Central Saint Martins, Chelsea College of Arts, London College of Communication, London College of Fashion and Wimbledon College of Arts. Library Services span all six colleges and feature a distinct library in each college, along with two learning zones and the Archives and Special Collections Centre.

Facilities and access

The six libraries have approximately 2000 study spaces and 400 workstations in total. The learning zones are featured at Central Saint Martins and London College of Communication. They provide informal facilities for developing student culture and peer support with an emphasis on digital production and making. UAL libraries serve over 19,000 students and 2500 academic staff, as well as creative practitioners, researchers and the general public.

Collections

The UAL Collections include approximately 500,000 print volumes, 7500 electronic books, 36,000 serial titles and 80 databases, with 5905 linear feet of archival and special collection materials. Areas comprehensively covered within the Archives and Special Collections are art, design, communication, fashion and performance, with unique materials including zines, artists' books, artists' multiples, the African-Caribbean, Asian and African Art in Britain Archive, Materials and Products Collection, the Stanley Kubrick Archive, and other media collections, including photography, film, sound arts and graphic design. The UAL libraries support the pedagogic institutional mission for inquiry and object-based learning, while the spaces facilitate visual browsing and making. Overall there is an emphasis on materials, and the collections serve as a source of inspiration.

Virginia Commonwealth University Qatar, VCUQatar Library

Web: www.qatar.vcu.edu/library
Size: 12,000 sq. ft
Weekly operating hours: 60
Visitors yearly: 85,000
Circulation yearly: 4300
ILS: ExLibris Alma
Staffing: 3 professional librarians (head: Director); 5 paraprofessionals; 5 student
assistants; 2 interns; the Director reports to the Associate Dean for Academic
Affairs.

VCUQatar Library provides comprehensive holdings in art, design and architecture that are aligned with the learning curricula of the institution. The Library is a unique resource for the creative community within Qatar and the Gulf region.

Facilities and access

Within the library there are 6 study rooms, a gaming lab, 16 computer workstations, a copy and scanning room, 20 study carrels and soft seating; outside the library are the Materials Library and Innovative Media Studio, overseen by the main library staff. The primary users of the library are the students and faculty of VCUQatar, but as the campus is located on the Education City campus, a shared campus environment, other higher education students make great use of the collections, as do the general public.

Collections

Focusing primarily on art, design and architecture, the collections also provide resources for support of the liberal arts general education. With approximately 45,000 print volumes

and 200 print serial subscriptions, VCUQatar Library also draws on the electronic collections of the University, which number over 648,000 electronic books and 60,000 electronic journals. Additionally there are 400 linear feet of archives and special collections, which include materials on institutional history and digital images. There are also noteworthy collections of illustrated children's books and artists' books. Owing to its location, the library is also particularly interested in materials relating to the Middle East and art and design in the Islamic world.

Academic branch libraries

Duke University, Lilly Library

Web: https://library.duke.edu/lilly
Size: 42,000 sq. ft
Weekly operating hours: 129 hours
Visitors yearly: 483,696
Circulation yearly: Unknown
ILS: Aleph
Staffing: 7 professional librarians, including a visual studies librarian (head: Branch Head Librarian); 5 paraprofessionals; 31 student assistants; the Branch Head Librarian reports to the Associate University Librarian for Branch and Public Services.

Facilities and access

Lilly Library was built in 1927 and functions as the main undergraduate library on campus, as well as the library dedicated to art, dance, film and philosophy. The main constituents are undergraduate and graduate students related to those disciplines. Renovations in 1993 updated the space and provide 45 student carrels, 6 study rooms, 2 main reading rooms, 2 multi-purpose rooms, a computer lab and 8 individual study areas located within the stacks. The library also provides 4 scanning stations with overhead book scanners, a quarto book scanner and a large flatbed scanner. The library maintains a small exhibition space near the entrance, as well as a browsable, current exhibitions catalogue that encompasses 15 major art museums.

Collections

With 153,000 print volumes on-site and 30,000 print titles off-site, Lilly Library provides a sizeable collection for research into art, dance, film and philosophy; the collection features particular areas of emphasis related to art markets, historiography, documentary photography and 19th-century France. The collection holds 6720 linear feet of moveable stacks and 330 linear feet of stationary stacks dedicated to fine art.

Pennsylvania State University, the Eberly Family Special Collections Library

Web: https://libraries.psu.edu/specialcollections
Weekly operating hours: 40–48 hours
Circulation yearly: Non-circulating
ILS: SirsiDynix
Staffing: 8 professional librarians (head: Head of Special Collections); 12
 paraprofessionals; 4 interns, student assistants and/or graduate assistants; the Head
 of Special Collections reports to the Associate Dean.

Facilities and access

In addition to the main reading room and separate reference room, the library provides
30 seats, 4 computer workstations, 2 scanners, a copier, a microfiche reader and an
audiovisual station. There is a large exhibition gallery adjacent to the reading room
specifically for special collections. The Eberly Family Special Collections Library serves
undergraduate and graduate students, early and tenured faculty, and the general public,
with strengths in art, architecture, English, comparative literature and history.

Collections

The Eberly Family Special Collections Library has over 200,000 printed volumes; over
25 million archival records and manuscripts; over 1 million photographs, maps and
audiovisual items; and approximately 60 terabytes of digital audiovisual materials and 2
terabytes of born-digital archives. There are broad holdings in diverse subjects such as
science fiction and utopian literature, labour history and labour organizations, political
propaganda, fine press publishing, artists' books, African-American and diaspora
literature, dance and costume history, architecture, children's literature, moveable books,
sports history, local history and the Penn State University Archives. Notable manuscript
collections include Lynd Ward's wood engravings and graphic art, and the papers of
graphic designer Chip Kidd.

Princeton University, Marquand Library of Art and Archaeology

Web: http://library.princeton.edu/marquand
Size: 46,000 sq. ft
Weekly operating hours: 100 hours
Visitors yearly: 150,000
Circulation yearly: Non-circulating
ILS: Voyager, with Blacklight for interface
Staffing: 2 professional librarians (head: Librarian); 3 professional staff; 5
 paraprofessionals; 9 FTE student assistants; the Librarian reports to the Deputy
 University Librarian.

One of the oldest and most extensive art libraries in America, Marquand Library of Art and Archaeology was officially established in 1908 with a gift from Professor Allan Marquand. Teaching with special collections has been integral to art history pedagogy at Princeton University, and continues in this same tradition, along with collaborative digital projects and initiatives such the Blue Mountain Project, digital library of avant-garde arts journals, and the Digital Cicognara Library.

Facilities and access

Renovated and expanded in 2003, Marquand Library spans 5 floors of McCormick Hall and provides 160 individual table and lounge seating and 109 private study carrels for users. For rare books, there is a separate reading room and vault. Additionally there are 5 media-ready classrooms, one of which is frequently used for class consultations and bibliographic instruction. The library serves Princeton's community of students, faculty and scholars, with its main constituents consisting of faculty, students and post-doctoral associates in the Department of Art and Archaeology, curators of Princeton University Art Museum, the Index of Christian Art editors, and faculty and scholars of the Institute for Advanced Study.

Collections

The library has over 500,000 print volumes, 7500 rare books, 1400 current serial subscriptions, thousands of microform, and 500 linear feet of vertical files. Additionally there are numerous electronic formats for books and journals, image databases, videos and other forms of media. Marquand Library collects current and antiquarian resources in the fine and decorative arts, photography, media and performance art, architecture, urbanism, garden design and archaeology. The collection is comprehensive from antiquity to the present, and the library acts as a library of record by preserving historic editions and retrospectively purchasing materials to fill gaps while supporting emerging areas of interest. Special collections holdings range from the 15th century to the present.

Southern Methodist University, Hamon Arts Library

Web: www.smu.edu/CUL/Hamon
Size: 46,000 sq. ft
Weekly operating hours: 90 hours
ILS: Voyager
Staffing: 5 professional librarians (head: Library Director); 2 curators; 1 archivist; 2 paraprofessionals; student assistants; the Library Director reports to the Dean of Central University Libraries.

Facilities and access

Recent renovations have provided Hamon with 14 study rooms, 27 computer workstations, a conference room for faculty and staff, a large room with enhanced audiovisual capabilities for meetings, and a visual resources library. The Mildred Hawn Exhibition Gallery is located in the Hamon Arts Library and provides rotating exhibitions throughout the year from professionals in the visual and performing arts. The library primarily provides services for students and faculty of the Meadows School of the Arts at Southern Methodist University (SMU), but also assists all SMU faculty, staff and students, as well as members of the local arts community.

Collections

There are 152,000 print resources including microfilm, 300 serial subscriptions, over 10,000 music recordings, 21,000 vinyl LP recordings, and access to 539 databases. Special collections include the Bywaters Special Collections on the arts, which has a large corpus of digital collections, and the G. William Jones Film and Video Collection. The collection's scope is aligned with the curricula of the Meadows School of the Arts, which includes art, music, dance, theatre, film studies, journalism, corporate communication and advertising.

Academic department-based libraries

Fashion Institute of Technology, Visual Resources

Web: www.fitnyc.edu/history-of-art/visual-resources.php
Size: 350 sq. ft
Weekly operating hours: 40 hours
Visitors yearly: Faculty only
Circulation yearly: Non-circulating
ILS: Madison Digital Image Database
Staffing: 1 curator; 1 technician; the curator reports to the Chair of the History of Art Department.

Facilities and access

Visual Resources is an image collection located within the History of Art Department of the Fashion Institute of Technology. Visual Resources provides faculty with access to 3 scanners, 2 printers, a copy stand, and a digital single-lens reflex camera with multiple lenses. Faculty members also have access to presentation clickers, USB drives, various cables, Blu-Ray drives, and additional technological equipment. Although the prime constituents of Visual Resources are the History of Art Department faculty, the Visual Resources staff also provide services to faculty and other staff of the School of Liberal Arts. They also offer in-class student instruction, research assistance, digital media assistance, technology help and digitization services.

Collections

Visual Resources hosts over 65,000 digital images and has a physical collection of 10,000 35mm slides. All images in the collection are primarily focused on art history and are encyclopaedic in nature from ancient to contemporary works, with no restraints on period or culture. The collection includes images of all forms of media, including painting, sculpture, architecture, prints and more, with a special emphasis on textiles and costume history.

Syracuse University, School of Architecture, Architecture Reading Room

Web: http://library.syr.edu/about/locations/arr/index.php
Size: 2292 sq. ft
Weekly operating hours: 86 hours
ILS: Voyager
Staffing: 1 professional librarian; 16 student assistants.

Facilities and access

The Architecture Reading Room (ARR) provides embedded collections directly within the School of Architecture to meet users' needs. It is supported jointly by the School of Architecture and Syracuse Libraries. Occupying three rooms on the third floor of the School of Architecture building, the ARR consists of the services area, the Working Drawings Room and the Main Collections Room. With an embedded location, the ARR provides quick access to print materials, current serials, reserves and reference resources. Photocopiers, multiple scanners and networked computer stations are available for use by School of Architecture students and faculty, landscape architecture students and staff in the State University of New York system, and anyone else requiring use of core architecture resources.

Collections

The ARR collection consists of a group of 1500 print volumes, which form the Reserve Collection of core materials on permanent reserve. It also has over 3500 print volumes located in the open stacks, which provide general information on architecture, basic surveys, architect biographies, building studies and technology resources. Other collection items include current serial titles related to architecture that are retained for approximately one year, a working drawings collection with approximately 300 sets, and the materials collection with more than 6500 samples of physical materials such as wood, stone, tile, plastics, acrylics, fabric and metals.

Main academic libraries supporting art and design curricula

California State University, Los Angeles, John F. Kennedy Memorial Library

Web: http://web.calstatela.edu/library
Size: 350,000 sq. ft
Weekly operating hours: 90.5 hours
Visitors yearly: 1.2 million
Circulation yearly: 500,000
ILS: Millennium
Staffing: 11 professional librarians, including the Media, Arts and Web Librarian
(head: Dean of University Library); 5 professional staff; 18 paraprofessionals; the
Dean of University Library reports to the Provost.

Facilities and access

With over 100 computer stations, 30 study rooms, 700 individual carrels and multiple
open seating areas, John F. Kennedy Library provides ample space for users to study or
collaborate. The library includes the Center for Effective Teaching and Learning,
exhibition space, a café, and multiple copiers and scanners. Recent renovations included
the removal of outdated reference stacks in order to provide an enhanced user services and
reserves stack area. Current renovations are under way to provide more study spaces,
updated aesthetics and 40 additional computer stations.

Collections

The John F. Kennedy Library holds approximately 864,000 print volumes and 142,890
electronic books, and subscribes to 289 serial titles. Additional access is provided to 181
databases and 11,726 media resources. There are approximately 3000 linear feet of
materials in the Archives and Special Collections. The focused areas of study in art and
design include animation, art education, art history, graphic design and visual
communication, fashion and textiles and studio art. The main collection supports
undergraduates and graduates, as well as faculty and staff; other constituents include
local community college and high school students, community members from other
California State University campuses and the general public.

Denison University, William Howard Doane Library

Web: http://denison.edu/campus/library
Size: 73,474 sq. ft
Weekly operating hours: 115 hours
Visitors yearly: 230,420
ILS: CONSORT Millennium

Staffing: 10 professional librarians, including the fine arts librarian (head: Director of Libraries); 13 FTE paraprofessionals; 10 FTE student assistants; the Director of Libraries reports to the Provost.

Facilities and access

The William Howard Doane Library occupies 7 floors and contains an information commons, 11 study rooms for group and quiet study, and the University Archives & Special Collections Resource Center. There are 52 computer workstations and 750 seats for study, a viewing room for review of media, a traditional classroom, and an electronic classroom that is fully networked, wireless enabled for 18 spaces, and includes a SMART board interactive screen. The library is open to all students, faculty and staff at Denison University.

Collections

Supporting the curricula of all fine arts programming at Denison, including art history and visual culture, studio art, cinema, dance, music, creative writing and theatre, there are over 51,000 print volumes, 11,000 electronic books, and over 600 print and electronic serials available; 32 databases expressly support research in these disciplines, and the University Archives and Special Collections hold over 250 artists' books for further exploration into the arts, architecture, dance, cinema and creative writing.

Oakland University, Kresge Library

Web: https://library.oakland.edu
Size: 164,522 sq. ft
Weekly operating hours: 168 hours
Visitors yearly: 650,000
Circulation yearly: 21,361
ILS: Voyager
Staffing: 13 professional librarians; 3 part-time librarians (head: Dean of Libraries); paraprofessionals; the Dean of Libraries reports to the Provost.

Facilities and access

Operating 24 hours daily, the Kresge Library provides more than 150 public workstations, several breakout rooms, 'cabanas' with computers linked to presentation screens, and approximately 80 individual and group study rooms that seat up to 1700 students. The library has a café, and a makerspace is under construction. Access to the library and its resources is available to undergraduate and graduate students, medical students, faculty, staff and the general public.

Collections

As the main library on campus, Kresge Library contains general encyclopaedic collections within the arts to facilitate undergraduate research in art and art history. The collection contains approximately 797,000 print volumes, 93,000 electronic books, 54,100 serial titles and 316 databases. Special Collections and University Archives provide rare and unique materials in digital and physical formats.

University of Colorado Boulder, University Libraries, Art and Architecture Collection

Web: www.colorado.edu/libraries
Weekly operating hours: 97 hours
Circulation yearly: 217,205
ILS: Sierra
Staffing: 76 professional librarians and staff, including the art and architecture librarian (head: Dean of Libraries) 92 paraprofessionals; 48 FTE student assistants; the Dean of Libraries reports to the Provost.

Facilities and access

When it opened in 1940, Norlin Library served as the main library; expansions have been added in 1964 and 1976. The Art and Architecture Collection in Norlin Library is located at the University of Colorado Boulder and provides numerous quiet and collaborative study areas, workstations, 15 individual and group study rooms, and four classrooms for instruction. A reading area for consulting art and architecture serials is near the Art and Architecture Collection and facilitates greater access to resources. The main constituents of the library include undergraduate and graduate students, faculty and staff, and the greater community of the Rocky Mountain region.

Collections

University of Colorado Boulder Libraries has approximately 5.5 million monograph titles, 7.6 million print volumes and 984,952 electronic books. Within the Art and Architecture Collection there are over 70,000 print volumes on-site, with further titles located in off-site storage. The collection is encyclopaedic in scope; emphasized areas of the collection include the art and architecture of the Middle Ages, Renaissance, Baroque and Modern periods. Holdings throughout the library's collection provide in-depth resources on the history of the UK and the American West. The library is currently working to enhance resources to support research in Latin America and Asian and Contemporary Art.

University of Vermont, Bailey/Howe Library

Web: http://library.uvm.edu

Size: 169,231 sq. ft
Weekly operating hours: 104 hours
Visitors yearly: 980,000
ILS: Voyager
Staffing: professional librarians and staff (head: Dean of Libraries); paraprofessionals; student assistants; the Dean of Libraries reports to the Provost.

Facilities and access

Bailey/Howe Library provides 8 group study rooms, 2 instruction classrooms, numerous workstations, a media lab with viewing stations and a 3D printer. The library is also home to the Center for Digital Initiatives, the Writing Center, the Teaching and Learning Center, the Foundational Writing and Information Literacy Program and the Writing in the Disciplines Program. In 2017 a connecting bridge linked the library's first floor to a new student residence hall, providing quick and easy access for students on campus. Collections and services are primarily geared towards faculty, staff, undergraduate and graduate students, and the community at large.

Collections

As the main library on campus, Bailey/Howe Library has a robust and vibrant collection that serves the needs of all disciplines at the University of Vermont. The collection has approximately 2,977,500 print volumes, 45,900 serial titles, 352,000 electronic books and 90,500 electronic journals. The library subscribes to 767 databases. The collection includes 19,370 media resources and 8400 electronic media. The library collects at all research levels in order to provide materials beneficial to faculty and graduate student research, as well as materials geared towards the interdisciplinary nature of undergraduate research. Special collections contain unique material, such as the Vermont Research Collection, Rare Book Collection and University Archives.

Valparaiso University, Christopher Center for Library and Information Resources

Web: http://library.valpo.edu
Size: 105,000 sq. ft
Weekly operating hours: 105 hours
Visitors yearly: 737,000
Circulation yearly: 25,000
ILS: Innovative Millennium
Staffing: professional librarians and faculty (head: Dean of Library Services); paraprofessionals; student assistants; interns and volunteers; the Dean of Library Services reports to the University Provost.

Facilities and access

With abundant natural light created by two primary structural glass walls, the Christopher Center for Library and Information Resources was designed by the architectural firm of Esherick, Homsey, Dodge and Davis. The Christopher Center provides access to 125 public computer stations, 25 study carrels, two classrooms, 18 study rooms, an exhibition space and a singular main reading room. The library includes other services, such as the Writing Center, Disability Support Services, IT Help Desk, Academic Success Center, VisBox technology and a coffee shop. The main constituents of the library are faculty, staff, undergraduate and graduate students and the local community.

Collections

The collection includes Lutheran materials and more than 600,000 print volumes, 150 databases and varied digital collections to support the research needs of the academic curriculum. The Archives and Special Collections are home to the Idael Makeever Collection and the Wienhorst Collection, along with numerous rare and unique objects that further enhance study and research.

Yeshiva University, Yeshiva University Libraries

Web: www.yu.edu/libraries
Size: 127,309 sq. ft
Weekly operating hours: 85.5 hours
Visitors yearly: 520,000
Circulation yearly: 45,780 print and electronic volumes
ILS: Virtua Innovative
Staffing: 14 professional librarians (head: Director of University Libraries); 4
 professional staff; 13 paraprofessionals; 10 student assistants; the Director of
 University Libraries reports to the Provost.

Facilities and Access

Comprising Pollack Library, Mendel Gottesman Library of Hebraica-Judaica, Hedi Steinberg Library and Archives and Special Collections, the university libraries provide 183 carrels, 48 workstations, 12 group study rooms, an instruction laboratory and a collaborative space. A 2015 renovation doubled seating space, provided access to natural light, installed a ground-floor café, added an information commons and created a laboratory for user education. The libraries serve the undergraduate students, graduate students and faculty of Yeshiva University in addition to providing resources and services to visiting researchers.

Collections

Yeshiva University Libraries hold more than 1,215,900 printed volumes, 649,561 electronic books, 8000 serial titles in print and 170,743 electronic journals. The Libraries provide access to 1025 databases and have over 6000 linear feet of archives and special collections. While Hebraica and Judaica are the strongest collections, the libraries also support the biomedical and social sciences, law, business, literature, languages and the arts. Art and design students regularly engage with resources in special collections and archives, such as realia, Judaic rare books and manuscripts, Sephardic publications and extensive archival materials documenting the Jewish experience.

Index